NATIONAL GALLERY CATALOGUES

THE
SPANISH SCHOOL

BY

NEIL MACLAREN

revised by

ALLAN BRAHAM

The first series of major catalogues of the various Schools of Painting in the National Gallery Collection was launched in 1945. The series is now being extensively revised. *The Early Italian Schools Before 1400* was published in 1988 and *The Dutch School* will be published in 1989.

Meanwhile six of the original text volumes have been reprinted. Each has been reissued without alteration to the text, but a list of paintings in the relevant school acquired since the publication of the last edition is added as an appendix. For further details about these paintings the reader is referred to the *Illustrated General Catalogue* (2nd edition, 1987) and successive volumes of the *National Gallery Report*.

NATIONAL GALLERY CATALOGUES
First series reprints

The Earlier Italian Schools by Martin Davies
The Sixteenth-Century Italian Schools by Cecil Gould
The Seventeenth and Eighteenth Century Italian Schools by
 Michael Levey
The Flemish School 1600–1900 by Gregory Martin
The Early Netherlandish School by Martin Davies
The Spanish School by Neil Maclaren, revised by Allan Braham

National Gallery Publications
Published by order of the Trustees

© The National Gallery 1952, 1970, 1988
First published 1952; 2nd edition 1970; Reprinted 1988

British Library Cataloguing in Publication Data
National Gallery, London, England
 The Spanish school.——2nd ed.——(National
 Gallery catalogues).
 1. Spanish paintings – Catalogues
 I. Title II. MacLaren, Neil III. Braham,
 Allan IV. Series
 759.6'074

ISBN 0 947645 46 2

Printed and bound in Great Britain by
William Clowes Limited, Beccles and London

Cover Bartolomé Esteban Murillo, *A Peasant Boy leaning on a Sill*

NOTE TO THE FIRST EDITION

THIS CATALOGUE deals with the paintings of the Spanish School in the National Gallery. It also includes for the sake of convenience the only Portuguese picture in the Gallery. At the end of the catalogue is a list, arranged according to the inventory numbers, of the pictures here catalogued; there are also lists of the attributions changed from the general catalogue of 1929 and of paintings attributed to the Spanish School in that catalogue but now excluded.

The sources of all information contained in the catalogue entries have been given in detail. For reasons of space it was not possible to do this in the brief biographical notices of the painters, but the titles of some useful works on individual artists are appended to the notices.

References are given to reproductions of the pictures in the volumes of illustrations published by the Gallery in 1937 and to the companion book of plates of the Spanish pictures which will be published at the same time as this catalogue.

Acknowledgments of help given in specific cases are made in the text. I should also like to express my particular gratitude to my colleagues at the Gallery; to Mr. F. I. G. Rawlins and Mr. A. E. Werner of the National Gallery laboratory for providing many radiographs and analyses of pigments; to Mrs. Wilson and the Gallery's photographic staff for the trouble they have taken over ultra-violet, infra-red and micro-photographs; to Mr. E. V. Heather of Messrs. Christie, Manson and Woods for information about sales; to Señor F. J. Sánchez Cantón, Sub-Director of the Prado Museum, for allowing me to consult his copies of the Spanish Royal inventories, and Miss Alma Starkie for transcribing parts of them; to the Duke of Wellington for allowing typescripts to be made of those copies of the inventories in his possession; to Lt.-Col. W. J. Stirling for generously lending for a long period the collection of prints after Velazquez and Murillo formed by Sir William Stirling-Maxwell; to Señores J. Hernández Díaz, E. Lafuente and X. de Salas for help of various kinds, and to Señor J. Gudiol, Director of the Instituto Amatller de Arte Hispánico, for unfailing help in procuring photographs of paintings in all parts of Spain.

NEIL MACLAREN

NOTE TO THE PRESENT EDITION

THE PRESENT CATALOGUE incorporates much of the text of the 1952 edition, additions and changes being made only where they appeared essential. Seven new paintings are included in the present edition, six being new acquisitions and one (Fortuny, no. 3138) having been transferred from the Tate Gallery. In addition to this many of the more important Spanish paintings have been cleaned since 1952. The list of changed attributions at the end of the 1952 catalogue has been extended to include the few changes proposed in the present edition. It is hoped to publish at some future date a volume of illustrations in succession to the one printed in 1952 in conjunction with the first edition of the catalogue. Photographs of all the pictures in their present condition are meanwhile available from the National Gallery.

My greatest debt in revising the catalogue is to Mr. Neil MacLaren who most kindly put at my disposal the notes he had made in preparation for a second edition. I have also drawn upon the entries written by Mr. Gregory Martin for three newly acquired Spanish paintings in the catalogue covering National Gallery Acquisitions 1952–1962. I am deeply grateful to other colleagues, especially to Mr. Michael Levey, for help and advice in many matters; to Miss Joyce Plesters and the Staff of the Gallery's Scientific department for providing many technical analyses of paintings, and to Mrs. V. Wilson and the staff of the National Gallery Photographic Department for the many technical photographs which have been provided. Others, outside the Gallery, who have helped on specific occasions are acknowledged in the text; here I should like to record my gratitude to those who have in various ways given me the benefit of their knowledge and judgement: Miss Enriqueta Harris (Mrs. Frankfort) of the Warburg Institute, Professor Nigel Glendinning of the University of Southampton, Mr. Eric Young and Miss Juliet Wilson; in Spain this debt of gratitude extends to Señores X. de Salas and A. E. Pérez Sánchez of the Prado Museum, to Father Gregorio Andrés Martínez of the Monastery of El Escorial, to Señor J. Ainaud de Lasarte, Director of Museums in Barcelona, and Señor J. Gudiol Ricart, Director of the Instituto Amatller, Barcelona.

<div align="right">ALLAN BRAHAM</div>

THE PRESENT VOLUME is one of a series produced under the editorship of the Director (formerly the Keeper) to replace the Catalogue of 1929.

EXPLANATIONS

CONDITION: Unless the contrary is stated, all canvases are to be taken as having been relined. The term 'engrained' applied to varnish denotes accumulations of varnish in the furrows of the paint, often darker than the rest and causing a spotty effect. The notes on condition naturally refer to the state of the pictures at the time of publication of the catalogue; it must be remembered that some may be rendered obsolete, especially as regards the remarks on the state of the varnish, by subsequent cleaning operations. A note has been added where cleaning has taken place fairly recently.

MEASUREMENTS: All the pictures in this catalogue have been remeasured; the measurements represent the area of the existing original painted surface unless otherwise stated. The size is given in inches, followed by metres in brackets. Height precedes width. The size is given to the nearest millimetre or sixteenth of an inch in the case of small and medium-sized pictures; to the nearest half centimetre or quarter inch in the case of large ones.

The Spanish *vara* has been taken to be 33·36 inches (0·847).

RIGHT AND LEFT: These are to be taken as referring to the spectator's right and left, except where the contrary is clearly implied by the context.

Pedro BERRUGUETE

Nos. 755 and 756, *Rhetoric*(?) and *Music*, ascribed by many critics to Pedro Berruguete, are catalogued (as by Joos van Wassenhove) in the Early Netherlandish School catalogue, 3rd edition, 1968, by Martin Davies and are, therefore, not discussed here.

Juan de FLANDES *See* JUAN

Mariano FORTUNY

1838–1874

His full name was Mariano José María Bernardo Fortuny y Carbó. Born in Reus, Catalonia: trained in Barcelona, winning a scholarship to Rome, where he stayed 1858/9; he returned to Barcelona in 1859 and spent some months in Morocco as a war artist, subsequently visiting Madrid, Barcelona, Paris and Rome. He visited Florence in 1861 and Morocco again in 1862. Resident mainly in Rome for the rest of his life, with visits in 1866 and 1867 to Paris, returning on both occasions to Rome via Spain, where he studied the work especially of Goya. In 1869 he was again in Paris, subsequently visiting Spain and residing in Granada 1870/2. A visit to London took place in 1874. Died in Rome. Fortuny is remembered for his genre and history paintings; his work is loosely related to that of Meissonnier.

LITERATURE: Thieme-Becker, *Allgemeines Lexikon der bildenden Künstler*, vol. XII (1916), pp. 231 ff. The earliest biography, including letters of the artist, is Baron J. C. Davillier, *Fortuny, sa vie, son œuvre, sa correspondance*, Paris, 1875; there is a recent biography by J. Folch i Torres, *Fortuny*, Reus, 1962.

3138 THE BULL-FIGHTER'S SALUTE

Signed, lower right: *Fortuny*.

Oil on canvas, 24 × 19¾ (0·610 × 0·502).

Painted on a buff ground. In good condition; slight cracking throughout; a small tear above the bull-fighter's head.

No. 3138 is one of a relatively small number of bull-fighting scenes produced by Fortuny, presumably during his visits to Spain in 1867/8 and 1870/2. The two most famous date from 1868, and both were apparently of the bull-ring of Seville.[1] The present painting may represent the Madrid bull-ring; the main figure is possibly a portrait of a well-known bull-fighter. The picture is said to have been painted in

1869;[2] the stamp of a Paris maker was visible on the canvas before re-lining,[3] and it may thus have been ordered on Fortuny's last visit to Paris in 1869. The picture is perhaps more likely to have been painted in Spain than in Paris.

Doubts have been raised about the authenticity of No. 3138,[4] but the picture seems a characteristic, if not very distinguished work by Fortuny. It is probably identical with a picture called 'The Bull-fighter's Salute' sent by the artist for exhibition and sale in London in 1873, the year before his death;[5] its authenticity would in this case appear to be beyond question.

PROVENANCE: Probably identifiable with a painting sent by the artist and ex-hibited for sale at the French Gallery, London, 1873 (no. 158). Certainly the painting in the Charles Waring sale, London, 28 April, 1888 (lot 20; £640 10sh.), bought by Koekkoek; in the Spanish Exhibition, Guildhall, 1901 (no. 178),[6] lent by Marcus van Raalte, by whom bequeathed to the Gallery, 1916.[7] Trans-ferred to the Tate Gallery[8] and returned in 1954.

REPRODUCTIONS: National Gallery, *Illustrations to the Catalogue*, III, 1926, p. 43; J. Folch i Torres, *Fortuny*, Reus, 1962, fig. 33.

REFERENCES: **1.** *La Plaza de Toros de Seville* and *Le Brindis de l'Espada*—see J. C. Davillier, *Fortuny* . . . , 1875, p. 150 and C. Yriarte, *Fortuny*, 1886, p. 45. No. 3138 was formerly known as *The Espada* (in the Waring Sale of 1888 and in the 1901 Guildhall exhi-bition, see below), but it cannot be identical with the second of these celebrated Seville paintings because it differs in subject matter and the can-vas is too small in size; the size of the *Brindis de l'Espada* is given as one metre in height and 67 cms. in width in the *Atelier de Fortuny* sale cata-logue, Paris, 1875 (26 April), p. 26, no. 48. The *Brindis* is presumably the picture at Edinburgh known as 'In the Arena' (National Gallery of Scot-land, no. 1189), which is of precisely the right dimensions. A third picture connected with bull-fighting in the sale of Fortuny's *atelier* was a *Course de taureaux*; *picador blessé* (80 × 60 cms.) and this was apparently painted in Madrid (p. 23, no. 36). A *Corrida de toros* (30 × 46 cms.) is in the Museo de Arte Contemporaneo at Madrid.

2. In the catalogue of the *Exhibition of Works of Spanish Painters*, Guild-hall, 1901, pp. 139 and 162.

3. *Vieille* . . . *Rue Bréda, 30, Paris.*

4. By Señor Enrique Lafuente, orally in 1947.

5. A possible identification with this work is proposed in notes provided by Mr. Ronald Alley of the Tate Gal-lery. The picture is no. 158 in the *20th Annual Exhibition* . . . *of Pictures, the contributions of Artists of the Conti-nental Schools*, at the French Gallery, 1873. No size for the picture is given in the catalogue, but a pencil note in the copy of the catalogue at the Victoria and Albert Museum describes the painting as vulgar and mentions that it showed a bull lying in blood.

6. As *The Espada*, with the date given as 1869.

7. Called *A Matador* in the National Gallery 1929 catalogue.

8. Called *A Toreador* in the 1934 Tate Gallery catalogue of the Modern Foreign Schools.

FRANCISCO DE GOYA

1746–1828

His full name was Francisco José de Goya y Lucientes. Born (30 March) at Fuendetodos, near Saragossa. He was studying with José Luzán in Saragossa, 1760; in 1766 in Madrid, where he was a pupil of Francisco

Bayeu. In 1771 mentioned as in Rome and later in the same year again in Saragossa. Settled in Madrid by 1775 and in 1776 painted for the Royal tapestry works the first of a series of cartoons which continued until 1791. In Saragossa, 1780/1; deputy director of the Academia de San Fernando, 1785. Appointed *pintor del rey* in 1786 and *pintor de cámara*, 1789. In 1792 he suffered a severe illness and became deaf. He became *primer pintor de cámara* in 1799, and continued in this position in the succeeding reigns. From 1824 onwards he lived in Bordeaux, where he died in 1828 (16 April).

LITERATURE: The biographical data are best given in V. von Loga's *Francisco de Goya*, 1903 (reprinted 1921). A. L. Mayer's *Goya*, 1921 (English ed. 1924), and X. Desparmet Fitz-Gerald's *L'oeuvre peinte de Goya*, 1950, contain *catalogues raisonnés* and reproductions of most of the paintings. A more recent general book is F. J. Sánchez Cantón's *Vida y obras de Goya*, 1951 (English ed. 1964). A. Calvert's *Goya*, 1908, contains a useful series of small illustrations.

1471 A PICNIC

Most probably a sketch for a tapestry cartoon.

Oil on canvas, $16\frac{1}{4} \times 10\frac{1}{8}$ (0·413 × 0·258).

In good condition; slightly rubbed in one or two places and under-cleaned in the sky.

There are *pentimenti* in the woman's head and the arm of the man behind her.

The present painting, together with Goya no. 1473 below, formed part of the celebrated collection of Goya sketches owned by Goya's patron the 9th Duke of Osuna (see Provenance). In the present case the painting was probably not commissioned directly by the Duke. In April 1799 he made an order to pay Goya 10,000 *reales* for paintings of the *Pradera de San Isidro*, four *Seasons of the Year* and two 'country subjects'.[1] It seems very probably that the two last-mentioned were the National Gallery *Picnic* and the small *Blind man's buff* in the Prado.[2] In the order for payment the seven paintings are said to have been made for the cabinet of the Duchess of Osuna and have, in consequence, sometimes been dated in the 1790's.[3] Of the seven, however, the five that can be identified beyond a doubt (*i.e.* the *Pradera*[4] and the *Seasons*[5]) are, like the *Picnic* and *Blind man's buff*, in the style of the 1780's and it is much more likely that all were painted long before the payment in 1799, as sketches for tapestry cartoons[6] for Charles III: four large cartoons corresponding to the designs of the *Seasons* were, in fact, painted by Goya in 1786/7[7] and Goya himself wrote that he was working on the subject of the *Pradera* in 1788.[8] The *Picnic* was probably, like the latter, one of the sketches Goya was then painting for cartoons for tapestries to decorate the Bedchamber of the Infantas at the palace of El Pardo;[9] only one of these cartoons seems to have been carried out,[10] although stretchers appear to have been made in preparation for all of them.[11]

ENGRAVING: Wood engraving by Roevens in C. Yriarte, *Goya*, Paris, 1867, facing p. 85.

PROVENANCE: Probably painted in 1788 for Charles III; sold by Goya to the 9th Duke of Osuna *ca.* 1799 (see above). In the collection of the Dukes of Osuna, Palacio de la Alameda, near Madrid, and presumably one of the fifteen small paintings by Goya hanging in the library there in the mid-nineteenth century.[12] Purchased by the National Gallery at the Osuna sale, Madrid, 18 May, 1896 (lot 78; £190 11sh.). Arts Council Spanish Paintings Exhibition, 1946 (no. 4) and 1947 (No. 8).

REPRODUCTION: *Illustrations: Continental Schools*, 1937, p. 137; *Spanish School, Plates*, 1952, p. 1.

REFERENCES, GENERAL: V. von Loga, *Goya* (2nd ed.) 1921, no. 451; A. L. Mayer, *Goya* (Eng. ed.) 1924, no. 563; V. de Sambricio, *Tapices de Goya*, 1946, no. 56; X. Desparmet Fitz-Gerald, *L'oeuvre peinte de Goya*, 1950, no. 163.

REFERENCES IN TEXT: **1.** '. . . siete Pinturas, que representan una la Pradera de S.ⁿ Ysidro; quatro de las Estaciones del año; y dos asuntos de Campo, que hizo para el Gabin.ᵗᵉ de la Condesa Duquesa [mi] muger'; the order is dated 26 April, 1799. (The text as given here is taken from Sambricio, *op. cit.*, p. cxxvii, document 192.)

2. *Cf.* Loga, *op. cit.*, p. 95. Loga suggests that the second 'asunto de Campo' was the *Hermitage of San Isidro* (Prado no. 2783; 0·42 × 0·44) but the description is more apt for the *Blind man's buff* (Prado no. 2781; 0·41 × 0·44). Sambricio (*op. cit.*, pp. 266 and 269) is wrong in supposing that both, as well as the *Picnic*, were among the seven pictures paid for in 1799 (see note 1) since, with the *Pradera* and four *Seasons*, this would make a total of eight. One of the three first-mentioned must, therefore, have been acquired by the Duke of Osuna at another time; most probably this one was the *Hermitage* which, nevertheless, almost certainly belongs to the same series as the *Pradera*, *Picnic* and *Blind man's buff* (see note 9).

3. A. de Beruete, *Goya*. II. *Composiciones y figuras*, 1917, p. 66; see also the Prado catalogue, 1933–49.

4. Prado no. 750; 0·44 × 0·94.

5. The pictures referred to in 1799 as the *Seasons* (see note 1) are *The flower-girls* (Duke of Montellano, Madrid. 0·35 × 0·24), *The harvest* (Museo Lázaro, Madrid. 0·34 × 0·76), *The vintage* (formerly Goupil, Paris. The picture now in the Sterling and Francine Clark Art Institute, Williamstown, Mass. (13½ × 9½ ins.) is probably a version) and *The snowfall* (formerly Silberman, New York. Now private collection, Chicago. 0·34 × 0·35).

6. Beruete, *loc. cit.*, suggested that the Osuna *Seasons* were later reductions by Goya; he is followed by F. J. Sánchez Cantón, *Vida y obras de Goya*, 1951, p. 68. It is true that the *Seasons* and *The harvest* are more finished than the others; Goya possibly worked on these later before selling them to Osuna.

7. *Cf.* Sambricio, *op. cit.*, nos. 40–3. The sketches for these cartoons were submitted to Charles III by Goya between October, 1786 and May, 1787 (Sambricio, *op. cit.*, p. lxxviii, document 103).

8. See Goya's letter of 31 May, 1788 to Martín Zapater (in F. Zapater, *Goya. Noticias biográficas*, 1868, pp. 53/4; reprinted in *Colección de . . . Cuadros, Dibujos . . . de Goya*, pub. Calleja, 1924, p. 39).

9. See Sambricio, *op. cit.*, pp. 264/5. The series was apparently to consist of four large tapestries and four *sopraporte* to judge from the bill (dated April, 1788) for stretchers for the cartoons (see Sambricio, *op. cit.*, p. lxxxv, document 113). Sambricio (pp. 156/7 and nos. 53–6) has shown that there is good reason to suppose that the *Pradera de San Isidro*, the *Picnic*, *Blind man's buff* and the *Hermitage of San Isidro* were the sketches for the designs of the large tapestries.

10. *i.e. Blind man's buff*, the cartoon for which was completed by the earlier part of 1789 and the tapestry by July 1790 (Sambricio, *op. cit.*, no. 55). The abandonment of the remainder of the series may have been

connected with Charles III's death in December, 1788.

11. See note 9. The stretcher presumably destined for the cartoon of

the *Picnic* measured $12\frac{1}{2} \times 8$ *pies* and had, therefore, exactly the same proportions as the sketch.

12. C. Yriarte, *Goya*, 1867, p. 14.

1472 A SCENE FROM *EL HECHIZADO POR FUERZA*

Inscribed on a book (?) in the lower right corner: LAM | DESCO
Oil on canvas, $16\frac{3}{4} \times 12\frac{1}{8}$ ($0\cdot425 \times 0\cdot308$).
In very good condition.

The scene is taken from Act II of Antonio de Zamora's comedy, *El hechizado por fuerza*.[1] In order to frighten the timorous Don Claudio into marriage with Doña Leonora, he has been made to believe that her slave, Lucía or Luciguela, has bewitched him and that his life will last only so long as a lamp in her room remains alight. He goes to replenish the lamp with oil to prolong his life; among the grotesque paintings which she has hung on the walls to frighten him is a 'dance of donkeys'. He apostrophizes the lamp:

> 'Lámpara descomunal,
> cuyo reflexo civil,
> me va á moco de candil,
> chupando el oleo vital' etc.

The first letters of the first two words are inscribed on the picture (see above). It has been suggested that Goya's picture represents a real stage, with the inscribed book(?) occupying the position of the script of a supposed prompter, and that the demon holding the lamp, who is not mentioned in the play, is in reality a wooden lamp holder—a piece of furniture placed upon the stage.[2] This interpretation makes good sense of what is indeed a puzzling composition, and it seems possible that the idea for the picture originated in this way. But the painting is obviously not in any literal sense a representation of a performance of the play; the ambiguities in the composition must presumably be intentional, reflecting—directly or indirectly—the troubled state of mind of Don Claudio.

This painting and five others of the same size (four scenes of witchcraft and *Don Juan and the statue*, a scene from Zamora's play, *No hay deuda que no se pague, y Convidado de Piedra*) are presumably the six pictures of 'witches' which Goya painted for the Alameda, the Duke of Osuna's country house, and which were paid for in 1798.[3] They were probably the six 'Capricos raros' exhibited at the Madrid Academy in 1799.[4] To judge from the style they cannot have been painted long before the date of payment. Many similar scenes of witchcraft occur in the etchings of the *Caprichos* series, the greater part of which were finished by about 1797.

ENGRAVINGS: Engraving by Jacob, recorded by Desparmet-Fitzgerald (see *references*); wood engraving by Roevens in C. Yriarte, *Goya*, Paris, 1867, facing p. 87.

PROVENANCE: Painted for the Duke of Osuna *ca.* 1798. Probably exhibited, with its five companions, in 1799 at the Real Academia de San Fernando, Madrid. In the collection of the Dukes of Osuna, Palacio de la Alameda, near Madrid, and presumably one of the fifteen small paintings by Goya hanging in the library there in the mid-nineteenth century.[5] Purchased for the National Gallery at the Osuna sale, Madrid, 18 May, 1896 (lot 88; £51). Arts Council Spanish Paintings Exhibition, 1946 (no. 5) and 1947 (no. 9). Exhibited at the Royal Academy, London, *Goya and his times*, 1963/4 (lent after the start of the exhibition and not included in the catalogue).

REPRODUCTION: *Illustrations: Continental Schools*, 1937, p. 137; *Spanish School: Plates*, 1952, p. 2.

REFERENCES, GENERAL: V. von Loga, *Goya* (2nd ed.) 1921, no. 445; A. L. Mayer, *Goya* (Eng. ed.) 1924, no. 557; X. Desparmet Fitz-Gerald, *L'oeuvre peinte de Goya*, 1950, no. 174.

REFERENCES IN TEXT: **1.** First performed in 1698. The text quoted here is that of the edition of 1744, i, pp. 123/4.
2. See F. Nordström, *Goya, Saturn and Melancholy*, 1962, pp. 154 ff.
3. There is an approval of payment by the Duke dated 29 June, 1798: 'para abonar á D. F? de Goya seis mil reales importe de seis cuadros cuya composición es de asuntos de Brujas que ha hecho para mi casa de campo de la Alameda' (see Loga, *op. cit.*, p. 165, note 185). Of the other five witchcraft scenes, two (Mayer nos. 548 and 552) are in the Museo Lázaro, Madrid; a third (Mayer no. 550 is in the Ministero de Gobernación, Madrid; Nordström, *op. cit.*, fig. 82); a fourth (Mayer no. 549) was in the collection of Gustave Bauer, Madrid, and was (?) formerly (?) in that of Edouardo Pani, Mexico. The location

of *Don Juan and the statue* (Mayer no. 558; A. Calvert, *Goya*, 1908, pl. 258) is not known.
4. Six paintings, described as 'Capricos raros' were exhibited by Goya in the Academy in this year, together with two portraits (archives of the library of the Real Academia, I–55. See note 2 to Goya no. 1951 below)
5. C. Yriarte, *op. cit.*, 1867, p. 14; the witchcraft scenes in the Osuna collection were singled out by V. Carderera y Solano, in 1838 in *Semanario Pintoresco*, 15 July, Vol. 3 —quoted by E. Lafuente Ferrari, *Antecedentes, coincidencias e influencias del arte de Goya*, Madrid, 1947, p. 306: 'Célebres son sus preludios de las corridas de toros, sus escenas de ladrones, de brujas, etc., que hay en la alameda del Conde—Duque de Osuna'.

1473 DOÑA ISABEL DE PORCEL

She is dressed in the costume of a *maja*.

Reverse: There is a modern inscription on the back of the relining canvas: RETRATO DE LA EXCMA. Sra. Dña. YSABEL COBOS DE PORCEL | PINTADO POR GOYA. | EL RETRATO DEL EXCMO. Sr. D. ANTONIO PORCEL CONSEJERO DE | CASTILLA POR SU AMIGO GOYA (SIC)[1] LLEVA LA FECHA 1806.

Oil on canvas, $32\frac{1}{4} \times 21\frac{1}{2}$ (0·820 × 0·546). Original edges on all sides; 1–$1\frac{1}{2}$ cms. of original canvas with red priming are folded over the edges of the stretcher on all sides.

In very good condition; yellowish varnish. There are earlier outlines of the right elbow and the skirt below; the *mantilla*, apparently, originally fell vertically across the lower part of the right sleeve.

The popular costumes of the *majo* and *maja* were also often worn by

people of fashion in Spain at the beginning of the nineteenth century.

The picture is presumably identical with a portrait of the wife of Don Antonio Porcel exhibited at the Academy of San Fernando in 1805.[2] This date appears to correspond well with the style of the painting, and of the dress and coiffure.[3] The sitter's full name was apparently Isabella Lobo y Mendieta de Porcel, not Cobos de Porcel, as is given in the inscription on the reverse.[4] Her marriage to Antonio Porcel took place in 1802.[5]

According to the grand-children of the sitter, this portrait and that of her husband, Antonio Porcel, were painted by Goya during a visit in gratitude for hospitality.[6] The supposed companion portrait of her husband, formerly in the Jockey Club, Buenos Aires,[7] was signed: *Don Antonio Porcel por su amigo Goya—1806.* The two portraits, however, can hardly be companion pieces; both look in the same direction, while that of Antonio Porcel was much larger (1·13 × 0·82) and painted on wood.[8] Of Antonio Porcel it is known that he was a protegé of Godoy and an associate of Goya's friend, Jovellanos.[9]

PROVENANCE: Presumably the portrait exhibited at the Real Academia de San Fernando, Madrid, in 1805. Together with the portait of Antonio Porcel, in the collection of the Porcel y Zayas family until *ca.* 1887,[10] when it was sold to Don Isidoro Urzaiz, from whose heirs it was purchased in 1896. Arts Council Spanish Paintings Exhibition, 1947 (no. 6).

REPRODUCTION: *Illustrations: Continental Schools,* 1937, p. 139; *Spanish School: Plates,* 1952, pp. 3 and 4.

REFERENCES, GENERAL: V. von Loga, *Goya* (2nd ed.) 1921, no. 309; A. L. Mayer, *Goya* (Eng. ed.) 1924, no. 391; X. Desparmet Fitz-Gerald, *L'oeuvre peinte de Goya,* 1950, no. 453.

REFERENCES IN TEXT: 1. The word *sic* is part of the inscription.

2. It is the fourth item listed for the exhibition of 1805: 'El Retrato de la S.ra Esposa del S.or D.n Ant.o Porcel pintado por el mismo S.or Goya'. This and a full length portrait of the Marquesa de Villafranca—the third on the list (presumably Prado no. 2448, signed and dated 1804)—were the only pictures exhibited by Goya in this year. The portrait of the sitter's husband (see main text here), Don Antonio Porcel, was included by Goya in the exhibition of 1806 (archives of the library of the Real Academia, I-55. See note 2 to Goya no. 1951 below). The date of the exhibition of the portrait was recorded by N. Sentenach in *Boletín de la Real Academia de Bellas Artes de San Fernando,* 1923, XVII, p. 172.

3. MacLaren suggested about 1806 for the date; as did Loga, *op. cit.,* p. 109—presumably in connection with the dated portrait of her husband (see below); A. de Beruete, *Goya, I. Pintor de retratos,* 1916, p. 63, dated the portrait *ca.* 1795–1800.

4. See N. Glendinning in *Apollo,* March, 1969, pp. 202/3, n. 36.

5. *Ibid.*

6. According to a letter of November 1897 in the Gallery archives from Miguel Cané, Argentine Minister in Madrid, who bought the portrait of Antonio Porcel from the Porcel family *ca.* 1887; the letter implies that this visit of Goya's was to Granada, where the grandchildren lived, but it seems highly unlikely that the portraits were made in Granada, especially since Goya exhibited them in 1805 and 1806 in Madrid (see note 2); Conde de la Viñaza, *Goya,* 1887, pp. 257/8, as in the collection of the Porcel y Zayas family.

7. This portrait was apparently destroyed when the Jockey Club was burnt down in a riot in April, 1953.

8. No. 1473 has not been cut down and the original edges have been preserved.

9. See Glendinning, *op. cit.*, pp. 202/3, n. 37.

10. See note 6. It is implied in the letter of Cané that the portraits were sold from the Porcel y Zayas family in Granada; however Z. Araujo Sánchez, *Goya*, [1895] p. 116, nos. 232 bis and 233, records the two portraits as in the collection of General Zayas (presumably in Madrid)—this reference was kindly provided by Professor Nigel Glendinning. It may be that General Zayas kept the portraits temporarily in Madrid(?) while their sale was being negotiated.

1951 DON ANDRES DEL PERAL

Oil on poplar,[1] $37\frac{3}{8} \times 25\frac{7}{8}$ (0·950 × 0·657). Original edges on all sides. The picture is not painted up to the edges of the panel and *ca.* $\frac{1}{4}$ inch of buff underpainting is visible on all sides.

In very good condition.

The left sleeve was at first longer.

Traditionally entitled 'Dr. Peral' and dated to about 1800, the present portrait is almost certainly identical with that of Don Andrés del Peral which was chosen by Goya for exhibition at the Royal Academy of San Fernando in Madrid in the summer of 1798.[2] The portrait was much praised at this time.[3]

The title 'Dr. Peral' derived from a modern label on the reverse of the picture where the sitter is described thus: '. . . D.^r Peral—a doctor of Laws—was the Financial representative in Paris of the Spanish Government at the close of the 18th century. . . .'[4] This inscription probably refers in error to a certain Juan del Peral, who headed a treasury delegation to Paris in the nineteenth century and died there in 1888.[5] The father of Juan del Peral was called Andrés and Andrés was the Christian name of the sitter in the portrait exhibited in 1798. These coincidences make it likely that the present portrait was indeed the one exhibited in 1798 and that it represents the father of Juan del Peral. Juan del Peral was born on 11 June, 1815 and baptized in San Lorenzo, Madrid; the name of his mother is given as Francisca Richart.

Andrés del Peral was famous during his lifetime as a collector of paintings and there were exhibited at the Real Academia between 1798 and 1806 pictures from his collection by, or said to be by Alonso Cano, Mengs, Mateo Cerezo, Ribera, Francisco Bayeu, and Rubens.[6] He is presumably identifiable with the Andrés del Peral who is recorded in 1838 as having formed a large collection of small early paintings by Goya himself of bull-fighting and genre scenes.[7]

The sitter in the present portrait is probably also identifiable with the Andrés del Peral who was in the service of the Spanish royal family as a gilder and painter from the late 1770's to the early 1820's.[8] This man would have been in some sense a colleague of Goya; though employed by the court in a humbler capacity, he was only slightly less well paid than the artist. He was born in Cifuentes (Prov. Sigüenza), probably in the 1750's, and would therefore be of approximately the right age for the sitter in the present portrait, who is perhaps a man in his mid-forties.

Peral is last recorded in 1823, and by 1833 he had apparently retired or died.[9]

A portrait of an old man ascribed to Goya (in the José Iturbi collection, U.S.A.[10]) was at one time called Dr. Peral but is obviously not the same man.

PROVENANCE: Almost certainly identifiable with a portrait exhibited at the Real Academia de San Fernando in the summer of 1798. Bought from the grand-daughter of 'Dr. Peral' in Seville by the Marques de la Vega-Inclán (probably at the end of the last century).[11] Spanish Exhibition, Guildhall, London, 1901 (no. 51), lent by Gaston Linden of Paris. Bought from (W ?) T. Dannat, Paris, in January 1902 by Sir George Donaldson,[12] by whom lent to the National Gallery, 1902–4, and presented in 1904. Arts Council Spanish Paintings Exhibition, 1947 (no. 4).

REPRODUCTION: *Illustrations: Continental Schools*, 1937, p. 138; *Spanish School: Plates*, 1952, pp. 5 and 6.

REFERENCES, GENERAL: V. von Loga, *Goya* (2nd ed.) 1921, no. 299; A. L. Mayer, *Goya* (Eng. ed.) 1924, no. 377; X. Desparmet Fitz-Gerald, *L'oeuvre peinte de Goya*, 1950, no. 366. N. Glendinning in *Apollo*, March, 1969, pp. 200 ff.

REFERENCES IN TEXT: **1.** Letter of 1944 from B. J. Rendle, Forest Products Research Laboratory, in the Gallery archives.

2. The lists of pictures exhibited at the Academy for the years 1793 to 1808 are preserved in a general file in the library of the Academy, archive no. I-55. They were found with the kind help of the librarian, Señora Lafuente Ferrari. The second and third exhibits for 1798 were 'Una Magdalena de Alonso Cano propria de D.ª Andres del Peral | El Retrato del mismo Peral echo por Goya'. The portrait was the only work by Goya exhibited in this year. The year 1798 for the exhibition of the portrait was noted by N. Sentenach in *Boletín de la Real Academia de Bellas Artes de San Fernando*, 1923, vol. XVII, p. 172. F. J. Sánchez Cantón, *Vida y obras de Goya*, 1951, p. 66, identifies no. 1951 with the portrait exhibited in 1798 and describes the sitter as the 'médico, Don Andrés Peral', though the sitter was formerly identified as a doctor of law (see note 4).

3. By a correspondent in the *Diario de Madrid* of 17 August, 1798; see E. Helman, *Trasmundo de Goya*, Madrid, 1963, p. 19 (giving the Spanish text), and in *The Burlington Magazine*, 1964, pp. 30–33, where the following translation is given: 'The portrait of Don Andrés del Peral, painted by the incomparable Goya, would be enough by itself to bring credit to a whole Academy, to a whole nation, to a whole contemporary period with respect to posterity, so sure is its draughtsmanship, its taste in colouring, its freedom, its use of chiaroscuro, in short, so great is the skill with which this Professor carries out his works.'

4. The full text reads: *Memo re D.ʳ Peral. The Marquis de | La Vega bought it from D.ʳ Peral's | grand-daughter in Seville. Her | husband is a Professor of the | University at Seville. | D.ʳ Peral—a doctor of Laws—was the | Financial representative in Paris of the | Spanish Government at the close | of the 18th century. The portrait | by Goya was painted 1800–1810.*

5. See Glendinning, *op. cit.*, p. 201.

6. See note 2 above; pictures from his collection were exhibited in 1798, 1800, 1805 and 1806. The collection was apparently mentioned in print for the first time by Ceán Bermúdez, *Diccionario . . .*, 1800, I, p. xxiv (for this and other early references to the collection see Glendinning, *op. cit.*, p. 203, note 30).

7. V. Carderera y Solano in *Semanario Pintoresco*, 15 July, 1838, vol. 3, p. 631, cited by E. du G. Trapier, *Goya, A study of his portraits, 1797–99*, 1955, p. 29, note 20, and in *El Artista* (1835), cited by Glendinning, *op. cit.*,

p. 203, note 30. Both texts are re-printed in E. Lafuente Ferrari, *Ante-cedentes, coincidencias y influencias del arte de Goya*, 1947, pp. 302 ff.

8. For this and the following information see Glendinning, *op. cit.*, pp. 201 f.

9. It has been suggested that the face in the portrait is that of a man afflicted with facial palsy (see *The Lancet*, 2 May, 1959). It has also been suggested with no justification that the sitter had a wooden left arm (B. Myers, *Goya*, 1964, p. 36). Trapier notes, *op. cit.* (p. 12), that the portrait shows Goya's disinclination to paint hands.

10. Mayer no. 378; in the Messmore Kendall sale (Parke-Bernet), New York, 3 December, 1942 (lot 29). Usually called 'Dr. Stafford' but Mayer (*Bulletin of the Bachstitz Gallery*, III/IV, 1923, and *Goya*, no. 378) confused it with Loga no. 299 (listed as formerly in the Dannat collection) which is certainly the National Gallery picture (see below) and tentatively identified the sitter as Dr. Peral. This confusion has been repeated in all subsequent literature about the 'Stafford' portrait, to which have been attributed also the measurements of the Dannat collection picture as given by Loga (0·92 × 0·65). The correct measurements of the 'Dr. Stafford' (0·70 × 0·57) are, however, given in *The Bachstitz Gallery*, n.d. [1921 or 2 ?], pl. 74, and in the Parke-Bernet sale catalogue of 1942 (there as 27½ × 21½ inches); the identity of the Dannat picture with the National Gallery one is established by Dannat's receipt to Donaldson, dated 10 January, 1902, which is preserved in the Gallery archives. The correct provenance of the 'Stafford' is: Pablo Bosch, Madrid (*Colección de . . . Cuadros, Dibujos . . . de Goya*, pub. Calleja, 1924, pl. 182, as formerly in the Bosch collection); Colnaghi, London; F. von Gans collection, Frankfurt; Bachstitz, Holland (*ca.* 1921 to after 1931); Messmore Kendall collection, New York (by 1937).

11. See note 4. The inscription presumably refers to the grand-daughter of the sitter, though it could perhaps be taken to refer to the grand-daughter of Juan del Peral.

12. See preceding note.

6322 THE DUKE OF WELLINGTON

He wears an ornament of the Order of the Golden Fleece on a red ribbon around his neck, and the Military Gold Cross surmounted by three clasps on a pink and blue ribbon around his shoulders. The pink sash and topmost star on his chest are of the Order of the Bath; the blue sash and lower left star, of the Order of the Tower and Sword (Portugal); and the lower right star of the Order of San Fernando (Spain).[1]

Oil on mahogany, 25¼ × 20½ (0·643 × 0·524). The panel consists of a large central piece, with narrow strips at the sides.

The figure in good condition, the background damaged at the edges. Cleaned and restored in 1965.[2]

Numerous *pentimenti* in the uniform (see below); the sitter's left eyelid heightened.

Painted in Madrid in 1812 and some alterations made by Goya in (?) 1814.

Arthur Wellesley, first Duke of Wellington (1769–1852), entered Madrid on 12 August, 1812, after winning the Battle of Salamanca (22 July).[3] He then held the rank of General commanding the British forces in Spain, and he had been created Earl of Wellington (28 February, 1812). He belonged at this time to three Orders of Knighthood: the Bath (28 August, 1804), the Tower and Sword of Portugal (18 October, 1811) and San Fernando of Spain (11 April, 1812). The badges of these

three Orders he wears in the present portrait. While in Madrid Welling-
ton learned that he had been made (7 August, 1812) a Knight of the
Order of the Golden Fleece.[4] He advanced from Madrid on 1 September
to undertake the siege of Burgos but this was unsuccessful and, evacua-
ting his troops from Madrid in October, he retired to Portugal for the
Winter. Created Marquess (3 October, 1812), he was made a Knight of
the Garter on 4 March, 1813,[5] which excluded him automatically from
the Order of the Bath, though as a mark of special distinction he was
re-instated on 2 January, 1815. Wellington defeated Joseph Bonaparte,
King of Spain, at the Battle of Vittoria, 21 June, 1813, and after this
victory he was made a Field Marshal.[6] Following this last battle of the
Peninsular War, fought at Toulouse on 10 April, 1814, Wellington
advanced to Paris, and from there he was sent in May to Madrid as
ambassador extraordinary to the newly-restored Spanish King,
Ferdinand VII, returning to England via France in June, 1814.[7]

The principal military decoration worn by General Officers in the
early years of the Peninsular War was a large medallion suspended on a
crimson ribbon edged with blue and inscribed with the names of the
battles at which the officer had served.[8] This was replaced in 1813 by the
Military Gold Cross.[9] Decorated with a lion in the centre, the arms
were inscribed with the officer's first four battles and a clasp to be worn
on a ribbon above the cross was issued for each additional battle.
Wellington wears three clasps above the Cross in the present portrait.
He earned this third clasp for the Battle of Salamanca (July, 1812), his
seventh victory, and his fourth clasp recorded Vittoria (June, 1813). The
Crosses were sent off in April, 1813, and the clasps up to and including
those for Salamanca in June.[10] Eventually Wellington received nine
clasps, having been present at thirteen battles and sieges.

Wellington wears in the portrait all the orders to which he was en-
titled in August, 1812, and there can be no doubt that, with the excep-
tion of the Gold Cross and clasps, the painting was made by Goya in
Madrid in that month.[11] Two other paintings of the Duke by Goya are
known, the equestrian portrait at Apsley House and a half-length in a
hat and cloak in the National Gallery of Art, Washington.[12] There are
also two drawings which correspond closely with No. 6322 (see below).
Wellington is recorded as sitting to an (unnamed) Spanish painter in
Madrid at this time,[13] and the equestrian portrait is documented. It was
exhibited at the Academy of San Fernando on 2 September, 1812, and
it is probably the picture referred to in a letter of the artist, where a
discussion between Goya and Wellington about the exhibition of the
work is mentioned.[14] In this painting the figure of the Duke is super-
imposed on that of an earlier sitter.[15] A rumour was current in the early
nineteenth century that a portrait of the Duke by Goya had been the
cause of a dispute between the two.[16]

The numerous *pentimenti* in No. 6322, clearly visible to the naked eye,
show that the portrait was extensively altered by the artist, and the
panel itself may have been used like the canvas of the equestrian por-
trait, for an earlier painting, or paintings. This is not visible in X-ray

photographs, but a cross-section of the painted surface reveals that many layers of paint are present beneath the grey background.[17] The grey itself covers the edges of the earlier paint layers and extends into cracks on their front surfaces. The present paint surface in the background is raised, unaccountably, in many places; traces of red paint are visible beneath the grey in the area behind the sitter's shoulder and some blue paint was visible beneath the damages at the edges.

In its first clearly defined stage the portrait had a close general correspondence with a portrait drawing by Goya in the British Museum.[18] This shows the Duke in a plain jacket, wearing the Peninsular Medallion on a ribbon around his neck, and three stars, sketchily drawn, on his chest. The sitter originally wore this Medallion in the painting—it is clearly visible as a raised oval disc beneath the three clasps hanging above the Gold Cross—and his jacket (a mess jacket?) was at first a plain crimson garment, the black surfaces decorated with gold, as well as the sashes, being added later by the artist. It had a lapel, of which the outlines are visible beneath the black paint, apparently secured by a button which appears in the painting as a small raised disc beneath the ribbon around the sitter's shoulders. It is possible that this early lapel was faced with black material, because the area within its outlines is a denser black than the overpainted crimson around its edges. At this early stage the two lower stars and the Duke's left arm were placed more towards the centre of his chest.

The figure therefore corresponded closely with that shown in the drawing, and the edges of the drawing were folded back to produce a format matching that of the painting. The area around the head was shaded up to the edges of the folds at the top and the sides, leaving a blank margin beneath the figure. The drawing must have been made so that the general pose of the sitter could be established in advance; since the panel was apparently prepared before it contained Wellington's portrait (see above), the edges of the paper were presumably folded not to determine the actual shape of the panel but so that the scale of the figure and its position on the panel could be easily visualized.

The drawing cannot have been followed for the decorations because they are shown in insufficient detail, and it is likely that Goya borrowed the Duke's jacket to paint these. And there is no reason to suppose that the face was copied from the drawing. The correspondence is close, but the *pentimento* of the sitter's left eye and the liveliness of the painted face suggest that it too must have been painted from the life. Of the other two portraits of Wellington, the one in Washington compares more closely, for the face, with the drawing. This was probably painted after Wellington had left Madrid and he was perhaps shown wearing a cloak because Goya had no record of the Duke's decorations beyond the vague indications of stars etc. in the drawing. The face in the equestrian portrait, as far as is possible to judge, appears to be based on No. 6322 before the sitter's left eye was enlarged (see below).

It is possible that the part at the very bottom of No. 6322 was executed in its first state in outline only, corresponding with the empty

margin in the drawing. But this area of the picture cannot have been entirely blank because the outlines of the first position of the sitter's left arm are visible almost to the bottom of the panel.

A note by Goya's grandson acquired with the British Museum drawing contains the claim that it was made at Alba de Tormes on the day after the Battle of Salamanca, but this is unlikely because Madrid was still occupied by the French until shortly before Wellington's arrival on 12 August. The existence, however, of a drawing by Goya corresponding so closely with a painted portrait is unusual.[19] It can perhaps be seen as yet another reflection of the troubled circumstances in which the painting had to be executed. It seems most likely that the drawing was made very shortly after Wellington's arrival in Madrid.

Not long after the painting had been completed, or almost completed, in its early state (probably about 20 August—see below) it was extensively altered.[20] The lower two stars on Wellington's chest were moved to the right, apparently causing the position of his arm to be moved outwards. The upper star remained unaltered; it is more richly painted than the lower stars in their final form and it appears to have been brushed in when the crimson of the jacket was still wet. The black panel decorated with gold braid was added in the centre, covering the original position of the lower left star, and on this the blue sash was superimposed. The pink sash too was probably added at the same time, greatly altering the balance of colours in the picture. It is too thickly painted for *pentimenti* to be visible beneath it, but it appears to be absent in the drawing and the abrupt change in its width in the centre would seem to confirm that it cannot have been planned at the start.

This group of changes transformed the crimson jacket into an approximation of Wellington's dress uniform, as recorded in other portraits of the time.[21] This was scarlet, and when the front was buttoned back a black lining decorated with gold braid was visible. It had a high black collar, also decorated with strips of gold braid, and it could apparently be worn with epaulettes on both shoulders or braid on the right shoulder only. The rather prominent plaited braid on the sitter's right shoulder was probably therefore added at this time. It would clearly have been difficult for Goya to re-colour the jacket and to change the whole shape of the collar, and in these respects the uniform is completely inaccurate.[22]

On 20 August, or shortly before, after Wellington had been in Madrid for about eight days, he received news from Cadiz that he had been awarded the Golden Fleece for the victory of Salamanca.[23] This was his fourth decoration, one of the greatest he received, and it is likely that the extensive alterations made by Goya to the uniform were planned in preparation for the inclusion of the Fleece in the portrait. The addition of the actual ornament of the Fleece was, it seems, one of several changes made at a slightly later stage than the alteration of the uniform. Goya's Fleece is not like any that the Duke is known to have owned (see below); the artist appears to have improvised the design of the ornament, and this may in part explain a slight delay which apparently occurred

between the alteration of the uniform and the addition of the Fleece.

That the Fleece was added at the last moment is suggested by a drawing at Hamburg, which appears to be for the most part a very accurate copy of the painting. The most important difference between the two lies in the treatment of the Fleece, for the drawing shows what appears to be a trial hanging for this ornament, with the Fleece itself covering the Peninsular Medallion. From the evidence of this drawing it would appear that Goya made several small adjustments to the painting at the last moment in 1812, not only adding the Fleece, but also broadening the black lapel of the jacket up to a line parallel with the ribbon of the Fleece, and enlarging the sitter's left eye, as well as altering the mouth slightly to conceal the prominence of the sitter's front teeth. The Hamburg drawing, like that in the British Museum, shows only the upper part of the sitter's chest, though it extends downwards to a rather lower point, and it is possible, though it seems unlikely, that a small margin at the bottom of the panel was still not fully brushed in when the second drawing was made.

Final alterations to the painting cannot have been made until the following year at the earliest for the Gold Cross and the clasps above, which are painted over the Peninsular Medallion, were not sent out to Spain until June, 1813 (see above). In theory Goya could have made these additions at any time after they arrived, but it is most likely that the picture was not returned to him until Wellington's second visit to Madrid in May, 1814. He had by then earned nine clasps, but he may not have been in possession of all of them and the artist has shown him with only those three to which he was entitled in August, 1812, after the Battle of Salamanca. The same ribbon was supplied for the Cross as for the Medallion so that it was not necessary for Goya to alter the ribbon.

The fate of no. 6322 after Wellington's first departure from Madrid is not known, but it is likely that he took the portrait with him, or had it sent to Portugal. The recent restoration of the picture revealed incised lines running parallel with the edges of the panel, which were probably made when the paint was still wet. They suggest that the picture was fitted in haste into a frame which was too small for the size of the panel. The close relationship between the half-length portrait in Washington, where Wellington also wears the ribbon of the Fleece, and the British Museum drawing would also suggest that Goya had parted with no. 6322 by the time that the Washington portrait was painted—it would presumably have been simpler to produce a variant of the painted portrait for this likeness, as Goya appears to have done for the equestrian portrait, rather than to adapt the drawing.[24] It is therefore likely that Goya had no further access to the panel until the Duke returned to Madrid in 1814, when the final alterations were made, and when the portrait was presumably restored at the edges and retouched by the artist himself.

All but two of the decorations worn by the Duke in all stages of the development of the portrait are preserved in the Wellington Museum at Apsley House. Goya appears to have 'improved' on these only in

using pink for the Bath sash and for the central panel of the Medallion ribbon. Both should have been a deeper red, closer in hue to the jacket itself. The Medallion (2·1 inches in diameter) has a relief of Britannia on one side and the other it is inscribed 'Roleia | Vimiera | Talavera | 1808/9'. The Gold Cross which replaced it has a lion in relief in the centre and the arms are inscribed *Vimiera, Talavera, Busaco* and *Fuentes d'Onor*. The first of the three clasps above the Cross, those shown by Goya, record the victories at Ciudad Rodrigo, Badajoz and Salamanca. The star of the Tower and Sword has a small gold tower in the group of rays at the top, represented by a brown streak in the picture, and the star of San Fernando is decorated in the centre with a representation of the saint.

The Bath star at Apsley House must be the one given to Wellington in 1815. In Goya's portrait he wears a simpler star, shown in other portraits made after 1804, which was presumably given up in 1813 when he became a Knight of the Garter. Neither of the two ornaments of the Fleece at Apsley House correspond with the one in the portrait.[25] Goya's Fleece differs in some respects from the traditional pattern—the full circle of rays around the central jewel, for example—and it is likely that the artist improvised the design (see above).

STUDY AND COPIES: A study in red chalk for stage one in the evolution of the portrait, in the British Museum. What is, probably, no more than a copy, in black chalk of the second stage in its development, apparently showing a trial hanging for the ornament of the Fleece, in the Kunsthalle, Hamburg. A painted copy on canvas of the finished work belonging to Mr. J. C. Blinckhorn, inscribed in English on the back with a list of the Duke's titles in 1812.[26]

PROVENANCE: Painted almost certainly for Wellington himself in Madrid in 1812, and altered for him probably in 1814. Believed to have passed into the possession of Louisa Catherine Caton, wife of the 7th Duke of Leeds (m. 1828), either directly from the sitter, or via her eldest sister, the wife of Wellington's eldest brother Richard, the Marquess Wellesley (m. 1825). The eldest sister died in 1853 and Louisa Caton, Duchess of Leeds, in 1874.[27] Recorded in the Duke of Leeds collection at Hornby Castle, Yorks, in 1878.[28] Exhibited: London, Grafton Galleries, National Loan Exhibition, 1909/10, (no. 27); Guildhall Art Gallery, Naval and Military Works, 1915 (no. 4); Sheffield, Mappin Art Gallery, 1915 (no. 39); on loan at the National Portrait Gallery, 1930–49; Wildenstein's, New York, *Goya*, 1950 (no. 39). Removed to Jersey in 1951.[29] Exhibited: St. Helier, Barreau Art Gallery, *Old Masters from Jersey Collections*, 1962 (no. 14); Basel, Kunsthalle, *Goya*, 1953 (no. 26); Tate Gallery, *The Romantic Movement*, 1959 (no. 191). Duke of Leeds sale, Sotheby's, 14 June, 1961 (lot 7). Bought, with aid from the Wolfson Foundation and a special Exchequer Grant, 1961. Taken from the Gallery in August, 1961[30] and recovered in May, 1965.[31]

REPRODUCTION: *National Gallery Catalogues, Acquisitions 1953–62* (before cleaning).

REFERENCES, GENERAL: A. L. Mayer, *Goya* (Eng. ed.), 1924, no. 449; Lord G. Wellesley and J. Steegman, *The Iconography of the first Duke of Wellington*, 1935, p. 12; C. Scott Moncrieff in *The Armorial*, III, no. 3 (August, 1962), p. 130; A. Braham in *The Burlington Magazine*, 1966, p. 78.

REFERENCES IN TEXT: **1.** These decorations were identified by Mr. David Piper and the staff of the National Portrait Gallery. An account with slight inaccuracies is given by Scott Moncrieff, *op. cit.* and one with many inaccuracies in an article in *The Sunday Times*, 30 May, 1965—corrected in a letter by M. Levey to *The Times*, 3 June, 1965.

2. An earlier cleaning, in 1951, is recorded in a letter of the Duchess of Leeds to *The Sunday Times*, 6 June, 1965, arising from the article printed in that newspaper on 30 May.

3. The biographical details in this and the following paragraphs are drawn largely from G.E.C., *The Complete Peerage* (revised G. H. White and R. S. Lea), XII, 1959, pp. 452–8.

4. On 20 August or just before, see below.

5. This entitled him to a blue sash worn over the left shoulder and a further badge.

6. His uniform as Field Marshal, recorded in Lawrence's portrait of 1814 at Apsley House, differed in several important ways from his uniform as a General, discussed below.

7. Wellington was in Madrid at least from 25 May, 1814, to 2 June; he left Bordeaux after 14 June and arrived in London before 26 June (see the dispatches transcribed in *Dispatches of . . . the Duke of Wellington*, XII (ed. Lt.-Col. J. Gurwood), 1838, pp. 27, 47, 62 and 70.

8. J. H. Mayo, *Medals and Decorations of the British Army and Navy*, I, 1897, pl. 20.

9. *Ibid.*, pp. 188/9, and Sir N. Nicolas, *History of the Orders of Knighthood*, IV, 1842, *History of Medals*, etc., pp. 32 ff.

10. *Ibid.*, pp. 32, note 5.

11. This is clear, on purely objective grounds, from the evolution of the portrait and its relationship to Goya's drawing in the British Museum (see below). Doubts about the authorship have been expressed on several occasions since 1961; for example in *The Sunday Times*, 30 May, 1965.

12. E. du G. Trapier, *Goya and his sitters*, 1964, p. 38.

13. *The Autobiography of Sir James McGrigor*, pp. 301 f. (a reference kindly pointed out by the Rev. Professor David Cairns).

14. Wellesley and Steegman, *op. cit.* and N. MacLaren, Arts Council Spanish Exhibition, 1947, Catalogue, p. 6.

15. A. Braham, in *The Burlington Magazine*, 1966, p. 618. It is suggested there that the earlier sitter was Joseph Bonaparte; the name of Godoy has also been maintained (letters from Señor X. de Salas in the Gallery archives).

16. An early reference to this is made by J. Somoza, in *Semanario Pintoresco*, 1838, p. 633; according to this account Wellington instigated the dispute by criticizing a portrait of him by Goya mainly because he had been made to look too heavy ('principalmente del talle, diciendo que le habia puesto mas grueso y pesado de lo que era'). Though this story is generally discredited, this particular criticism applies rather well to the equestrian portrait (see note 15).

17. Cross-section made by Miss Joyce Plesters in the Gallery archives.

18. The following account of the evolution of the portrait is based largely on Braham, *op. cit.*, 1966, pp. 78 ff., text and illustrations.

19. It is suggested by MacLaren, *op. cit.*, pp. 6/7 that the drawing was made for a projected etching which was never executed. It may be that the possibility of an etched portrait crossed Goya's mind and this may account for the blank lower margin of the drawing, but the connections with the painted portrait in both content and format seem to provide in themselves an adequate explanation of the purpose of the drawing. The folds in the drawing were not produced by the sheet being attached to an etching plate, as is quite common in drawings by the artist which were made in preparation for etchings.

20. Braham, *op. cit.*, fig. 31.

21. *Ibid.*, fig. 32.

22. The presence of these inaccuracies may in part account for Wellington's willingness to part with the portrait (see Provenance).

23. He learnt of this in a letter of 9 August sent by his brother, Sir Henry Wellesley, from Cadiz (*Sup-*

plementary Dispatches . . . of the Duke of Wellington, VII (ed. 2nd Duke of Wellington), 1860, p. 379), and wrote on 20 August from Madrid to ask for the permission of the Prince Regent to accept (*Dispatches . . .*, IX (ed. Lt.-Col. J. Gurwood), 1838, p. 372).

24. It is not known exactly when this portrait was made, but it was probably painted for General Alava, a Spanish officer who entered Madrid with Wellington in August, 1812 (Trapier, *op. cit.*), and since Wellington wears the ribbon of the Golden Fleece it must have been executed after *ca.* 20 August and possibly before the evacuation of the capital in October.

25. The first is a jewelled ornament believed to have belonged to Don Luis de Borbón and given to the Duke by the Countess of Chinchón; the second is a metal ornament with the Fleece itself hanging in the wrong direction.

26. Letter from the owner of 18 December, 1965, in the Gallery archives.

27. Biographical facts taken from *The Complete Peerage*, VII, 1929, p. 517 and IX, 1936, pp. 238/9.

28. *The Athenaeum*, 1878, II, p. 343.

29. Letter of the Duchess of Leeds, see note 2 above.

30. *The National Gallery: January 1960–May 1962*, pp. 30 ff.

31. *The National Gallery: January 1965–December 1966*, pp. 32 ff.

El GRECO

1541–1614

His real name was Domenikos Theotokopoulos. In Spain he was called by his contemporaries Dominico Greco or *el Griego* (*i.e.* the Greek) but he is now generally referred to as *El Greco*, a form apparently not used until much later.

He was born in Crete, then a Venetian possession. Nothing is known of his earlier years but a few surviving paintings attributed to him suggest that he began in the Byzantine style of the Cretan icon-painters. The date of his arrival in Italy is unknown; it is probable that he went first to Venice, where he was almost certainly a pupil of Titian and underwent the influence of Tintoretto and the Bassani. There is little doubt that he was the *Giovane Candiotto, discepolo di Titiano* mentioned in November 1570 by Giulio Clovio as having arrived in Rome. There he came under the influence of Michelangelo's work; he may also have studied Correggio's paintings in Parma. By 1577 he was in Toledo, where he settled for the rest of his life. He was commissioned to paint a picture for Philip II for the Escorial in 1580 but it failed to please; he executed commissions for churches and convents in many parts of Spain as well as in the province of Toledo. He died (7 April) in Toledo.

El Greco painted several versions of most of his compositions and still further versions were, apparently, often produced by his studio assistants; the degree of studio participation in certain of the works attributed to him, and the exact chronology of his works are questions which still admit a certain degree of vagueness.

LITERATURE: M. B. Cossío, *El Greco*, 1908; for his Italian period, E. K. Waterhouse in *Art Studies*, 1930, pp. 61–88; *catalogues raisonnés*, and reproductions of most of the paintings by El Greco and his studio, in A. L. Mayer,

El Greco, 1926, and J. Camón, *Dominico Greco*, 1950. The most complete catalogue of his works and their derivatives is H. E. Wethey's *El Greco and his School*, 1962.

1457 CHRIST DRIVING THE TRADERS FROM THE TEMPLE

In the centre, Christ; to the right, some of the Apostles(?); on the left the traders. To the left of the arch in the background is a relief of *The Expulsion of Adam and Eve from Paradise*, on the right one of *The Sacrifice of Isaac*. The buildings seen through the archway are Italianate.

Oil on canvas, $41\frac{7}{8} \times 51\frac{1}{8}$ ($1 \cdot 063 \times 1 \cdot 297$). The top, bottom and right edges of the canvas are very ragged, and fragments of painted canvas turned over the stretcher on the right and at the bottom suggest that here at least the field of the composition originally continued for *ca.* 2 cms. and *ca.* 1 cm. respectively.

In good condition generally; some slight wearing (especially in the yellows on the right); more damaged along the bottom edge and in the upper part of the background.

The subject, also referred to as *The Purification of the Temple*, is taken from Matthew, xxi, 12 etc.

The Sacrifice of Isaac is often depicted as the Old Testament proto-type of the *Crucifixion*, and it probably stands here for redemption, referring to the 'redeemed' figures on the right-hand side of the picture; the *Expulsion from Paradise*, referring to the *Purification of the Temple*, is probably related, more specifically, to the 'unredeemed' traders on the left-hand side of the picture. It has further been suggested that this subject, which was a favourite one with El Greco (see below), may have been regarded by the artist as symbolic of the Counter Reformation movement to purge the church of heresy.[1] It seems likely that such an idea would lie behind the paintings of this subject by El Greco.

There are many versions of this composition (see Versions and Copies); at least five appear to be autograph. Of the autograph versions, those at Washington (formerly Cook collection) and at Minneapolis are in El Greco's early style and both must almost certainly have been painted before El Greco went to Spain. In all the subsequent versions the composition has been considerably clarified. The National Gallery and the (much smaller) Frick versions are of almost identical composi-tion. Cossío dates the National Gallery picture 1584–94 and the Frick version 1575–77; Mayer dates them after 1604 and 1598–1604 respec-tively, and Wethey *ca.* 1600–5 and *ca.* 1595–1600. They seem in fact to have been painted about the same time, probably shortly before or after 1600. The latest version of the subject is that in S. Ginés, Madrid.

Many motifs in this composition have been adapted from the works of Italian Renaissance masters.[2] (Some of these derivations are more apparent in the earliest version, in Washington, than in the later ones, where they have been modified.) The man with raised arm stepping

over a recumbent woman, to the left of Christ, is taken from Michelangelo's *Conversion of S. Paul* in the Cappella Paolina at the Vatican.[3] The man with a basket on his head, further to the left, is ultimately derived from a figure in *The Last Judgment*[4] in the Sistine Chapel, and the general arrangement of the composition seems to be dependent on Michelangelo's composition studies of the Purification of the Temple.[5] The old man seated in profile in the right foreground is rather closely related to the Pythagoras in the left foreground of Raphael's *School of Athens* (but inverted),[6] the architectural background of which seems to have inspired El Greco.[7] The figure of Christ (except for the right arm) is similar to that in Titian's *Transfiguration* in San Salvatore, Venice, but is inverted. The recumbent woman on the left of the Washington version has been compared[8] to the sleeping Ariadne in Titian's *Bacchanal* (Prado) but it seems possible that both were derived from a classical antique source;[9] in any case the pose was altered considerably in the Minneapolis and all subsequent versions (including No. 1457). The bending man in the left foreground may perhaps be derived from that in the right foreground of Tintoretto's *Marriage at Cana* in Santa Maria della Salute, Venice, or from a related figure.[10]

VERSIONS OR COPIES: Four paintings of this subject are mentioned in the 1614 inventory of El Greco's possessions drawn up by his son, Jorge Manuel Theotocopuli;[11] four are listed in the 1621 inventory of Jorge Manuel's own goods.[12] A painting of the subject by El Greco is mentioned in the 1629 inventory of El Greco's friend Pedro Salazar de Mendoza,[13] and another was in the sacristy of S. Sebastián, Madrid, towards the end of the eighteenth century, according to Ponz.[14] A signed version, smaller than No. 1457, is in the National Gallery of Art, Washington,[15] another signed version is in the Minneapolis Institute of Arts.[16] A small version, very close to no. 1457, is in the Frick collection, New York.[17] A variant, with additional figures and a different background, and with the field of the composition greatly extended above, is in S. Ginés, Madrid.[18] Other versions or copies are in the Abrisqueta collection, San Sebastián;[19] Norton Gallery, West Palm Beach, Florida,[20] Fogg Art Museum, Cambridge, Massachusetts;[21] Manuel E. Kulukundis collection, New York;[22] Félix Labat collection, Madrid, 1921;[23] Museo Lázaro, Madrid, no. 1527;[24] (?) formerly Agero collection, Madrid[25] (the last two are after the Minneapolis composition).

Cossío mentions a small copy, apparently of the Frick/National Gallery composition, in the Paris market shortly before 1907;[26] and Wethey a copy of the San Ginés picture in the Museum at Pontevedra.[27]

PROVENANCE: Possibly identifiable with one of the paintings of the same subject in El Greco's and Jorge Manuel's inventories (see Versions and Copies). No. 1457 was in an anonymous sale [vendor, Samuel S. Mira] at Christie's, 30 June, 1877 (lot 63; £25 4sh.), bought by Robinson.[28] Presented by Sir J. C. Robinson in 1895. Arts Council Spanish Paintings Exhibition, 1947 (no. 11); Cleaned Pictures Exhibition, National Gallery, 1947 (no. 46).

REPRODUCTION: *Illustrations: Continental Schools*, 1937, p. 143; *Spanish School: Plates*, 1952, pp. 7–9.

REFERENCES, GENERAL: M. B. Cossío, *El Greco*, 1908, no. 342; A. L. Mayer, *El Greco*, 1926, no. 53; J. Camón, *Dominico Greco*, 1950, no. 86; H. E. Wethey, *El Greco and his school*, 1962, no. 108.

REFERENCES IN TEXT: **1.** For the iconography of the picture outlined here see R. Wittkower in *Art News*, LVI, 1957, p. 54.

2. El Greco has added to the foreground of one of the versions of this composition (Minneapolis) portraits of three of the masters from whom he has borrowed (Titian, Michelangelo and Raphael) together with the portrait of Giulio Clovio, who apparently introduced him to his first Italian patron. (There is no valid reason for rejecting the traditional identification of Raphael's likeness.) The picture might thus seem to be a simple tribute to those Italian artists to whom El Greco felt himself indebted, but their presence is ambiguous in relation to the subject matter of the picture, if El Greco indeed regarded it as symbolic of the Counter-Reformation cleansing of temples.

3. This figure is in the opposite direction to that of Michelangelo's fresco, and was probably taken from Giovanni Battista de Cavalieri's engraving (which is also inverted).

4. The derivation, which was pointed out by E. Harris (*El Greco: The Purification of the Temple*, n.d. [1944], pp. 7/8) is only apparent in the Washington and Minneapolis versions; in the others the pose has been modified considerably.

5. Michelangelo's conception of the subject is preserved in three drawings at the British Museum (J. Wilde, *Italian drawings . . . in the British Museum, Michelangelo and his studio*, 1953, nos. 76–78) and one in the Ashmolean Museum (*cf.* especially British Museum no. 1860–6–16–2/3). No. 1194 of the National Gallery (catalogued as after Michelangelo, and traditionally attributed to Marcello Venusti) is derived from a Michelangelo drawing of the subject. It is perhaps worth noting that Giulio Clovio, El Greco's first patron, made copies after Michelangelo drawings (many such are in the Clovio inventory of 1577; *cf.* E. Steinmann & R. Wittkower, *Michelangelo Bibliographie*, 1927, pp. 433/4).

6. Not in the earlier versions (Washington and Minneapolis) where this figure is different.

7. This is clearer in the earliest version (Cook collection) where statues of Minerva and Apollo stand, in place of the reliefs, on each side of the arch as in Raphael's fresco. Wethey, *op. cit.*, II, p. 68, suggests that the female figure is of Hera.

8. E. K. Waterhouse in *Art Studies*, 1930, p. 70.

9. Of the type of the *Sleeping Ariadne* or the *Sleeping Faun*.

10. *E.g.* Tintoretto's drawing in the Uffizi (reproduced in Hadeln, *Handzeichnungen des Tintoretto*, 1922, pl. 62).

11. See F. de B. de San Román, *El Greco en Toledo*, 1910, pp. 192–5, items 84, 101, 127 and 155. The sizes are not given but no. 127 is described as very small (*chiquita*).

12. See San Román in *Archivo Español*, 1927, pp. 285 ff: no. 8: 'de dos terzias de alto y tres quartas de ancho' (= *ca.* 22 × 25 ins.; 0·57 × 0·64); no. 20: 'de dos terzias de ancho y media bara de alto' (= *ca.* 17 × 22 ins.; 0·43 × 0·57); no. 24: 'de bara y terzia de alto y bara y dos terzias de largo poco mas,' (= *ca.* 44 × 56 ins.; 1·12 × 1·42) 'y es el original'; no. 217: 'de dos baras menos quarta de largo y bara y terzia de alto' (= *ca.* 44 × 58 ins.; 1·12 × 1·48). The inventory does not state the authorship of the pictures; no. 24 is the only one described as 'the original'.

13. Wethey, *op. cit.*, II, p. 67.

14. A. Ponz, *Viage de España*, V, 2nd ed., 1782, p. 63. In the first edition (1776) of this volume (pp. 68/9) Ponz calls the picture in the Sacristy a *Prendimiento de Cristo* but in the 2nd ed. (*loc. cit.*) and 3rd ed. (1793, p. 66) he describes it as an *Expulsion of the Merchants from the Temple*. Ceán Bermúdez, who also lists a *Prendimiento de Cristo*, and no other picture by Greco, in S. Sebastián (*Diccionario*, 1800, V, p. 12) was presumably only repeating the misinformation in the first edition of Ponz.

15. Formerly in the Cook collection. Wethey no. 104, figs. 3, 386; 25¾ × 32¾ (0·650 × 0·832). Mayer no. 49.

16. 46 × 58 (1·17 × 1·47). Wethey no. 105, figs. 11, 30, 387. Mayer no. 50. See also note 2.

17. $16\frac{1}{2} \times 20\frac{5}{8}$ (0·423 × 0·528). Wethey no. 106, fig. 199. Mayer no. 51. See the Frick Collection Catalogue, 1968, II, pp. 314 ff.

18. $41\frac{3}{4} \times 41$ (1·06 × 1·04). Wethey no. 110, fig. 197. Mayer no. 54. There is no support for Mayer's suggestion that this is the picture mentioned by Ponz in S. Sebastián, Madrid (see note 14). It seems improbable that the S. Ginés *Purification* is the *pequeño quadro del Greco* mentioned in the Sacristy of the Chapel of Christ at S. Ginés by the anonymous author of the *Paseo por Madrid ó Guía del Forastero en la Corte*, pub. by Repullés, Madrid, 1815, pp. 33/4 (it is the only Greco mentioned there by him).

19. Wethey no. 109; $41\frac{1}{2} \times 49$ (1·05 × 1·25). This must be the picture mentioned by Cossío in the collection of Doña Dolores Alonso, no. 163 and p. 93 (note) as a repetition of the National Gallery/Frick composition.

20. $16\frac{7}{8} \times 21\frac{5}{8}$ (0·43 × 0·55). Wethey no. X-132. Formerly in Boston Museum. A poor copy, nearer to the Frick version, to which it is equal in size, than to no. 1457. (*Boletín de la Sociedad Española de Excursiones*, 1925, p. 31, when in the collection of the Marqués de Tablantes, Seville; reproduced in *Blanco y Negro*, 27 January, 1929).

21. 17×21 (0·430 × 0·535). Ex coll. Naumberg. Wethey no. 107. Mayer no. 52. In poor condition and probably only a copy of the Frick version (of approximately the same size).

22. $40\frac{5}{8} \times 35$ (1·03 × 0·89). Ex colls. Cromberg, Quinn, Kerrigan (sale, New York, 8–10 January, 1942) and Bowes (sale, New York, 1 November, 1946). Reproduced in *Art in America*, XV, 1927, p. 124. Wethey no. X-131. Apparently a copy or pastiche of the National Gallery/Frick design, with the field of the composition extended at the top.

23. Wethey no. X-134; $24\frac{3}{4} \times 32\frac{2}{3}$ (0·63 × 0·70); apparently not traceable beyond 1922. See *Boletín de la Sociedad Española de Excursiones*, 1921, p. 73.

24. Wethey no. X-130; $19\frac{3}{10} \times 27\frac{1}{2}$ (0·49 × 0·70). Ex coll. Ramón Díaz, Jerez de la Frontera. Cossío, *op. cit.*, pp. 34/5 and 93 (note) and pl. 8 *bis*; *La Colección Lázaro*, II, 1927, p. 365. It is a very poor pastiche of the Minneapolis picture; possibly the copy of that composition mentioned by Cossío (*Lo que se sabe de la vida del Greco*, 1914, p. 70) as in the possession of Doña María Florentín, Madrid.

25. 1·10 × 1·45. Wethey no. X-129. According to Camón, *op. cit.*, I, p. 118, it is a much later replica of the Minneapolis picture and according to Wethey, *op. cit.*, a copy possibly of the seventeenth century.

26. Cossío, p. 93; perhaps the picture in the Fogg Art Museum (note 21), which Wethey traces to Paris.

27. Wethey no. X-128; $42\frac{1}{2} \times 42$ (1·08 × 1·07).

28. Sir J. C. Robinson, writing in 1895, stated that he bought the picture from the Marqués de Salamanca of Madrid 'some 15 or 20 years ago' (letter in the Gallery archives). It is not, however, in the catalogues of the Salamanca sales, Paris, 1867 and 1875; moreover it bears on the back the marks corresponding to the 1877 sale at Christie's, at which its buyer was certainly 'Robinson'. It is conceivable that Robinson confused no. 1457 with the Washington picture which was also at one time in his possession (see J. C. Robinson, *Memoranda on Fifty Pictures*, 1868, p. 38, no. 28) and the earlier provenance of which has not yet been traced.

6260 THE ADORATION OF THE NAME OF JESUS

The kneeling figure in black in the foreground represents King Philip II of Spain. Next to him is the figure of a Doge and between them, facing outwards, the figure of a Pope. At the top of the picture hosts of angels surround the monogram of Jesus and on the right is a representation of Hell, from which emerges a whale-like creature, its jaws open to reveal the damned in torment. The subject is a mixture of a votive picture and a Last Judgement.

Signed in Greek capitals on a rock in the left foreground: ΔΟΜΗΝΙΚΟC (MH in monogram) | ΘΕΟΤΟΚΌΠΥΛΟC (TO in monogram) | ΚΡΗC E᾽ΠΟΙΑ (Domenikos Theotokopoulos Cretan made it). An old inventory number, 76, in white paint is present in the lower right corner.[1]

Oil and tempera on pine, $22\frac{3}{4} \times 13\frac{1}{2}$ (0.578×0.342), the painted surface, excluding the painted black border, measures approximately $21\frac{5}{8} \times 13\frac{5}{16}$ (0.551×0.338).

In good condition. Some areas of local damage, including the cloak and breeches of Philip II which are re-painted. Cleaned on acquisition in 1955.[2]

A number of very small *pentimenti*, of which the most obvious visible to the naked eye is a slight change in the position of the left hand of the main angel to the right. Infra-red photographs reveal that the angle of inclination of the head of Philip II was altered, and they show careful underdrawing beneath most of the composition.

Philip II of Spain was born at Valladolid on 21 May, 1527, the son of the Hapsburg Roman Emperor Charles V. On the abdication of his father in 1556, he became sovereign of part of the Empire and King of Spain. A man of extreme piety, he commissioned the building of the Escorial near Madrid which was to act as a palace and a monastery, and to contain the mausoleum of his father. Work began on this in 1562. Philip died at the Escorial on 13 September, 1598.

No. 6260 is sometimes considered to be a finished sketch for the larger picture of the same subject in the Escorial ($55\frac{1}{8} \times 43\frac{1}{4}$), but it seems more likely that it is an autograph replica painted about 1580 (see below). The Escorial picture is wider in format, the whale's mouth broader, the figures more amply spaced, and it contains an additional figure in the foreground—a man near the left-hand edge who points upwards, looking out of the picture to the left.

Both versions of the composition were popularly known by conflicting and misleading titles—No. 6260 as the *Last Judgement of Charles V*,[3] and the Escorial picture as the *Dream of Philip II*.[4] The real subject of both compositions has been identified as an allegory of the Holy League, formed by Spain, Venice and the Holy See against the Turks, a union which led to the great naval victory at Lepanto in 1571.[5] Similar allegories are recorded in a number of engravings of the time.[6] The Escorial picture was probably commissioned by Philip II about 1578/9, shortly after El Greco's arrival in Spain, and it may have been destined for the Pantheon there (the mausoleum beneath the chapel) where its presence is recorded in the seventeenth century.[7]

It has been further suggested that the picture was intended to honour Philip II's illegitimate brother, Don Juan, the victor of the battle of Lepanto, who had died in Flanders in 1578, and whose body was placed in the Pantheon in the following year.[8] This theory rests partly on the supposition that the upright figure to the left of the Pope, his arms stretched to the left and resting on a sword (an element visible only in the Escorial picture), is in some way an idealized portrait of Don Juan.[9]

This seems unlikely (see below), but it is still just possible that the picture was commissioned in Don Juan's honour, if only because it is reasonably dated to the late 1570's, when the victor of Lepanto, fought in 1571, was buried in the Pantheon.

Attempts have been made to identify the figures in the foreground of the picture, but only Philip II is unquestionably recognizable.[10] The Doge at the time of Lepanto was Alvise I Mocenigo († 1577) and the reigning Pope, Pius V (Ghislieri, † 1572).[11] It has been suggested that the bearded figure behind the pope to the left may be Cardinal Granvella (though his robe is not crimson, but orange in colour in the Escorial picture and muted pink in no. 6260), and the red-robed figure to his right Cardinal Pacheco, two members of the Curia who took a prominent part in the forming of the League.[12] An alternative theory would have it that the figure to the left of the Pope could represent S. Charles Borromeo.[13] If the soldier facing the Doge was intended as an idealized portrait of Don Juan, then the two figures towards the left edge of the Escorial composition might be expected to be the heads of the Papal and Venetian troops at Lepanto,[14] and a possible identification of the kneeling figure with the Papal commander, Marcantonio Colonna, has been proposed.[15]

But all these figures, with the exception of Philip II, are probably more or less allegorical. El Greco could surely have alluded more specifically to the actual heroes of the Holy League, had he so wished. The three secondary figures in the foreground, the kneeling man (left), the soldier and the Cardinal (right) are probably no more than idealized incarnations of the physical and spiritual forces on which the success of the League depended. The generalized features or amorphous dress of all the figures but Philip II, coupled with the Last Judgement scene of Hell on the right, carries the strong implication that the whole crowd is not one of living people, but of figures risen from the dead who hopefully await judgement or are already amongst the ranks of the redeemed. Some confusion about the status of these figures would appear to arise inevitably from the nature of the subject matter (see note 21), not least because Philip himself, of the three heads of state at the time of Lepanto, was still alive. Ambiguities of a similar kind, but less extreme and deriving from an established iconographic tradition, are present in Titian's *Gloria* (Prado, no. 432), sent off to Charles V, Philip's father, in 1551. The connection between the present composition and Titian's painting would appear to have been acknowledged as early as the seventeenth century when the Escorial picture was known as El Greco's *Gloria* (see note 4).

The composition contains echoes of artists whose work El Greco had probably seen in Italy—the influence of Correggio seems to lie behind the vision in the sky[16] and that of Dürer's *Rosenkranzfest*, a picture still in Venice when El Greco was there, can perhaps be detected in the arrangement of the foreground figures. Allusions to Michelangelo are present in the poses of the damned in the whale's mouth. The whale itself and the scene in the middle distance behind it appear to be based

on an engraving of the *Last Judgement*, published probably in 1578, and designed by Giovanni Battista Fontana, a little known Italian artist who worked largely in Austria.[17] The greater detail in this engraving, and the fact that as a print it must have been widely circulated, suggest that it was El Greco who followed Fontana and not *vice versa*. The probable date for the print—after 1578—could provide a definite *terminus post quem* for the start of El Greco's work, were it not possible that both artists drew from a common source, or that they had access to each other's ideas before El Greco finally left Venice, where Fontana also worked for a time.

The tradition of representing Hell as a sea inhabited by Leviathan derives from medieval practice and it lingered, especially in northern Europe, at least until the sixteenth century.[18] The scene in the middle distance is more obscure in its meaning. A cavern with a flaming interior is preceded by an arched vestibule containing a gallows, leading to a bridge over the fiery sea on which a group of figures are apparently being dragged; two plunge from the bridge and two figures on white horses seem to direct the operations. This scene must refer to the tradition whereby the souls of the dead pass from the cavern of Purgatory across a bridge suspended over a pit in their passage to the other world.[19] Echoes of this tradition, especially the actual bridge, re-appear in a number of sixteenth-century representations of Hell and Purgatory,[20] but it is not always clear whether the artists intended a very precise meaning to be attached to the bridge. In the present case El Greco seems to have treated the bridge merely as a platform from which the souls of the damned are cast into the sea.[21]

Reasons can be given for interpreting the National Gallery picture as a sketch for that in the Escorial, or as a replica of it, but on balance the latter seems the more probable, taking into account the careful underdrawing revealed by infra-red photographs of the smaller panel.[22] Certain details in the Escorial picture, which are absent in no. 6260, seem to be based directly on Fontana's engraving—the beam projecting over the bridge from the right, or the uneven teeth of the whale, for example, and these suggest that the National Gallery picture must be a simplified version of the larger picture. This is borne out by some obscure passages in the National Gallery picture. The sword, for example, which supports the arms of the soldier in the left foreground of the Escorial composition is absent in the smaller picture, so that his pose is unintelligible except as a sequel to the figure in the Escorial painting. El Greco is known to have kept small-scale versions of his compositions[23] but it is not certain that these were strictly sketches, rather than records made of the artist's compositions for reference and future use; the provision of sketches was a procedure that would have been unusual at the time.

The fact that the National Gallery painting resembles in its technique and signature pictures produced by El Greco in Italy cannot be taken as proof that the work was executed before El Greco's arrival in Spain.[24] It may well be accountable to the small size of the panel which demanded a fussier treatment than the larger picture if it was to contain anything

like the same amount of detail. It is nevertheless strange that a replica should disagree in format and to some extent in composition from the work which it purports to record, and this may be explicable in terms of a reduced replica of El Greco's *Espolio* to which it apparently acted as a pendant. This is a picture now at Upton House which corresponds in style, size and technique with the National Gallery picture and almost certainly shares the same provenance.[25] It reproduces the large *Espolio* painted by El Greco in the late 1570's for the Cathedral of Toledo, and corresponds closely with it in format.[26] The two small panels record the most important commissions El Greco received in the years immediately following his arrival in Spain.

VERSIONS AND COPIES: The larger painting of the same composition by El Greco in the Escorial is discussed above. There is a later repetition in the Museo Lázaro Galdeano, Madrid.[27]

PROVENANCE: Almost certainly the painting recorded together with its pendant in a list of pictures belonging to Don Luis Méndez de Haro y Guzmán, Marqués del Carpio, II Conde-Duque de Olivares († 1675), and to his son Don Gaspar, etc., Marqués de Eliche (or Liche) († 1687).[28] Gaspar was by 1651 the owner of the Rokeby Venus (Velázquez, no. 2057 below) but he may not have acquired the two panels by El Greco until after the death of his father (see note 29). From him they passed, probably, into the Alba Collection *via* his daughter, Doña Catalina who married in 1688 the 10th Duke of Alba. Most probably two of a group of four pictures taken from the palace of Loeches, near Madrid, by the governor, Don José Jeronimo de Somoza, and not returned to the Alba Collection until 1729.[29] Probably taken from Spain at the time of the Peninsular war, though by whom is not known. No. 6320 was exhibited in the Spanish collection of King Louis Philippe at the Louvre (1838–48);[30] Louis-Philippe sale, London, 7 May, 1853 (lot 112; £31), bought by Graves for Sir William Stirling Maxwell. Exhibited: London, New Gallery, 1895/6 (no. 173); London, Burlington Fine Arts Club, 1928 (no. 45); London, Spanish Art Gallery, 1938 (no. 1); Arts Council Spanish Paintings Exhibition, 1947 (no. 13); Edinburgh, *Spanish Paintings*, 1951 (no. 18). Bought from the grandson of Sir William Stirling Maxwell, Lt.-Col. W. J. Stirling of Keir, in 1955.

REPRODUCTION: *National Gallery Catalogues, Acquisitions 1953–62*.

REFERENCES, GENERAL: M. B. Cossío, *El Greco*, 1908, no. 337; A. L. Mayer, *El Greco*, 1926, no. 123a; A. Blunt, in *Journal of the Warburg and Courtauld Institutes*, 1939/40, III, nos. 1/2, pp. 58 ff.; J. Camón Aznar, *Dominico Greco*, 1950, no. 261; H. E. Wethey, *El Greco and his school*, 1962, no. 116; *National Gallery Catalogues, Acquisitions 1953–62*, pp. 35 ff.

REFERENCES IN TEXT: **1.** The number is difficult to see at first glance though the lettering is large. Its presence, which appears to be unrecorded, was kindly pointed out by Monsieur A. G. Xydis.

2. According to a report in the Gallery Archives by Miss Joyce Plesters on the support and technique of the picture, the cloak of the man kneeling in the left foreground and that of the principal angel on the right have faded, being originally blue to grey in colour (see J. Plesters in *Studies in Conservation*, 14 (1969), p. 66).

3. The subject of 6260 was described as *una visión que tuvo Felipe II* in the seventeenth century, but by the eighteenth it was apparently known as the *Juicio de Carlos V* (i.e. Philip's father—see notes 28 and 29 below). When exhibited at the Louvre in 1838, one of the figures in the foreground was taken to be François Ier (presumably the one identifiable with

Philip II) and another to be Charles V (probably the figure meant to represent a Pope)—see note 30 below.

4. Palomino called the Escorial picture 'una pintura pequeña del Juicio' (1724—see F. J. Sánchez Cantón, *Fuentes literarias* . . . , IV, 1936, p. 88). The title *El sueño de Felipe II* occurs in print, apparently for the first time in D. Vicente Poleró y Toledo, *Catálogo de los cuadros del Real Monasterio de San Lorenzo*, 1857, p. 39, though this title is not far removed from that used to describe no. 6260 in the seventeenth century (see preceding note). The most balanced account of the subject formerly given is that by Fr. Francisco de los Santos in his *Descripción breve del monasterio de S. Lorenzo el Real del Escorial*, 1657 (F. J. Sánchez Cantón, *Fuentes literarias* . . . , II, 1933, pp. 287/8). He states that the picture is known as *la Gloria del Greco*, that it contains a representation of Purgatory and Hell, with the Church Militant, including a portrait of Philip II, and he refers finally to the text of S. Paul, on which pictures of the adoration of the Holy Name are based, Philippians, ii, 9/10: 'Wherefore God also hath highly exalted him, and given him a name which is above every name: That at the name of Jesus every knee should bow, of things in heaven, and things in earth, and things under the earth;' Los Santos was cited by Cossío, *op. cit.*, pp. 317 ff., who seems to have been the first to question the title, *El sueño de Felipe II* (p. 316). The present title for no. 6260 appears to derive from Mayer, *op. cit.*

5. Blunt, *op. cit.* He states that General Stirling, a former owner of the picture, suggested that the subject was essentially an allegory of the Holy League.

6. Three engravings are particularly relevant: one published by Pieter Balten in the late sixteenth century (Blunt, pl. 10a) showing the Church Militant before a Holy Vision —in the foreground kneels a Pope and an Emperor on the sole of whose shoe is a crescent, a symbol of Islam; second is an engraving by Martin Rota of 1571 showing Philip II and the Doge kneeling before the Pope on a dragon, at whose side is a broken scimitar; the third shows the three generals of the League and their rulers kneeling (engraving by Giacomo Franco, in *Habiti d' huomini et donne venetiane*, II, *Città di Venezia*, 1614— cited by Blunt, and illustrated by A. Vallentin, *El Greco*, trans. A. Révai and R. Chancellor, 1954, pl. 23 and pp. 130f., note 1). Other pictures alluding to the League and the battle of Lepanto are discussed by Blunt, pp. 62 ff.

7. De Los Santos, *op. cit.*, 1657.

8. Theory proposed by Blunt, *op. cit.*, pp. 67 f. Cossío, dating the picture exceptionally late, suggested (p. 322) that it could have been destined for the tomb of Philip II himself. This would seem to remain a possibility in spite of the revised dating of the work. A connection with the Holy Inquisition was proposed by H. Kehrer, *Spanische Kunst*, 1926, p. 69.

9. E. du G. Trapier, *El Greco, Early Years at Toledo 1576–86*, 1958, pp. 22 f., doubts the identification of Don Juan in the painting and notes that he was not high in Royal favour at the time of his death.

10. Trapier, *op. cit.*, p. 21, suggests that this representation may have been influenced by those on letters patent of nobility (*cartas ejecutorias de hidalguía*). R. Byron and D. Talbot Rice, *The Birth of Western Painting*, 1930, pp. 191/2, cite Byzantine models.

11. The likeness of Doge Mocenigo is supposedly recorded in a portrait by Tintoretto (Venice, Accademia, cat. no. 233). He looks less aged and venerable than the figure in the foreground of El Greco's pictures.

12. Blunt, *op. cit.*, p. 65. The figure on the left of the Pope bears some resemblance to Titian's portrait of Granvella at Besançon.

13. Wethey, *op. cit.*, II, p. 75.

14. Blunt, *op. cit.*, p. 65, argues that only Don Juan is present.

15. Wethey, *op. cit.*, II, p. 75. What are evidently portraits of the three commanders are shown in the engraving by Giacomo Franco mentioned in note 6 above. Though the scale of the engraving is small, it is clear that all three are bearded and considerably older than the figures in El Greco's composition.

16. Blunt, *op. cit.*, p. 69. D. Talbot Rice, *The Listener*, 16 March, 1961, exaggerates the Byzantine sources of the vision. Mayer, *op. cit.*, p. 21 (no. 123) draws a parallel with Dürer's *Allerheiligenbild* at Vienna.

17. A. Braham, in *The Burlington Magazine*, 1966, pp. 307 f. The engraving bears a dedication to Johann Thomas, Bishop of Brixen, and this would appear to refer to Johann Thomas von Spaur who was appointed bishop in 1578. It is argued there that El Greco may have regarded the engraving as a good corrective to Michelangelo's *Last Judgement* in the Sistine Chapel, of which he is believed to have disapproved (G. Mancini, *Considerazioni sulla pittura*, ed. 1956, I, pp. 230 f.)

18. The same motif occurs in a triptych at Modena which is generally thought to be an early work by El Greco, and in this case there is a very close resemblance to Dürer's *Last Judgement* in the Small Woodcut Passion (see L. Hadermann—Misguiche, in *Gazette des beaux-arts*, 1964, I, pp. 355 ff.). Earlier examples are cited by E. Mâle, *L'art religieux du XIIIᵉ siècle en France*, 1923, p. 384, and the origin of the theme is discussed. Blunt (p. 59) suggests that in showing the lake behind the whale as a flaming area, El Greco follows closely the text of Revelation (xix, 20); in this respect Fontana's engraving is non-committal.

19. An analysis of the Purgatory scene is given by Blunt (pp. 59/60).

20. In Fontana's engraving of the Last Judgement, and in a picture of Purgatory attributed to Tintoretto in the Gallery at Parma (Cossío, p. 318 and fig. 58/3). The figures on white horses are not present in Fontana's engraving.

21. The figures on the left of the picture are isolated psychologically from the scenes of Hell and Purgatory, and it is not made clear whether they too are in Purgatory, still awaiting judgement (see Camón Aznar, *op. cit.*, I, p. 223), or whether they are already amongst the blessed (see Trapier, *op. cit.*, p. 21). The figures in the immediate foreground overlap with those behind whose dress is more amorphous, and these in turn merge with the figures who appear in the background to the rear of the dark shadow. This shadow is taken by Blunt (p. 62) to be the Shadow of the Almighty (Psalm 91, 1). Some distinction was perhaps intended between the figures in front of the shadow and those behind it. There is, however, no clear evidence in the composition that judgement is taking place in the area of the shadow, although in the Escorial picture the shadow is larger and it reaches nearly to the bridge. Some confusion about the status of the foreground figures would appear to be inherent in the subject matter, and it would be understandable that El Greco should have refrained from prejudging the issue too exactly.

22. Taken to be a sketch by MacLaren, Arts Council Spanish Paintings Exhibition, 1947 (no. 13) of *ca.* 1580; by Camón Aznar, *op. cit.*, I, p. 233; by Waterhouse, *Spanish Paintings*, Edinburgh, 1951 (no. 18), of 1578 (?); and by Wethey, *op. cit.*, of *ca.* 1578—and perhaps commissioned when El Greco was in Madrid in 1577. Cossío, Mayer and Blunt describe the picture as a version or a replica.

23. See Pacheco's account of his visit to El Greco, *Arte de la Pintura*, 1649, p. 337.

24. Trapier, *op. cit.*, p. 20, lays stress on these resemblances.

25. Wethey, *op. cit.*, fig. 57. See *The Bearsted Collection*, catalogue of exhibition at Whitechapel Art Gallery, 1955, p. 17; the size of the picture, minus strips added to the top and sides, is 0·553 × 0·316 and it is executed on pine. As stated in this catalogue: 'On the back of the panel is a facsimile (?) of the brand of Don Gaspar de Haro, Marques de Heliche, who died in 1687.' No such brand is present on the back of no. 6230, but the two pictures almost certainly remained a pair in the seventeenth and eighteenth centuries (see notes 28/29 below).

26. The picture is generally accepted as a replica and the history of the commission of the large Espolio and the disputes which arose (summarized by Wethey, II, pp. 52 f.) show that no sketch can have been provided.

27. Wethey no. X-11; Camón Aznar, *op. cit.*, I, p. 235, fig. 136.

28. A. M. de Barcia, *Catálogo de la colección . . . del . . . Duque de Berwick y de Alba*, 1911, p. 246: 'Otra pintura en tabla de una visión que tuvo Felipe II, de mano de Dominico Greco, de tres cuartas de alto y cerca de media vara de ancho. [*ca.* 25 × 17 ins.] Otra dicha, compañera de la antecedente en el tamaño, y del mismo autor, del prendimiento de Cristo.' The sources on which this list of pictures is based are not described by the author, and certain of the inventories of the collection are now missing (see J. M. Pita Andrade in *Archivo Español*, 1952, p. 225, note 4, and *Velázquez*, no. 2057, below).

29. *Discorsos leídos ante la Real Academia de Bellas Artes de San Fernando . . . del Excmo. Sr. Duque de Berwick y de Alba*, 1924, p. 92. The list given here under the heading *Olivares* perhaps refers to pictures originally in the collection of Don Luis de Méndez,

II Conde-Duque de Olivares († 1675). No explanation is given in the text of the various headings under which the inventories appear. No. 6320 is described as the *Juicio de Carlos V* and is given the wrong measurement for width: 'Juicio de Carlos V. (Tabla del Greco, de ¾ de alto por 1 [sic] vara de ancho. Extraído del Palacio de Loeches por el Gobernador D. José Jerónimo de Somoza; embargado entre sus bienes y entregado por el depositario al Duque de Alba en 1729.)' The companion is listed as: 'Prendimiento de Cristo. (Tabla del Greco del 3 y ¼ [sic] de alto por 1 [sic] vara de ancho.' etc.

30. By this time the two pictures had parted company. According to Cossío, p. 605, the picture was described thus: '256. *Le jugement dernier*. On distingue dans ce tableau Charles Quint, François Ier, le Doge de Venise et plusieurs personnages célébres de cette époque.'

Ascribed to EL GRECO

1122 S. JEROME AS CARDINAL

The damaged remains of a signature in Greek in small black letters, corresponding with the type of signature usually found on El Greco's pictures, are present near the right edge of the canvas towards the bottom edge. They are interrupted by the present edge of the canvas. Two lines of letters are present and the upper line appears to consist of some of the letters making up the artist's christian name: δ(ο)μη (νϊ/ . . . (domenikos). The second line of letters is vaguer than the first. (For the words used in El Greco's signature see preceding entry.)

Oil on canvas (irregular edges), *ca.* 23¼ × *ca.* 19 (*ca.* 0·59 × *ca.* 0·48). Comparison with the other versions, especially that in the Adanero collection (see Versions and Copies) suggests that the picture has been cut down slightly on all sides; the truncated signature shows that this is certainly the case on the right side.

Somewhat worn, especially in the beard, the top of the head, the hands and the background; the reds have faded. A piece of the original, *ca.* 3½ × *ca.* 1¾ (*ca.* 0·09 × *ca.* 0·045), is missing from the arm at the left elbow; a tear in the left background continues into the forehead. Cleaned in 1952 when the remains of the signature were uncovered.

The right-hand page of the book carried before cleaning a worn inscription added by a later hand: L. CORNARO | *Æt suæ* 100 1566.[1]

S. Jerome († 420), the most frequently depicted of the Doctors of the Church, is generally represented as a Cardinal although he was not one.

He is often shown reading the Scriptures, a reference to his having translated the Bible (Vulgate).

Some of the versions of this composition have been thought to be portraits of Don Gaspar de Quiroga, Cardinal Archbishop of Toledo (1513–94);[2] the National Gallery picture has been supposed to represent Alvise (Luigi) Cornaro or Corner (1475–1566), the allegedly centenarian Venetian author of *Trattato de la Vita Sobria* (1558),[3] or Cardinal Luigi Cornaro (born 1516).[4] The first of these suggestions has been disposed of by comparison with the authentic likeness of Quiroga formerly in the Beruete collection;[5] the second by comparison with the portrait by Tintoretto in the Pitti Palace;[6] the third is entirely dependent on the inscription formerly on the present picture which was certainly a later addition[7] and, moreover, obviously intended to refer to the 'centenarian' Luigi Cornaro. But in any case none of the versions seems to have been intended to be a likeness.

This seems to be a weaker version of a composition of which there are several almost identical repetitions, two of them much larger (in the Frick and Lehman collections: see below). Traditionally considered an autograph work, this picture was catalogued as a studio production by MacLaren, who considered that the head may have been by El Greco himself. The poor state of preservation makes a definite judgement about the authenticity of the picture difficult, but the brushwork throughout is like that of El Greco (as opposed to the harder style of his studio), and the emergence of a signature, though by no means a proof of authenticity, lends support to such an attribution.

The present picture is generally dated to the 1590's and the other versions of the composition to the same period, or later.

VERSIONS AND COPIES: In the 1614 inventory of El Greco's possessions made by Jorge Manuel Theotocopuli are two paintings of *S. Jerome as Cardinal*, one described as small.[8] Two (possibly the same two) are listed in the 1621 inventory of Jorge Manuel's belongings.[9] There is a signed version in the Frick collection, New York;[10] another wrongly said to be in the parish church, Pastrana (Guadalajara Province).[11] Unsigned versions are in the Lehman collection, New York,[12] the Conde de Adanero collection, Madrid,[13] and the Musée Bonnat, Bayonne.[14] A later copy was formerly in the Soler y March collection, Barcelona.[15] Cossío[16] mentions an old copy, with the addition of a trumpet in the top left corner, then in the Federico A. Hernández collection, Madrid; a copy with a cardinal's hat, top left, and a trumpet, top right, is in the collection of the Marquesa Viuda de Heredia, Madrid,[17] and another (with a trumpet only, top right) was formerly (?) in the Marqués de Gorteiz's collection, Madrid.[18]

PROVENANCE: Possibly identifiable with the smaller of the two *S. Jeromes* in El Greco's 1614 inventory or no. 162 of Jorge Manuel's 1621 inventory (*cf.* Versions and Copies). In the collection of Lord Northwick, Thirlestane House, Cheltenham, by 1858;[19] Northwick sale, Thirlestane House, 26 July *sqq.* 1859 (lot 237; £25 14sh. 6d.),[20] bought by Kneller. In the Duke of Hamilton's collection; bought for the National Gallery at the Hamilton sale, 17 June *sqq.* 1882 (lot 748; £336).[21] Greek Art Exhibition, Royal Academy, 1946 (no. 349); exhibited Whitechapel Art Gallery, 1948 (no. 18).

REPRODUCTION: *Illustrations: Continental Schools*, 1937, p. 143; *Spanish School: Plates*, 1952, p. 12 (both before cleaning).

REFERENCES, GENERAL: M. B. Cossío, *El Greco*, 1908, no. 341; A. L. Mayer, *El Greco*, 1926, no. 279; J. Camón, *Dominico Greco*, 1950, no. 506; H. E. Wethey, *El Greco and his school*, 1962, no. 243—as El Greco and workshop, *ca.* 1595–1600.

REFERENCES IN TEXT: **1.** *Cf.* the reproduction (before cleaning) in *Spanish School: Plates*, 1952, p. 12. Most of this false inscription was removed in cleaning in 1952; only illegible traces now remain. The date was sometimes given as 1556 but was certainly intended for 1566, the date of Cornaro's death (formerly supposed to have occurred when he was 100).

2. *Cf.* C. Justi, *Velazquez und sein Jahrhundert*, 1888, I, p. 79.

3. For Alvise Cornaro's dates etc. see P. Molmenti, *Curiosità di storia veneziana*, 1919, pp. 175 ff.

4. E. Beck in *The Burlington Magazine*, VII, 1905, p. 285, note 28.

5. See Cossío, pp. 94–6 and pl. 120.

6. It may also be observed that all the known versions must, to judge by their style, have been painted in Spain and twenty to thirty years after Alvise Cornaro's death.

7. None of the other versions has a similar inscription. That on no. 1122 was first mentioned in the catalogue of the Hamilton sale, 1882; there is no trace of any other earlier inscription.

8. 'Un S. Jeronimo cardenal pequeño' and 'Un S. Jeronimo cardenal' (see F. de B. de San Román, *El Greco en Toledo*, 1910, pp. 192 and 193).

9. No. 131: 'Un San Jeronimo de Cardenal, de bara y bara y terzia' (*ca.* 44 × 33 ins.) and no. 162: 'Un San Jeronimo de Cardenal del mesmo tamaño (*i.e.* 'tres quartas de alto y dos terzias de ancho' = *ca.* 25 × 22 ins.) (See F. de B. de San Román in *Archivo Español*, 1927, pp. 299 and 301.) San Román (p. 301) identifies no. 162 with the Lehman picture but the latter is much larger (see note 13) and the measurements in the inventory are approximately those of the National Gallery and Adanero versions.

10. $43\frac{1}{2} \times 37\frac{1}{2} (1\cdot10 \times 0\cdot953)$; Wethey no. 240, figs. 286, 400. Mayer, *op. cit.*, no. 278. Presumed to be from Valladolid Cathedral; not, as Mayer says, ex coll. Marqués del Arco (the Arco version is now in the Lehman collection). See the Frick Collection catalogue, 1968, II, pp. 309 ff.

11. It is confirmed by Wethey (no. X-376) that this is a copy of El Greco's composition of S. Jerome in Penitence.

12. Wethey no. 241, fig. 288; $42\frac{1}{2} \times 34\frac{1}{4}$ ($1\cdot08 \times 0\cdot87$). Mayer no. 277. Ex coll. Marqués del Arco, Madrid, and Durand-Ruel.

13. $25\frac{1}{8} \times 21\frac{1}{4}$ ($0\cdot64 \times 0\cdot54$). Ex coll. Marqués de Castro Serna. Wethey no. 242. Mayer (no. 277) has confused this with the Lehman version which is considerably larger (see note 12).

14. $11\frac{3}{4} \times 9\frac{3}{8}$ ($0\cdot30 \times 0\cdot24$). Wethey no. 244, fig. 287. Mayer no. 280. Bust only, without hands; probably cut down from a larger composition. Ex coll. E. Mélida.

15. Wethey no. X-372. Ex coll. José Dalmau. Catalogue of the *Exposición de retratos y dibujos antiguos y modernos*, Barcelona, 1910, pl. 8; reproduced twice in error in Camón (*op. cit.*, II, figs. 691 and 692) and catalogued as two separate paintings (nos. 508 and 509).

16. Wethey no. X-375. Cossío, p. 96.

17. Wethey no. X-374.

18. Wethey no. X-373. Reproduced in Camón, *op. cit.*, II, fig. 690.

19. *Hours in Lord Northwick's Picture Galleries*, 1858, p. 66, no. 558 (as *Louis Cornaro* by Titian). It is not mentioned in the 1846 edition of this work (*Hours in the Picture Gallery of Thirlestane House*), nor in the catalogues of the collection in *Art-Union*, VIII, 1846, pp. 251–6 and 271–4.

20. As *Luigi Cornaro* by Titian.

21. In the Hamilton sale catalogue as *Ludovico Cornaro, Doge of Venice* by Titian, but sold as by El Greco.

Studio of EL GRECO

3476 THE AGONY IN THE GARDEN OF GETHSEMANE

In the centre, the kneeling Christ, to whom appears an angel with a cup; in the background below the angel are the Apostles Peter, James the Greater and John. In the right background, Judas with the chief priest's men.

Oil on canvas, $40 \times 51\frac{1}{2}$ ($1 \cdot 02 \times 1 \cdot 31$).

In good condition generally, despite what is sometimes said;[1] two or three old tears. The paint is thin in the top right corner and the red preparation shows through slightly.[2]

This representation of the subject is a synthesis of the varying accounts given in the Gospels: the number (and names) of the Apostles are mentioned only in Matthew, xxvi, 37, and Mark, xiv, 43; the appearance of the angel only in Luke, xxii, 43, and the 'lanterns and torches' of the chief priest's men only in John, xviii, 3. The cup held by the angel is an allusion to Christ's words: O my Father, if this cup may not pass away from me, except I drink it, thy will be done.[3]

Accepted by Cossío[4] as a work of El Greco's last years. Mayer[5] believed it to be a workshop repetition of a picture of identical composition now in the museum at Toledo, Ohio (see Versions and Copies), and attributed to the same hand a *S. Peter Penitent* in the possession of Count Contini-Bonacossi[6] and a *S. Louis* formerly in the Vega-Inclán collection, Madrid;[7] his view about the status of no. 3476 has been accepted generally. Mayer did not suggest a date for no. 3476 but placed the Toledo (Ohio) version in the years 1590–8.[8] It was suggested by MacLaren that the greater hardness of the present picture could be explained if it were an earlier autograph version of the Toledo (Ohio) picture, made a little after the Escorial *Martyrdom of S. Maurice* which was commissioned in 1580. Wethey dates both pictures *ca.* 1590–5 and describes the National Gallery version as 'El Greco and workshop'. It seems most likely that no. 3476 is a workshop repetition of the Toledo (Ohio) picture.

A damaged version of the composition with some variations in the Félix Valdés collection, Bilbao, in which the figure of Christ is nearer to those of the vertical versions of this composition[9] (see below), is later than the Toledo (Ohio) picture and may be a studio work.

There are also many vertical versions of this composition by El Greco and his studio, all of which seem to be later than the Toledo (Ohio) picture. In them the group of sleeping Apostles has been brought forward to occupy the whole of the foreground, while Christ and the angel have been placed farther back and in the upper half of the picture. (This drastic alteration of the composition may be due to the influence of Titian's painting of the same subject at El Escorial, which was in Spain by 1574.)

VERSIONS AND COPIES: Three paintings of this subject are listed in the inventory of El Greco's possessions drawn up by Jorge Manuel Theotocopuli in 1614.[10] Five are in the 1621 inventory of Jorge Manuel's goods[11] (of these

one certainly, probably two, were horizontal compositions, the rest vertical). Ponz[12] mentions a small picture of the same subject by El Greco then in the Capilla de Copacavana of the Convento de Recoletos, Madrid (repeated by Ceán Bermúdez[13]). A signed picture almost identical in composition with no. 3476 is in the museum at Toledo, Ohio;[14] another version with some variations is in the collection of Félix Valdés, Bilbao.[15] Vertical versions of the composition are in the Museum of Fine Arts, Budapest (signed);[16] the Cathedral Treasury, Cuenca (signed);[17] formerly in the chapel of the Ducal Palace, Medinaceli (signed);[18] the church of Santa María, Andújar, Jaén (signed);[19] Buenos Aires Museum (signed);[20] Lille Museum;[21] in the possession of Count Contini-Bonacossi, Florence (signed);[22] formerly in the Hospital General, Avila.[23]

A later derivative of the design, of vertical format but nearer to the horizontal compositions, and with an inexplicable signature: (*A° G°? f.* Thatocopulo | 16 *y* 16 | *Toledo* [*sic*]) is in the Escuelas Pías de San Antón, Madrid.[24]

PROVENANCE: Possibly to be identified with one of the paintings of this subject in the El Greco inventory of 1614 (see Versions and Copies). Formerly in the Convento de las Salesas Nuevas, Madrid,[25] whence it was bought, apparently in May, 1919,[26] by Lionel Harris; purchased from him (with the aid of the Lewis, National Loan Exhibition and Temple-West Funds) in November, 1919. Greek Art Exhibition, Royal Academy, 1946 (no. 348); Arts Council Spanish Paintings Exhibition, 1946 (no. 6) and 1947 (no. 12).

REPRODUCTIONS: *Illustrations: Continental Schools*, 1937, p. 144; *Spanish School: Plates*, 1952, pp. 10 and 11.

REFERENCES, GENERAL: M. B. Cossío, *El Greco*, 1908, no. 80; A. L. Mayer, *El Greco*, 1926, no. 55a; J. Camón, *Dominico Greco*, 1950, no. 108; H. E. Wethey, *El Greco and his school*, 1962, no. 30.

REFERENCES IN TEXT: **1.** Cossío (*loc. cit.*), speaking of the picture before it was cleaned, says it is in poor condition with bad repaints; Mayer (*loc. cit.*), describing it after cleaning, calls it 'restored'. The picture was cleaned in 1919 and it was found that under a thick dark layer of dirt and dark varnish the paint was very well preserved except for several tears (*e.g.* across the mouth and ear of Christ and by his shoulder) and some crude repaint, now removed.

2. It is stated in the catalogue of the Arts Council Spanish Exhibition, 1947 (no. 12), that the foliage on Christ's left was at first different. This statement was based on a radiograph taken in 1927 which was faulty; a further radiograph taken in 1948 shows no *pentimenti* in this area.

3. Matthew, xxvi, 42, etc.

4. *Loc. cit.*

5. *Loc. cit.*

6. Mayer no. 202a. See below, Greco no. 3131 for further discussion of this picture.

7. Mayer no. 292a.

8. Mayer no. 55.

9. Especially the Buenos Aires and S. María, Andújar, versions (see Versions and Copies).

10. See F. de B. de San Román, *El Greco en Toledo*, 1910, pp. 191, 192 and 194, items 60, 66 and 139; in each case: 'Una orazion del guerto'. The sizes are not given.

11. The two horizontal pictures are items 30, 'Una orazion del guerto, en tabla guarnecida de negro, de media bara de largo y una terzia de alto' (*=ca.* 11 × 17; *ca.* 0·28 × 0·43) and 139, 'Una orazion del guerto, de bara y bara y quarta' (*ca.* 33 × 42; *ca.* 85 × 1·07); see San Román in *Archivo Español*, 1927, pp. 290 and 300. Although in item 139 it is not stated which measurement is the height and which the width, in by far the greater number of cases the height comes first in this inventory. There are two more pictures of the *Agony in the Garden* in the 1621 inventory than in the 1614 one. It is difficult to believe, *pace* San Román (p. 157), that these two pictures and the 120 other additions in the 1621 inventory are not the work of Jorge Manuel or El Greco's studio.

12. A. Ponz, *Viage por España*, V, 1782 ed., p. 50. Ponz calls it a 'quadrito.'

13. Ceán Bermúdez, *Diccionario*, 1800, V, p. 12.

14. Wethey no. 29, fig. 162; $40\frac{1}{4} \times 44\frac{3}{4}$ ($1\cdot02 \times 1\cdot14$). Mayer no. 55 (reproduced p. 10). Apparently bought from the Cacho collection, Madrid, by Lionel Harris; it later passed, via Durlacher, to Arthur Sachs who sold it to the Museum of Art, Toledo, Ohio.

15. Wethey no. 31, fig. 163; $39\frac{1}{4} \times 56$ ($1\cdot00 \times 1\cdot43$). Also reproduced in Camón, *op. cit.*, II, fig. 632. Probably cut down considerably on all sides. Said to have come from Santa Teresa, San Sebastián [?].

16. Wethey no. 33, fig. 165; $67 \times 44\frac{3}{4}$ ($1\cdot70 \times 1\cdot13$). Mayer no. 56.

17. Wethey no. 34, fig. 166; $34 \times 19\frac{3}{4}$ ($0\cdot86 \times 0\cdot50$). From the parish church at Pedroñeras. Reproduced reversed in *The Burlington Magazine*, LXXXVII, 1945, p. 298; the composition is not in the opposite direction to all the other versions as stated in the text (*op. cit.*, p. 295); it was correctly reproduced in *Pantheon*, 1930, p. 184.

18. Wethey no. 36; $68\frac{7}{8} \times 43\frac{1}{8}$ ($1\cdot75 \times 1\cdot10$). Mayer no. 58a. Reproduced in *Boletín de la Sociedad Española de Excursiones*, XXVI, 1918, p. 238. Now apparently destroyed.

19. Wethey no. 32, fig. 164; $66\frac{1}{2} \times 44$ ($1\cdot69 \times 1\cdot12$). Also reproduced in Camón, *op. cit.*, II, fig. 811.

20. Wethey no. 35, fig. 167; $43\frac{1}{3} \times 30$ ($1\cdot10 \times 0\cdot76$). Mayer no. 56a. From the Pidal collection, Madrid, and Uriburu collection, Buenos Aires. Camón, *op. cit.*, nos. 105 and 107 (figs. 629 and 631), both referring to this one painting.

21. Wethey no. X-14, as a replica of the Budapest composition; $63\frac{1}{3} \times 35\frac{3}{4}$ ($1\cdot61 \times 0\cdot91$). Mayer no. 57 (reproduced p. 11).

22. Wethey no. X-15, as a copy of the Budapest composition; $29\frac{1}{2} \times 17\frac{1}{4}$ ($0\cdot74 \times 0\cdot44$). Mayer no. 58 (reproduced p. 11).

23. E. Tormo (in *Boletín de la Sociedad Española de Excursiones*, XXV, 1917, p. 220) as 'estropeada (no tiene repeticiones)'. It is no longer in the Hospital and is said to have disappeared during the civil war of 1936–39.

24. Sight size, $74\frac{3}{4} \times 50\frac{3}{4}$ ($1\cdot90 \times 1\cdot29$). Wethey no. X-12. Reproduced in Mayer, *op. cit.*, p. 59, incorrectly as by 'Alonso Thalo' (!) The signature appears to be genuine but nothing is known of any descendant or relative of El Greco of this name. There is no indication that it is an altered signature of Jorge Manuel Theotocopuli, to whose certain work the painting in any case bears no resemblance. A very similar composition, formerly in the Convento de Recoletos, León, was destroyed in 1936 when in Madrid for restoration, and is known only from photographs—Wethey no. X-13. One further picture of the subject is listed by Wethey (no. X-16), but no record of its appearance appears to be known.

25. The convent was founded in 1798 (see E. Tormo, *Iglesias del Antiguo Madrid*, II, 1927, pp. 282 and 385) and its church was apparently built by 1801 (see J. A. Gaya Nuño, *Madrid (Guías artísticas de España)*, 1944, pp. 84–6), but no painting of the Agony in the Garden is mentioned there either in the anonymous *Paseo por Madrid*, published by Repullés, 1815 (who notes there, p. 41, only a *crucifixo* by El Greco) or in P. Madoz, *Diccionario geográfico-estadístico-histórico de España*, 1847, vol. X. The picture was certainly there by 1908 (see Cossío, *loc. cit.*).

26. Information supplied by Mr. T. Harris (letter of 1945 in the Gallery archives).

After EL GRECO

3131 S. PETER (?)

Oil on vellum (?), $8 \times 6\frac{1}{4}$ ($0\cdot203 \times 0\cdot159$), mounted on a pine[1] panel. The painted surface continues up to the inner edges of the (original?) frame which is attached to the panel.

Thin in places but the appearance of damage is partly due to engrained varnish.

There is a *pentimento* in the left side of the neck.

This head repeats with small variations a detail of an El Greco composition known as the *Penitence of S. Peter*,[2] of which there are many variants by El Greco and his school, dating probably from the late 1580's onwards. The earliest stage in the evolution of the composition is almost certainly the (signed) picture in the Bowes Museum (see note 4). No. 3131 has a close general resemblance with the heads in the Bowes Museum picture and its derivatives, but it is closest of all to the head in a version of the composition in the Contini-Bonacossi collection.[3] It was suggested by MacLaren that the Contini-Bonacossi picture probably reproduces a lost original showing El Greco's first essay of the subject, but it is probably no more than a later copy of the Bowes Museum type of composition, with certain variations introduced.[4]

No. 3131 may conceivably be a fragment of a version of the complete composition, but there are no visible traces that this is so and its unusually small size makes it unlikely.

VERSIONS: See above and note 4.

PROVENANCE: Perhaps bought in Spain, between 1869 and 1877,[5] by Sir Austen Henry Layard († 1894); in his collection in Venice;[6] Layard Bequest, 1916. Greek Art Exhibition, Royal Academy, 1946 (no. 350).

REPRODUCTION: *Illustrations: Continental Schools*, 1937, p. 144; *Spanish School: Plates*, 1952, p. 13.

REFERENCES, GENERAL: A. L. Mayer, *El Greco*, 1926, no. 205; J. Camón, *Dominico Greco*, 1950, no. 443; H. E. Wethey, *El Greco and his school*, 1962, no. X-438.

REFERENCES IN TEXT: **1.** Letter of 1947 from E. W. J. Phillips of the Forest Products Research Laboratory (in the Gallery archives).

2. Though the subject of this and the other versions (see note 4) is usually described as *The Penitence of S. Peter*, it does not show S. Peter immediately after his denial of Christ (Matthew, xxvi, 75) but at the moment when the Magdalen is bringing him the news of the Resurrection (Matthew, xxviii, 8). S. Peter's penitent attitude is to be explained by the belief (for which there is no Gospel authority) that he wept for his fault every day of his life (*cf.* E. Mâle, *L'Art religieux après le Concile de Trente*, 1932, p. 66; see also J. López-Rey in *Art in America*, XXXV, 1947, pp. 313 ff.). The subject is described in the inventory of El Greco's estate merely as 'S. Peter weeping' (see note 4).

3. Wethey no. X-443, fig. 309; Mayer no. 202a; reproduced in *Antichi pittori spagnuoli della collezione Contini-Bonacossi*, 1930, pls. XXVIII and XXIX.

4. Besides the Contini version, at least a dozen others are known, all three-quarter length: versions are in the Bowes Museum, Barnard Castle (Wethey no. 269, fig. 310; Mayer 202), Oslo Museum (Wethey no. 272, fig. 313; Mayer 206), Casa del Greco, Toledo (Wethey no. X-433; Mayer 210), Phillips Memorial Art Gallery, Washington (Wethey no. 271; Mayer 208) and San Diego Gallery (Wethey no. 270, fig. 311; Mayer 210a), the Hospital de San Juan Bautista and Cathedral, Toledo (Wethey nos. 273, fig. 312, and X-435; Mayer 207 and 207a), Cau Ferrat Museum, Sitges (Wethey no. X-434; Mayer 204), Alejandro de Mora y Aragón collection, Madrid (Wethey no. X-436;

Mayer 203), formerly (?) Guillermo de Guillén García collection, Barcelona (Mayer 209), formerly Felipe Sanghen collection, Madrid (Wethey no. X-444; Mayer 211) and Stavros Niarchos collection, Paris (Wethey no. X-437; Mayer 205a). Several other versions and copies are listed by Wethey: nos. X-439, X-440, X-441, X-442, X-445 and X-446. Two paintings of *S. Peter weeping* (one described, as small) are in Jorge Manuel Theotocopuli's inventory of El Greco's possessions, 1614 (see F. de B. de San Román, *El Greco en Toledo*, 1910, pp.

193 and 194); two are in the 1621 inventory of Jorge Manuel's possessions (see San Román in *Archivo Español*, 1927, p. 288, no. 19 (*ca.* 33 ins. square; *ca.* 0·85) and p. 290 no. 38 (*ca.* 25 × 22; *ca.* 0·64 × 0·57).

5. Layard was British Minister at Madrid, 1869–77, and is known to have purchased some of his pictures there (*e.g.* no. 3116, Netherlandish School, and no. 3115, ascribed to Patenier).

6. Layard mss. in the Gallery archives.

JUAN de Flandes

Juan Askat ?

Active from 1496; died before December, 1519

A *Juan de Flandes* (*i.e.* John of Flanders) is recorded as one of the painters in the employ of Queen Isabella of Castille in 1496 and from 1498 until her death in 1504. This artist is almost certainly identifiable with the Juan de Flandes who was commissioned in 1505 to paint pictures for a retable in the chapel of Salamanca University, and who undertook in 1509 to paint a polyptych for Palencia Cathedral. In December 1519 there is mention of his widow in Palencia.

His real name is unknown; his Spanish nickname implies that he came from the Netherlands and this is supported by the style of the few remaining documented works: the Palencia altarpiece and the fragments of the Salamanca pictures. The attribution to him of the small panels which belonged to Queen Isabella is discussed below; if his participation in these is accepted, some connection with the Burgundian miniaturists of the last quarter of the fifteenth century seems probable. There are slighter traces in his work of the influence of Hugo van der Goes and possibly of the 'Master of Moulins'. There are no grounds for identifying him with the *Juan Flamenco* said to have been painting in the Charterhouse at Miraflores between 1496 and 1499. Hulin de Loo mentions (in *Trésor de l'art flamand* etc., I, 1932, pp. 49/50) several unidentified Bruges and Ghent masters with the Christian name Jan who could conceivably be Juan de Flandes.

LITERATURE: F. J. Sánchez Cantón, 'El retablo de la Reina Católica', *Archivo Español*, 1930, pp. 97–133 and 1931, pp. 149–152; E. Bermejo, *Juan de Flandes*, 1962; I. Vandevivere, *La Cathédrale de Palencia et l'église paroissiale de Cervera de Pusuerga* (*Les Primitifs Flamands, Corpus*, no. 10), 1967.

Studio of JUAN de Flandes

1280 CHRIST APPEARING TO THE VIRGIN WITH THE REDEEMED OF THE OLD TESTAMENT

The scroll issuing from Christ's mouth is inscribed:[1] Mater·mea: dulci(ss?)ima (ego?) (sum?) · resvrrexi | (adhuc?) | (m?) |

...... | . (mse ?) ...; the Virgin's scroll: Gaud(eo ?) (tio?) et exultabo. . (ote ?) . (o ?) .. | Jhū.meo: . | ..; that of the Redeemed: G(au ?) dium··. redempti | precioso · sanguin | (filii ?) tui · [2]

The nude man and the woman beside him immediately behind Christ are probably intended to represent Adam and Eve.

One of a series of 47 panels.[3]

Oil on chestnut,[4] $8\frac{7}{16} \times 6\frac{5}{16}$ (0·214 × 0·160); painted surface $8\frac{1}{4} \times 6$ (0·209 × 0·153).

Much worn, especially in the left half of the picture; the inscriptions are partly effaced and overpainted. At the sides and top about $\frac{1}{8}$ inch of the panel is unpainted, likewise a small strip at the bottom. The edges were formerly covered by added gilding. Cleaned in 1967/8.

Verso: extensive remains of marbled paint, mostly red, over gesso, which were uncovered during cleaning. They are clearly very early in date and might be thought to be original, although marbling has not so far been recorded on the back of any others of the series.[5]

Infra-red photographs show variations from the underlying drawing in the shaft of Christ's Cross, the cushion on which the Virgin is seated and the upper end of her scroll.[6]

There is no Gospel authority for Christ's descent into Hell or Limbo, his liberation thence of the righteous of the Old Testament and his subsequent appearance to the Virgin, but they were accepted by the Church from early times: the Descent into Limbo is described in the apocryphal *Acts of Pilate* and all three episodes are referred to in the *Gospel of Bartholomew*, etc.[7] The presence of the Old Testament redeemed at Christ's appearance to the Virgin is not mentioned in any of the New Testament apocrypha but is, perhaps, implied in the *Book of the Resurrection of Christ by Bartholomew the Apostle* and they are generally supposed to have been present when Christ appeared to the Virgin after the Harrowing of Hell. That their appearance may have been thought of as a separate episode is suggested by the inclusion of both the present picture and the appearance alone of Christ to the Virgin[8] in the same cycle, though it is possible that one of the scenes was made as an alternative to the other. This variation of the subject appears to have originated in Spain and the present picture is one of the earliest instances of its appearance.[9] The subject is said[10] to occur frequently in Valencian art and its occurrence in both Valencian art and literature has been attributed[11] to its prominence in the sermons of S. Vincent Ferrer († 1419). It also occurs occasionally in contemporary Netherlandish art;[12] but no prototype for the composition of no. 1280 in either Netherlandish or Spanish painting is apparently known.

This panel is one of a series of 47 of approximately the same size[13] and mostly with scenes from the lives of Christ and the Virgin,[14] which belonged to Queen Isabella the Catholic. Twenty-eight[15] of them are known to have survived, fifteen being in the former Royal Palace at Madrid. The *Ascension of Christ* and the *Assumption of the Virgin* are

documented in an inventory of 1516[16] as the work of *Michiel* (the so-called *Master Michiel*, i.e. Michel Sittow, 1469–1525, who was in the service of Queen Isabella, 1492–1502[17]); these have survived, together with the *Coronation of the Virgin* which is obviously by the same hand. The author of the rest of the series is not mentioned in any of the documents concerning them and they are quite distinct in style from Sittow's three panels. (It was observed by MacLaren that the name *Juan Astrat* is inscribed, apparently in a sixteenth-century hand, on the back of the *Raising of Lazarus* and that the *Mocking of Christ* is inscribed, also on the reverse and in the same hand: *Juº Astrat*. He concluded that this might well be a Spanish rendering of a Netherlandish name (Straat, Straaten?[18]), but that there was no particular reason for supposing this to be the name of the painter and no artist of this or similar name is identifiable in the Netherlandish archival sources at the relevant time.)

Crowe and Cavalcaselle[19] and then Justi attributed the fifteen panels at Madrid (all then known) to Juan de Flandes[20] and this attribution has been extended to all those discovered since.[21] Some are certainly very close in style to the documented altarpiece at Palencia and the best of them are almost certainly by Juan himself, but, as Sánchez Cantón[22] first pointed out, quite apart from the three by Sittow, the series seems not to be all by the same hand. He divides them into a larger group, of superior quality, which he gives to Juan de Flandes, and a smaller one, of inferior execution, which he ascribes to a lesser painter. His smaller group consists of *Christ on the Sea of Galilee*, *Christ in the House of Simon*, *The Last Supper*, *The Agony in the Garden*, *The Taking of Christ*, *The Mocking of Christ*, *Christ before Pilate*, *Christ appearing to the Virgin*[23] and also, apparently, *Christ bearing the Cross*.[24] In the view of MacLaren, if the last were omitted and *Christ entering Jerusalem* included, the group would be distinct and homogeneous; but he suggested that apart from the pictures by Sittow and the well-defined group by an inferior craftsman mentioned above, a further two if not more hands are discernible,[25] though the design of all the panels, except Sittow's, could be due to a single artist who, to judge by the Palencia altarpiece, was Juan himself.

The question of attribution will perhaps not be settled until it is possible to reassemble the surviving pictures of the series. The weakest group[26] of the pictures look rather later in date than the remainder, darker in tone and coarser in handling, and they appear to number amongst them many of the less well preserved of the series. The National Gallery painting is exceptional amongst the surviving pictures of the series in its composition, since the figures are small and much of the space is taken up with scrolls, lettered in Gothic script. These differences would clearly have been obtrusive had the series been framed as a sequence, and it is just possible that the Berlin painting of *Christ appearing to the Virgin* was produced as an alternative to the National Gallery painting. The poor state of preservation makes judgement difficult about its authorship, though in details

of faces etc., it appears to correspond with others of the series. It thus seems reasonable to ascribe the painting to Juan de Flandes, or (more safely) to his studio.

The 47 panels may have been intended for an altarpiece of many compartments, a type popular in Spain.[27] The first document concerning them (1505) describes them as in an *armario*:[28] this could mean that they were in an altarpiece with doors,[29] but it seems more likely that they were indeed in a cupboard, since they were sold separately (see Provenance).[30] Justi[31] questions whether the series was ever completed since the 1505 list makes no mention of a *Resurrection, Christ washing the Apostles' feet* and other scenes usual in such cycles. The execution of the series might have been interrupted by the Queen's death in 1504. It must be noted, however, that the *Washing of the feet* is depicted in the background of the *Last Supper*, the *Denial of S. Peter* in that of the *Mocking of Christ* and, apparently, *Christ on the road to Emmaus* in that of the *Supper at Emmaus*. Similarly, other episodes not mentioned in the 1505 list may have appeared as subsidiary scenes in some of the missing panels, although the *Resurrection*, which could hardly have been omitted altogether, does not appear as might have been expected in the background of the *Maries at the Sepulchre, Christ appearing to the Virgin* or the *Noli me tangere*, or in any other of the surviving pictures. A final question which remains to be settled about the series is why three of the paintings should have been painted by Sittow, who was not an artist dependent upon Juan de Flandes.

PROVENANCE: No. 1280 is listed as one of 47 panels, of the same size, in the inventory of 25 February, 1505, of the possessions of Queen Isabella († 25 November, 1504) at the Castle of Toro (Zamora Province).[32] Forty-three of them had apparently been sold by 13 March, 1505;[33] no. 1280 was one of the four[34] panels then still remaining unsold. There is no further trace of it until it reappeared in the collection of Henry Attwell, Barnes, London,[35] whence it was purchased[36] (out of the Walker Fund) in 1889.

REPRODUCTION: *Illustrations: Continental Schools*, 1937, p. 182; *Spanish School: Plates*, 1952, p. 13 (both before cleaning).

REFERENCES, GENERAL: F. J. Sánchez Cantón, 'El retablo de la Reina Católica', in *Archivo Español*, 1930, pp. 97–133 and 1931, pp. 149–152; M. Davies, *Les Primitifs Flamands, Corpus*, no. 11, *The National Gallery London*, III, 1970, no. 125, p. 4.

REFERENCES IN TEXT: **1.** In Gothic script. The inscriptions on all the other known panels of this series are in Roman letters, with the exception of that on the pennant in *Christ on the Sea of Galilee* (Madrid). **2.** Suggestions in the reading of the inscriptions were kindly made by Mr. Francis Wormald. The first is related to a text commonly employed for this subject (the Pseudo-Bona- ventura, ch. 86): '*Mater mea dulcissima ego sum, resurrexi, et adhuc tecum sum.*' It re-occurs in the picture of Christ appearing to the Virgin, from the same series as the present picture (see note 3), in an abbreviated form and with the addition of the word *Alleluya*. The second text is related to a passage in Habacuc (iii, 18): '... *in Domino gaudebo; et exsultabo in Deo. Jesu Meo.*' (as was discovered by Mr. J.-P.

Sosson). A point of reference for the third text remains to be discovered; it appears not to be in the Latin concordance of the Bible.

3. Not 46 as sometimes stated. For ease of reference a list of all the panels mentioned in the earliest document concerning the series (see Provenance) is given here in historical sequence, with the present location where known: *Annunciation*; *Visitation*; *Nativity*; *Adoration of the Kings*; *Flight into Egypt*; *Presentation in the Temple* (formerly and wrongly supposed to be the *Circumcision* in A. Hirsch collection, Buenos Aires—see below); *Christ in the Temple*; *Baptism*; *Temptation of Christ* (Washington, National Gallery of Art, formerly Oliver Watney collection, Cornbury Park; see H. Isherwood Kay in *The Burlington Magazine*, 1931, I, pp. 197 ff; E. Bermejo, *Juan de Flandes*, 1962, pl. 2); *Christ and the Woman of Samaria* (Louvre; Bermejo, pl. 4); *Marriage at Cana* (formerly Watney collection; see H. Isherwood Kay, *op. cit.*, Bermejo, pl. 2); *Christ on the Sea of Galilee* (Palace, Madrid; Bermejo, pl. 3); *Christ in the House of Simon* (Madrid; Bermejo, pl. 6); *Feeding of the Five Thousand* (Madrid; Bermejo, pl. 1); *Christ and the Woman of Canaan* (Madrid; Bermejo, pl. 4); *Transfiguration* (Madrid; Bermejo, pl. 5); *Raising of Lazarus* (Madrid; Bermejo, pl. 5); *Entry into Jerusalem* (Madrid; Bermejo, pl. 7); *Last Supper* (Apsley House, London; Bermejo, pl. 8); *Agony in the Garden* (Bermejo, pl. 8—as private collection, Munich); *Si ergo me quaeritis* [John, xviii, 8]; *The Betrayal* (Madrid; Bermejo, pl. 9); *Christ before Pilate* (Madrid; Bermejo, pl. 9); *Flagellation*; *Christ crowned with thorns* (Detroit Institute of Arts; Bermejo, pl. 11); *Mocking of Christ* (Madrid; Bermejo, pl. 10); *Ecce Homo*; *Christ bearing the Cross* (Vienna; Bermejo, pl. 12); *Christ nailed to the Cross* (Vienna; Bermejo, pl. 12); *Christ on the Cross*; *Descent from the Cross*; *Pietà*; *Descent into Limbo* (Madrid; Bermejo, pl. 13); *The three Maries at the Sepulchre* (Madrid; Bermejo, pl. 15); *Christ and the Redeemed appearing to the Virgin* (no. 1280); *Christ appearing to the Virgin* (Berlin; Bermejo, pl. 14); *Noli me tangere* (Madrid; Bermejo, pl. 16); *Supper at Emmaus* (Madrid; Bermejo, pl. 17); *Christ appearing to S. Peter*; *Incredulity of S. Thomas*; *Ascension* (Earl of Yarborough collection); *Descent of the Holy Ghost* (Madrid; Bermejo, pl. 18); *Assumption of the Virgin* (Washington, National Gallery of Art; formerly Jules Quesnet collection, Paris; see C. T. Eisler in *Art News*, September, 1965, pp. 34 ff.); *Coronation of the Virgin* (Louvre; formerly Heugel collection, Paris; see N. Reynaud in *La revue du Louvre*, 1967, pp. 345 ff.); *SS. Peter, Paul, John and James*; *Archangels Michael and Gabriel*; *Last Judgment*. The *Baptism* in Guadalupe Monastery, attributed by E. Tormo to Juan de Flandes, differs entirely in style, form and size from any of the series and is ascribed by M. J. Friedländer (*Altniederländische Malerei*, IX, 1932, p. 147) to Jan Provoost. The *Circumcision* in the Hirsch collection, said by Mayer to belong to the series and possibly incorrectly described in the 1505 inventory as *The Presentation* (see Sánchez Cantón, *op. cit.*, p. 119), is now known to be unconnected with the series.

4. Oral information from E. W. J. Phillips of the Forest Products Research Laboratory. All the other extant panels are said to be of oak, with the possible exception of the *Temptation* (Washington).

5. See photograph illustrated in Davies, *op. cit.*, pl. V. The *pentimento* at the top of the Virgin's scroll affects only the shape of the scroll, not the wording.

6. Infra-red photograph reproduced in Davies, *op. cit.*, pl. VI.

7. On the iconography of Christ's appearance to His mother see J. D. Breckenridge in *The Art Bulletin*, 1957, pp. 9 ff. No. 1280 is not taken into account in this study.

8. Now in the Bode Museum, Berlin.

9. See Breckenridge, *op. cit.*, pp. 28 ff. He illustrates, fig. 16, the picture of the same subject by Miguel Esteve.

10. C. R. Post, *History of Spanish Painting*, VI, part I, 1935, p. 270.

11. By L. de Saralegui; see Post, *loc. cit.*, and Breckenridge, *op. cit.*

12. To the two Netherlandish representations noted by Post (*loc. cit.*) may be added (*a*) a painting, dated 1529, attributed to 'Frei Carlos' (Lisbon Museum; reproduced in J. Couto, *A Pintura Flamenga em Évora no século* XVI, 1943, fig. 1); (*b*) one of 64 miniatures of the lives of Christ and the Virgin, sometimes attributed to Simon Bening (Walters Art Gallery, Baltimore). Among later representations of this rare subject may be mentioned Titian's altarpiece at Medole (see E. Panofsky, *Problems in Titian*, 1969, pp. 39 ff.) and one by Alessandro Allori in S. Marco, Florence, pictures by Veronese (El Escorial), Guido Reni (Dresden) and Ludovico Carracci (formerly in the church of Corpus Domini, Bologna) and a fresco by Giovanni Battista Carlone in the Santissima Annunziata, Genoa. On these later representations of the subject see Breckenridge, *op. cit.*

13. The height of the surviving panels varies from $8\frac{1}{4}$ to $9\frac{1}{2}$ inches (0·210–0·242), the width from $6\frac{3}{16}$ to $7\frac{1}{2}$ (0·157–0·191).

14. One of them represented Saints and another, Archangels (see note 3).

15. See note 3.

16. In the July, 1516, inventory of pictures belonging to Margaret of Austria, Regent of the Netherlands, in the palace at Malines (published by [A. J. G.] Le Glay in *Correspondance de Maximilien I et de Marguérite d'Autriche*, 1839, II, p. 482): 'deux qui estoient faiz de la main de Michiel'. Michel was apparently in Margaret's service not long before this inventory was made (*cf.* the order for payment to him signed by Margaret in March, 1515, published in Crowe and Cavalcaselle, *Les anciens peintres flamands*, II, 1862, p. cccxi, note 3; see also Sánchez Cantón, *op. cit.*, p. 115, and Davies, *op. cit.*, pp. 10/11).

17. His surname, birth and death dates and much other documentary material were published by P. Johansen in *Jahrbuch der Preussischen Kunstsammlungen*, 1940, pp. 1–36. On his activity in Spain see especially E. A. de la Torre in *Hispania*, 1958, no. LXXI, pp. 190 ff.

18. Such a transformation of name occurs later in the case of Joris van der Straeten (also called Joris van Gent; documented 1556–77 and active as court painter in Spain, Portugal and France), whose name is variously given in Portuguese documents as Estrata, Estraten and Strata (see A. Raczynski, *Les arts en Portugal*, 1846, pp. 215/16, and L. Dimier, *Le Portrait en France*, I, 1924, p. 125).

19. *The Early Flemish Painters*, 1857, pp. 284 ff.

20. C. Justi in *Jahrbuch der Königlich Preussischen Kunstsammlungen*, 1887, pp. 157–67; to these he added later the *Last Supper*, the *Temptation*, the *Marriage at Cana* and the National Gallery picture (*Miscellaneen aus 3 Jahrhunderten Spanischen Kunstlebens*, 1908, I, pp. 318/19).

21. They are accepted as all by the same hand by G. Hulin de Loo, *Trésor de l'art flamand, Memorial de l'exposition de l'art flamand à Anvers 1930*, 1937, I, pp. 49 ff. and more recently by Bermejo, *op. cit.*, p. 11.

22. *Op. cit.*, pp. 117/18.

23. In his *catalogue raisonné* of the panels (pp. 120–32) Sánchez Cantón varies this distribution: he suggests (p. 124) that the *Last Supper* does not fit exactly into either of his groups; the *Crowning with Thorns*, included in the first group on p. 118 is described as characteristic of the second on p. 127.

24. *Op. cit.*, p. 127.

25. Sánchez Cantón remarks the differences in the form of the Cross in the two Vienna panels but rejects difference of authorship; he also observes stylistic differences between, on the one hand, the *Raising of Lazarus* and the *Maries at the Sepulchre* and, on the other, the rest of his first group, but does not believe that these authorize their removal from it.

26. This group would appear to include *Christ on the Sea of Galilee*, *The Taking of Christ*, *The Mocking of Christ*, *Christ before Pilate*, *Christ in the House of Simon* (all Madrid), and *The Last Supper* (formerly in the same collection and now at Apsley House—see E. Wellington, *A Descriptive and Historical Catalogue of the Collection . . . at Apsley House, London*, 1901, I, p. 219).

27. Twenty of them were, in fact, made into a diptych later (see note 33).

28. In the 1505 Toro inventory (see Provenance) a marginal note referring to the 47 panels states: 'Estan en un armario todas estas tablicas, yguales todas . . .' (see Sánchez Cantón, *op. cit.*, p. 99 and *Libros, tapices y cuadros que coleccionó Isabel la Católica*, 1950, p. 185).

29. For the (later) use of the word *armario* or *almario* in the sense of altarpiece, see Ribalta no. 2930 of this catalogue, note 9.

30. It is noted by Davies, *op. cit.*, p. 9, that the absence of a *barbe* around the edges of the painted surface would indicate that the picture was not immediately framed.

31. *Jahrbuch der Königlich Preussischen Kunstsammlungen*, 1887, p. 162.

32. See Sánchez Cantón, *op. cit.*, pp. 99–101. No. 1280 is the 38th item in the list of the panels: 'quando aparesció a nuestra señora con los santos padres', valued at 5 ducats. (The individual valuations vary from 2½ to 6 ducats, but the majority are 4 or 5 ducats.)

33. Ten were sold to the Marquesa de Denia and 1 to the *Alcaide de los Donceles*; of these 4 survive. Thirty-two were bought, 13 March, 1505, by Diego Flores, Treasurer to Margaret of Austria; they were registered in Margaret's collection at Malines in 1516 (*cf.* note 16) and admired there by Dürer in June, 1521 (see *Quellenschriften für Kunstgeschichte*, III, 1872, p. 126). Twenty-four of the panels reappear in a Malines inventory of 1523/4 (see H. Michelant, *Bulletin de la Commission royale d'histoire de Belgique*, 3rd series, XII, 1870, pp. 89/90). Twenty of the latter had been made into a diptych which was sent to Spain by Charles V between 1530 and 1539 (Sánchez Cantón, *op. cit.*, pp. 106–8); this diptych was broken up and the number of panels had dwindled by 1857 to the 15 now in the Palace at Madrid. Seven of the others from Margaret's collection have since reappeared elsewhere. Two of the 4 still unsold in March, 1505, have been preserved. See also note 3.

34. Not 3, as Sánchez Cantón states (*op. cit.*, p. 103); he has not counted the *Coronation of the Virgin*.

35. As by Memlinc.

36. As Flemish School.

IGNACIO DE LEON Y ESCOSURA

1834–1901

Born at Oviedo. Studied at the Academy in Madrid and under J.-L. Gérôme in Paris, where he spent much of his life. Painted, *inter alia*, historical and costume pictures in the style of Meissonnier. Died at Toledo.

Ascribed to IGNACIO DE LEON

1308 A MAN IN SEVENTEENTH-CENTURY SPANISH COSTUME

Oil on canvas, 36½ × 27½ (0·925 × 0·700).
In good condition.

Has been attributed to Juan Bautista del Mazo[1] but is a nineteenth-century imitation of Velázquez based on the life-size portrait of a dwarf (formerly called *Don Antonio el Inglés*) in the Prado.[2] Radiographs and cleaning tests show that it has been painted on top of a seventeenth- or eighteenth-century flower piece (possibly a fragment of a larger composition). According to Charles Terry, writing in 1897,[3] he was told by Ignacio de León that it was a pastiche painted by him from Velázquez

portraits in the Prado and given to a London dealer. Despite this statement it must be remarked that León usually worked in an entirely different style, although this difference would not be surprising in an imitation. In the absence of comparable paintings by León no. 1308 is now catalogued only as ascribed to him.

PROVENANCE: Given to Charles Henry Crompton-Roberts by a friend,[4] and presented by him to the Gallery in 1890.[5]

REPRODUCTION: *Illustrations: Continental Schools*, 1937, p. 342; *Spanish School Plates*, 1952, p. 140.

REFERENCES, GENERAL: *Klassiker der Kunst: Velazquez*, 1925, p. 229 (among school works); A. L. Mayer, *Velazquez*, 1936, nos. 456 and 456a (as a late imitation); J. López-Rey, *Velázquez*, 1963, no. 439 (repeating MacLaren).

REFERENCES IN TEXT: **1.** Attributed to Mazo by Sir J. C. Robinson (letter of 1890 in the Gallery archives) and so catalogued until 1920.

2. Prado no. 1203; sometimes attributed to Carreño, to Mazo, or to an unknown seventeenth-century artist (see López-Rey, *op. cit.*, pp. 269 ff.). The main variations in no. 1308 are that the right hand rests on a chair instead of on a dog and the features are different.

3. Letter of 1897 in the Gallery archives and further letters of 1921 and 1924 with similar statements by the same writer (who had then changed his surname to Pettiward).

4. Information provided by the donor (letter of 1890 in the Gallery archives).

5. It is erroneously described in *Klassiker der Kunst: Velazquez*, p. 229, as in Earl Stanhope's collection, with the measurements of an unrelated picture in that collection (see H. I. Kay in *The Burlington Magazine*, LXX, 1937, p. 197); no. 1308 was never in the Stanhope collection. Mayer erroneously took the reproduction in *Klassiker der Kunst* to be a picture other than no. 1308 and catalogued it separately (Mayer 456a).

THE MASTER OF RIGLOS

Active mid-fifteenth century

Worked in Aragon; named after the retable formerly in the church of S. Martin at Riglos (Huesca province), of which no. 6360 below formed the pinnacle. A nucleus of works associable with this artist were grouped together by Post and attributed to an artist named by him the Sant Quirse Master, the name deriving from the altarpiece of SS. Julitta and Quiricus (Diocesan Museum, Barcelona); Post considered the artist as a Catalan painter, active in his youth in Aragon. The panels of the Riglos retable are not, however, convincingly similar to those of the SS. Julitta and Quiricus altarpiece, and it seems likely that the works of Post's Sant Quirse Master were produced by two (if not more) separate artists, as proposed by Gudiol. The larger part is attributed by Gudiol to Pedro García de Benabarre, and a smaller group to an artist named by him the Master of Riglos. Amongst a number of works which appear to be in the style of the Riglos retable are the retable of S. Anne (Deering collection, Tamarit), that of the life of Jesus (private collection, Barcelona) and the now destroyed retable of the Virgin formerly at Villarroya del Campo (Prov. Zaragoza).

LITERATURE: C. R. Post, *A History of Spanish Painting*, Vol. VII, 1938, pp. 198 ff., and Vol. IX, 1947, pp. 852 ff. J. Gudiol Ricart, *Pintura gótica (Ars Hispaniae*, Vol. IX), 1955, p. 301; the same author's *Historia de la pintura gótica en Cataluña*, [1944?], pp. 49 ff., deals with Pedro García de Benabarre.

6360 THE CRUCIFIXION

Christ on the Cross in the centre, his head and arms interrupted by the tracery mouldings across the top of the main painted surface; in the central compartment formed by the tracery, a scroll inscribed: *INRI*; to the left of the Cross the Magdalene, and the Virgin supported by two holy women; to the right of the Cross S. John and a figure with a scalloped halo (see below) who is possibly S. Anne.

Tempera on pine; the panel itself, composed of five pieces of wood, measures $28 \times 42\frac{1}{8}$ ($0\cdot711 \times 1\cdot045$); the principal painted area measures *ca.* $17 \times 40\frac{3}{8}$ (*ca.* $0\cdot430 \times 1\cdot025$). The tracery and ornaments across the surface of the picture are evidently original; the outer framing is modern. Beneath the priming on the front are raised mounds concealing the heads of nails, by means of which the panel was affixed to three large battens placed horizontally across the back; the battens are now removed.

In good condition; the blue above the tracery, decorated with stars, is retouched in places.

No. 6360 comes from the church of S. Martin at Riglos (Huesca province). It is recorded in a photograph published by del Arco in 1916,[1] as forming part, together with six other panels, of the retable of S. Martin in this church.[2] The frame within which the seven paintings are enclosed appears in the photograph to date from the (?) late sixteenth century, and it must be assumed that the original altarpiece was taken down and reassembled at this date. The original arrangement of the altarpiece was clearly altered in adapting the panels to their Renaissance frame, but the alteration may have been only slight and there is no special reason for believing that any panels were discarded at this time.[3] The central panel as recorded in the photograph can be identified with the *S. Martin and the beggar* (Museo de Arte de Cataluña, Barcelona),[4] and above this was the Crucifixion (no. 6360). Six small scenes of events in the life of S. Martin were placed vertically in the side compartments of the altarpiece, three to each side; the lowest on the left can be identified with *S. Martin's vision of the Virgin and Saints* (Barnes Foundation, Merion, Pennsylvania),[5] and the lowest on the right with the *Death of S. Martin* (Pinacoteca, Bologna).[6] The altarpiece is also believed to have had a predella of which five panels are recorded.[7]

In style and composition no. 6360 is close to the rather simpler Crucifixion (top centre) in the retable of the Virgin and S. Anne (Deering collection, Tamarit).[8] A number of derivative paintings of the same kind are recorded.[9]

The present Crucifixion is unusual, possibly unique, in subject matter in the presence, extreme right, of a saint with a scalloped halo;

this type of halo denotes an Old Testament figure, and a possible identification with S. Anne, the mother of the Virgin, has been suggested.[10]

No. 6360 is evidently a work which can be dated very approximately to the middle of the fifteenth century. A more precise date would appear to be difficult to determine in the absence of any documentation or dated works for the Master of Riglos. Gudiol considers the Riglos retable to be a late, rather decadent, work of the artist, datable to *ca.* 1460.[11]

PROVENANCE: Painted, presumably, for the church of S. Martin at Riglos; reframed in the (?) late sixteenth century, remaining in the church until about 1916 or later (see above). Tomás Harris, London; Satori of Vienna, from whom purchased by Sir Ronald Storrs in 1928.[12] Exhibited on loan at the National Gallery, 1929 to 1954, and bequeathed by Sir Ronald Storrs in 1964. Exhibited at the Bowes Museum, Barnard Castle, *Four centuries of Spanish Painting*, 1967 (no. 2).

REPRODUCTION: C. R. Post, *A History of Spanish Painting*, Vol. VII (1938), fig. 64 (p. 232).

REFERENCES, GENERAL: C. R. Post, *A History of Spanish Painting*, Vol. II (1930), p. 466 (as by a follower of the Master of S. George), Vol. IV (1933), p. 556; Vol. VII (1938), pp. 230 and 264, note 3 (as by the Sant Quirse Master), and Vol. IX (1947), pp. 852 ff.; J. Gudiol Ricart, *Pintura gótica* (*Ars Hispaniae*, vol. IX), 1955, p. 301; E. Young in the catalogue of the Bowes Museum Spanish Painting exhibition, 1967, pp. 10 f.

REFERENCES IN TEXT: **1.** R. del Arco in *Arte español*, Vol. III, 1916/17, p. 19.

2. The presence of no. 6360 in this photograph was first noted by Post, *op. cit.*, Vol. VII (1938), p. 264, note 3.

3. See note 7 below.

4. Inventory number 4352; reproduced in Gudiol Ricart, *op. cit.*, p. 303 (fig. 260).

5. Post, *op. cit.*, Vol. IX (1947), fig. 360 (p. 851).

6. Post, *op. cit.*, Vol. VI (1935), fig. 47, as Valencian school. The scenes from the life of S. Martin are difficult to see in the photograph; three of them appear to represent, as suggested by Mr. Eric Young, the Consecration of S. Martin (upper right), the Mass of S. Martin with the miracle of the sleeves (middle right) and possibly S. Martin's vision of the Saviour and Saints (middle left).

7. On the predella see Post, *op. cit.*, Vol. VII, p. 236. It is not recorded in the photograph, but is believed to have contained panels representing the *Dead Christ* (Sir Michael Sadler collection, Oxford; *ibid.*, Vol. VII, fig. 65), *S. Catherine* (formerly Tomás Harris; *ibid.*, Vol. VII, fig. 65), *S. John*

the *Baptist* and *S. Barbara* (both Judge Nathan Ottinger collection, New York) and one, finally, of an unidentified saint (formerly Adam Paff collection). Except for this predella the Riglos retable as recorded in del Arco's photograph has the same basic ingredients as the retable of S. Anne and the Virgin (Tamarit, Deering Collection; photo Archivo Mas no. B-1046—detail illustrated in Post, VII, 1938, fig. 62) and this suggests that the altarpiece may well have been preserved in its entirety when transferred to its Renaissance frame. As in the Tamarit altarpiece the tracery above the Riglos Crucifixion matches that above the upper scenes of the two sides, although the height of the central panel and the Crucifixion combined would appear from the photograph to have slightly exceeded the height of the three panels at the sides, whereas there is no discrepancy in height between the sides and the centre in the Tamarit altarpiece.

8. No detail photograph appears to have been taken of the Crucifixion scene of the destroyed Villarroya del Campo altarpiece.

9. Photographs of two such derivative crucifixions are filed at the Instituto Amatller, Barcelona (Archivo Mas photographs nos. C-95921 and 24358—the latter being the pinnacle of a retable of S. Blas and the Virgin at Almudebar (Huesca province).

10. See Post, *op. cit.*, Vol. II, p. 466.

11. Gudiol, *op. cit.*

12. Letter from Sir Ronald Storrs in the Gallery archives.

JUAN BAUTISTA DEL MAZO
ca. 1612/16–1667

His full name was Juan Bautista Martínez del Mazo. He was born in the diocese of Cuenca, probably at Beteta. The date of his birth is not known but can be conjectured from the facts that his mother was born in 1596 and he married in 1633; also unknown is the date of his entry into the studio of Velázquez, whose daughter he married in 1633 (21 August).

He apparently became painter to Prince Baltasar Carlos († 1646) and seems to have accompanied the Court on Philip IV's journey to Pamplona and Saragossa in 1646; in 1647 he signed the *View of Saragossa* in the Prado. A visit to Naples is recorded in 1657. After Velázquez's death he was appointed *pintor de cámara* in his place, April, 1661. His portrait of Queen Mariana, no. 2926 below, is dated 1666. He died in Madrid, 10 February, 1667.

There are few certain works by Mazo. Only two certainly signed works by him are known: the *View of Saragossa* and no. 2926 below; the feeble repetition of the latter in Toledo, also signed, may be no more than a copy. (The suggestion, often made, that Velázquez painted part of the *View of Saragossa* is completely unacceptable.) The *Portrait of a painter's family* at Vienna bears an escutcheon charged with a mace (*mazo* in Spanish) and there is little doubt that it is his work, but it too has been rejected by some scholars. (The supposed Mazo signature on the *Conde de Benavente* in the Vizconde de Baiger collection, Madrid, is *Md*, an abbreviation for *Madrid*.) The *Stag hunt at Aranjuez* in the Prado was attributed to him already in 1686, and further light is cast on his landscape style by the small version or copy at Apsley House of the lost *View of Pamplona*, a documented work. Some views in the Prado which were already attributed to his pupil, Benito Manuel de Agüero, in an Aranjuez inventory of 1700 (at a time when a son of Mazo was in charge of the palace there) confirm the impression of Mazo's landscape style conveyed by the *Stag hunt*.

A very large number of works after Velázquez or in his style have been attributed to Mazo, mostly with little reason. Nevertheless the few signed and semi-documented works do provide some basis for an accurate view of his style. If, as seems likely, no. 1315 below is an independent work by Mazo of *ca.* 1647, a high standard could apparently be achieved by the artist in relatively early portraits, and a decline in his abilities towards the end of his life (after the death of Velázquez?) seems to have occurred.

LITERATURE: Documentary information about Mazo and his family has been published in *Archivo Español* by J. López Navío, 1960, pp. 387 ff., and by M. L. Caturla, 1955, pp. 73 f.

2926 QUEEN MARIANA OF SPAIN IN MOURNING

The Queen wears a white wimple and black habit. In the left background is a view of the *Pieza ochavada* of the Alcázar, Madrid.[1] Within is the child King, Charles II, surrounded by two nuns or widows (one of whom holds him in leading-strings), a maid of honour, a male dwarf and a girl or female dwarf. Beyond this group, against the wall, is a bronze statue of Venus and, over a door, a sculptured bust; to their right is the front part of a carved and gilt toy coach. Hanging on the wall to the left are framed paintings.

The paper in the Queen's hand is inscribed: *Señora* and signed below this *Juan Bap*[(ta?)] *de(l?) Mazo 1666*. (The signature is damaged and has been gone over[2]). Inscribed in the left bottom corner by an eighteenth(?)-century hand:[3] LA REINA. Nᴬ S | Dᴬ MARIANA. DE. (DE in monogram) | AVSTRIA MADRE | DE. (DE in monogram) EL REI. Dᴺ CARLOS II. | Q̇. DE (DE in monogram) Dˢ GOZA.

Oil on canvas, $77\frac{1}{2} \times 57\frac{1}{2}$ ($1\cdot97 \times 1\cdot46$).

Some wearing and damage in the background, the floor and the dog. There are tears above the Queen's left eye, on her right hand and on her left cheek. Further damages occur on her dress and one lies immediately to the left of the head of Charles II. Cleaned and restored in 1960.

The dog's hindquarters were at first much higher. The curtain has been painted on top of the head and right arm of the statue.

Maria Anna (called in Spain *Mariana de Austria*), daughter of Emperor Ferdinand III and the Infanta María (Philip IV of Spain's sister), was born in 1634. She was betrothed to Prince Baltasar Carlos, Philip IV's heir-presumptive, but he died in 1646. Philip himself, although her uncle, took her as his second wife in 1649. She was widowed in 1665 and from then until 1677 acted as Regent. She died in 1696. In the present picture she is wearing a nun's habit as mourning, in accordance with the custom of noble Spanish widows.[4]

Charles II of Spain (Carlos II), the son of Philip IV and Mariana, was born in 1661. Although feeble-minded, he assumed full kingship in 1677. He died in 1700.

The small scale and sketchy execution of the background figures make it impossible to identify most of them. The boy is obviously Charles II. The small fair-headed female behind Charles II may be intended for the German or Austrian dwarf, Maria Barbara Asquen or Asquin, known as Maribárbola, who appears in Velázquez's *Meninas* of 1656. She entered the palace service in 1651 and is perhaps the 'Barbarica' who returned to Austria or Germany between 1695 and 1700.[5]

The room in the background has been convincingly identified on the basis of architectural drawings as the *Pieza ochavada*, an octagonal room in the south wing of the Alcázar, the palace destroyed by fire in 1734.[6] On the left of it in the picture is probably one of the two large doors on

the main axis of the wing, leading towards the *Galeria de medioda*, and on the right one of the four smaller doors in the corners of the room.[7] The Queen herself would probably be sitting at the entrance to the *Salón de los espejos*, but the undecorated wall behind the figure is no more than a neutral backdrop.[8]

Although the top of the bronze statue in the background is hidden by the curtain, the whole of it was at first visible and a radiograph shows the right arm bent and half raised, the head erect.[9] It can, therefore, be identified with certainty as the Venus now in the Salón de Columnas of the Royal Palace at Madrid, to which it corresponds exactly. This statue, $75\frac{1}{2}$ inches (1·92) high, is one of the seven *Planets*, perhaps by a Flemish sculptor, sent by the Cardinal Infante Ferdinand to Philip IV in 1637 and placed in the Buen Retiro at Madrid in the same year.[10] The *Planets* were later removed to the *Pieza ochavada* of the Alcázar, forming half of the total number of statues around the walls.[11]

The idea of the background group, with the King surrounded by attendants, one of whom offers him a small red cup, may conceivably have been suggested by Velázquez's *Meninas*.[12]

The signature is in the form of the beginning of a petition from Mazo to the Queen.[13]

This composition was clearly the prototype of the many portraits of Queen Mariana in mourning seated at a table produced in the studio of Juan Carreño (who became *pintor del Rey* in 1669 and *pintor de cámara* in 1671).[14]

Curtis[15] connected no. 2926 or a similar picture with a passage in Palomino, but that seems clearly to refer to separate portraits of Mariana and the King.[16]

VERSIONS AND COPIES: A weaker repetition (or a copy), bearing a signature, is in the Casa del Greco, Toledo;[17] a signed repetition was in the collection of the Duke of Villahermosa, Madrid, by 1883.[18] A contemporary three-quarter-length copy of a version of this design, slightly reduced, was formerly in the Cook collection.[19]

PROVENANCE: In the collection of the Earl of Carlisle by 1848;[20] exhibited Royal Academy, 1890 (no. 129) and 1912 (no. 91). Presented by Rosalind, Countess of Carlisle, in 1913. Exhibited, Madrid, *Velázquez y lo velazqueño*, 1961 (no. 135).

REPRODUCTION: *Illustrations: Continental Schools*, 1937, p. 225; *Spanish School: Plates*, 1952, pp. 15 and 16 (both before cleaning).

REFERENCES: 1. On the identification of the room see Y. Bottineau in *The Burlington Magazine*, 1955, pp. 114 ff., and in *Bulletin hispanique*, 1958, I, pp. 55 f.

2. Reproduced in actual size in *Spanish School: Plates*, 1952, p. 54. In its reworked state the surname reads *Mizo* but the original is visible beneath. The date, though very faint, appears to be *1666* and not *1668* as Justi thought (*Velazquez und sein Jahrhundert*, 1888, II, p. 294).

3. This inscription must have been added after 1700, since it refers to Charles II as dead.

4. Cf. *Voyages faits . . . en Espagne* [1670] . . . *Par Monsieur M.* [Bernardin Martin], 1699, pp. 148/9 (p. 515 of the reprint in *Revue Hispanique*, LXVII, 1926): 'Nous la [*i.e.* Queen Mariana] trouvâmes assise prés d'une table; elle étoit vétue de

13. *Cf.* that published by G. Cruzada Villaamil, *Anales de la vida ... de Velazquez,* 1885, p. 249; see also Velázquez no. 1129 of this catalogue.

5. See J. Morena Villa, *Locos, enanos, negros y niños palaciegos,* 1939, pp. 66/7.

6. Bottineau, *op. cit.*

7. It is suggested by Bottineau (p. 115) that a strip of one of the windows of the room might be shown on the left, but it is clear from the section of the room published by him (fig. 20) that the aperture on the left must be one of the two main doorways. They can be distinguished from the windows by their greater height, and in having only one statue beside the adjacent pilasters, whereas the pilasters flanking the windows had a statue to each side.

8. Bottineau notes that the tiling of the floor corresponds with that of the *Salón de los espejos,* where the Queen sits in portraits of her by Juan Carreño (see note 14).

9. In the ex-Cook collection copy (see Versions and copies), where the whole statue is visible, the right arm is extended above the head which is inclined forward, and the left hand is different. These variations are obviously inventions of the author of the copy, which is very summary.

10. See Justi, *op. cit.*, 1888, I, p. 344, and II, p. 402. The *Planets* were booty captured from a Frenchman at Liège. The other six are now divided between the Salón de Columnas and the Salón del Trono of the Madrid palace. Sr. X. de Salas first suggested that the statue in no. 2926 might be one of the Madrid *Planets.*

11. Inventory of 1686, quoted by Bottineau, *op. cit.*, p. 115.

12. The similarity was first remarked by Justi (*op. cit.*, II, p. 294).

14. *E.g.* Prado no. 644. A signed version is at Sarasota, Ringling Museum (1949 catalogue, no. 338, repr.). (*Cf.* also the British Museum drawing published by K. T. Parker in *Old Master Drawings,* III, 1928/9, p. 63 and pl. 54.) A portrait of Mariana in her old age, at Munich (no. 146) shows that this design persisted even later. The Munich picture was rightly attributed by Justi, *op. cit.*, II, p. 295, to Claudio Coello, who became *pintor del Rey* in 1683 and *pintor de cámara,* 1686, and it is now catalogued as by Coello, *ca.* 1690; see Munich 1963 Spanish School catalogue, by H. Soehner, pp. 45 ff.

15. C. B. Curtis, *Velazquez and Murillo,* 1883, p. 318.

16. A. Palomino, *Museo Pictórico,* III, 1724, p. 372; 'Retratò tambien en su menor edad al Señor Carlos Segundo, y à la Reyna Madre nuestra Señora en su Viudedad, con grande acierto, y semejanza'.

17. Inscribed and signed on a paper in the Queen's hand: *Señora | Jn Bap del Mazo.* Formerly in the collection of the Marqués de la Vega Inclán.

18. According to Curtis, *op. cit.*, p. 319, who says it was signed: J.Bta. del Mazo and came from the collection of Valentín Carderera.

19. Reproduced in the *Catalogue of ... the collection of Sir F. Cook,* III, 1915, oppos. p. 146 (no. 508). Cook sale, Sotheby's, 25 June, 1958 (lot 45).

20. As by Juan Pareja (see W. Stirling, *Annals of the Artists of Spain,* 1848, II, p. 710).

Ascribed to JUAN BAUTISTA DEL MAZO

1315 DON ADRIAN PULIDO PAREJA

He wears on a ribbon the badge of the Order of Santiago; a commander's baton is in his right hand.

Inscribed, left, on the level of the shoulder: *Did. Velasq? Philip. IV. acubiculo. | eiusq? pictor.* 1639 and, at the bottom: ADRIAN | PVLIDO-PAREJA. Both inscriptions appear to be of later date than the picture.

Oil on canvas, $80\frac{1}{4} \times 45$ ($2 \cdot 04 \times 1 \cdot 145$). The lower edge of the painted

surface was apparently at first intended to be about $1\frac{1}{4}$ inches above the present one, and touched the tip of the right foot.

In good condition, apart from local damages. A tear runs across the left half of the moustache and there is damage to the cheek and nose above it. A longer tear runs across the neck, and the original paint is missing from a join across the centre of the canvas, just below the sash. Beneath this are several damages, principally across the hand on the right, to the right of the left wrist and above the end of the baton. Cleaned and restored in 1960, when overpainting was removed from the background.

An earlier outline of the right leg is visible farther to the left; the outline of the cloak shows through the baton.

Don Adrián Pulido Pareja (1606–60) distinguished himself in the Antilles and, in 1638, during the siege of Fuenterrabía by the French. He fought against the French fleet near Cadiz in 1640 and in the following year was in another naval action off Cape St. Vincent. He was Captain General of the Spanish forces in the New World. In 1647 he was made a knight of the Order of Santiago. He died at Vera Cruz.[1]

Palomino[2] says that in 1639 Velázquez painted a life-size portrait of Pulido Pareja in Madrid. According to him it was painted with long-handled brushes that Velázquez sometimes used and was one of the best of Velázquez's portraits, who therefore signed it. He gives the signature as *Didacus Velazquez fecit, Philip. IV. à cubiculo, eiusque Pictor, anno 1639*. Palomino says the portrait then belonged to the Duke of Arcos; he also tells a story of Philip IV mistaking the painting, when he saw it in the painter's studio, for Pulido Pareja himself (similar legends have been told about many paintings from the earliest times onwards).

The present picture (which was still catalogued in 1929 as by Velázquez) has often been taken to be the Velázquez mentioned by Palomino,[3] although the elder Beruete[4] already disputed Velázquez's authorship and later attributed it to Mazo.[5] Allende-Salazar[6] rejected the ascription to Mazo and suggested the face alone might be by Velázquez, the rest by Juan de Pareja. Mayer believed it to be a characteristic work by Mazo and this attribution is accepted by López Rey.[7]

The signature is obviously false[8] and the omission of *fecit* or a similar word,[9] renders it meaningless. The brushwork of the picture is clearly only an imitation of Velázquez's. The few certain works by Pareja[10] are quite different from and inferior to this. There is no signed or documented work by Mazo exactly comparable, but the portrait of Queen Mariana (no. 2926 of this catalogue) and the Vienna *Family Portrait* show a closely similar caricature of Velázquez's manner and make the attribution to Mazo very reasonable even if not certain.

It was proposed by MacLaren that the present picture is probably a copy by Mazo of the Velázquez known to Palomino, with the inscription copied later, probably from the text given by Palomino, the quality and character of the design seeming to confirm that such an original must have existed. This theory, though complicated, may well be true, but a

simpler theory seems on balance to be slightly more probable, namely that no. 1315 is the original described by Palomino and that he was misled by the inscription into supposing it to be by Velázquez.

In the first place the 'signature' transcribed by Palomino is quite unlike that on any other portrait by Velázquez; it differs in being in Latin and in its eccentric wording, and it seems to be derived from the signature of Velázquez's lost *Expulsion of the Moriscos*, which was painted for the King and a major commission (see note 8). Judging by the very few existing signed portraits by Velázquez, he would appear to have added his signature, not because these portraits were necessarily finer than the unsigned ones, as Palomino apparently supposed, but because of the exalted rank of the sitter (see Velázquez nos. 1129 and 6380 below) and even then only when the signature could be introduced in a naturalistic manner (i.e. in the form of a letter or a petition held by the sitter in his hand).[11] Neither of these conditions are met in the present portrait. Two facts about the sitter in no. 1315 make it seem doubtful that it is a copy of a painting of 1639; he wears the badge of the order of Santiago, awarded in 1647, and this date would seem to correspond with his apparent age in the portrait; it is easier to see him as a man of forty or more years than as one of thirty-three. (The badge of Santiago appears not to be a later addition, and it is sometimes suggested that, in incorporating the badge, Mazo brought up to date Velázquez's 'original'.) Although, finally, the portrait is weaker in handling than anything by Velazquez himself, it can be seen after cleaning to be a good deal more spontaneous in the treatment of the paint than would normally be expected in a close copy.

Taking into account all these factors, however tenuous in themselves, no. 1315 seems more acceptable as a good original by Mazo, one executed perhaps with the help of Velázquez, than as a copy of a lost Velázquez of 1639. Thus the portrait would seem to have been executed by Mazo about 1647 or shortly after; before 1724, when described by Palomino, it had entered the collection of the Duke of Arcos and acquired a certain degree of fame, as well as its false Velázquez signature; this was transcribed approximately by Palomino, who added the words *fecit* and *anno*, and who took up (or actually conceived) the theory of the picture being painted with long-handled brushes. Why Velázquez should have chosen to execute this painting with long-handled brushes Palomino does not say, but this theory presumably seemed to him to account in a quite logical way for the discrepancy between the rather obtrusive and clumsy handling of the present portrait and Velázquez's own style. It thus seems doubtful for all these reasons that a portrait of Pulido Pareja by Velázquez himself was ever in existence.

The younger Beruete[12] supposed the version of the portrait in the Duke of Bedford's collection to be the original by Velázquez; that picture, however, appears to be a weak copy, with later additions.[13]

VERSIONS AND COPIES: A version in the collection of the Duke of Bedford, discussed above.[14] A copy of no. 1315 was in the Sir W. Gregory sale, London, 6 May, 1893 (lot 80), bought by Agnew. A full-length portrait said to be of Pulido Pareja and attributed to Velázquez in the Altamira sale, London,

29 June, 1833 (lot 53), was probably of different composition.[15] A portrait of 'General Pareja' by Velázquez is listed as no. 342 in the 1840 inventory of Don Serafín García de la Huerta, Madrid, and a copy of Velázquez's portrait as no. 526.[16]

PROVENANCE: Probably the picture seen by Palomino in the collection of the Duke of Arcos, before 1724. In the sale of property belonging to John Calcraft of Ingress Abbey, Kent († 1772), London, 18–25 June, 1788 (lot 31; £210),[17] bought by Hudson. Later in the possession of [Benjamin] Vandergucht,[18] who sold it to the 2nd Earl of Radnor in 1790.[19] Exhibited Royal Academy, 1873 (no. 149). Purchased from the 5th Earl of Radnor[20] with the aid of gifts from Charles Cotes, Sir E. Guinness, Bt. (Lord Iveagh), and Lord Rothschild, in 1890. Included in the exhibition of paintings from Woburn Abbey, Royal Academy, 1950 (no. 97). Exhibited, Madrid, *Velázquez y lo velazqueño*, 1961 (no. 96).

REPRODUCTION: *Illustrations: Continental Schools*, 1937, p. 371; *Spanish School: Plates*, 1952, p. 17 (both before cleaning).

REFERENCES, GENERAL: C. B. Curtis, *Velazquez and Murillo*, 1883, no. 178; A. L. Mayer, *Velazquez*, 1936, no. 357; J. López Rey, *Velázquez*, 1963, no. 524.

REFERENCES IN TEXT: **1.** *Cf.* A. de Beruete y Moret in *Gazette des beaux-arts*, 1917, p. 242, note.
2. A. Palomino, *Museo Pictórico*, III, 1724, p. 331: 'El año de 1539 [*sic*!] hizo el Retrato de Don Adrian Pulido Pareja, natural de Madrid, Cavallero de la Orden de Santiago, Capitan General de la Armada, y flota de Nueva-España, que estuvo aqui en aquella sazon à diferentes pretensiones de su empleo con su Majestad. Es del natural este Retrato, y de los muy celebrados, que pintò Velazquez, y por tal puso su nombre, cosa, que vsò rara vez: hizole con pinceles, y brochas, que tenia de hastas largas, de que vsaba algunas vezes, para pintar con mayor distancia, y valentia: de suerte, que de cerca no se comprehendia, y de lexos es un milagro; la firma es en esta forma: *Didacus Velazquez fecit, Philip. IV. à cubiculo, eiusque Pictor, anno 1639.* . . . Esta oy este peregrino Retrato en poder del Excelentisimo Señor Duque de Arcos'.
3. *E.g.* A. de Beruete, *Velazquez*, 1898, pp. 90–3.
4. A. de Beruete, *loc. cit.*
5. A. de Beruete, *Velazquez*, Eng. ed., 1906, p. 64; so also the younger Beruete (A. de Beruete y Moret, *The School of Madrid*, 1909, pp. 76–83).
6. *Klassiker der Kunst: Velazquez*, 1925, p. 285 (note to p. 190).
7. Mayer, *loc. cit.*; J. López-Rey, *loc. cit.*,

8. The calligraphy is unlike that of the few existing Velázquez signatures and may not even be of the seventeenth century. The position of the 'signature' is also peculiar (see also note 11). Although its form is unlike that of any surviving genuine one, the lost *Expulsion of the Moriscos* had, according to Palomino (*op. cit.*, p. 327), an elaborate signature in Latin on a paper: *Didacus Velazquez Hispalensis. Philip. IV. Regis Hispan. Pictor ipsiusque iusu, fecit, anno 1627.* The signature on no. 1315 was apparently first noted in recent times in the Royal Academy 1873 exhibition catalogue. Neither the Longford Castle catalogue of 1853 (p. 34, no. 131), nor Stirling (*Annals*, 1848, II, pp. 621/2, and *Velazquez and his Works*, 1855, p.134), nor Waagen (*Treasures of Art*, III, 1854, p. 141) mention it, but this is probably due to the fact that it was (especially before cleaning) rather difficult to see except in a good light.
9. It should be noted that there is no space for the word *fecit* or even the abbreviation *f.* after either *Velasq?* (as in Palomino's transcription) or after *pictor*, the only two possible positions for it. There is room after the word *cubiculo*, but it would have made no sense here and there is no trace of any effaced word or letter. It is perhaps just worth noting that whereas Palomino gives the spelling *Velazquez*, a form never used by Velázquez himself (see biography of Velázquez

below), on no. 1315 the name is correct.

10. *E.g.* the signed *Calling of Matthew* of 1661 in the Prado (no. 1041) or the *Flight into Egypt*, signed and dated 1654, now in the Ringling Museum, Sarasota (1949 catalogue, no. 339, repr.), or *The Baptism of Christ* in the Huesca Museum, signed and dated 1667. Allende-Salazar was also apparently inclined to ascribe to Pareja the Vienna *Family* (in Thieme-Becker's *Künstler-Lexikon*, XXIV, 1930, p. 301).

11. Of the existing portraits painted after Velázquez became court painter only three are signed: the portraits of Philip IV (no. 1129 below), of Archbishop Fernando de Valdes y Llanos (see no. 6380 below), and of Pope Innocent X (Rome, Galeria Doria-Pamphilj). In each case the signature occurs on a paper in the sitter's hand, and Latin words are not used. Only in the portraits of the King and of the Pope is there a reference to Velazquez being court painter to Philip IV. A latin inscription on an equestrian portrait of the King of 1625 is recorded by Palomino, accompanied by a signature on a paper. Some early portraits are signed in the background: the two versions of *Madre Jeronima de la Fuente* (Prado no. 2873 and Araóz collection, Madrid) and possibly also *Cristóbal Suárez de Ribera* (S. Hermenegildo, Seville).

12. A. de Beruete y Moret in *Gazette des beaux-arts*, 1917, pp. 236–252.

13. $78\frac{3}{4} \times 43\frac{3}{4}$ inches. It was in the Bedford collection by 1818, when it was exhibited at the British Institution (no. 5). It lacks the 'signature'. In the right background is a fleet at sea, in the left a red curtain and in the lower left corner a cartouche inscribed: ADRIAN | PVLIDO PAREJA | *Capitan General* | *de la Armada y* | *flota de nueua* | *España.* | *Fallecio en la Ciudad* | *de la nueua Vera* | *Cruz* | *año 1660.* Reproduced in *Gazette des beaux-arts*, 1917, opp. p. 248. Examination in a strong light in 1950 showed that all these, together with the plume on the hat, were added much later, and the original grey background shows through them in many places. (No. 1315 and the Bedford picture were for a time hung side by side at the exhibition of paintings from Woburn Abbey, Royal Academy, 1950, nos. 96 and 97.) In the Bedford version Pareja does not wear the badge of Santiago but he has the Cross embroidered on his breast; this is apparently not a later addition.

14. See note 13.

15. It seems likely that the Altamira portrait was that later in the Aston Hall sale, 6 August, 1862 (lot 25; 79×46 inches; bought by Redhead) and R. Milne Redhead sale, London, 7 July, 1900 (lot 103); in all three sales there was a companion portrait of Pulido Pareja's wife. From the description in the Redhead sale catalogue it is clear that this was an entirely different design.

16. See J. López Rey, *op. cit.*, nos. 526 and 529 ($1 \cdot 890 \times 1 \cdot 150$ and $0 \cdot 560 \times 0 \cdot 420$, respectively).

17. As *Velazquez Whole length portrait of a gentleman*. The sitter is named as Pulido Pareja in *The World*, 26 February, 1790 (*cf.* W. T. Whitley, *Artists and their Friends*, 1928, II, p. 133).

18. *The Gazeteer*, 27 February, 1790, states that Vandergucht bought it from Calcraft (*cf.* Whitley, *op. cit.*, p. 134).

19. According to *The World*, 2 February and 26 February, 1790 (*cf.* Whitley, *op. cit.*, p. 133).

20. Together with nos. 1314 (Holbein's *Ambassadors*) and 1316 (Moroni's *Italian Nobleman*).

Luis de MORALES
Active 1546, died 1586(?)

Sometimes called, from the seventeenth century onwards, *el divino Morales*. He was apparently born at Badajoz; Palomino, writing at the end of the seventeenth century, says he died in 1586 at the age of seventy-seven. 1546 is the date on an undocumented *Virgin and Child with a bird*

(S. Augustín, Madrid) generally accepted as by him and the earliest documentary mention is also of 1546. He was active mainly in Badajoz, but also produced work for a number of towns in the vicinity (including Évora, in Portugal, where his presence is recorded in 1565). His activity is last documented in 1584. The theory of an early journey to Seville and the Spanish Court is usually accepted, possibly in the late 1550's.

His style is based principally on that of Italianizing Flemish painters (*e.g.* Quinten Massys), from whom he probably derived in part the Leonardesque element in his manner. Some influence from German art, Dürer especially, is also traceable in pictures like no. 1229 below. Morales' style may also be related in some way to that of the contemporary Valencian School, but the nature of the connection is obscure. His works show little evolution of style. There are repetitions and copies of many of his compositions and it is likely that he had a number of studio assistants.

LITERATURE: The biographical facts are given in I. Bäcksbacka, *Luis de Morales*, 1962, together with transcriptions of documents, a catalogue raisonné, and many small illustrations.

1229 THE VIRGIN AND CHILD

Oil on oak.[1] Original painted surface, $11\frac{1}{4} \times 7\frac{11}{16}$ (0·285 × 0·196); fillets have been added later at each side and the painted surface increased to $11\frac{1}{4} \times 8\frac{1}{16}$ (0·285 × 0·204).

In very good condition; the reds slightly faded. Cleaned in 1956.

There are several versions of this design by Morales or from his studio (*cf.* Versions and Copies). No. 1229 differs only slightly from two in the Prado and is superior to both of them; it is equal in quality to a three-quarter length variant also in the Prado and is probably autograph. The date of the picture would appear to be difficult to determine; it is placed by Bäcksbacka in the late 1560's.

VERSIONS AND COPIES: Two larger versions in the Prado[2] differ only in detail from the National Gallery picture except for the left hand of the Virgin, which in no. 1229 corresponds to that of a three-quarter length variant in the Prado[3] (of which there is a repetition in the Lisbon Museum[4]). A late derivative was in the Lázaro collection, Madrid.[5] The Child is repeated in a *Virgin and Child* in the Ashmolean Museum, Oxford.[6]

PROVENANCE: In the S. Herman de Zoete sale, London, 8/9 May, 1885 (lot 339; £71 8sh.), bought by Colnaghi. Presented by Gerard F. de Zoete, 1887. Exhibited at The Bowes Museum, 'Four Centuries of Spanish Painting', 1967, no. 18.

REPRODUCTION: *Illustrations: Continental Schools*, 1937, p. 237; *Spanish School: Plates*, 1952, p. 18 (both before cleaning).

REFERENCES, GENERAL: I. Bäcksbacka, *Luis de Morales*, 1962, no. 49, fig. 94, and p. 112.

REFERENCES IN TEXT: **1.** Letter of 1947 from E. W. J. Phillips, Forest Products Research Laboratory (in the Gallery archives). **2.** No. 944 (0·57 × 0·40); Bäcksbacka, no. 60, fig. 103; and no. 946 (0·43 × 0·32); Bäcksbacka, no. 27, fig. 63.

3. No. 2656 (0·84 × 0·64); Bäcks-
backa, no. 26, fig. 62.

4. Bäcksbacka, no. 25, fig. 61.

5. 0·25 × 0·20; reproduced in the
catalogue of the Morales Exhibition,
Madrid, 1917 (no. 10); Bäcksbacka,
no. A5, fig. 13.

6. Spanish Exhibition, Grafton
Gallery, London, 1913/14 (no. 22A);
Bäcksbacka, no. 77, fig. 124; formerly
in the collection of Sir Augustus M.
Daniel.

Bartolomé Esteban MURILLO
1617–1682

Baptized in Seville, 1 January, 1618. He is thought to have been a pupil
in Seville of Juan del Castillo († 1640). According to Palomino (*Museo
Pictórico*, III, 1724, p. 420) he went to Madrid and studied the pictures
in the Royal collections; Palomino puts this visit before the execution of
a series of paintings for the *claustro chico* of San Francisco at Seville, one
of which is dated 1646 and it is difficult to believe that these paintings,
although they are grounded in the naturalistic tradition of Seville, were
produced without first-hand knowledge of Rubens and Van Dyck. On
the other hand, Murillo himself made a declaration in February, 1645,
in which month he married, that he had never left Seville. Palomino,
who took his information from Murillo's intimates, is very emphatic
that the Madrid visit took place; it is possible that he was mistaken in
the matter of date, or that the declaration by Murillo of February, 1645
did not exclude visits, as opposed to residence, outside the confines of
Seville. A later visit to Madrid, in 1658, is documented, and other visits
may have taken place, influencing developments in Murillo's style
based on the artist's increasing awareness of Flemish and Italian art,
and the post-Sevillian work of Velázquez. In 1655 the pictures of SS.
Leandro and Isidoro were placed in Seville Cathedral, and he was then
described as the best painter in Seville. He had completed the *Vision of
S. Anthony* for the Cathedral in 1656. In 1660 he was one of the founders
and first president of the Seville Academy. In the late 1660's he was
working on the paintings for the church of the Caridad (see no. 5931
below), and from 1678 on he was painting those for the Hospital de los
Venerables Sacerdotes. At the time of his death in Seville, 3 April, 1682,
he was engaged on pictures for the Capuchin church at Cadiz.

Murillo's total production was very considerable. He had many
assistants and followers (*e.g.* Tobar, Meneses Osorio, Gutiérrez,
Márquez, Sebastián Gómez) and, according to Ceán Bermúdez
(*Diccionario*, 1800, II, p. 56), his style persisted in Seville at the begin-
ning of the nineteenth century. A large proportion of the very great
number of works which commonly pass as Murillo's is certainly by
others but a thorough investigation of his work remains to be made. The
pictures, in particular, which generally pass for early works, produced
before 1645, are extremely dubious; no. 232 below may be a work by
Murillo of *ca.* 1640.

LITERATURE: C. B. Curtis, *Velazquez and Murillo*, 1883, contains a valuable and extensive catalogue of works attributed to Murillo, reproductions of many of which are in *Klassiker der Kunst: Murillo*, 2nd ed., 1923. The best modern biography is S. Montoto, *Murillo*, 1932.

13 THE TWO TRINITIES ('THE PEDROSO MURILLO')

Above is God the Father; the Holy Ghost hovers above the child Christ who is standing between the Virgin and S. Joseph, the latter holding the flowering rod.

Oil on canvas, $115\frac{1}{4} \times ca. 81\frac{1}{2}$ (2·93 × ca. 2·07). The top and bottom edges of the painted surface are original,[1] the sides are ragged.

In good condition. There are some damages in the sky and in the lower part of Christ's robe. The Virgin's blue robe is rubbed and discoloured in places. Some of the glazes, especially the madder glazes, have faded, being now paler than the artist intended. Cleaned and restored in 1956.

Previously described as *The Holy Family*; the subject is, however, the comparatively rare one of *The Heavenly and Earthly Trinities*. This type of composition, with Christ between his parents in a landscape and God the Father and the Holy Ghost above, developed out of *The Return from the Temple*. Schelte van Bolswert's engraving of a Rubens design of this kind, for example, is inscribed with words from Luke, ii, 51, which refer to that episode.[2] But already by the end of the sixteenth century the Holy Family was considered the earthly counterpart of the Trinity,[3] and compositions of the type mentioned had come to have the ulterior meaning of the Two Trinities.[4] This subject seems to have enjoyed some slight popularity in Spain. In depictions of it the Holy Family is no longer shown in the act of walking back from Jerusalem but standing still with the Virgin and S. Joseph on either side of Christ. Paintings of this kind are in the National Museum at Stockholm, attributable to Murillo and datable to the late 1640's,[5] in Zurbarán's retable of 1643/4 at Zafra[6] and in a Barcelona collection (ascribed to the School of Castille).[7] Sometimes the symbolical nature of the subject is emphasized by the introduction of the Cross either placed behind Christ (as in Juan Martínez Montañés' relief commissioned for S. Ildefonso, Seville, in 1609)[8] or held by him (as in Juan de Uceda's painting of 1623 in Seville Museum).[9] In Murillo's later picture the transformation of the original source, *The Return from the Temple*, is complete and the new significance is accentuated by placing Christ on a higher level than his parents, with S. Joseph kneeling at his feet.

It is sometimes said that Murillo painted this picture for the Marqués del Pedroso in Cadiz 1681/2. This is based on a passage in Palomino which is merely to the effect that Murillo painted many pictures *for* Cadiz (he mentions an *Immaculate Conception*) and that the present picture was then in the house of the Marqués del Pedroso (presumably in Cadiz).[10] Elsewhere Palomino says[11] that Murillo met with an accident, which eventually caused his death (in April, 1682), while working on a picture for the Capuchin church of Cadiz, but he does not

say that Murillo was painting it *in* Cadiz. Evidence, however, has been said to exist showing that Murillo was indeed in Cadiz in the last year of his life.[12] The present picture was in Cadiz in 1708 (see Provenance) and it is undoubtedly in Murillo's later manner.

STUDIES: A small variant, possibly a study (or a copy of a study) for the National Gallery picture, was in the Henry Say sale, Paris, 30 November, 1908 (lot 15).[13] According to Stirling,[14] a 'highly finished sketch' for no. 13 was bought from D. Francisco de la Barrera Enguidanos by Julian Williams, British Consul at Seville, and sold by him (before 1848) to an English collector. A reputed finished sketch in the Delessert sale, Paris, 15–18 March, 1869 (lot 58), was of exactly the same measurements as the Say sale picture mentioned above and may be the same painting.[15]

VERSIONS AND COPIES: For a possible variant see STUDIES. A slightly reduced copy by José de Rubira or Rovira (1747–87) is in Seville Museum.[16] A small replica attributed to Alonso Miguel de Tovar (1678–1758) is said to have been in Munich in 1912.[17] A copy, but without the figure of God the Father, is in the church of S. Chrisogono, Rome. Several recent copies have appeared, since 1949, in London sales (photographs in the Gallery archives).

ENGRAVINGS: Three engravings of the nineteenth century are recorded.[18]

PROVENANCE: In the collection of Don Carlos Francisco Colarte, second Marqués del Pedroso, at Cadiz in 1708;[19] in the Pedroso collection at Seville by 1800.[20] It was bought in Seville by James Campbell, apparently for Buchanan,[21] and brought to England in or shortly before January, 1810.[22] By 1824 it was in the collection of Thomas Bulkeley Owen.[23] It was on exhibition, for sale, at George Yeates' gallery in London in May, 1837,[24] and was purchased[25] by the National Gallery in that year.

REPRODUCTION: *Illustrations: Continental Schools,* 1937, p. 239; *Spanish School: Plates,* 1952, p. 19 (both before cleaning).

REFERENCES, GENERAL: C. B. Curtis, *Velazquez and Murillo,* 1883, no. 135.

REFERENCES IN TEXT: **1.** There is about an inch of unpainted original canvas at both top and bottom (now turned over the edge of the stretcher).

2. See C. G. Voorhelm Schneevogt, *Catalogue des estampes . . . d'après Rubens,* 1873, p. 25, no. 116; reproduced in M. Rooses, *Œuvre de Rubens,* I, 1886, pl. 65. Both Schneevogt and Rooses (*op. cit.,* p. 247) mistakenly describe the subject as *The Return from Egypt* but the quotation from Luke, ii, 51, in the title of the print makes it certain that *The Return from the Temple* is intended.

3. E. Mâle, *L'art religieux après le Concile de Trente,* 1932, pp. 312/13, quotes a number of references to the Earthly Trinity in religious literature of the time and mentions some seventeenth-century representations of it.

4. The subject is called *The two Trinities* in Juan Martínez Montañés' contract of 1609 for the relief at S. Ildefonso, Seville: 'una ystoria de las dos trinidades . . . que es jesus maria i jose por lo bajo y por lo alto dios padre y el espiritu santo de manera que el espiritu santo benga sobre la cabeça del niño jesus . . .' (published by C. López Martínez, *Desde Martínez Montañés hasta Pedro Roldán,* 1932, p. 247).

5. Curtis, Murillo no. 136; reproduced in *Klassiker der Kunst: Murillo,* 1923, p. 3; see A. Braham, in *The Burlington Magazine,* 1965, p. 449, fig. 5; exhibited, Stockholm, National-museum, *Stora Spanska Mästare,* 1959/60, no. 76 (catalogue, p. 65).

6. Reproduced in M. Soria, *The paintings of Zurbarán,* 1953, p. 181.

7. Reproduced in the catalogue of the exhibition of Castilian paintings from Barcelona collections, Sala Parés, Barcelona, 1949, pl. xlv.

8. Reproduced by J. Hernández Díaz, in *Boletín de Bellas Artes* [Seville]: *Homenaje á Martínez Montañés*, 1939, fig. 32. See note 4.

9. Seville Museum catalogue, 1912, no. 154; reproduced on pl. 58 (where it is captioned erroneously as J. Rovira, no. 148, which is actually the copy of the Pedroso Murillo mentioned in Versions and Copies). Although God the Father is lacking in Uceda's picture, the presence of the glory above makes it more than probable that he was shown in an upper part of the picture now cut off or in a lunette. In any case the Holy Family is depicted as the Earthly Trinity in this picture.

10. A. Palomino, *El Museo Pictórico*, III, 1724, p. 422. The whole passage is as follows: 'Hizo tambien para Cadiz muchas Pinturas, especialmente de la Concepción Purísima. Y en lo publico es muy señalada la del Altar Mayor de la Iglesia de la Congregacion del Oratorio de san Phelipe Neri, y por cada vna le daban cien doblones, siendo de dos baras y media. Y en Casa del Marquès del Pedroso ay otro Quadro grande de cerca de seis baras, donde estàn Jesus, Maria, y Joseph, y arriba el Padre Eterno, y el Espiritu Santo, con vn pedazo de Gloria, que es vna admiracion!' Although Palomino gives the height of the picture as about 6 *varas* (= *ca.* 200 ins.) and there is clear evidence that no. 13 has not been reduced in height (*cf.* note 1), there can be little doubt that he is describing the same picture. Although he does not state definitely that the picture was in Pedroso's house in Cadiz, this is implied by the context and it was certainly there in 1708 (see Provenance).

11. Palomino, *op. cit.*, III, p. 423.

12. Fray Ambrosio de Valencina (*Murillo y los Capuchinos*, 1908, pp. 100–104) mentions, but does not quote, documents which he claims prove that Murillo was in Cadiz for some 12 months or more from late 1680 or early 1681 until his accident. The value of his evidence, however, is not at all certain and S. Montoto (*Murillo*, 1932, p. 215) quotes a document which shows that Murillo was in Seville at least on 28 June, 1681.

13. 0·48 × 0·38. It has considerable variations from no. 13. It is impossible to judge from the plate in the Say sale catalogue whether it is a sketch, a copy of a sketch or a copy of a larger variant.

14. W. Stirling, *Annals of the Artists of Spain*, 1848, III, p. 1425.

15. 0·48 × 0·38. In the Delessert sale catalogue as *The Holy Family*. It was earlier in the Marquis de Forbin-Janson sale, Paris, 2 *sqq.* May, 1842 (lot 2), bought by Daillet(?); the identification is made in the Delessert sale catalogue.

16. Seville Museum catalogue, 1912, no. 148 (see also note 9). 2·55 × 1·68; signed: *Copia de Murillo | Por Jose(f?) de R(. . . .)a*. This is presumably the copy by Rubira of the Pedroso picture in the collection of D. Francisco de Bruna [Seville], mentioned by J. A. Ceán Bermúdez (*Diccionario*, 1800, IV, p. 278).

17. According to A. L. Mayer, *Klassiker der Kunst: Murillo*, 1923, p. 293, note to p. 199.

18. See Sir W. Stirling-Maxwell, *Essay towards a Catalogue of prints . . . of . . . Velazquez and . . . Murillo*, 1873, p. 76, and Curtis, *op. cit.*

19. According to Ceán Bermúdez, *op. cit.*, II, p. 57 (who gives the size as 4 × 3 *varas*); it was then valued at 800 *pesos*.

20. Ceán Bermúdez, *ibid.*

21. See W. Buchanan, *Memoirs of Painting*, 1824, II, p. 202.

22. According to J. Penrice, no. 13 is the 'large Murillo . . . just arrived from Spain' which Sir Thomas Lawrence saw at Buchanan's in January, 1810 (see *Letters . . . to the late Thomas Penrice . . . 1808–14*, n.d., pp. 11/12: Lawrence's letter of 10 January, 1810).

23. Buchanan, *ibid.*

24. Minutes of the May, 1837 meeting of the National Gallery Board of Trustees; see also W. T. Whitley, *Art in England: 1821–1837*, 1930, p. 313.

25. Together with Rubens' *Brazen Serpent* (National Gallery, no. 59) from the same collection.

74 A PEASANT BOY LEANING ON A SILL

Oil on canvas, *ca.* $20\frac{1}{2} \times ca.$ $15\frac{1}{8}$ (*ca.* $0 \cdot 52 \times ca.$ $0 \cdot 385$). Ragged edges; possibly cut down slightly on the left and below.

In very good condition except for some slight wearing in the darks and the part of the breast painted over an earlier outline of the shirt. Cleaned in 1950.

The style is that of Murillo's later years.

M. S. Soria has suggested[1] that this is the *pendant* to the *Girl raising her veil* (of almost exactly the same size), formerly in the Jakob Gold-schmidt collection, New York.[2] He supports this suggestion by pro-posing the identification of these two pictures with the *Jeune garçon* and *Jeune fille tenant son voile*, of approximately the same size as no. 74 and the Goldschmidt *Girl*, which may have been in the Comtesse de Verrue sale, 1737,[3] and were certainly in the Randon de Boisset sale, 1774.[4] He further suggests that the Goldschmidt picture is the *Portrait of a girl* which was the companion of the National Gallery picture in the Lansdowne sale of 1806.[5] The two paintings may be acceptable as a pair from the point of view of style but it must be noted that they differ in composition and in scale,[6] and the Goldschmidt *Girl* looks as if it may have been cut down considerably on each side, and possibly below. Even if not originally painted as companion pieces, however, the pro-posed provenance is not necessarily invalidated since the possible cut-ting down could have been done prior to 1737 (or at least 1777) to make them match in size.

ENGRAVING: Mezzotint by W. Ward, 1825.[7]

PROVENANCE: Possibly in the Comtesse de Verrue sale, Paris, 27 March and 29 April, 1737 (2nd part, lot 66),[8] and the Randon de Boisset sale, Paris, 27 February *sqq.* 1777 (lot 19; 3000 francs the pair),[9] the latter bought by Paillet. It was certainly in the Marquis of Lansdowne sale, London, 19/20 March, 1806 (2nd day, lot 50; £115 10sh.).[10] Exhibited British Institution, 1821 (no. 96), lent by M. Zachary; presented by M. M. Zachary, 1826. Arts Council Spanish Paintings Exhibition, 1947 (no. 23).

REPRODUCTION: *Illustrations: Continental Schools*, 1937, p. 239; *Spanish School: Plates*, 1952, p. 20.

REFERENCES, GENERAL: C. B. Curtis, *Velazquez and Murillo*, 1883, no. 412.

REFERENCES IN TEXT: **1.** In *The Burlington Magazine*, XC, 1948, p. 22.

2. Its size is *ca.* $20\frac{5}{8} \times ca.$ $15\frac{1}{2}$ (*ca.* $0 \cdot 524 \times ca.$ $0 \cdot 394$). Curtis no. 430; re-produced in *The Burlington Magazine*, XC, 1948, p. 20. It was in Sir T. Baring's collection and passed thence after 1837 to R. S. Holford; Holford sale, 17/18 May, 1928 (lot 144); Jakob Goldschmidt sale, London, 28 November, 1956 (lot 125).

3. The first part of the Verrue sale took place on 27 March, 1737, the second on 29 April, 1737. All known copies of the sale catalogue are in

ms. (*cf.* F. Lugt, *Répertoire des cata-logues de ventes*, 1938, no. 470); four copies are at the Rijksbureau voor Kunsthistorische Documentatie at The Hague. Soria's remarks (*loc. cit.*) about the entries in these catalogues are not quite accurate and a further note is, therefore, necessary here. In all four copies the last lot, which is among a number of items 'retirés et vendus avec référé', refers to two Murillos. In two copies (apparently in early nineteenth-century hands) these paintings are merely listed (in the same hand as the rest) respectively as

'Deux Morillos vendus dans un autre tems' and 'Deux Morillos vendus dans la main dans un autre tems'. (In the latter copy the lot number is 178, the numbers being consecutive throughout, instead of recommencing at 1 for the second half of the sale as in the other copies.) The third copy (apparently also in a nineteenth-century hand) repeats this and adds 'L'un représente un jeune garçon et l'autre une jeune fille tenant son voile, figures à mi-corps: sur toile de 19 pouces de haut sur 14 pouces 6 lignes de large. Nª ces tableaux ont été acheter [sic] à la vente de Mʳ Randon de Boisset 2999. 19.' The description and size in this third copy tally almost word for word with those of the Randon de Boisset sale catalogue, where provenance from the Verrue collection is claimed (see note 4); this fact and the reference to the Randon de Boisset sale show that, since the note is in the same hand as the rest of the copy, the whole of it is posterior to that sale. The fourth copy is in a nineteenth-century hand and also has the reference to the Randon de Boisset sale. It is, therefore, not at all certain that the Randon de Boisset pictures came from the Verrue sale. (See also C. Blanc, *Trésor de la curiosité*, I, 1857, p. 16, and on the Verrue and Randon de Boisset collections, L. Clément de Ris, *Les amateurs d'autre-fois*, 1877, pp. 153 ff. and 359 ff.).

4. Lot 19 of the Randon de Boisset sale was *Un jeune garçon & une jeune fille tenant son voile; figures à mi-corps*, on canvas, each 19 *pouces* × 14 *pouces* 6 *lignes*; said to come from the cabinet of the Comtesse de Verrue.

5. The National Gallery picture was lot 50 of the 2nd day's sale: *A Laughing Boy*; lot 51, *Portrait of a Girl*, is described in the sale catalogue as its companion.

6. They are reproduced side by side and the same size in *The Burlington Magazine*, XC, 1948, p. 20, where the discrepancies between the two can be easily appreciated. In contrast to them is the pair of genre scenes by Murillo both formerly in the Hermitage, Leningrad (one now transferred to Moscow), showing a peasant boy and girl (reproduced in A. L. Mayer, *Murillo (Klassiker der Kunst)*, 1923, pp. 210/11); these pendants are perfectly matched in scale and composition, and directly linked with each other in theme.

7. According to Curtis no. 412. Further nineteenth-century engravings are recorded by Curtis and in Sir W. Stirling-Maxwell, *Essay towards a catalogue of Prints . . . of . . . Velazquez and . . . Murillo*, 1873, p. 115.

8. See note 3.

9. See note 4.

10. See note 5. The Lansdowne provenance was first mentioned in the 1838 National Gallery catalogue.

176 THE INFANT S. JOHN WITH THE LAMB

Inscribed on the scroll of the Cross on the ground: ECCE AGNVS DEI. Oil on canvas, $64\frac{3}{4} \times ca.\ 41\frac{3}{4}$ ($1 \cdot 65 \times ca.\ 1 \cdot 06$). There is about $\frac{1}{2}$ inch of unpainted original canvas at each side.

In good condition (as far as can be judged through the brown varnish) but the background may be damaged and the sky retouched in places.

In post-Renaissance art S. John Baptist is frequently represented in the wilderness, usually with a scroll inscribed *Ecce Agnus Dei* (in reference to John, i, 29 and 36) which is often attached to a reed Cross, or with a lamb as symbol of these words or, as here, with both. In many such representations he is shown as a child or youth, since he is supposed to have gone to live in the wilderness at an early age.[1] Murillo painted S. John many times, almost always as a child with the lamb.[2]

This is the companion piece to the *Infant Christ as the Good Shepherd* formerly in the Rothschild collection,[3] whose history it shared until 1840. As far as can be seen, it is in Murillo's style of the sixteen-fifties.

3—S.S.C.

VERSIONS AND COPIES: A version or copy was apparently in the collection of Samuel Athawes in 1784;[4] another is in the Earl of Lovelace's collection, Ben Damph Forest, Ross-shire.[5] A copy is in the Hermitage, Leningrad;[6] another was in an anonymous sale, Christie's, 8 July, 1927 (lot 76), bought by Kleinberger;[7] another is in the collection of Major and Mrs. Reinhold Engdahl, Göteborg (1960);[8] and another was in an anonymous sale, Sotheby's, 1 November, 1961 (lot 37).[9] A small pastiche is in the Stirling-Maxwell collection[10] and further recent pastiches are known (photographs in the gallery archives). Copies with variations[11] of no. 176 and the *Good Shepherd*, attributed to Alonso Miguel de Tobar (1678–1758), are in S. Isidoro, Seville. Possibly other copies of no. 176 and its companion were in the Comtesse de Verrue sale, Paris, 27 March and 29 April, 1737,[12] and in the collection of Count A. Stroganoff, St. Petersburg, 1800.[13]

ENGRAVINGS: Several nineteenth-century engravings of no. 176, or its derivatives, are recorded.[14]

PROVENANCE: No. 176 and the Rothschild *Good Shepherd* were in the collection of the Comte de Lassay († 1750),[15] which passed in part to the Comte de la Guiche; la Guiche sale, Paris, 4–6 March, 1771 (lot 13; 13,000 francs the pair), bought by Donjeux. They were afterwards in the Aranc (Harenc) de Presle sale, Paris, 16–24 April, 1792 (lot 7)[16] and the Citoyen Robit sale, Paris, 11 May *sqq.* 1801 (lot 60; 40,650 francs the pair), bought by Paillet for Bryan.[17] Together with other pictures from the Robit collection, they were exhibited for sale by Bryan in London, November, 1801–May, 1802 (nos. 13 and 27), and sold to Sir Simon Clarke, who exhibited them at the British Institution, 1816 (nos. 71 and 76) and 1838 (nos. 5 and 11). At the Clarke sale, London, 8/9 May, 1840, the two pictures were separated, the *S. John* (lot 109; £2,100) being bought by Lord Ashburton, who ceded it a few days later to the National Gallery.

REPRODUCTION: *Illustrations: Continental Schools*, 1937, p. 240; *Spanish School: Plates*, 1952, p. 21.

REFERENCES, GENERAL: C. B. Curtis, *Velazquez and Murillo*, 1883, no. 322.

REFERENCES IN TEXT: **1.** *Cf. Les petits Bollandistes*, VII, 1882, p. 275. This belief is based on Luke, i, 80.

2. See Curtis nos. 317–336[1] for paintings of S. John by Murillo and his followers.

3. Curtis no. 167. It is now in the collection of the Hon. Mrs. George Lane, Ashton Wold. Exhibited: City of Manchester Art Gallery, *European Old Masters*, 1957, no. 154 (pp. 43 f. of the catalogue).

4. Engraved when in that collection by James Stow, 1784 (according to Curtis, *loc. cit.*). This print is in the opposite direction to no. 176; there are some slight variations from no. 176 in the background and foliage and the upper edge is only a head above S. John. The impressions in the British Museum and Stirling-Maxwell collection bear no mention of the Athawes collection.

5. Curtis no. 323. 64×45 ins. Said to have come into the possession of the Hon. Thomas King (later 5th Baron Lovelace) in 1734; engraved in mezzotint by Valentine Green.

6. Hermitage catalogue, I, 1891, no. 379. 1·73 × 1·19. Engraved 1785 by G. Skorodumoff when in the collection of Prince G. A. Potemkin. Repr. in *Klassiker der Kunst: Murillo*, 1923, p. 261.

7. This is Curtis no. 324 (then in the collection of the Earl of Dudley and exhibited Royal Academy, 1871, no. 402, as after Murillo); it was in the Viscount Ednam [heir of the 2nd Earl of Dudley] sale, London, 17 July, 1925 (lot 142), bought in. 45 × 32½ ins.; the field of the composition has been reduced on each side and by about a fifth at the top.

8. 1·65 × 1·08 m.

9. 65 × 42 ins.

10. J. Caw, *Catalogue of Pictures at Pollok House*, 1936, no. 36, attributed to Tobar. Said to be lot 25 of the Louis-Philippe sale, 6 May *sqq.* 1853 (bought by Favard), but that measured 1·70 × 1·24 (*Notice . . . de la Galerie Espagnole*, 1838, no. 261), whereas the Pollok House picture measures 31¾ × 23¾ ins. (0·81 × 0·60).

11. *Cf.* W. Stirling, *Annals*, 1848, III, p. 1303.

12. See note 15.

13. Curtis nos. 173i and 332b. *Catalogue raisonné des tableaux Stroganoff*, 2nd ed., 1800, nos. 32 and 33: 2 *pieds* 3 *pouces* × 1 *pied* 10 *pouces*. Neither appears in *Collection d'Estampes d'après quelques tableaux de la Galerie . . . Stroganoff*, 1807, or in A. Benois' article in *Trésors d'Art en Russie*, 1901, pp. 165–80, or in the Stroganoff sale, Berlin, 29 May, 1929.

14. See Curtis, *op. cit.*, and Sir W. Stirling-Maxwell, *Essay towards a Catalogue of Prints . . . of . . . Velazquez and . . . Murillo*, 1873, pp. 80 f.

15. According to P. Remy, *Catalogue des Tableaux de feu M. le Comte de la Guiche*, 1770, p. 3, all the pictures in this collection previously belonged to the Comte de Lassay. Curtis (no. 167) suggests that the *Good Shepherd* and *S. John* may have been among those pictures which de Lassay acquired by bequest and by purchase from the collection of the Comtesse de Verrue († 1736). There is no list of the pictures bequeathed and neither appears in the catalogue of the Verrue sale, Paris, 27 March and 29 April, 1737 (all recorded copies of this catalogue are in ms.; there are four copies at the Rijksbureau voor Kunsthistorische Documentatie, The Hague) but it may be noted that lot 52 of the Verrue sale (lot 53 in some copies) is 'Deux tableaux moiens en hauteur, tous les deux copies, l'un representant J. C. enfant en pasteur avec des Brebis, l'autre S.^t Jean aussi en pasteur'. These may conceivably have been copies of the two Murillos (Caix de St.-Aymour, *Les Boullongne*, 1919, p. 208, follows Blanc, *Trésor de la curiosité*, I, 1857, p. 5, in assuming without sufficient reason that these copies were made by Louis de Boullongne the elder). Curtis (no. 167) notes a reference claiming that the two Murillos had been presented to the Marquis de Lassay when ambassador to Madrid, but there is no record of either the Marquis de Lassay (1652–1738) or his son the Comte de Lassay being ambassador to Spain.

16. According to the Robit sale catalogue (see below) they had been in the Presle collection for 25 years. They were perhaps the two Murillos mentioned as in that collection in the *Almanach des Artistes* for 1777 (p. 180 —see *Livre-Journal de Lazare Duvaux*, I, 1873, p. cclxxvi). Curtis (no. 167) erroneously states that they were in a 'Marquis de Presle' sale, Paris, 18 November *sqq.*, 1779; this sale was, in fact, of the Loriol collection (see G. Duplessis, *Ventes de tableaux . . . aux XVII & XVIII siècles*, 1874, no. 1133).

17. Bryan, who bought most of the pictures in the Robit sale, commissioned a number of French dealers to bid for him, according to a ms. note in the copy of the Robit sale catalogue in the Bibliothèque Doucet, Paris. W. Buchanan, *Memoirs of Painting*, II, pp. 35 f. speaks of Bryan enlisting the help of Sir Simon Clark before the sale and (pp. 50 f.) valuing the pair of Murillos to him for 4,000 guineas.

5931 CHRIST HEALING THE PARALYTIC AT THE POOL OF BETHESDA

Christ, accompanied by three disciples, is addressing the recumbent paralytic. In the right background is the pool of Bethesda, around which other sick people are waiting; the angel is descending from the sky.

One of a series of paintings made for the church of La Caridad, Seville.

Oil on canvas, 93¼ × 102¾ (2·37 × 2·61).

In very good condition except for slight thinness in some of the figures in the right background.

The subject is taken from John, v, 2–8: 'Now there is at Jerusalem by the sheep market a pool, which is called in the Hebrew tongue Bethesda, having five porches. In these lay a great multitude of impotent folk, of blind, halt, withered, waiting for the moving of the water. For an angel went down at a certain season into the pool, and troubled the water: whosoever then first after the troubling of the water stepped in was made whole of whatsoever disease he had. And a certain man was there, which had an infirmity thirty and eight years. When Jesus saw him lie, . . . he saith unto him, Wilt thou be made whole? The impotent man answered him, Sir, I have no man, when the water is troubled, to put me into the pool . . . Jesus saith unto him, Rise, take up thy bed, and walk.'

The church and hospital of San Jorge, Seville, known as La Caridad, belonged to the Hermandad de la Santísima Caridad, a lay confraternity founded about the beginning of the sixteenth century for the succour of the poor and the burial of the dead. By the beginning of the seventeenth century the church had fallen into decay. The confraternity was re-formed about 1661,[1] largely as the result of the efforts of Don Miguel Mañara who was *hermano mayor* 1663–79,[2] a hospital for the poor was built and the church reconstructed.

Murillo was accepted as a member of the confraternity in 1665. The recommendation of his admission mentions specifically that he will be of service for the adornment of the church,[3] and he did in fact paint a number of canvases for it, in particular a series of six, to which no. 5931 belongs, illustrating works of mercy taken from the Bible. These were hung on the North and South walls of the church; on the Gospel side were, proceeding from the East end, *Moses striking the Rock* (still in the Caridad), *The Return of the Prodigal Son* (Washington) and *Abraham and the three Angels* (Ottawa). On the Epistle side were *The Feeding of the Five Thousand* (still in the Caridad), *Christ healing the Paralytic* (no. 5931) and *The Liberation of S. Peter* (Leningrad).[4]

A thorough search in the Caridad archives, recently undertaken by Mr. Jonathan Brown, has revealed in greater detail than was known hitherto the circumstances of the commissioning of the church and its decoration.[5] The church itself was begun in 1645 and only partly completed on Mañara's election as *hermano mayor* in 1663; work was resumed in 1667 and by 1670 the church was completed. By July 13, 1670, Murillo's six canvases had apparently been installed in the church,[6] although they were not paid for until 1670 (*Moses striking the Rock*—13,300 *reales*), 1671 (*The Feeding of the Five Thousand*—15,975 *reales*), and 1674 (the remaining four canvases, including no. 5931, for which Murillo received 8,000 *reales* each).[7] The pictures thus appear to have been painted in 1667–70 in readiness for the completion of the church, instead of in the early 1670's, as was formerly supposed.

The decoration of the church was completed by four further paintings, two by Murillo and two by Valdés Leal, and by the installation of

the altar—all still *in situ* in the church. Murillo's paintings represent *The Charity of S. Juan de Dios* and *S. Elizabeth of Hungary healing the sick* and they were hung in the nave at a lower level than his six large canvases;[8] the pictures by Valdés Leal are the two large *Hieroglyphs of the Four Last Things, In Ictu Oculi* and *Finis Gloriae Mundi*, which hang on each side of the nave nearest to the 'west' wall of the church.[9] These four pictures are not mentioned in the document of 1670 which refers to the six large Murillos, but they are recorded in a payment of 1672.[10] The altarpiece was designed by Bernardo Simón de Pineda in 1670 and completed in 1674; its principal feature is a sculptural representation of the *Entombment of Christ* by Pedro Roldán.

The Caridad documents clarify the iconographic programme of the chapel, making it clear that Murillo's six paintings, together with the altarpiece, represent the seven cardinal Acts of Charity, no. 5931 standing for visiting the sick.[11]

Murillo's paintings in the Caridad were celebrated already in the artist's lifetime[12] and remained the most famous works of art in Seville until their partial dispersal in 1810.

COPIES: Ceán Bermúdez[13] says that many copies were made of the eight pictures. Copies were in the church of the Convento de S. Agustín, Seville, in the eighteenth century;[14] others, by Juan Espinal († 1783) were in the monastery of S. Jerónimo de Buenavista at Seville until *ca.* 1834.[15] Copies of three of the group of four nave pictures, including one of no. 5931, were in the Marquis of Lansdowne sale, London, 19/20 March, 1806 (lots 69–71);[16] copies of the set of four nave pictures were apparently among the paintings removed from Sevillian churches by the French in 1810.[17] A copy of no. 5931 by Antonio María Esquivel (1806–1857) is in the palace at Aranjuez. A small copy was in an anonymous sale, Christie's, 1 August, 1957 (lot 136), together with copies of the other three nave pictures now removed from the Caridad.

ENGRAVING: T. Vernon (line, 1872).[18]

PROVENANCE: Painted for the church of the Hermandad de la Caridad, Seville, *ca.* 1667/70 (see above) and remained there until 1810. It was among the 999 paintings from Sevillian churches and convents, destined for the proposed museum in Madrid or the Musée Napoléon in Paris, which were transferred to the Alcázar in Seville, February–May, 1810.[19] Together with four others[20] of the Caridad Murillos it was appropriated by Marshal Soult (Duke of Dalmatia) and taken to Paris before August, 1812.[21] In the Soult collection, Paris;[22] sold by Soult to King Louis-Philippe in 1835, but the sale was cancelled;[23] it was purchased from Soult by Buchanan for George Tomline in 1846 or 47.[24] In the George Tomline collection at Orwell Park;[25] inherited by his cousin, E. G. Pretyman; exhibited at the Royal Academy, 1910 (no. 46); George Pretyman sale, London, 28 July, 1933 (lot 22; 1,450 gns.), bought by Martin for Owen Hugh Smith. Sold in 1949 to Messrs. Agnew, from whom purchased by the executors of W. Graham Robertson and presented in his memory (through the National Art-Collections Fund) in 1950.

REPRODUCTION: *Spanish School: Plates*, 1952, pp. 22 and 23.

REFERENCES, GENERAL: C. B. Curtis, *Velazquez and Murillo*, 1883, no. 182.

REFERENCES IN TEXT: 1. The new rule of the confraternity was approved in June, 1661 (see D. Ortiz de Zúñiga, *Annales eclesiásticos y seculares . . . de Sevilla*, 1677, p. 767.

2. See J. Gestoso, *Sevilla monumental y artística*, III, 1892, pp. 321 and 330. See also below.

3. See F. M. Tubino, *Murillo*, 1864, p. 90, note: 'nos parese será

muy del servicio de Dios nrs. y de los pobres tanto para su alivio como por su arte para el adorno de nuestra capilla.'

4. *Moses striking the Rock* and *The Feeding of the Five Thousand* measure 132 × 216 (3·35 × 5·50); no. 5931 and the remaining three are of the same size, approx. 93 × 103 (2·36 × 2·62). For the arrangement of the pictures in the church *cf.* A. Ponz, *Viage de España*, IX, 1780, pp. 147–9, and Ceán Bermúdez, *Carta ... sobre ... la Escuela Sevillana*, 1806, pp. 73–88.

5. The results of this research are due to be published in *The Art Bulletin*, September, 1970. Mr. Brown has most kindly allowed the publication here of a summary of his work.

6. *Ibid.*, Appendix I.

7. *Ibid.*, note 32. Several of these payments were published, through the kindness of Señor J. Hernández Díaz, in an appendix to the first edition of the present catalogue. The payments were evidently known to Ceán Bermúdez (J. A. Ceán Bermúdez, *Diccionario*, 1800, II, pp. 52 and 53, and *Carta*, 1806, p. 87), who gives the year 1674 for the completion of the series.

8. Each measures 128 × 96 (3·25 × 2·25). *S. Elizabeth*, formerly in the Prado (no. 993), was returned to the Caridad *ca.* 1940.

9. See E. du G. Trapier, *Valdés Leal*, 1960, pp. 54 ff.; Valdés worked also on gilding and ornamentation of the High Altar of the church (see the documents given in A. L. Mayer, *Die Sevillaner Malerschule*, 1911, p. 220).

10. J. Brown, *op. cit.*, note 35.

11. *Ibid.*, Appendix I. It is further suggested in the text, as indeed seems logical, that Murillo's paintings were to be seen in relation to those of Valdés as representing the means by which death may be overcome and salvation achieved through the performance of charitable acts, and this idea can be followed through in the writings of Mañara, who would presumably have established the iconographic programme for the decoration of the church.

12. *Cf.* Ortiz de Zuñiga, *loc. cit.*

13. *Carta*, p. 87.

14. Ponz, *op. cit.*, p. 136. See also note 16.

15. A. Sancho Corbacho in *Archivo Hispalense*, 1949, p. 141.

16. That after no. 5931 was lot 71. There is no particular reason for supposing, as Curtis (note to no. 254) does, that these three pictures came from the Augustine convent.

17. See M. Gómez Imaz, *Inventario de los cuadros sustraídos por el Gobierno intruso en Sevilla*, 2nd ed., 1917, p. 149, no. 301. Although listed merely as copies, without the name of the author of the originals, the combination of the correspondence of size with that of subject makes it likely that they were after the four nave pictures.

18. See Curtis, *op. cit.*, and Sir W. Stirling-Maxwell, *Essay towards a Catalogue of Prints ... of ... Velazquez and ... Murillo*, 1873, pp. 89 f.

19. See Gómez Imaz, *op. cit.*, pp. 85–96. No. 5931 is the seventh item in the inventory of pictures in the Alcázar made 1 June, 1810 (Gómez Imaz, p. 121).

20. The others were *The Liberation of S. Peter, Abraham and the three Angels, The Return of the Prodigal Son* and *S. Elizabeth healing the sick.* (The last was taken back to Spain in 1816.)

21. Seville was recaptured from the French on 27 August, 1812.

22. Engraved in outline by Reveil when in the Soult collection (in *Musée de Peinture*, IV, 1829, pl. 262).

23. *Kunst-Blatt*, 30 July, 1835, p. 256.

24. Probably at the end of 1846, certainly before 9 February, 1847 (see *Bulletin des Arts*, V, p. 284: 10 February, 1847, and *Kunst-Blatt*, 29 May, 1847, p. 104).

25. G. F. Waagen, *Treasures of Art*, 1854, III, p. 440 ('... I look upon this as the finest Murillo in England').

6153 SELF-PORTRAIT

The artist is portrayed within a painted oval frame, placed on a ledge before a niche. His right hand rests upon the lower edge of the frame. On a shelf beneath are attributes of painting and drawing, and an inscribed tablet, hanging from the shelf in the centre.

Inscribed on the tablet: *Bart.us Murillo seipsum depin | gens pro filiorum votis acpreci | bus explendis* (Bart(olo)mé Murillo portraying himself to fulfil the wishes and prayers of his children—*or* sons).

Oil on canvas, $48\frac{1}{4} \times 42$ ($1\cdot220 \times 1\cdot070$). About $\frac{1}{4}$ in. of original paint is turned over the stretcher at the top and the right side, and about 1 in. at the bottom.

In good condition. Some wearing in the background and in the shadows of the face. Cleaned before acquisition, probably in 1951.

The inscription appears to be contemporary with the rest of the picture, as is in any case suggested by the provision of the tablet and the personal nature of the message it carries. There is no reason to doubt the truth of what it says. The colours on the palette are clearly more or less those which the artist needed to paint the portrait. The red chalk drawing on the ledge appears to be a figure study of a seated model of which only the legs are visible. It was perhaps based on a sheet which the artist had in his studio at the time and which he used in a painting, but the drawing itself is not known to have survived and, without it, the painting cannot easily be identified.[1]

In its general character the portrait resembles an engraved frontispiece, the inscription being at one remove from the spectator, and the author of the painting at two removes, except for the fingers of his right hand, pointed in the direction of the palette. Painted portraits within simulated oval frames are rare in Spain in the seventeenth century except in the work of Murillo and his followers. The motif of the protruding right hand, ambiguous in the context of a frame, occurs more frequently when the sitter is placed behind a window. The composition of no. 6153 was probably suggested by an engraving, but no exact source is known.[2]

In 1724 Palomino mentions two self-portraits by Murillo, one painted at the insistence of his sons which was engraved in Flanders for Nicolas Amazurino, and one showing the artist in a *golilla* (a stiff white collar)— a picture which belonged to Murillo's son, Gaspar.[3] There can be little doubt that no. 6153 is the first of these pictures referred to by Palomino. The composition was engraved in reverse, with slight variations, by Richard Collin in Brussels in 1682, the year of Murillo's death. The painted inscription referring to Murillo's children is reproduced more or less verbatim in the engraving, followed by a legend explaining that the work had been ordered by Nicolas Omazur as a mark of his friendship with the artist (see Engraving).[4]

The portrait is generally considered to be a late work, and despite the comparatively unlined appearance of the face, it is reasonably datable to the 1670's, when the artist would have been in his fifties.[5] Signs of

ageing are already present in the face of the self-portrait with a *golilla*, which seems stylistically a work of Murillo's maturity and the face in no. 6153 looks older still by some years.[6] A much earlier date can be dismissed on the evidence of the inscription: Murillo married in 1645, and the first two of his nine children whose baptisms are recorded were born in 1646 and 1647. Assuming that these first children survived, they would scarcely have been of an age for their wishes to influence the artist before the 1660's. Murillo was outlived by only three of his children: Francisca María, born in 1655, who became a nun and renounced her claim on the artist's inheritance in 1676, Gabriel, born in 1657, who was in the Indies at the time of Murillo's death and who apparently died there, and Gaspar (1661–1709).[7]

ENGRAVINGS: Richard Collin, Brussels, signed and dated 1682, inscribed: *BARTHOLOMEUS MORILLUS HISPALENSIS | SE-IPSUM DEPINGENS PRO FILIORUM VOTIS AC PRÆCIBUS EXPLENDIS. | NICOLAUS OMAZURINUS ANTVERPIENSIS | Tanti VIRI simulacrum in Amicitiae Symbolon | in aes incidi Mandauit. Anno 1682.* The sitter is shown in reverse, his right hand cut off by the frame at the wrist. The tablet and the attributes of drawing and painting are omitted, and the lower edge of the picture extended. Several later engravings after no. 6153, or its derivatives, are known.[8]

VERSIONS AND COPIES: Prado Museum, no. 1153 (as by Alonso Miguel de Tobar, 1678–1758), and no. 2912 (based apparently on Collin's engraving of 1682); Duke of Wellington Collection; Petworth House, no. 68.[9] The same composition used by Tobar for his *Portrait of a Gentleman*, signed and dated 1711, in the Museum of Art, Rhode Island School of Design.[10]

PROVENANCE: Presumably inherited after Murillo's death (3 April, 1682) by his son, Gaspar, and transported to Brussels later in the same year at the instigation of Nicolas Omazur. Gaspar is recorded by Palomino as the owner only of the self-portrait in a *golilla*,[11] suggesting that no. 6153, if also owned by him, was relinquished before his death (1709). It presumably remained in Seville in the early years of the eighteenth century (see portrait of 1711 by Tobar under *Copies and Versions*). Probably acquired at about this time by Sir Daniel Arthur, 'a rich Irish merchant who died in Spain', passing by February, 1729, to a Mr. Bagnall (Bagnal, or Bagnols), who married Arthur's widow.[12] Sold before 1740, or in that year, to Frederick, Prince of Wales, and recorded in his possession in 1747 and 1750.[13] Acquired by Sir Lawrence Dundas († 1781), perhaps at the time of Frederick's death in 1751.[14] Recorded for certain in the Dundas sale, 31 May, 1794 (25; £105), and bought by Lord Ashburnham, as recorded in a MS of his collection of 1793 (*sic*), p. 8, no. 95.[15] Seen with other pictures from the Dundas sale at Ashburnham's house in Dover Street in 1804.[16] Earl of Ashburnham sale, 20 July, 1850 (50; £829 10sh.; at this sale it was hoped that the National Gallery would be able to buy the picture).[17] Recorded in the following year in the collection of Earl Spencer at Althorp House.[18] Exhibited: British Institution, 1855 (no. 53); Manchester, *Art Treasures*, 1857 (no. 640); Leeds, 1868 (no. 342); South Kensington Museum, 1876–80 (no. 77);[19] London, The New Gallery, 1895/6 (no. 103); London, Grafton Galleries, 1913/14 (no. 99); Royal Academy, 1920/1 (no. 83); Birmingham, *Art Treasures*, 1934 (no. 7); London, Agnew's, *Pictures from Althorp*, 1947 (no. 22); Edinburgh, Arts Council, *Spanish Paintings*, 1951 (no. 28). Bought from Earl Spencer in 1953.

ILLUSTRATION: *National Gallery Catalogues, Acquisitions 1953–1962.*

REFERENCES, GENERAL: C. B. Curtis, *Velazquez and Murillo*, 1883, no. 462. *National Gallery Catalogues, Acquisitions 1953–62*, pp. 65 ff.

REFERENCES IN TEXT: **1.** The drawing looks as though it might be connected with one of Murillo's genre pictures of peasant boys.

2. There are resemblances with the frontispiece of J. de Casanova, *Primera parte del arte de escribir*, engraved by Pedro de Villafranca, 1650, as pointed out by M. López Serrano in *Varia velazqueña*, 1960, p. 510, fig. 217a. The arrangement of the composition—portrait in oval frame with attributes of painting beneath—is close to a portrait of Lucas van Leyden drawn by Rubens (J. S. Held, *Rubens Selected Drawings*, 1959, I, fig. 61).

3. 'Hizo tambien su retrato á instancias de sus hijos, cosa maravillosa, el qual está abierto en estampa en Flandes por Nicolás Amazurino, y otro de golilla quedó en poder de don Gaspar Murillo, hijo suyo.' A. Palomino, *El museo pictórico*, 1797 ed., II. p. 625. The portrait in a *golilla* to which Palomino refers is probably the picture which later belonged to Bernardo Iriarte (engraving by Manuel Alegre, 1790, reproduced by A. L. Mayer, *Murillo* (Klassiker der Kunst), 1923, p. XXIII; Curtis, no. 465) and which is now, much cut down, in the collection of Elizabeth, Lady Musker. Here too the portrait is presented in a simulated oval frame, but the frame is a stone moulding, chipped in parts, carved on the front surface of a block of stone.

4. Omazurinus is presumably the Nicolas Olnasur (or Osnasur) mentioned in Murillo's will (see Sir W. Stirling-Maxwell, *Annals of the Artists of Spain*, 3, 1891, p. 1061, note) and the Nicolas Omazur, poet and silk merchant of Antwerp, born 23 September, 1609 (*Biographie Nationale*, vol. 16, 1901). Portraits of him and his wife, Isabel Malcampo, also within painted oval frames, were painted by Murillo probably in 1672, and the former is now in the Prado Museum (D. Angulo Iñiguez, in *Archivo Español*, 1964, pp. 269 ff.).

5. Curtis, *op. cit.*, believed the artist to have represented himself at about the age of 60 (about 1677/8); Mayer, *op. cit.*, frontispiece, suggested about 1675. E. K. Waterhouse, in the catalogue of *Spanish Paintings*, Edinburgh, 1951, p. 23, suggests a date 'perhaps hardly later than 1655'. Since Omazur knew of the portrait, it is possible that Murillo was working on it about 1672, the probable year when Omazur and his wife sat to the artist (see note 4); other occasions when he might have visited Seville are not recorded.

6. Curtis, *op. cit.*, no. 465, takes the artist to be about 50 in the portrait in a *golilla* (about 1667/8), but he is perhaps rather younger than this.

7. On Murillo's children see J. Cascales Muñoz, *Las bellas artes plásticas en Sevilla*, 1929, I, pp. 120, 125, and on his heirs see Stirling Maxwell, *op. cit.*, pp. 1059 ff.

8. They are listed by Sir W. Stirling-Maxwell, *Essay towards a Catalogue of Prints . . . of . . . Velazquez and . . . Murillo*, 1873, pp. 124 f. (no. 6153), and Curtis, *op. cit.*

9. Curtis nos. 463 (Petworth), 464 (Duke of Wellington) and 464a (Prado no. 1153).

10. D. G. Carter in *Bulletin of The Rhode Island School of Design, Museum Notes*, December, 1963, pp. 9 ff. A famous English painting of which the composition was probably suggested by no. 6153 is Hogarth's self-portrait of 1745 (Tate Gallery).

11. See note 3.

12. *Diary of the first Earl of Egmont*, Historical Manuscripts Commission, 1923, 3, p. 344, 3 February, 1729: 'I would not omit that this morning Mr. Bagnall showed me a great number of very fine original paintings which he got by marriage with the Lady Arthur, widow of Sir Daniel Arthur, a rich Irish merchant who died in Spain. There are . . . several pieces of Monglio (*sic*), a famous painter in Spain little known here, together with his own picture. He was fond of painting cupids.' Attention was first drawn to this passage by E. K. Waterhouse in *The Burlington Magazine*, 1947, p. 78. Biographical details about Sir Daniel Arthur are given by Waterhouse in note 5—he was knighted by James II in 1690. During the reign of William and Mary his property in Ireland was forfeited (*Analecta Hibernica*, March, 1930, I, p. 79). He is identified by Waterhouse, note 5, with the 'Francesco (*sic*)

Artur (*sic*)' whose collection of pictures by Murillo is mentioned by Palomino. Against this it might be argued that the name which is in fact given by Palomino, *op. cit.*, ed. 1797, II, p. 623, *Francisco Artier*, differs considerably from the name Daniel Arthur, and the five pictures which Palomino describes as in Artier's possession, having acquired them from Murillo's patron Don Juan Francisco Eminente, were none of them portraits. However, the first of the pictures in the Artier collection described by Palomino is probably the *Cherubs scattering flowers* at Woburn Abbey (Curtis, no. 234) and this was acquired by the Duke of Bedford in the mid-eighteenth century from a Mr. Bagnols (*Lord Orford's Works*, 1798, 11, p. 251). The Bagnall who inherited pictures by Murillo from Arthur and the Bagnol who owned a Murillo once belonging to Artier are presumably the same person, and it may be assumed that Daniel Arthur and Francisco Artier are also identical, or at least of the same family. It is therefore possible that no. 6153 was owned by Palomino's Artier, acquired by him perhaps after the pictures from the Eminente collection.

13. The Walpole Society, XXVI, 1937/8, *Vertue Note Books*, V, 1740, pp. 126/7: 'Mr. Bagnals Soho Square ... a head—Moriglio's own portrait—Moriglio ⟨sold to the prince⟩'. An account by John Anderson for work on the Prince's pictures includes for 1747: 'Lineing & Cleaning Morellas Head 1 : 1 : 0' (Household Accounts of Prince Frederick and his wife, Duchy of Cornwall office)—information kindly supplied by Mr. Oliver Millar, together with the following reference from an unpublished volume

of Vertue's notes: 'Morriglio the painter by himself'—from a list of the Prince's collection in 1750 (B.M., MS. 19027, f. 20v.). The re-lining canvas at present on the picture is probably that supplied by John Anderson in 1747. (Lot 38 at the sale of the collection of Mr. Bagnal (*sic*) and Lady Arthur, 1757, *Man's Head ... Morillios's head by himself ... Rembrandt*, bought for 12 guineas by Lady Cardigan, was presumably a copy of a Murillo self-portrait, sold as a pair with a portrait attributed to Rembrandt, or itself attributed to Rembrandt.)

14. Probably the picture referred to four years after Dundas's death in a letter from Reynolds (14 December, 1785), recommending or approving its possible acquisition for the Duke of Rutland: 'The portrait of Morilio which I have seen is very finely painted, and there is not the least doubt about it being an original of his hand; it will be a very considerable acquisition to your Grace's collection.' (*Letters of Sir Joshua Reynolds*, ed. F. W. Hilles, 1929, p. 145.)

15. National Gallery Archives, typescript copy of MS. The date 1793 presumably refers to the year in which the inventory was begun, since the Dundas sale took place in 1794.

16. The copy of the Dundas sale catalogue in the National Gallery bears notes in pencil of the pictures seen in 1804 by J. E. Breen at Lord Ashburnham's.

17. Parliamentary Papers, 1853.

18. Catalogue of pictures at Althorp House, 1851 (272).

19. Science and Art Department of the Council of Education, *List of Art Objects in the South Kensington Museum*, p. 38 (Victoria and Albert Museum archives).

Ascribed to MURILLO

232 THE ADORATION OF THE SHEPHERDS

The Virgin kneels behind the infant Christ, who is in the manger; standing in the centre is S. Joseph. In the right background is the Annunciation to the Shepherds (night scene).

Oil on canvas (right edge very broken) $89\frac{3}{4} \times ca.\ 64\frac{3}{4}$ ($2\cdot28 \times ca.\ 1\cdot645$).

In good condition; some repainted local damages and wearing at the edges, especially on the right. The blue pigment (smalt) of the jacket of the boy in profile with hands joined in prayer has faded.[1] Cleaned and restored in 1957.

Pentimenti: Christ's drapery originally covered his neck and right ear and extended farther above his feet; the drapery of the man in profile with clasped hands was at first higher up on the neck; the arm of the boy holding a fowl was apparently not present in the original design, the whole being a late addition by the artist.

The two bound lambs in the foreground are allusions to the sacrifice of Christ.[2]

Traditionally ascribed to Velázquez[3] (as a youthful work) and later to Zurbarán,[4] but quite clearly not by either. Cook[5] was the first to suggest a stylistic similarity to *The meeting of Joachim and Anna* in the Budapest Museum,[6] but the two seem quite different in handling. The same writer suggested Francisco Pacheco (1571–1654) as the author of the two pictures, but comparison with authentic paintings by Pacheco shows this to be impossible in either case, and Mayer's ascription[7] of both to Pablo Legote (*ca.* 1590–*ca.* 1670-2) is similarly unacceptable. Other Spanish painters suggested as the author of no. 232 are Antonio del Castillo (1603–67)[8] and Pedro Orrente (*ca.* 1570/80–1644); their certain works are entirely different. Longhi[9] attributed the National Gallery picture to Francesco Fracanzano (1612–*ca.* 1656) and the Budapest one to Massimo Stanzione (1585–1656); the first hypothesis will not stand comparison with documented works by this artist, but the theory of a Neapolitan origin has found a certain degree of acceptance.[10]

The picture is said[11] to have been painted for an ancestor of the Conde del Aguila who owned it in the eighteenth century, but its presence in Seville is not documented until the second half of that century.[12] Nevertheless the existence of several seventeenth-century Spanish copies (see below), of which two are of Sevillian provenance, provides some evidence that the picture was in Seville at least fairly soon after it was painted, and that it enjoyed a certain reputation. It was felt by Mac-Laren that the picture would be intelligible as the work of a foreigner, not necessarily an Italian, active in Seville.

The present attribution[13] depends to a large extent on the weight of circumstantial evidence. The technique, deriving from Velázquez's Sevillian paintings, is similar to that of Murillo's surviving early works, though harder and less assured. The general, rather Italianate, character of the picture, the colour, and the type of composition used for this subject, closely foreshadow later developments in Murillo's work.

If by Murillo, then the picture would be datable to the late 1630's or about 1640, as is in any case reasonable for a Sevillian picture of this character.[14]

COPIES: A seventeenth-century copy is in the collection of Dr. Schäfer, Barcelona;[15] another is in the collection of Don Jesús Sáenz de Olazábal, Madrid.[16] Another copy was in the collection of Don Nicolás Díaz Molero, Seville, in 1935.[17]

ENGRAVINGS: Two nineteenth-century engravings are recorded.[18]

PROVENANCE: Said to have been painted for an ancestor of the Condes del Aguila (see above). Certainly in the collection of Don Miguel Espinosa y Maldonado Saavedra, Conde del Aguila, Seville, in 1777;[19] bought from his heir by Baron Taylor for King Louis-Philippe, supposedly in 1832 or 1833 for £4,800[20] and exhibited with the Galerie Espagnole at the Louvre, 1838–48.[21] Louis-Philippe sale, London, 6 sqq. May, 1853 (lot 250; £2,060), as Velázquez, bought for the National Gallery.

REPRODUCTION: *Illustrations: Continental Schools*, 1937, p. 372; *Spanish School: Plates*, 1952, pp. 33 and 34 (both before cleaning).

REFERENCES, GENERAL: C. B. Curtis, *Velazquez and Murillo*, 1883, Velázquez no. 8.

REFERENCES IN TEXT: **1.** See J. Plesters in *Studies in Conservation*, 14, 1969, pp. 64 f.

2. In reference to Isaiah, liii, 7.

3. From as early as 1777, when the picture is first documented (see note 19).

4. The attribution to Zurbarán was first put forward in *El Correo Nacional*, 28 June, 1838; it was later taken up by A. de Beruete (*Velazquez*, 1898, pp. 24/5), and by V. von Loga (*Die Malerei in Spanien*, 1923, p. 278) who apparently gave (*op. cit.*, p. 212) the Budapest picture to Estéban March, whose *oeuvre* at that time was not properly established.

5. H. Cook in *The Burlington Magazine*, XII, 1907/8, p. 300.

6. Budapest Museum, 1954 catalogue, no. 766, 2·29 × 1·78, as by Massimo Stanzione.

7. A. L. Mayer, *Die Sevillane Malerschule*, 1911, pp. 136/7, and *Ribera*, 1923, p. 183.

8. J. Allende-Salazar, *Klassiker der Kunst: Velazquez*, 1925, p. 261.

9. R. Longhi in *L'Arte*, XIX, 1916, p. 248.

10. *E.g.* A. de Rinaldis, *Neapolitan Painting of the Seicento*, 1929, pl. 37; M. Soria in *Gazette des beaux-arts*, 1944, p. 158 (who sees in it a Neapolitan work under the influence of Ribera). More recently it is attributed by the same author to Giovanni Dò, *Art and Architecture in Spain and Portugal 1500–1800*, 1959, p. 232; for another painting attributed to Dò see R. Longhi in *Paragone*, 227, 1969, p. 48.

11. According to the Louis-Philippe 1853 sale catalogue (first part, p. 4). The title *Conde del Aguila* was created for Don Fernando Espinosa Maldonada de Saavedra (J.

de Atienza, *Nobiliario español*, 1954, p. 362). The family had apparently been connected with Seville since the fifteenth century (F. Gonzalez de León, *Noticia artistica ... de Sevilla*, 1844, p. 79).

12. See note 19.

13. A. Braham, in *The Burlington Magazine*, 1965, pp. 445 ff. The picture is said to have been illustrated in an early (1906) edition of A. Calvert's *Murillo*. The second picture listed here under 'Copies' has been published as a Murillo in several Spanish and Portuguese newspapers—for example, in *Informaciones*, 15 September, 1948.

14. *Cf.* the 'Adoration of the Shepherds' of 1638 by Zurbarán at Grenoble, reproduced in M. S. Soria, *The Paintings of Zurbarán*, 1953, pl. 70.

15. 75 × 55½ (1·90 × 1·41). Belonged formerly to the Ladrón de Guevara family (letter of 1924 from H. F. Hastings in the Gallery archives).

16. 83½ × 65 (2·12 × 1·65).

17. 78¾ × 55½ (2·00 × 1·41) [?]. A recent (1954) copy hangs between arches 367 and 368 leading to the Madonna di S. Luca, Bologna.

18. See Curtis, *op. cit.*, and Sir W. Stirling Maxwell, *Essay towards a Catalogue of Prints ... of ... Velazquez and ... Murillo*, 1873, p. 3.

19. First mentioned as in his collection, 2 July, 1777: 'un cuadro grande que tengo en mis casas del Nascimiento de Ntro. Sr. Jesús Xpto. original de don Diego Velázquez, ...' (quoted by S. Montoto, 'La adoracion de los pastores, de Velazquez,' in *ABC*, 14 October, 1960); then again, after Aguila's death (17 January, 1784), in an inventory drawn up on behalf of his wife and son, Juan Ignazio, where

the picture is valued at the high price of 5,000 *reales de vellón* (*ibid.*); and finally in an inventory of 11 February, 1786: 'Otro Quadro grande del nacimiento de nuestro Redemtor, su autor Velazquez'... (reproduced in facsimile in S. Viniegra, *Catálogo*... *de la esposición de las obras de Zurbarán,* 1905, pp. 12/13).

20. According to R. Ford (see W. Stirling, *Velazquez and his works,* 1855, p. 229). According to the introduction to the Louis-Philippe sale catalogue (pp. 3 f.) the acquisition was made in 1835 or later.

21. *Tableaux de la galerie espagnole exposés... au Louvre,* 1838, no. 292.

After MURILLO

1257 THE BIRTH OF THE VIRGIN

In the centre, the infant Virgin surrounded by women and angels; cherubs hover above. In the left background is S. Anne in bed; seated near her, S. Joachim.

Oil on canvas, $10\frac{1}{2} \times 17\frac{13}{16}$ ($0\cdot266 \times 0\cdot452$). Painted arched top. In very good condition.

Neither the birth of the Virgin nor her supposed parents, SS. Joachim and Anne, are mentioned in the Gospels, but only in the New Testament Apochrypha, etc.

No. 1257 has been supposed[1] the sketch for the large picture executed in 1655[2] by Murillo for Seville Cathedral and now in the Louvre.[3] It is, in fact, a copy of that design made after 1804 at the earliest.[4] It is unlikely to be after a lost Murillo sketch since it corresponds in all but the smallest details to the Louvre picture,[5] and it is probably a copy of that picture made in Paris after *ca.* 1810 (when the latter was sent there by Marshal Soult).

PROVENANCE: Said to have been in the collection of the Duchesse de Berry.[6] Bought in Vienna in May, 1854, by John Savile Lumley[7] (later 1st Baron Savile); Société Néerlandaise de Bienfaisance exhibition, Brussels, 1873 (no. 219). Presented by Lord Savile in 1888.

REPRODUCTION: *Spanish School: Plates,* 1952, p. 24.

REFERENCES: **1.** A label on the back is inscribed in Lord Savile's hand: *No. 4 | Birth of the Virgin original sketch for the picture in the Louvre from the Collection of the Duchesse de Berri | bought at Vienna—May 1854 | J. Savile Lumley.*
2. According to J. A. Ceán Bermúdez, *Carta... sobre... la escuela sevillana,* 1806, p. 59.
3. $1\cdot85 \times 3\cdot60$. Curtis no. 55. Ceded to the State by Marshal Soult in 1858.
4. Microchemical investigation (in the National Gallery laboratory, 1952) of the (unretouched) blue shawl of the kneeling woman on the right showed it to be painted with cobalt blue ('Thénard's blue'), a pigment not discovered until 1804 (see L. J. Thénard in *Journal des Mines,* XV,

1804, p. 128; A. M. de Wild, *The Scientific Examination of Pictures,* 1929, p. 28, gives the date incorrectly as 1802. Mr. A. E. Werner kindly checked the reference to Thénard's essay.)
5. The 1929 catalogue erroneously states that it is in the opposite direction to the Louvre picture.
6. See note 1. It is not in the catalogues of the Berry sales of 8 December, 1830 (Paris), April, 1834 (London) or 4–6 April, 1837 (Paris). It is possible that the Duchess also sold some other pictures by private contract in London, whither she had fled from France in 1830 (*cf.* D. Cooper in *The Burlington Magazine,* LXXXVIII, 1946, pp. 116/17.
7. See note 1.

Follower of MURILLO

3910 THE IMMACULATE CONCEPTION OF THE VIRGIN
Oil on canvas, $83 \times 49\frac{1}{2}$ (2·11 × 1·26).
The flesh throughout is cracked and rubbed and, in places, retouched.

The representation of the Immaculate Conception of the Virgin as a, so to speak, historical event instead of symbolically dates from at least the beginning of the sixteenth century[1] but did not become at all common until the end of that century. By that time the manner of representation had become more or less fixed in its final form by the Italians: the Virgin is shown in the sky 'clothed with the sun, and the moon under her feet, and upon her head a crown of twelve stars'[2] and surrounded by cherubs who bear the emblems of the Virgin and sometimes hold a crown over her head. God the Father and the Holy Ghost often appear also and, especially in the earlier pictures, further emblems of the Virgin are introduced on the earth below. In this form the subject achieved immense popularity in Spain and above all in Seville, particularly after the publication there in 1618 of the Papal Bull encouraging the cult of the Conception (cf. Valdés Leal, no. 1291 and Velázquez, no. 6264, which is discussed below in relation to its pair, the Frere collection *Immaculate Conception*). Murillo, probably under the influence of the Italians, developed a simpler kind of representation of the subject, without the emblems on the earth below and usually omitting also God the Father and the Holy Ghost; in his latest versions and those of his followers the cherubs surrounding the Virgin bear few or (as here) none of her emblems.[3]

There are innumerable paintings of the Immaculate Conception by Murillo and his following.[4] The present picture was until the first edition of the present catalogue attributed to Murillo himself but is clearly by an imitator,[5] possibly of the early eighteenth century. The figure of the Virgin repeats with slight variations that in the *Conception* in the church of Santa Catalina (Capuchin monastery), Cadiz,[6] in which occur also the upper half of the cherub on the left holding the Virgin's cloak and the head and wings of the cherub in the right bottom corner. The cherub in the left bottom corner is perhaps taken from one in the so-called *Assumption of the Virgin* in the Hermitage.[7]

It is perhaps worth noting that in all the *Conceptions* undoubtedly by Murillo the Virgin stands in the hollow of a crescent moon and not, as here, on its circumference[8] (except in 'La Gran Concepción' in the Seville Museum, where there is a full moon[9]).

VERSION: For the related picture in Santa Catalina, Cadiz, see above.

ENGRAVINGS: The following are after a picture, formerly in the Louis-Philippe collection, almost certainly to be identified with no. 3910 (see Provenance): (line) G. Paterson;[10] J. C. Armytage;[11] (lithographs) Weber (two—one before 1848);[12] Marin-Lavigne; Maggi (reversed); A. Maurin (bust only).[13]

PROVENANCE: No. 3910, or a picture of identical composition and size, is said to have been acquired from a convent at Cordova[14] for King Louis-Philippe,

ca. 1835–7,[15] and was exhibited with the *Galerie Espagnole* at the Louvre, 1838–48;[16] Louis-Philippe sale, London, 6 May *sqq.*, 1853 (lot 163; £810), bought by Cave; William Cave sale, London, 29 June, 1854 (lot 78; £745 10sh.),[17] bought by C. Levy. No. 3910 was in the collection of Joseph Trueman Mills, Rugby, by 1883,[18] and was bequeathed by him in 1924.

REPRODUCTION: *Illustrations: Continental Schools*, 1937, p. 241; *Spanish School: Plates*, 1952, p. 25.

REFERENCES, GENERAL: C. B. Curtis, *Velazquez and Murillo*, 1883, nos. 50(?), 50h(?) and 54a.

REFERENCES IN TEXT: **1.** Cf. E. Mâle, *L'Art religieux de la fin du moyen âge*, 2nd ed., 1922, pp. 210 ff. In a simpler form this type of *Immaculate Conception* occurs even earlier in a picture by Carlo Crivelli in the National Gallery (no. 906), which is dated 1492.
2. In allusion to the Woman of the Apocalypse (Revelation, xii, 1) with whom the Virgin was generally identified.
3. For the iconography of the subject see also F. Pacheco, *Arte de la Pintura*, 1649, pp. 481–4; K. Künstle, *Ikonographie der christlichen Kunst*, I, 1928, pp. 646–58; E. Mâle, *loc. cit.*, and *L'art religieux après le Concile de Trente*, 1932, pp. 40–8.
4. A number of them are listed by Curtis, nos. 18–50hh. They are discussed by I. Elizalde, *En torno a las Inmaculadas de Murillo*, 1955.
5. If this is the picture formerly in the *Galerie Espagnole* (see Provenance), as seems almost certain, it was already noted as doubtful by Stirling (*Annals*, 1848, III, p. 1419).
6. Curtis no. 25; repr. in E. Romero de Torres, *Provincia de Cádiz* (*Catálogo Monumental de España*), 1934, pl. CCXXXI. Romero de Torres suggests (*op. cit.*, p. 345) that it may be by Francisco Meneses Osorio, who is said to have completed the high altar in the same church after Murillo's death (Ceán Bermúdez, *Diccionario*, 1800, III, p. 119), but it is so much damaged and repainted as to make any attribution hazardous. The Virgin in this picture is related to those in the *Conception, with God the Father* (Seville Museum; Curtis no. 18) and the 'Soult Conception' (Prado no. 2809; formerly in the Louvre but exchanged in 1940).

7. Curtis no. 54. It seems probable that this represents the Conception and not the Assumption, although it does not contain a moon, the least dispensable emblem of the Virgin of the Conception.
8. Despite the injunctions of Pacheco (*op. cit.*, p. 483).
9. Curtis no. 21. See also note 7. The 'Esquilache Conception' in the Hermitage (Curtis no. 44), in which the Virgin stands on the moon's circumference is described by Mayer as possibly studio work (*Klassiker der Kunst: Murillo*, 1923, p. 291, note to p. 77); the repetition from Bedwell Park now in the Melbourne Gallery (Curtis no. 45) is by a follower.
10. In *Gems of European Art*, ed. S. C. Hall, n.d. [1843–5], II, facing p. 65; with the title: *Adoration* [*sic*] ... *The Original in the Gallery of the Louvre*.
11. In W. B. Scott, *Murillo*, 1873, facing p. 5.
12. The impression in the British Museum Printroom (48–12–21–140) was acquired in 1848.
13. Curtis (no. 50h) lists lithographs by Weber, Marin-Lavigne, Maggi, A. Maurin, Ricaud, Turgis and Lafosse as after 'variations' of the composition engraved by Patterson and Armytage; the first four of these certainly repeat the composition of no. 3910. Curtis mentions also three other lithographs, by Bequet, Schiller and Llanta, as variations of this design with a serpent and globe below; that by Llanta is nearer to Curtis no. 34.
14. In the Louis-Philippe sale catalogue as 'obtained from a convent at Cordova'. (The provenance is not given in the *Galerie Espagnole* 1838 catalogue.) Palomino (*Museo Pictórico,*

III, 1724, p. 422) mentions a *Conception* in the Convent of La Victoria at Cordova but rejects its attribution to Murillo; Ponz (*Viage de España*) does not note the latter nor any other painting that could be identified with the Louis-Philippe picture in his chapters on Cordova (XVI, 1791, chap. 7, and XVII, 1792, chaps. 1–3).

15. Louis-Philippe's collection, known as the *Galerie Espagnole*, was formed for him in Spain, 1835–7, by

Baron Taylor; see the introduction to the sale catalogue of 1853.

16. *Notice . . . de la Galerie Espagnole . . . au Louvre*, 1838 (no. 148; no. 152 of later [4th?] edition); 2·07 × 1·24.

17. As *Assumption of the Virgin*; 'one of the chief attractions in the Spanish Gallery of King Louis Philippe'.

18. Curtis (1883) no. 54a; incorrectly described as *Assumption of the Virgin*.

Follower of MURILLO

3938 S. JOHN BAPTIST IN THE WILDERNESS

Inscribed on the scroll on the saint's reed Cross: ECCE AGN

Oil on canvas, $47\frac{1}{4} \times 41\frac{1}{2}$ (1·200 × 1·055).

The sky is much worn on the right; many small retouches in the flesh. Yellow varnish.

For S. John the Baptist see Murillo, no. 176. The saint is here shown in the wilderness and dressed in camel's hair, in reference to Matthew, iii, 1–4, and Mark, i, 4–6.

Attributed to Murillo himself until publication of the first edition of the present catalogue. Although it achieved some fame in the eighteenth century, it seems too clumsy to be his work and is probably by one of his many imitators. No original of this design by Murillo is known.

PROVENANCE: No. 3938 has been supposed to be the picture said to have been bought *ca.* 1670 from Don Juan del Castillo for 2,500 *reales* by Don Francisco Eminente for Charles II of Spain.[1] It was, fairly certainly, brought from Spain by Richard Cumberland[2] (*i.e.* in 1781[3]); shortly afterwards it came into the hands of Noel Desenfans and was bought by Gainsborough, apparently early in 1787.[4] After Gainsborough's death it was exhibited for sale with his collection at Schomberg House, 30 March *sqq.*, 1789 (lot 34), and in April, 1789, was sold to Sir Peter Burrell[5] (later 1st Baron Gwydyr). Lord Gwydyr sale, London, 8/9 May, 1829 (2nd day, lot 84; £105),[6] bought by Maxwell; Hon. Marmaduke Constable Maxwell sale, London, 1 March, 1873 (lot 107; £451 10sh.),[7] bought by Rutley. Exhibited at the Royal Academy, 1877 (no. 238), lent by G. A. F. Cavendish Bentinck; G. A. F. Cavendish Bentinck sale, London, 8 *sqq.* July, 1891 (lot 558; £535 10sh.), bought by Richter for Dr. Ludwig Mond. Mond Bequest, 1924.

REPRODUCTION: *Illustrations: Continental Schools*, 1937, p. 241; *Spanish School: Plates*, 1952, p. 26.

REFERENCES, GENERAL: C. B. Curtis, *Velazquez and Murillo*, 1883, nos. 336, 336f, 336g and 336k.

REFERENCES IN TEXT: **1.** No. 3938 (then in Gainsborough's collection) is identified in the *Morning Herald* (18 April, 1787) with the *S. John in the Desert* mentioned by Richard Cumberland (*Anecdotes of Eminent Painters in Spain*, 1782, II, p. 117; 2nd ed. 1787, II, p. 117, in a garbled passage derived from Palomino, *Museo Pictórico*, 1724, III, p. 423). But on the one hand, Palomino (who does not state the location of the picture in his time)

had some doubts as to whether the transaction ever took place, remarking that at the time Charles II was scarcely ten; on the other hand, Cumberland himself speaks of the Castillo picture as 'now in the Palace of Madrid' and does not state that it was in his possession either elsewhere in the *Anecdotes* or in his *Memoirs* (1807), although in the latter he mentions other and less valuable pictures he brought from Spain. Yet, despite his statement in the *Anecdotes*, the only painting by Murillo of S. John listed in Cumberland's *Accurate and Descriptive Catalogue of the several Paintings in the King of Spain's Palace at Madrid, 1787*, is a *Jesus with St. John the Baptist* (presumably Prado no. 964). It remains to be stated that both the *Anecdotes* and the *Catalogue* are so inaccurate that little reliance can be placed on either statements or omissions and that, while there is now no painting by Murillo of *S. John in the Desert* either in the former Spanish Royal collections or the Prado, it is quite possible that Cumberland was referring to the *Infant S. John with a lamb* (Prado no. 963), or the more famous *Infant Christ as Good Shepherd* (Prado no. 962) which passed for a *S. John* in the Royal inventories of

the eighteenth century (*cf.* P. de Madrazo, *Catálogo ... del Museo del Prado*, 1872, I, p. 473).

2. According to the Gainsborough 1789 sale catalogue. The *Morning Herald* (16 April, 1787) merely states that it was brought to England by 'a gentleman of taste, who some little time past visited Spain'.

3. Cumberland arrived in Spain in June, 1780, and left in April, 1781 (see *Memoirs, passim*).

4. See *Morning Herald*, 16 and 18 April, 1787; *cf.* W. T. Whitley, *Gainsborough*, 1915, p. 275.

5. According to *Morning Herald* of 20 April, 1789. The picture is also listed in a ms. inventory of Lord Gwydyr's pictures at Grimsthorpe Castle completed in 1812: *St. John in the Wilderness—Murillo* (copy of inventory in the National Gallery library).

6. As *St. John, with one hand upon his breast, in prayer*.

7. As *St. John in the Wilderness. From the collection of Lord Gwyder, 1828* [*sic*]. Curtis (no. 336g) erroneously identified this picture with one in the Noel Desenfans sale, 24–28 February, 1795 (4th day, lot 50), but that was a *St. John with the Lamb*.

Style of MURILLO

1286 A YOUNG MAN DRINKING

About his head are vine leaves; he holds a square black bottle.

Oil on canvas. The original painted surface has been reduced[1] and now measures *ca.* $22\frac{5}{8} \times ca.$ $18\frac{1}{8}$ (*ca.* $0.575 \times ca.$ 0.46). Strips have been added later on all sides[2] and the picture surface thus enlarged to $24\frac{3}{4} \times 18\frac{7}{8}$ (0.628×0.479).

In fair condition. Worn in some of the darks; the stem and base of the wine-glass retouched; a number of other small retouches. Engrained brown varnish.

The neck of the bottle has been painted on top of the neck-cloth.

Traditionally attributed to Murillo but the execution differs somewhat from his. It may be a copy of a lost original by him although the design has a somewhat eighteenth-century air; it is, perhaps, an imitation of Murillo, possibly by a French painter of the first half of the eighteenth century.

VERSIONS AND COPIES: A picture in the Eude (Michel) sale, Paris, 22 December, 1873 (lot 125),[3] was apparently a repetition of no. 1286;[4] another is

said to have been in the possession of a Spanish Viceroy of Peru.[5] A three-quarter length version belongs to the Stockholm Museum;[6] a pastel copy of the upper part by Maurice-Quentin de La Tour (1704–88) is in the St.-Quentin Museum.[7] Recent copies are in the collection of Professor A. K. George, Cincinatti (1956); and in an anonymous sale, Christie's, 10 June, 1960 (lot 112).[8]

PROVENANCE: No. 1286 or a picture of the same composition, attributed to Murillo and apparently from the Berger and Godefroid collections,[9] was in the Duc de Tallard sale, Paris, 22 March sqq., 1756 (lot 127; 974 francs), bought by Silvestre; Jacques-Augustin de Silvestre sale, Paris, 28 February–25 March, 1811 (lot 50; 1,840 francs).[10] No. 1286 is stated to have been in the collection of Prince de Talleyrand[11] but is not traceable in any of the Talleyrand sales.[12] It was certainly in the collection of Lord Charles Townshend; Townshend sales, London, 11 April, 1835 (lot 39; 380 gns.), bought by Morant (bought in), and London, 6 May, 1836 (lot 54; £414 15sh.), bought by Hobbs. Exhibited British Institution, 1838 (no. 41), lent by Col. [Richard Hobart] Fitzgibbon (later 3rd Earl of Clare). Lord Clare sale, 17 June, 1864 (lot 39; £1,365), bought by Rutley for Beckett.[13] John Staniforth Beckett Bequest, 1889.

REPRODUCTION: *Illustrations: Continental Schools*, 1937, p. 240; *Spanish School: Plates*, 1952, p. 27.

REFERENCES, GENERAL: C. B. Curtis, *Velazquez and Murillo*, 1883, nos. 425p, 425yy (and 425ii?).

REFERENCES IN TEXT: **1.** A radiograph shows that the ragged upper edge of the surviving original painted surface touches the top of the headcloth. In the Stockholm copy (see Versions and Copies) there is a space between the figure and the edge of the picture on all sides (widest at the top). The measurements of the picture in the Tallard and Silvestre sales (see Provenance) are given as 31 *pouces* × 25 (= *ca.* 33 × *ca.* 26½ inches).
2. The additions are: *ca.* 1½ inches at the top, *ca.* ⅜ at the sides, *ca.* ⅝ at the bottom. The reduction and subsequent enlargement were noted already in 1864 (letter of Sir Charles Eastlake in the Gallery archives).
3. Ascribed to the French School: *Le Buveur; figure à mi-corps.* (Measurements not given.)
4. Memorandum in the Gallery archives (undated but *post* 1899) from E. Pasteur, Paris. Pasteur apparently supposed no. 1286 to be the Eude picture, which he had sold to Germain Halphen in Paris. He ascribed no. 1286 (and therefore presumably the Eude version) to Pierre Danloux (1753–1809).
5. According to Frank Skilleter (letter of 1892 in the Gallery archives), who gives the Viceroy's name as 'Guzman'. The only Viceroy of this

name was Don Luis Henríquez de Guzmán, Conde de Alba de Liste y Villaflor, who held the office from 1655 to 1661, when he returned to Spain (cf. Domingo de Vivero, *Galería de retratos de los Gobernadores y Virreyes del Perú*, 1909).
6. No. 754 (1821 catalogue, no. 134, as by Murillo); 0·74 × 0·60. Probably already in the Swedish Royal collection in the eighteenth century, according to Dr. Sixten Strömbom (letter of 1945 in the Gallery archives). Sometime on loan to the Museum at Gävle, Sweden.
7. Head and shoulders and part of the right hand. Reproduced in H. Lapauze, *Pastels de La Tour à St.-Quentin*, 1919, no. 31. 0·31 × 0·39 metres. It is inscribed: C(ru?) ap(res?) d'au(tr?); there is another, completely illegible inscription. It is perhaps worth noting that another copy by La Tour (Lapauze no. 71, after Paolo Veronese) is also inscribed, in the same hand: dautr(·).
8. 23½ × 19 ins., as from the collection of Baroness Burdett-Coutts and W. Burdett-Coutts, M.P., 1922.
9. P. J. Mariette (*Abecedario*, IV, pub. 1857/8, p. 24) says that the Duc de Tallard bought it from 'la Godefroid', who had it from the heirs of M. Berger. Curtis (no. 425 ii) states

that it was bought by the Duc de Tallard at the Charles Godefroy sale, Paris, 22 April *sqq.*, 1748, but it is not in the catalogue of that sale.

10. The picture is described in the Tallard sale catalogue as painted on wood but in the Silvestre sale catalogue as on canvas (with same measurements; *cf.* note 1). The Silvestre picture is specifically stated in the sale catalogue to be no. 127 of the Tallard catalogue.

11. In the Clare 1864 sale catalogue.

12. It is not in the catalogues of the Talleyrand sales of 7/8 July, 1817 (Paris) or 1 June, 1833 (London); the reference in the Clare catalogue may be due to a confusion of Talleyrand with Tallard.

13. According to documents in the possession of the late Sir Hickman Bacon, Bt. (letters of 1931 in the Gallery archives).

PAOLO DA SAN LEOCADIO
Active 1472–1520

Paulo de Regio or *de Sent Leocadio* was Italian and came from San Leocadio near Reggio d'Emilia. He and Francesco Pagano were brought to Valencia in 1472 to paint frescoes in the Cathedral. He is documented in Valencia several times between 1472 and 1484, in which year he was commissioned to do further work in Valencia. In 1501 he was in Gandía and contracted to paint a retable; in 1507 he agreed to change his domicile to Gandía and to paint, *inter alia*, an altarpiece for the Convent of Clares in that town. He received some payments for a series of paintings for the organ doors at Valencia Cathedral in 1513/14. Work on the altarpiece for the church of Santiago at Villarreal is documented between 1512–20, and Paolo was resident at Villarreal in 1517–19. A second work in this church (the *Salvator Mundi* retable) was probably painted during the same period.

It is impossible to determine Paolo's share in the ruined fresco of the Nativity in Valencia Cathedral. His mature style could be seen in the Gandía altarpiece commissioned in 1501 (destroyed in 1936); it showed a mixture of the contemporary Ferrarese-Bolognese style with Flemish influences, the latter presumably derived from Valencian sources, but with the Italian element still preponderant. The fragments of the Clares' altarpiece commissioned in 1507 and, still more, the Valencia organ door paintings paid for in 1513/14 show that later he absorbed more of the local Hispano-Flemish style and this is evident too in the Villarreal altarpiece, which appears to be partly a school work.

LITERATURE: Many of the documents concerning the artist have been published by E. Bertaux in *Gazette des beaux-arts*, 1908, I, pp. 206 ff., J. Sanchis y Sivera, *Pintores medievales en Valencia*, 2nd ed., 1930, pp. 182 ff., and J. M. Doñate Sebastiá, *Los retablos de Pablo de Santo Leocadio en Villarreal de los Infantes*, Castellón de la Plana, 1958. General accounts of his work are given by C. R. Post, *A History of Spanish Painting*, XI, 1953, pp. 8 ff., and XIII, 1966, pp. 420 ff., and by L. Condorelli in *Commentari*, 1963, pp. 134 ff., 246 ff.

4786 THE VIRGIN AND CHILD WITH SAINTS
 Left wing of a triptych (?)
 Christ is seated on the Virgin's knee, his hand raised in blessing; on

the right, S. Catherine of Alexandria. In the walled garden is S. Agatha, seated; another female saint stands by her. S. Joseph, a joiner's saw in his hand, is entering the garden through an archway; in the pediment above is a half-length carving of God the Father, and two nude figures in the spandrels. In the carved capital of the column on the right is a cherub. The border of the Virgin's robe is ornamented with imitation Cufic script in pale gold, between lines of slightly darker gold.

Signed in the centre of the border of the Virgin's robe: PAVLVS (AV in monogram).[1]

Oil on oak. The existing panel measures $18\frac{1}{16} \times 10\frac{3}{16}$ (0.459×0.258); the painted surface is $17\frac{1}{8} \times 9\frac{3}{16}$ (0.435×0.233). The edges of the painted surface are original and can be seen to have been painted up to a missing frame. The present edges of the panel, which run through some inscriptions on the back,[2] show that it has been cut down at least at the top and on the left.

In very good condition except for slight wearing in parts of the gold paint. Cleaned in 1952.

SS. Catherine and Agatha are identified by their usual attributes. The third female saint bears a martyr's palm and a short sword[3] which are not sufficient to distinguish her among the many female saints who met their death by the sword.[4] The walled garden (*hortus conclusus*) and the rose hedge (*plantatio rosae in Jericho*) are usual emblems of the Virgin.

The present picture, together with an *Adoration of the Kings* at Bayonne[5] and an *Annunciation* in the collection of Dr. Fritz Haniel at Munich,[6] were attributed by Mayer[7] to the author of the *Virgin and Child with SS. Benedict and Bernard adored by a Knight of Montesa* in the Prado.[8] Although there are some slight stylistic connections between the last three pictures, it is not at all certain that any two of them are by the same painter. The National Gallery panel is not certainly by the author of any of them, though it has affinities with the Prado picture, which could be acceptable as a rather earlier work by the same artist.[9] Post[10] rightly gave no. 4786 to Paolo da San Leocadio on the evidence of the signature and the close resemblance to documented works by Paolo.

Post insisted on a date for the picture of *ca.* 1490, or a little later;[11] MacLaren considered that the picture was of 1501 to *ca.* 1508, having Flemish characteristics in common with the Gandía altarpiece commissioned in 1501,[12] where Hispano-Flemish influence can be detected in Paolo's style. His works indeed become increasingly Hispano-Flemish in character—in the fragments of the Clare's altarpiece from Gandía (now in the Museo Diocesano, Valencia), which was commissioned in 1507[13] in the Valencia Cathedral organ doors, paid for in 1513/14, and in the altarpiece of Santiago, Villarreal, documented in 1512–20.[14] No. 4786, despite its Flemish character, appears to be slightly more reminiscent of North Italian *quattrocento* art than any of Paolo's documented altarpieces, and it may date from the last part of the fifteenth century, as suggested by Post, though it is difficult to be certain of this

in the absence of any surviving documented works of this period. Alternatively the links with fifteenth-century Netherlandish and Italian painting may be in part due to the smallness of scale of the panel.

The size and shape of the picture indicate that it formed part of a small altarpiece. They would be consistent with its having come from the *guardapolvo* of a larger altarpiece, but the subjects painted on *guardapolvos* were apparently confined to figures of saints. Individual compartments of Spanish predellas are often of greater height than width but even so no. 4786 is too narrow to have been one. On the other hand it could well have been the (left?) wing of a triptych or a leaf of a small polyptych (the former type was more common in Spain at this time). Although the commencement of a second arch is visible on the extreme left, at this period it is rather unlikely that it would have formed part of an architectural background continued in another panel to the left.

PROVENANCE: Said to be from the Palazzo Cerretani, Florence.[15] In the Sebright collection, Beechwood Park, apparently by the early nineteenth century.[16] Purchased from the executors of Sir Guy Sebright, Bart., in 1935. Exhibited at The Bowes Museum, 'Four Centuries of Spanish Painting', 1967, no. 7.

REPRODUCTION: *Illustrations: Continental Schools*, 1937, p. 266 (before cleaning); *Spanish School: Plates*, 1952, p. 28.

REFERENCES: **1.** Reproduced in actual size in *Spanish School: Plates*, 1952, p. 54. A similar signature occurs on a *Dead Christ supported by Angels* (private collection, Valencia), published by L. de Saralegui in *Archivo Español*, 1954, pp. 310 ff.
2. The back of the panel is covered by a layer of white gesso (not original?) which continues up to the edges; on this is inscribed in dark brown paint: 65 (crossed out) and in black paint: C(?) B | 33 and 28.
3. C. R. Post (*History of Spanish Painting*, VII, 1938, part ii, p. 885, note 2) thought it might be the awl with which S. Lucy's eyes were removed but it is quite certainly a short sword with a broad blade and a triangular point.
4. The sword is a general emblem of martyrdom; as far as female saints are concerned it is most frequently used as that of SS. Agatha, Agnes and Lucy. S. Christina, also mentioned by Post (*loc. cit.*), is occasionally shown with a sword but much more frequently with arrows or a mill-stone or both.
5. Reproduced in *Archivo Español*,

1933, pl. LXXIX (between pp. 184 and 185).
6. Reproduced in *Archivo Español*, 1933, pl. LXXVIII (between pp. 184 and 185). The picture is perhaps no longer in this collection. Mayer (see following note) gives the name of the owner as Hannish.
7. A. L. Mayer in *Archivo Español*, 1935, pp. 207/8.
8. Prado no. 1335; reproduced in *Archivo Español*, 1933, pls. LXXII–LXXVII (between pp. 184 and 185).
9. Mayer is followed by L. de Saralegui in connecting the Prado 'Montesa Madonna' with no. 4786, see *Archivo Español*, 1945, p. 25, and 1950, p. 195.
10. *Op. cit.*, pp. 883–90.
11. *Ibid.*, and vol. XI, 1953, pp. 18, 43, and vol. XIII (ed. H. E. Wethey), 1966, pp. 419 f., where a similar date is ascribed to a picture of *S. Luke* (?) *Healing* (private collection, Valencia). Post suggested (vol. VII, p. 888) that the provenance may indicate that the picture was painted during a supposed visit to Italy, but there is no evidence of such a journey, and the presence of the picture in Italy is not in any case

certain before the nineteenth century.

12. This altarpiece was destroyed in the disturbances of 1936; fairly good detail photographs were taken in 1932 by Archivo Mas, Barcelona.

13. See E. Bertaux in *Gazette des beaux-arts*, 1908, I, pp. 212/13.

14. J. M. Doñate Sebastiá, *Los retablos de Pablo de Santo Leocadio en Villarreal de los Infantes*, 1958; Post, *op. cit.*, XIII, pp. 418 f.

15. It appears in an undated list of pictures at Beechwood Park which seems to be of the early nineteenth century: 'Madonna & Child &c. H. Hemlick [*i.e.* Memlinc]. From the Casa Ceretani, Florence'. (In another note, referring to an *Adoration of the Magi* by G. Sanzio, the name is given as 'Caretani'.) This presumably refers to the Palazzo Cerretani or Cerretani-Gondi which, according to several guide books of the late eighteenth and early nineteenth centuries, contained a collection of paintings (*cf. L'Antiquario fiorentino, ossia Guida . . . della Città di Firenze*, 1765, p. 125, and *Guida della Città di Firenze*, 1830, p. 114). In 1765 this collection belonged to the Marchesa Capponi.

16. Some of the pictures in the Beechwood list (see preceding note) were acquired by the 7th Baronet, Sir John Sebright († 1846) and the collection was apparently formed by him and the 8th Baronet, Sir Thomas († 1864). No. 4786 is not among the pictures at Beechwood described by Waagen (*Galleries and Cabinets of Art in Great Britain*, 1857, pp. 325 ff.).

Francisco RIBALTA

1565–1628

Born at Solsona in Catalonia (baptized 2 June). In 1571–3 Ribalta removed with his parents to Barcelona and remained there until 1581, in which year he is already described as a painter. His earliest known work (*The Crucifixion* at Leningrad) was signed and dated in 1582 in Madrid, and his son was born there in 1596 or 1597. By 1599 he was living in Valencia and seems to have remained there or in that vicinity for the rest of his life.

Palomino says that Ribalta studied in Italy, reputedly under Annibale Carracci (*Museo Pictórico*, III, 1724, p. 291, but he contradicts himself in the second volume, p. 63), and he is generally supposed to be one of the principal channels through which Caravaggesque 'tenebrism' reached Spain. There is no very obvious internal evidence to support Palomino's assertion about Ribalta's presence in Italy, but a copy of Caravaggio's *Martyrdom of S. Peter* (S. Maria del Popolo), bearing Ribalta's signature, is known (Principe Pio collection, Mombello). Ribalta's earlier style is based principally on that of the Escorial School, especially Juan Fernández Navarrete († 1579), and on the works of Italian Mannerists such as Sebastiano del Piombo, some of whose works in Spain he copied and borrowed from (*cf.* no. 2930 below). After about 1615 his works appear to be more Caravaggesque in character, the 'tenebrism' of his early style, based on the Escorial school, merging with the 'tenebrism' of Caravaggio. By 1615 paintings by Caravaggio's followers had certainly reached Spain. Ribalta's latest work seems to show some contact with Ribera, some of whose pictures had reached Spain by about 1620.

LITERATURE: The best account of Ribalta's life and works is by J. Ainaud in *Anales y Boletín de los Museos . . . de Barcelona*, V, 1947, pp. 346–63. New documentary facts published in the same bulletin by J. M. Madurell Marimón (1947, pp. 9 ff.) and A. Llorens Solé (1951/2, pp. 83 ff.). Much of the earlier documentary material and reproductions of most of the paintings are in D. Fitz Darby's *Francisco Ribalta and his School*, 1938. The copy of Caravaggio with Ribalta's signature is published by J. Ainaud in *Goya*, 1957, no. 20, pp. 88 f.

2930 THE VISION OF FATHER SIMON

In the centre Christ, bearing the Cross, looks down at Father Simón kneeling on the right. Behind Christ on the left are soldiers in Roman costume, one blowing a trumpet, and other figures, one with Eastern(?) headgear; above them a banner inscribed: S.P.Q.R. In the right background are S. John Evangelist and the Virgin (the latter only partly visible). On the left side of the street behind is a doorway with a Cross over it, from which emerges a man bearing on his head a tray of loaves(?); above is a tower. At the end of the street are two men and a covered cart.

Signed on a cartellino below: FRANCISC° RIBALTA· | FECIT·ANNO· 1612·[1]

Oil on canvas (irregular edges), $83 \times 43\frac{1}{2}$ ($2 \cdot 11 \times 1 \cdot 105$). The arch of the curved top edge begins about 2 inches in on each side. The canvas has obviously been reduced on each side and probably at the top;[2] possibly slightly at the bottom.

Much worn throughout and torn in a number of places; the right side much damaged.

The figure of Father Simón was painted out probably in the nineteenth century[3] and uncovered again when the picture was cleaned in 1945/6.

There is a *pentimento* in the outline of S. John's drapery.

Francisco Gerónimo Simón or Simó,[4] son of a French father and a Spanish mother, was born in Valencia in 1578. He obtained the benefice of the parish church of S. Andrés in Valencia and was ordained in 1605. He led a life of extreme asceticism and became famous for his piety and charity. It was his practice to walk alone each Friday night through the streets along which condemned criminals were led to execution, meditating on the Road to Calvary. On one such occasion, as he was going along the Calle de Caballeros, he heard trumpets and saw Christ bearing the Cross, surrounded by his executioners and followed by the Virgin, S. John the Evangelist and Mary Magdalene. Christ's long locks covered his face but as he passed by he drew them aside and looked at Simón. Father Simón afterwards saw the same vision many times.[5] He died on 25 April, 1612, and was at once generally acclaimed as a saint. Despite the opposition of the Franciscans and Dominicans, altars were erected in his honour not only throughout the province of Valencia but even farther afield. Application was eventually made to Rome for his beatification but it was not granted. In 1614 the Inquisition prohibited the representation of Simón with a halo[6] and in March 1619 an edict was published in Valencia ordering the removal of all images of Simón and all altars erected to him.[7] This provoked serious riots but the order

was, nevertheless, carried out some weeks later. Despite this the cult persisted[8] and as late as 1763 an altarpiece depicting Simón's vision was still in one of the principal streets of Valencia and was repaired in that year.[9]

The National Gallery picture was previously thought to represent a similar vision seen by S. Ignatius Loyola[10] (see also below). The identity of the visionary is, however, put beyond doubt by the engraved portrait of Simón in Jan van den Wouwer's *Vita B. Simonis Valentini* of 1614.[11] In addition the picture, which was painted in the year of Simón's death, follows faithfully the contemporary accounts of his vision (see above). There is furthermore an engraving by Michel Lasne after Ribalta showing Father Simón, and including seventeen scenes from his life; amongst them (top row, second from the left, no. VII) is the episode represented in the present painting.[12] In the engraving the scene is adapted to an oblong format, but it is close to the painting in the placing of the figures.

The street in the background of the painting may be intended for the Calle de Caballeros but it cannot now be identified.

A great number of pictures of Simón were painted, including some of his vision. Ribalta, as well as designing the engraving mentioned above, was paid in January, 1613, for three pictures of him (one each for the Pope, the King of Spain and the Duque de Lerma) commissioned by the Chapter of Valencia Cathedral;[13] these were probably portraits. Richard Ford,[14] who bought the present picture in Valencia, believed it to be the large painting of *Christ bearing the Cross appearing to S. Ignatius* in the convent of S. Catalina at Saragossa mentioned by Ceán Bermúdez,[15] and to have been removed thence by the French during the Peninsular War. There is no supporting evidence for either opinion and if the picture mentioned by Ceán Bermúdez is the one described by Jusepe Martínez,[16] who was writing *ca.* 1675, Ford's identification is certainly wrong. (Martínez speaks of a painting by Ribalta at Saragossa [the exact location is not stated] representing Christ bearing the Cross appearing to the kneeling S. Ignatius; in the upper part is God the Father with angels and seraphs in a glory. He gives the size as 4 *varas* high by 3 *varas* 1 *palmo* wide, *i.e.*, approximately 133 × 108 (3·38 × 2·74). The appearance of God the Father makes it clear that this was a representation of S. Ignatius' vision[17] and in any case the National Gallery picture has not been so greatly reduced in size[18] as to account for the considerable difference from the measurements given by Martínez.)

Before the removal of the paint covering the figure of Simón it was also suggested[19] that no. 2930 was the *Christ bearing the Cross, and the Virgin* which Ponz[20] saw in the chapter house of the Dominican church at Saragossa, and which to him 'seemed in the style of Ribalta'; it is unlikely that he would not have mentioned the kneeling priest (which was not overpainted until later) and did not see the very obvious signature.

It seems very likely that no. 2930 was the painting of Simón's vision commissioned, according to Domingo Salzedo de Loayza,[21] from

Ribalta by the priest of S. Andrés, Simón's church, some time after the latter's death in April, 1612. This was completed and placed in position on the altar in the new chapel where Simón's body then lay on 5 September, 1612. A difficulty is that according to Salzedo de Loayza the picture showed the three Maries following Christ, whereas the Virgin and S. John are seen in the National Gallery picture. The most reliable account of the vision, however, that of Madre Francisca Llopiz,[22] says that Christ's followers were the Virgin, S. John and Mary Magdalene. It is possible that Salzedo de Loayza was mistaken;[23] if no. 2930 is the picture he was referring to he may have taken the long-haired S. John for one of the Maries. The absence of Mary Magdalene from no. 2930 can be accounted for by the cutting-down of the canvas.[24]

The figure of Christ is derived from Sebastiano del Piombo; cf. The Descent into Limbo in the Prado[25] (which is in the opposite direction) and the half-length Christ bearing the Cross formerly (?) in the Andrassy collection, Budapest.[26]

VERSIONS: A representation of the subject of no. 2930 in an engraving after Ribalta by Michel Lasne is discussed above. What may have been a version of the painting is recorded in the church of S. Salvador, Valencia (see note 21).

PROVENANCE: Bought from the Pescuera[27] collection, Valencia, by Richard Ford in 1831.[28] In the Richard Ford sale (at Rainy's), London, 9 June, 1836 (lot 44), bought in. Exhibited at the British Institution, 1852 (no. 101), lent by Richard Ford. Richard Ford died in 1858 and his collection (at Heavitree House, Exeter) was inherited by Francis Clare Ford (died, 1899). Exhibited at the Royal Academy, 1873 (no. 104) and Spanish Exhibition, New Gallery, 1895/6 (no. 50), lent by Sir F.C. Ford; National Loans Exhibition, Grafton Gallery, 1909/10 (no.26), lent by Mrs. Ford. On loan to the National Gallery, 1910–13; purchased from Capt. Richard Ford in 1913. Cleaned Pictures Exhibition, National Gallery, 1947 (no. 47). Exhibited, Bowes Museum, 'Four centuries of Spanish Painting', no. 33.

REPRODUCTION: Illustrations: Continental Schools, 1937, p. 299 (before removal of the overpainting); Spanish School: Plates, 1952, p. 29.

REFERENCES: 1. Reproduced in actual size in Spanish School: Plates, 1952, p. 54.

2. It is difficult to judge how far the picture may have been cut down, for figures and objects (the cross) are often cut off at the edges of the canvas in Ribalta's work. The present placing of Simón and the fact that only one eye of the Virgin is visible show that the canvas must originally have extended for some inches on the right; it is also fairly certain (see below) that the Magdalene was present beside the Virgin. The way the present left edge runs through the trumpeter and the other figures on the left suggests that a similar amount has been cut off that side. The existing shaped top cuts through the banner, the upper arm of the Cross and the buildings in the background; the canvas may have been taller originally, and it may also have been rectangular, although the disposition of the letters SPQR seems to suggest a rounded top from the beginning. This may not have corresponded exactly in shape with the present top, which is an unusual one for the period.

3. It may have been painted out after June, 1836, since the catalogue of the Ford sale of 9 June, 1836, describes the picture as The Vision of San Loyola [sic], to whom the Saviour is appearing, bearing his cross; it is, however, possible that the figure of S. John was taken to be S. Ignatius, Father Simón having been painted out at an earlier date. Waagen, who

saw the picture in 1850 or 1851 (*Treasures of Art in Great Britain*, II, 1854, p. 223), mentions only the figure of Christ in his description. In the British Institution exhibition catalogue of 1852 and all subsequent exhibition catalogues (*cf.* Provenance) it is described as *Christ carrying the Cross*.

4. The facts about Simón's life have been taken from Francisco Martínez, *Las Exequias y fiestas funerales que hizo la Santa Iglesia de Origuela . . . a la dichosa muerte del Venerable y Angelico Padre Mossen Francisco Geronymo Simõ . . . Con vna breue summa de su vida y muerte*, 1612; Domingo Salzedo de Loayza, *Breue y, Sumaria Relacion de la Vida, Muerte y Milagros del Venerable Pres. Mos. Fr. Hier. Simon Valenciano, . . .*, Segorbe, 1614; Jan van den Wouwer (Woverius), *Vita B. Simonis Valentini*, Antwerp, 1614; and *Vida del Venerable Mosen Francisco Geronymo Simon*. A copy of the last mentioned book is in the Biblioteca Nacional, Madrid (pressmark 5 | 1546); it consists of Part I only and lacks the title-page. Internal evidence on p. 269 shows that it was written in 1705 or 1706 and it is fairly certainly the life written by Isidoro Aparici Gilart, Bishop of Croya (1633–1711), the printing of which was never completed (see *Biografía Eclésiastica Completa*, I, 1848, pp. 828–30); for the sake of convenience he is, therefore, referred to in the present text as the author. The events subsequent to his death are taken principally from the contemporary diary of Juan Porcar (*Coses evengudes en la civtat y regne de Valencia: Dietario de Mosén Juan Porcar, 1589–1629*, edited by V. Castañeda Alcover, 1934; especially volume I, pp. 128, 139/40, 142/3, 145/6, 148, 152, 159, 166, 169, 185, 193, 196/7, 204, 235, 309, 313, 320, and M. Fuster y Membrado, *Sucesos Memorables de Valencia* (ms. in the municipal archives, Valencia), volume II, f. 196r. (See also T. Llorente, *Valencia*, I, 1887, pp. 688 ff.).

5. There are many accounts of Father Simón's vision, all very similar, but the most authentic is that given in Aparici Gilart, *op. cit.*, pp. 58/9, which is a verbatim report of the de-

position made to a commission of enquiry by the Venerable Mother Francisca Llopiz, who had the details from Simón himself.

6. Porcar, *op. cit.*, I, p. 185.

7. Porcar, *op. cit.*, I, p. 309.

8. *Cf. Relacion de algunos . . . castigos que Dios . . . ha hecho en los fomentadores de la devocion de Mosen Simón . . . Anno 1693* (ms. in the University Library at Valencia).

9. Fuster y Membrado, *loc. cit.*, marginal note: 'Un almario ay deste V.[enerable] en la calle de cavalleros esquina del callejon que entra en S. Nicolas, frente de casa Albayda, alli esta su Retrato, y de cuando se le aparecio el Señor en la calle de Amargura . . .' 'ahora se a rrenovado el dicho Almario . . . en el año 1763'.

10. For S. Ignatius' vision, see *Les Petits Bollandistes*, IX, 1882, p. 165.

11. This engraving of Simón is by Cornelis Galle and bears the title: *Viva imago B. Simonis Sacerdotis Valentini* etc. In a letter to Balthasar Moretus (n.d.; 1613 or 1614?) Wouwer says that a portrait (*imago*) of Simón is in the hands of Rubens who will prepare it for an engraving by Galle (M. Rooses & C. Ruelens, *Correspondance de Rubens*, II, 1898, pp. 67–9). Reproduced in H. F. Bouchery & F. van den Wijngaert, *P. P. Rubens en het Plantijnsche Huis*, 1941, fig. 92.

12. Published by J. Ainaud de Lasarte in *Goya*, no. 20, 1957, pp. 86 ff., where six of the compartments of the engraving are illustrated (parts are again illustrated in *Archivo Español*, 1958, opposite p. 164). The engraving, of which there is a copy in the Barcelona Museum, is signed *F. Rib. inv | M. lasne fecit.* and entitled *IMAGO VENERABILIS FRANCISCI HIERONYMI SIMONIS. . . .* It is mentioned by Orellana, *Biografía pictórica valentina* (ed. X. de Salas), 1969, p. 129. In the scene corresponding with the present painting three figures are present in the right background in the engraving (see note 2).

13. J. Sanchis y Sivera, *La Catedral de Valencia*, 1909, p. 82, note 1.

14. On the back of the picture is a label with an inscription in Richard Ford's handwriting: *Christ bearing the*

Cross Francisco | Ribalta. This solemn specimen of the | great Spanish imitator of Sebastiano | del Piombo was painted by him in 1612 for | the convent of Santa Catalina at Zaragoza. (See | Cean Bermudez, Diccionario IV. 174). It was | stolen from the convent by the French. I bought | it at Valencia in Sept. 1831 out of the ce | lebrated Gallery of Pescuera: there is a | replica of it in Magdalen College Oxford | Rich. Ford. (This transcription was made in 1939; the inscription has since become partially effaced.) The 'replica' to which Ford refers is a Spanish painting of Christ bearing the Cross, not connected with no. 2930; it is reproduced and discussed in T. S. R. Boase, Christ bearing the Cross, 1955.

15. J. A. Ceán Bermúdez, Diccionario, 1800, IV, pp. 174/5.

16. Jusepe Martínez, Discursos practicables del nobilisimo arte de la pintura (ms. of ca. 1675?); see F. J. Sánchez Cantón, Fuentes literarias para la historia del arte español, III, 1934.

17. A typical representation of S. Ignatius' vision is the very large picture by Jerónimo Jacinto Espinosa, signed and dated 1653, in Valencia Museum.

18. See note 2.

19. D. Fitz Darby, Ribalta and his School, 1938, pp. 54/5. The further suggestion that no. 2930 was commissioned by Baltasar de Valtierra of Saragossa is completely without foundation.

20. A. Ponz, Viage de España, XV, 1788, p. 52.

21. Op. cit., pp. 506/7: 'Determino el Clero [of S. Andrés] muchos dias antes del ochauario hazer pintar a Francisco de Ribalta pintor famosissimo en España vn quadro grande de Christo nuestro Redemtor con la Cruz acuestas, las tres Marias siguiendole, y el Presbitero Simon arrobado, y arodillado a sus pies. Y este para que sirua de Altar en la Capilla nueua donde esta por agora depositado su cuerpo . . . Y llegandose ya los dias de las fiestas, el Iueues antes que côtauamos cinco de dicho mes de Setiembre, se puso el quadro. . . . Es vno de los mas admirables, y deuotos que tiene Valencia, y su Reyno.' Salzedo de Loayza mentions (p. 523) a version of this picture (a la mesma traça y modo) in San Salvador, Valencia.

22. Cf. note 5.

23. Aparici Gilart, the only other of the sources mentioned in note 4 who speaks of Ribalta's painting, also says (p. 245) that Christ is followed by three Maries, but as he describes it in the past tense it is probable that he had not seen it but was copying another description.

24. Cf. note 2.

25. Prado, no. 346.

26. Reproduced in R. Pallucchini, Sebastian Viniziano, 1944, pl. 70.

27. Not Pescueta, or Pesanera as stated in the 1929 catalogue.

28. See note 14 and R. E. Prothero, Letters of Richard Ford, 1905, p. 58.

JUSEPE DE RIBERA

1591(?)–1652

In Italy known as Lo Spagnoletto. He was born at Játiva, near Valencia, and is almost certainly the 'Joan Jusep Ribera' baptized at Játiva, 17 February, 1591. According to Palomino he was a pupil of Francisco Ribalta at Valencia. He went, apparently at an early age, to Italy and remained there for the rest of his life. He studied in Parma (?) and in Rome, where he is documented in 1615/6. Apparently by 1616 he had settled in Naples, where he did much work for the Spanish Viceroys. There are dated etchings from 1621 onwards; the earliest dated painting is of 1626, by which time he was a member of the Roman Accademia di S. Luca. He died in Naples (5 September).

His style is based on that of Caravaggio and his followers; many of his works were sent to Spain by his patrons and, despite what is sometimes said, it is clear that they were one of the principal sources of the Caravaggesque style in Spain.

LITERATURE: A. L. Mayer, *Ribera* (2nd, revised, ed.), 1923; E. du G. Trapier, *Ribera*, 1952. Documents about the Roman period of Ribera's career are published by J. Chenault in *The Burlington Magazine*, 1969, pp. 561 f.

235 THE LAMENTATION OVER THE DEAD CHRIST

Christ is supported by S. John; at his feet the Magdalen and, in the centre, the Virgin.

Oil on canvas, $51 \times 71\frac{1}{4}$ ($1 \cdot 295 \times 1 \cdot 810$).

Many small losses, and wearing, in the background especially towards the edges; several thin cracks and small areas of damage on the body of Christ. Cleaned in 1953.

An infra-red photograph shows that the Magdalen's head was at first much farther to the left, with her lips touching Christ's feet.

Traditionally ascribed to Ribera. Other attributions have been suggested in the recent past,[1] but the composition, handling and facial types are characteristic of Ribera's style and the attribution to Ribera was restored in the first edition of the present catalogue. The justness of the attribution can be more easily appreciated now that the picture has been cleaned.

No. 235 is related in composition to a group of horizontal *Lamentations* by Ribera and his followers, one of which (formerly in the collection of Cavaliere d'Angelo, Naples[2]) is signed and dated 1644. Another related composition is known only by two copies or imitations, one bearing a false Ribera signature and date 1645.[3] A third composition of the *Lamentation* is in the Louvre,[4] and MacLaren suggested that the present picture was nearest in style to this work, noting that it had been unjustifiably attributed to Giordano.[5] There is also an etched *Lamentation*[6] in which the Virgin and the Magdalen are similar to those in no. 235; although this is signed *GR* it seems too coarse to be the work of Ribera himself.[7] The motif of the Magdalene kissing the feet of Christ, visible in infra-red photographs of the present painting, occurs in the upright *Lamentation* by Ribera of 1637 in Naples (Certosa di San Martino). A horizontal adaptation of this composition is recorded in a painting in the Marqués de Heredia collection, Madrid;[8] and a further horizontal composition of a similar type, but with a half-length Magdalene at Christ's feet is recorded in a composition in the Real Academia de San Fernando, Madrid.[9]

No. 235 clearly forms part of this series of *Lamentations* by Ribera but it is difficult to know where precisely to place it. The composition appears to be more static than in the other works, the chiaroscuro more intense, the drawing (especially of the draperies) more carefully rendered; the body of Christ is certainly less idealized. The general effect is thus more Ribaltesque, more Spanish than in the other compositions. It seems possible that the present painting may be a very early work,

dating from before 1626 and thus occupying a special place in the series of *Lamentations*, but so little is known at present of the first decade or so of Ribera's activity that no definite judgement can be made.[10]

PROVENANCE: Said to have been in the Royal Gallery at Naples and removed thence by Eugène de Beauharnais (later Prince Eugène and Duke of Leuchtenberg, who died in 1824).[11] Brought to England from Paris;[12] in an anonymous sale (vendor, Hogarth) at Christie's, 19 July, 1851 (lot 14; £36 15sh.),[13] bought in. Probably bought from Hogarth by David Barclay,[14] by whom it was presented in 1853.

REPRODUCTION: *Illustrations: Italian Schools*, 1937, p. 343 (as by Stanzione); *Spanish School: Plates*, 1952, p. 30 (both before cleaning).

REFERENCES: **1.** The picture is ascribed to Massimo Stanzione in C. J. Holmes, *The National Gallery*, II, 1925, pp. 245/6; National Gallery catalogue, 1925 and 1929. It is given to Nicolas Tournier by R. Mesuret in *Revue historique et littéraire du Languedoc*, July, 1946, pp. 137 ff. (No. 235 is there reproduced in reverse.) More recently withdrawn from Tournier by the same author and ascribed to the Sevillian School, early seventeenth century (*Gazette des beaux-arts*, 1957, II, p. 342).

2. In the Principe di Fondi sale, Naples, 22 *sqq.*, April, 1895 (lot 404; reproduced in the sale catalogue); later in the collections of M. Schilizzi and Cavaliere d'Angelo; said to have passed after 1908 to the U.S.A. (*cf.* W. Rolfs, *Geschichte der Malerei Neapels*, 1910, p. 302, note 2). Copies with slight variations are in the Prado (no. 1068) and the Escorial (reproduced in J. R. Mélida, *El Escorial*, n.d., I, p. 24); a picture in the Cadiz Museum is said by Mayer (*Ribera*, 1923, p. 110) to be a copy with variations of the former d'Angelo picture; it is, in fact, a copy of the Louvre picture, no. 1722 (see below, and note 4).

3. One in the Louvre (1926 catalogue, no. 1725 A), the other (with the addition of Nicodemus(?) on the left) in the Academia de San Fernando, Madrid. The Madrid picture has a false signature and date (perhaps copied from an original?): *Jusepe de Ribera español | Academico Romano Ft 1645*. Also in the Academia de San Fernando are copies or adaptations of two other compositions of the *Lamentation* by Ribera—see notes 4 and 9 below.

4. Louvre 1926 catalogue, no. 1722. Copies or variants of the Louvre picture are in the Cadiz Museum (see note 2, and *Museo Provincial de Cadiz*, catalogue, 1964, no. 41, p. 100); in the Bob Jones University Collection, Greenville, U.S.A. (1962 catalogue, vol. II, p. 345; the picture is possibly the same as the one formerly at Denstone School, England, in 1958); in the Real Academia de San Fernando, Madrid; and in the Soler Rovirosa collection, Barcelona (Photo Archivo Mas, no. C-95966).

5. By Mayer, *op. cit.*, p. 109. Following MacLaren, Soria linked these two pictures, dating both about 1644 (*Art and Architecture in Spain and Portugal 1500–1800*, 1959, p. 242).

6. A. Bartsch, *Le Peintre Graveur*, XX, 1820, p. 79, no. 1.

7. Mayer, *op. cit.*, p. 113, suggests that the clumsiness of the print may be due to overworking, but the impression in the British Museum Printroom shows no evidence of this other than the addition of a ladder on the left.

8. Photo Archivo Mas, no. 27965. This horizontal adaptation of the Naples picture happens to resemble no. 235 fairly closely.

9. Photo Archivo Mas, no. 94942.

10. The *Crucifixion* in the Colegiata, Osuna, which was possibly done before 1620 is discussed by E. du G. Trapier, *Ribera*, 1952, pp. 17 ff. A *Nailing to the Cross* at S. Maria, Cogolludo, appears to be comparable in some respects with the present *Lamentation*; this has been regarded as a very early work, though the date is not known for certain (first published by F. Layna

Serrano in *Boletín de la Sociedad española de excursiones*, 1949, pp. 281 ff.). On pictures of the five senses, said by Mancini (*Considerazioni sulla pittura*, ed. 1956, I, p. 251) to have been painted in Rome and thus (?) before 1615, see R. Longhi in *Paragone*, 1966, no. 193, pp. 79 ff. and E. Schleier in *Paragone*, 1968, no. 223, p. 79. Professor José Milicua of the University of Barcelona, who is engaged on a detailed survey of Ribera, has arrived at the same conclusion as that outlined above concerning the date of no. 235; he feels that the picture might be identical with the *Christo Deposto*, which is also mentioned by Mancini (*op. cit.*, p. 251) and which may therefore date from Ribera's Roman period.

11. According to the catalogue of the anonymous Christie sale, 19 July, 1851. Eugène de Beauharnais was in the Italian campaign of 1796/7 and became Viceroy of Italy in 1805.

12. According to David Barclay (letter of July, 1853, in the Gallery archives). Mayer (*op. cit.*, p. 112) erroneously identifies no. 235 with a *Pietà* seen by Waagen at Wardour Castle (G. F. Waagen, *Galleries . . . in Great Britain*, 1857, p. 393), which is a version of the vertical composition in the Certosa di S. Martino. It was in an anonymous sale, Sotheby's, 22 April, 1953 (lot 56), 102 × 70 ins.

13. As by Ribera. Christie's markings relating to this sale are on the back of the picture.

14. In a letter of July, 1853 (see note 12), Barclay says that the picture is to be seen at Hogarth's house.

244 JACOB WITH THE FLOCK OF LABAN (FRAGMENT)

Signed on the rock in the lower right-hand corner: *Jusepe de Ribera español | academico Romano | F 1638(?)*.[1]

Oil on canvas, *ca.* 52 × *ca.* 45¾ (*ca.* 1·320 × *ca.* 1·180). Comparison with two old copies shows that the picture, which is evidently a fragment, was originally a horizontal composition; the copies suggest that the picture was twice cut down on the left-hand side (see below), and slightly reduced on the right.

Worn and damaged throughout, especially at the edges, in the sky and across the head of Jacob. The lower half of the picture is the best preserved part. Cleaned and restored in 1970, when the signature was uncovered, and likewise the backs of the sheep occupying the left-hand side of the canvas; a later enlargement, about one inch wide, to the top of the canvas was removed at this time.

Pentimenti: An infra-red photograph shows that the left eye was at first where the bridge of the nose now is and the mouth was apparently further to the left—the whole head was probably intended at first to be further to the left. The legs of the lamb in Jacob's lap and the lower part of its breast appear to have been added over Jacob's cloak.

The subject is taken from Genesis, xxx, 37 and 38: 'And Jacob took him rods of green poplar, and of the hazel and chestnut tree; and pilled white strakes in them, and made the white appear which was in the rods. And he set the rods which he had pilled before the flocks in the gutters in the watering troughs when the flocks came to drink, that they should conceive when they came to drink.'

No. 244 has sometimes been called *Christ as the Good Shepherd*[2] or *Moses with the flock of Jethro on Mount Horeb*[3] but the identification of the scene is put beyond doubt by the presence of peeled rods in the

picture and by comparison with the Museo Cerralbo copy (see below) in which can be seen several sheep drinking or about to drink at the stream.

It was shown by MacLaren, on the basis of an old copy in the Museo Cerralbo, Madrid,[4] that this picture is only part of a larger one. The copy shows that it was originally a horizontal composition and that a wide strip has been cut off the left side. In the part of the copy corresponding to the missing piece is a speckled ram drinking (in profile towards the right), with a speckled sheep behind it (also in side view towards the right). The copy shows the two sheep present on the left in no. 244; these were formerly visible in X-ray photographs and they were uncovered in the recent cleaning of the picture.

The Museo Cerralbo picture appears to be in all essentials a faithful copy of no. 244, except at the upper edge of the composition. Here the copyist evidently lengthened the tree trunk behind the figure of Jacob, adding unconvincing wisps of foliage down the left side of the trunk. His field of composition is approximately 6 inches (ca. 0·150) higher than in no. 244. The very narrow space between Jacob's head and the upper edge of the composition in the National Gallery picture, coupled with the low viewpoint from which the figure is shown, suggests that the painting was intended for a high position. Assuming that the artist of the Museo Cerralbo copy made no alterations at the sides of the composition of the kind he permitted himself at the top, it would appear that no. 244 has been cut down approximately 30 inches (ca. 0·760) on the left and ca. 6 inches (ca. 0·150) on the right.

A second copy of the painting (in the Villa Rocca at Chiavari, near Genoa, collection of the municipality) suggests that the original of which no. 244 formed the major part was cut down on two occasions. This copy shows the composition up to a point about 10 inches beyond the present left edge of the canvas,[5] and it includes the heads, but not the bodies, of the two sheep present in profile on the left in the Museo Cerralbo copy. It differs, however, from the latter in showing the head and shoulders of a shepherdess (?) immediately above the heads of the two sheep. This figure faces towards Jacob across the canvas and carries in her hand a stick. This figure must once have been present in the National Gallery painting because the stick which she carries is to be seen at the left of the canvas; and a part of her hand and a tress of her hair (?) became visible beneath the stick subsequent to the recent cleaning of the canvas. The paint-work of this fragment appears to be indistinguishable in date from the paint of the sky behind, but it is very unlikely that this figure formed part of Ribera's original composition; not only is she absent in the Museo Cerralbo copy, but she seems to be far too weak an element in the composition to have been introduced by Ribera himself. It is most likely that this figure was added in order to strengthen the left-hand side of the composition after its first cutting. The apparent date of the fragments of the figure remaining on no. 244 would therefore suggest that this first cutting took place not long after the execution of the painting. The second cutting, reducing the picture

to its present format, was presumably connected with the overpainting (in easily soluble pigment) of the backs of the sheep in the left half of the present canvas. This second operation must have taken place before 1829, when the appearance of the painting in its overpainted state is recorded in a view of the exhibition rooms of the British Institution by John Scarlett Davis.[6]

The present picture was traditionally catalogued as by Ribera until the 1952 edition of the Spanish school catalogue, when it was labelled 'Style of Ribera' because its condition before cleaning precluded a more accurate judgement. The pose of the head and torso are very similar to those of Jacob in Ribera's painting of the same subject at El Escorial (signed and dated 1634). There are also stylistic similarities to *Jacob's Dream* of 1639 (?) in the Prado.[7]

COPIES: Copies of this design in the Museo Cerralbo, Madrid, and in the Villa Rocca, Chiavari, are discussed above.

PROVENANCE: In an anonymous sale (by White), London, 17 April, 1806 (lot 42; £40),[8] bought by N. W. Ridley Colborne (later Lord Colborne). Exhibited British Institution, 1829 (no. 110)[9] and 1847 (no. 124).[10] Lord Colborne Bequest, 1854.

REPRODUCTION: *Illustrations: Continental Schools*, 1937, p. 299; *Spanish School: Plates*, 1952, p. 31 (both before cleaning).

REFERENCES: **1.** The date is worn, but the first three figures are clearly visible, the third corresponding with the type of elongated number 3 characteristic of Ribera. A damage cuts off the left half of the last letter but the remains appear to correspond with the type of number 8, much flattened at the top, which is commonly employed by Ribera. The general character of the signature, including references to the painter's nationality and his membership of the Roman Academy of S. Luke, appears in various forms on ten or so of the artist's larger paintings between the *S. Jerome* (Hermitage) of 1626 and the *Holy Eucharist* (Naples, Certosa di S. Martino) of 1651.
2. Cf. G. F. Waagen, *Treasures of Art*, 1854, II, p. 241.
3. Mayer, *op. cit.*, p. 81.
4. $59\frac{7}{8} \times 81\frac{1}{8}$ ($1\cdot52 \times 2\cdot06$). Repro-duced in *Museo Cerralbo* (Guías de los Museos de España, V), 2nd ed., 1969, pl. [30].
5. The field of composition in this copy has been considerably extended at the top by means of a strip of canvas evidently added some time after the copy was executed.
6. Heywood-Lonsdale collection; reproduced and discussed in *The Connoisseur*, 1912, vol. 33, pp. 215 and 222.
7. No. 1117; signed and dated. The date cannot be clearly read; various readings have been proposed in different editions of the Prado cata-logue. The most recent of them give 1639 and this last date is generally found acceptable on stylistic grounds.
8. As *Spanish Shepherd* by Murillo.
9. As by Ribera.
10. As by Ribera.

PAOLO DA SAN LEOCADIO *See* PAOLO

LO SPAGNOLETTO *See* RIBERA

SPANISH School, XVII century

1376 LANDSCAPE WITH FIGURES

Oil on canvas, $35\frac{7}{8} \times 49\frac{5}{8}$ (0·912 × 1·260).
Very badly rubbed; engrained brown varnish.

The description of the scene as *A duel in the Pardo*[1] or on the banks of the Manzanares[2] is entirely fanciful.

No. 1376 has been ascribed to Velázquez[3] and to Mazo.[4] It is too feeble to be attributable to any specific hand. There seems to be no connection with Velázquez's landscape style; there is some resemblance to that of Mazo but not sufficient to justify an attribution to one of his followers.

The five men and the mule in the foreground have been copied from Velázquez's *Philip IV chasing wild boar* (no. 197 of this catalogue), or from a version of this composition.

PROVENANCE: John Watkins Brett sale, London, 8/9 April, 1864 (lot 836; 27 gns.),[5] bought by Ripp. Exhibited at the Royal Academy, 1880 (no. 118),[6] lent by Sir William H. Gregory, by whom bequeathed in 1892.[7]

REPRODUCTION: *Illustrations: Continental Schools*, 1937, p. 225; *Spanish School: Plates*, 1952, p. 35.

REFERENCES, GENERAL: C. B. Curtis, *Velazquez and Murillo*, 1883, Velázquez no. 57; A. L. Mayer, *Velazquez*, 1936, no. 141 (as probably a pastiche of Velázquez); J. López-Rey, *Velázquez*, 1963, no. 148 (as probably a late pastiche).

REFERENCES IN TEXT: **1.** First so described in the Royal Academy 1880 catalogue.
2. J. C. Robinson in *The Burlington Magazine*, X, 1906/7, p. 177.
3. Brett sale catalogue; National Gallery catalogue, 1892–1920.
4. W. Armstrong, *Life of Velazquez*, 1896, pp. 96/7; National Gallery catalogue, 1921–29.
5. As by Velázquez.
6. As by Velázquez.
7. As by Velázquez.

Ascribed to the SPANISH School

2526 A MAN, AND A CHILD EATING GRAPES

Oil on canvas, $28\frac{3}{4} \times 22\frac{3}{4}$ (0·730 × 0·578).[1]

Unfinished: *e.g.* the man's body is lacking, the child's left arm and half the table top are roughly sketched only. There are slight indications that the man's left hand was to hold the child's left.

In good condition.

Has been attributed to Velázquez[2] and to Pedro Núñez de Villavicencio (1644–1700)[3] but is obviously of later date, probably nineteenth century. In the 1929 catalogue as Unknown. Its country of origin is uncertain; since it is possible that it was intended as an imitation of Velázquez, and is sometimes referred to in the older Velázquez literature, it has been catalogued with the Spanish School.

COPY: A copy was in an anonymous sale, London, 18 December, 1953 (lot 50).[4]

4+S.S.C.

PROVENANCE: Earl of Clare sale, London, 17 June, 1864 (lot 29; £34 13sh.), bought by Robinson. J. C. Robinson sale, Paris, 7/8 May, 1868 (lot 49; 4,840 francs).[5] Apparently in the collection of George Salting by 1883.[6] Spanish Exhibition, New Gallery, 1895/6 (no. 44),[7] lent by George Salting. Salting collection exhibition, Agnew's, January, 1910 (no. 170).[8] Salting Bequest, 1910.

REPRODUCTION: *Spanish School: Plates*, 1952, p. 35.

REFERENCES, GENERAL: C. B. Curtis, *Velazquez and Murillo*, 1883, Velázquez no. 83.

REFERENCES IN TEXT: **1.** Various incorrect measurements are given in earlier National Gallery catalogues.
2. In the Clare and Robinson sale catalogues (see Provenance); Curtis, *loc. cit.*
3. National Gallery catalogue, 1911–15.

4. 27 × 24½ ins.; as Velázquez.
5. See also J. C. Robinson, *Memoranda on Fifty Pictures*, 1868, pp. 42 ff., no. 29.
6. Salting notebook in the Gallery archives.
7. As by Velázquez.
8. As ascribed to Velázquez.

DOMENIKOS THEOTOKOPOULOS *See* EL GRECO

JUAN DE VALDES LEAL
1622–1690

His full name was Juan de Nisa y Leal Valdés. Of Portuguese descent; born at Seville in 1622 (baptized 4 May). His first works were produced in Cordova, where he may have been a pupil of Antonio del Castillo, and he stayed there until at least 1654, but perhaps worked in Carmona in 1653. By 1656 he had apparently settled in Seville and stayed there for the rest of his life except for visits to Cordova, and to Madrid in 1664 or 1674. He was one of the founders of the Seville Academy in 1660 and its President, 1664–6. Died in Seville (14 October).

LITERATURE: E. du G. Trapier, *Valdés Leal*, 1960.

1291 THE IMMACULATE CONCEPTION OF THE VIRGIN, WITH TWO DONORS

The Virgin stands on a full moon; above, left, God the Father, and the Holy Ghost in the form of a dove.

Signed on a paper lying before the donor: JUAN | BALDES [both in monogram] FAC | A(o?) 1661.[1] (The signature and date are made up in places but the only possibly doubtful part is the last figure of the date.)

Oil on canvas, 74¾ × 80½ (1·90 × 2·045).

In fair condition; rather thin in places; a number of old repaints, especially in the Virgin's dress. Uneven brownish varnish.

Catalogued before 1952 as the *Assumption of the Virgin*; the symbolism is clearly that of the Conception. In this as in most of his versions of the subject Valdés Leal follows the more elaborate iconography of the

subject instead of the simplified form popularized by Murillo (*cf.* Follower of Murillo, no. 3910). The cherubs bear some of the emblems of the Virgin: below, left: olive (*oliva speciosa in campis*[2]) and palm (*palma exaltata in Cades*[3]); below, right: a rose (*plantatio rosae in Jericho*[4]); and an iris; above, right: a mirror (*speculum sine macula*[5]) and lilies (*lilium inter spinas*[6]). The throne at the top of a staircase in the left background, before which stands S. Michael(?) and other angels, is probably intended for the throne of Solomon,[7] the portal in the right background perhaps for the *patens coeli janua.*[8]

It is not clear whether the dress of the donor is clerical or secular. MacLaren suggested that he was probably a canon, with a black biretta on the table and wearing a black mozzetta over a white rochet. Trapier suggests, alternatively, that he may be a *jurado*, or a city official.[9] The donatrix's dress is probably mourning rather than a nun's habit.[10] There is no external evidence that she is, as sometimes stated, the donor's mother.

Though the style of the two portraits below is somewhat unusual for Valdés Leal the difference does not warrant an attribution to another hand.

VERSIONS: The figure of the Virgin is repeated with variations in an *Immaculate Conception with SS. Peter and Paul* by Valdés Leal in the Louvre.[11]

PROVENANCE: Acquired in Spain by Captain the Hon. Frederick William Charteris;[12] exhibited British Institution, 1862 (no. 73). Purchased from his widow, Lady Louisa Charteris, in 1889.

REPRODUCTION: *Illustrations: Continental Schools*, 1937, p. 367; *Spanish School: Plates*, 1952, p. 36.

REFERENCES: **1.** Reproduced in actual size in *Spanish School: Plates*, 1952, p. 55. The monogram is difficult to decipher but seems to be made up of the letters comprising JUAN BALDES which is the usual form of the artist's signature.
2. Ecclesiasticus, xxiv, 14 (Vulgate 19).
3. Ecclesiasticus, xxiv, 14 (Vulgate 18).
4. Ecclesiasticus, xxiv, 14 (Vulgate 18).
5. Book of Wisdom, vii, 26.
6. Song of Solomon, ii, 2.

7. Office of the Immaculate Conception.
8. Office of the Immaculate Conception.
9. E. du G. Trapier, *Valdés Leal*, 1960, pp. 35 f.
10. *Cf.* Mazo no. 2926 of this catalogue.
11. Louvre catalogue, II, Italian and Spanish Schools, 1926, no. 1753; reproduced in P. Massa, *Valdés Leal*, 1942, pl. 10; Trapier, *op. cit.*, fig. 18.
12. According to the 1892 National Gallery catalogue.

DIEGO VELAZQUEZ

1599–1660

His full name was Diego Rodríguez de Silva Velázquez; he invariably signed *Diego Velasquez* [sic] or *Diego de Silva Velasquez*. He was born in Seville (baptized 6 June) and is supposed to have worked there for a

short time under Francisco Herrera the elder, *ca.* 1612. From 1613 to 1618 he was a pupil of Francisco Pacheco, whose daughter he married in 1618. He first went to Madrid for a short visit in 1622; he was recalled there the following April by Philip IV's minister, the Conde-Duque de Olivares. His success on this second visit was immediate; almost at once he was commissioned to portray the King, and in October he entered the Royal service with the promise that he alone should paint Philip IV. For the rest of his life he remained attached to the Court and hence-forward most of his paintings were portraits of the Royal family and members of the Court. In 1627 he was made a Gentleman Usher (*Ugier de Cámara*), the first of a series of Court appointments, some with onerous duties, which he held in succession.

He met Rubens in Madrid during the latter's visit of 1628/9. In July 1629 he left Madrid to visit Italy, where he first spent some time in Venice, studying and copying the great Venetian painters; in 1630 he travelled on to Rome and towards the end of the year to Naples. He returned to Madrid at the beginning of 1631. Early in 1649 he again went to Italy, visiting Genoa, Venice, Naples and Rome, and was back in Madrid in June 1651. His most important work, *Las Meninas*, was apparently completed in 1656. He was made a Knight of Santiago in 1659, and in 1660 (6 August) died in Madrid.

Despite the existence of a number of paintings datable by external evidence, the chronology of Velázquez's works remains somewhat uncertain. Documents such as those concerning the Court jesters published in 1939 by Moreno Villa and that discovered by MacLaren concerning the 'Rokeby Venus' (no. 2057 below) provide evidence of the inadequacy of pure style criticism in this respect.

Judging by the large number of contemporary copies and versions of his portraits, he employed many assistants; the number of surviving autograph works is relatively small. A few were lost in the Alcázar fire of 1734; there is, however, evidence both that he was slow and that his Court duties encroached increasingly on his time, and it is unlikely that his total production was at all considerable.

LITERATURE: C. Justi, *Velazquez und sein Jahrhundert*, 1888 (2nd, revised ed., 1903; Spanish ed. by J. A. Gaya Nuño, 1953), although now out of date in many respects is still the most important work on the subject. C. B. Curtis, *Velazquez and Murillo*, 1883, contains a valuable catalogue of works by and connected with Velázquez. A. L. Mayer, *Velazquez*, 1936 and J. López-Rey, *Velázquez*, 1963, contain fairly complete collections of reproductions and *catalogues raisonnés*; that of the second book is a critical catalogue, highly personal in many of its judgements. Most of the information about Velázquez and his work which had accrued since Justi's time is to be found in E. du G. Trapier's *Velázquez*, 1948 (which has a comprehensive bibliography). Many studies on various aspects of Velázquez were published in 1960, the tercentenary year of his death, in the second part of the *Archivo Español* for this year and in *Varia velazqueña*, vol. I. The second volume of this last publication contains transcriptions of much of the source material and others are to be found in the volume published by the Instituto Diego Velázquez in 1970: *Velázquez, Biografías de los siglos XVII y XVIII*, etc.

197 PHILIP IV HUNTING WILD BOAR ('LA TELA REAL')

In the right foreground of the canvas enclosure Philip IV is meeting the charge of a boar; immediately to his left is the Conde-Duque de Olivares and beyond him the Infante Don Carlos (?). The white-bearded man on a white horse, slightly to the left of the second coach from the extreme right, may be the Master of the Hunt, Juan Mateos.

Oil on canvas, *ca.* $71\frac{5}{8} \times 118\frac{7}{8}$ (*ca.* 1.82×3.02). The top edge is original;[1] narrow strips have been cut from the other three edges which are ragged.[2]

Reverse: The word *Pardo* was discovered on the back of the canvas during relining in 1969. This must refer to the palace of El Pardo (near Madrid), indicating (see below) either the supposed region where the hunt took place, or more probably referring to the palace itself, where the picture probably hung from 1713.

The condition of the picture has been the subject of a good deal of comment in the past,[3] but prior to the removal (in 1950–2) of the dark brown varnish and repaint[4] it was impossible to form an accurate opinion. It could then be seen that the state was better than was generally thought. The figures in the foreground outside the enclosure are, on the whole, well preserved except for the darks which are mostly badly damaged (especially the mules and the group to the right of them). The ground in the enclosure is very badly worn. Of the figures in the foreground of the enclosure, the group of four horsemen, left centre, is fairly well preserved; the rest, and the coaches, are more worn, especially in the darks which have been reduced to shadows. All the more distant figures in the enclosure are little more than shadows. Almost all the foliage, except for the highlights, is very badly worn, the best preserved part being an area perpendicularly above the King; the clearing with three horsemen in the upper left background and the surrounding trees have been reduced to a shadow. The sky is worn, particularly on the right.

There are very many *pentimenti*, of which the following are the most important. To the right of the man holding the dogs in the left foreground there was originally another man, in blue, profile left (now partly covered by the tree). At the near side of the enclosure, above the man drinking in the foreground, left of centre, a coach, originally seen end-on, has been painted out. The red cloak of the man in the left centre foreground is painted over a dark blue one, the skirt of which was lifted behind by his sword; his right leg was at first placed much farther forward. The hats of the three men in the pale ochre, blue and mauve cloaks in the right centre foreground were originally much lower and smaller (presumably the figures were then intended to seem nearer the enclosure). There are many other less important *pentimenti*, especially in the figures of the right half of the foreground.

For Philip IV, see Velázquez no. 745 below.

Don Gaspar de Guzmán y Pimentel, Conde de Olivares, and, later, Duque de San Lúcar (known as the Conde-Duque), was born in 1587.

He was the favourite of Philip IV and became first minister when Philip ascended the throne in 1621. He remained in power until his disgrace and banishment from the Court in January, 1643, and he died in 1645.

Juan Mateos was the King's Master of the Hunt (*Ballestero principal*) and author of a book on hunting (see below).

Philip IV and Olivares are the only figures that can be identified with complete certainty. The white-bearded horseman looks very like Mateos [5] but the scale of the head is too small to permit positive identification. The young man on a white horse on Olivares' left bears some resemblance to Philip's brother, the Infante Don Carlos [6] (1607–1632); if this identification is correct the horseman on Philip's right may be intended for his other brother, the Infante Fernando (1609–1641)—both brothers usually hunted with the King—but the features are not now sufficiently distinct to be recognizable. It has also been suggested [7] that the lady in the coach to the left of the tree in the right foreground is Philip IV's first wife, Queen Isabella (1602–1644), but she also is unrecognizable.

The other riders in the centre foreground of the enclosure also seem to be portraits but have not been identified.

The picture is a representation of a form of boar hunt commonly practised by the Spanish Kings. The hunting of game within an enclosure of canvas (*tela*) was apparently introduced into Spain from Germany by the Emperor, Charles V; [8] owing to the tremendous expense involved only the King could afford it. (Hence the name sometimes given to the present picture *La Tela Real, i.e.* the Royal enclosure.) The descriptions of such hunts given in Juan Mateos' *Origen y Dignidad de la Caça*, 1634, [9] and Alonso Martínez de Espinar's *Arte de Ballesteria y Monteria*, 1644, [10] show that the picture is accurate even in the smallest details. [11] Areas in which boars had been located were enclosed by a continuous wall of canvas supported on stakes (the *tela*), sometimes as much as a league in circumference. The stakes were transported on wagons like the one visible behind the tree in the lower right-hand corner of the present composition. The nearest level piece of ground was then cleared of bushes and undergrowth and enclosed with canvas; this second enclosure, known as the *contratela*, was about 100 yards in diameter, and is the arena represented in the National Gallery picture. A passage was then made from the *tela* to the *contratela*, [12] in which the King and his companions awaited the boar. It was the duty of the Conde-Duque de Olivares, as Master of the Horse (*Caballerizo mayor*), to remain at the King's side (as here) during the hunt. [13] The Queen and her ladies watched from coaches within the enclosure, and were guarded by huntsmen on foot with lances. When the horses had been removed from the coaches, the canvas blocking the ends of the passage were lowered and the boars were driven into the *contratela*, the entrance being afterwards closed again. The King and his gentlemen were armed with two-pronged blunt forks, the width of a boar's muzzle, mounted on shafts (*horquillas*); [14] the sport consisted of meeting the boar's charge and turning it by means of the *horquilla*. As a rule, many shafts were

broken during the hunt; a stock of replacements can be seen near the far side of the *contratela* and in the centre a hunt servant is running up with several in his hand. When the boar was tired, hounds were loosed on him and he was finally dispatched by the huntsmen. (This final phase is taking place on the extreme left.)

Hunts of this kind were sometimes made in honour of a distinguished visitor; the Princess of Carignan attended one in January, 1637,[15] and the Duchesse de Chevreuse another in January, 1638.[16]

In the 1772 and 1794 Buen Retiro inventories a copy of the National Gallery picture (now in the Prado; see Copies) is described as a hunt at El Pardo. The landscape features would scarcely be identifiable, but the type of country is very like that around El Pardo, near Madrid, close to which was the Torre de la Parada, a hunting lodge built for Philip IV, *ca.* 1635/6 (no. 197 was probably painted for the Torre—see below). The exact spot where the hunt is taking place has sometimes been said to be called El Hoyo del Pardo (*hoyo* means a hollow or pit). Justi[17] suggested that this was due to a confusion of the subject with a different kind of hunt, the so-called *montería* or *caza del hoyo*, in which the game was driven by beaters into a deeply-dug pit.[18] The word *Pardo* inscribed on the back of the canvas seems more likely to refer to the hanging of the picture in the palace of El Pardo (see below) than to the site where the hunt is taking place.

The references to the National Gallery picture and the Prado copy in the inventories of the Spanish Royal collections in the seventeenth and eighteenth centuries are somewhat confusing (see below) but it is clear that no. 197 was always attributed to Velázquez in them (the first mention of it being apparently of 1700). Doubts about the attribution to Velázquez have been raised in the past, and subsequent to the cleaning of the picture in 1950–2. The landscape background was attributed by Armstrong[19] to Mazo and the whole painting is ascribed to that artist by Miss Trapier.[20] The composition of the painting cannot, however, be taken as evidence of Mazo's authorship, since the picture must have been largely determined in composition by the subject matter. In the absence of any works by Velázquez of comparable subject-matter, the attribution to him must depend mainly on an assessment of the quality of the picture.

The cleaning of the picture left little doubt that the most important parts of the painting must be by Velázquez himself. The figures in the foreground are greatly superior to any in paintings of similar subjects by Mazo, in both their rendering as single figures and in their composition as a group. The hastily painted figures of the right half of the foreground may be compared with those in the two Villa Medici sketches (Prado), to which they are, indeed, superior. It also appears that Velázquez painted some of the nearer figures within the enclosure and retouched others. On the other hand, those of the more distant horses and riders which are well enough preserved to permit judgement (*e.g.* the group on the extreme left of the arena) seem too wooden and formless to be his work. The landscape has suffered to such a degree that it

would be impossible to assign it with reasonable certainty to any individual hand, but enough is preserved to show that in general form it is quite unlike any of the landscapes which can be ascribed with certainty to Velázquez, as for example those in the backgrounds of his portraits and in the SS. *Anthony Abbot and Paul the Hermit*. It is, however, very close to the type of landscape seen in the *Stag hunt at Aranjuez* (Prado), which is a semi-documented work of Mazo,[21] and in other landscapes attributable to him and his follower, Benito Manuel de Agüero.[22] Mazo was known to his contemporaries as a painter of views and hunt scenes with small figures[23] and he is the most likely collaborator of Velázquez in such a picture as the present one, but as already stated the condition does not permit an exact ascription of the landscape.

The picture was catalogued by MacLaren as by 'Velázquez and an assistant'; this attribution is slightly changed here, since it can be assumed that the most important part of the composition is by Velázquez himself, in which case it is likely that any assistance he received on the painting would have been carried out under his supervision.

It is sometimes suggested[24] that no. 197 was painted *ca.* 1638/9; one of the reasons for the choice of this particular date is the supposition that the picture represents either the hunt given in honour of the Princess of Carignan in 1637 or that for the Duchesse de Chevreuse in 1638 (see above). It is, however, only by mere chance that these particular occasions are recorded,[25] and there is no evidence that either is here depicted. January, 1643, is a reliable *terminus ante quem* since it is most unlikely that Olivares should have been introduced after his disgrace into a picture painted for the King. If either of the Infantes is portrayed, as suggested above, a date before Don Fernando's departure for good from Madrid in April, 1632 and Don Carlos' death in July, 1632 is a possibility, and need not be rejected on stylistic grounds. On the other hand it is not at all improbable that they should be represented in a commemorative painting of later date since they were the King's constant companions in the hunt. There is a probability that the picture was painted for the Torre de la Parada, where it is first registered (see below), and which was under construction *ca.* 1635/36; if so, it could be the commission Velázquez had in hand for the Torre *ca.* 1636, according to a petition sent by him to the King.[26] (Rubens was commissioned to paint a series of mythological subjects for the same place in 1636[27]). In any case it accords fairly well with Velázquez's style of the early and middle 'thirties.

In the Spanish Royal inventories from 1700 to 1772 two pictures of boar hunts are described as originals by Velázquez. There exists in the Prado (no. 1230) a copy of the National Gallery picture, which can be identified on the basis of its inventory numbers with the picture listed from 1747 in the inventories of the Buen Retiro palace (see below). Unfortunately it is not known when this copy was made, and whether it can be identified with either of the pictures described as being by Velázquez in the inventories prior to 1747.

The first mention of one of the originals is in the Alcázar inventory of
1686: 'Vna pintura de tres varas y media de largo y dos de alto [= *ca.*
66 × *ca.* 116 inches], de vna monteria de jabalies del Rey neustro Señor
don Phelipe Quarto, que sea en gloria, original de mano de Diego
Velazquez'.[28] This picture was in a room in the tower facing the park
together with seven other hunting subjects, two of which were por-
traits, listed as by Velázquez, of Philip IV and the Infante Fernando in
hunting dress. The same eight pictures were still together in the same
room in 1700, and the Alcázar inventory of that year repeats the descrip-
tion of 1686 word for word, the picture being valued at 150 doublons.[29]
In the Torre de la Parada inventory of the same year (1700; no earlier
inventories of the Torre exist) is 'Otra pintura del mismo tamaño [*i.e.*
3½ varas wide = *ca.* 116 inches], de la tela Real, de mano de Velazquez',
valued at 200 doublons. This also was hung in a room with other
hunting pictures, three of which were portraits by Velázquez of the
King, the Infante Ferdinand and Prince Baltasar Carlos in hunting
garb. It is highly probable that the picture in the Alcázar in 1686 and
the one listed there in 1700 are the same. The Torre de la Parada
painting was one of those removed thence to the palace at El Pardo in
1714.[30] The word *Pardo* on the reverse of the present canvas suggests
that it was the National Gallery painting which hung in the Torre de la
Parada, until its removal to El Pardo. It may have been a better work
than the Alcázar picture since it had the higher valuation in 1700,
despite the fact that at a later period the Prado copy was valued higher
than the National Gallery picture.

From 1747 onwards the National Gallery picture must be the one
listed in the Royal Palace at Madrid: 1747 (no. 381),[31] 1772 (no. 920)[32]
and 1814 (no. 920).[33] The Prado copy still bears one of its old numbers
(no. 29, see below) and it must therefore be the picture which appears
in the inventories of the Buen Retiro, 1747 (no. 1186),[34] 1772 (no.
1186),[35] 1794 (no. 29)[36] and the Royal Palace, Madrid, 1814 (no. 29),[37]
and from 1823 onwards in the Prado Museum catalogue. The Prado
picture may be identical with the 'original' by Velázquez described in
the Alcázar inventories of 1686 and 1700, but it looks stylistically as
though it could be a copy of the early eighteenth century, in which case
it might have been made as a replacement for the Alcázar original which
would presumably have suffered in the fire of 1734.

COPIES: A seventeenth or eighteenth-century copy of approximately the same
size in the Prado, Madrid,[38] is discussed above. An old copy is in the collection
of Dr. Carl David Moselius, Stockholm.[39] A much damaged reduced copy in
the Wallace Collection, London,[40] lacks many of the figures. Another copy or
derivation was in the Sir George Hayter sale, London, 3 May, 1845 (lot 5),[41]
bought by Wedgwood. The man in the red cloak and his three companions
(in the foreground, left centre) are copied in an old pastiche in the collection of
Lady Lucas[42] and, with the addition of the man holding the dogs, in no. 1376
of this catalogue (Spanish School, seventeenth century). Another pastiche,
corresponding with the one in the Lady Lucas collection, is in the Musée
Magnin, Dijon.[43] The same group of five men appearing in the Lucas copy and
other episodes of the foreground scene, appear in two copies in recent sales:

4*

anonymous sale, Christie's, 10 May, 1963 (lot 106),[44] and anonymous sale, Sotheby's, 17 June, 1964 (lot 90).[45]

PROVENANCE: Painted for Philip IV, probably for the Torre de la Parada (its history while in the Spanish Royal collection is dealt with above). It was presented by Ferdinand VII to Sir Henry Wellesley (British Minister in Spain, 1811–22; later Baron Cowley) after 1814[46] and probably before 1818.[47] Exhibited at the British Institution, 1819 (no. 88) and 1838 (no. 6); sold by Lord Cowley to Henry Farrer, from whom it was purchased in 1846.

REPRODUCTION: *Illustrations: Continental Schools*, 1937, p. 368 (before cleaning); *Spanish School: Plates*, 1952, pp. 47–9.

REFERENCES, GENERAL: C. B. Curtis, *Velazquez and Murillo*, 1883, no. 37; A. L. Mayer, *Velazquez*, 1936, no. 131; J. López-Rey, *Velázquez*, 1963, no. 138.

REFERENCES IN TEXT: **1.** There are about 2 centimetres of unpainted canvas beyond the top edge of the painted surface.

2. In the Prado copy (see Copies) the hindquarters of the horse in the extreme left foreground are visible (and on the farther side of them a standing man), another horseman is to be seen above and to the right of that in the bottom right corner, and the bottom edge of the canvas lies more than an inch below the tip of the left foot of the drinking man in the foreground, left of centre.

3. See the account by L. Justi in *Repertorium für Kunstwissenschaft*, 1929, pp. 255 ff.

4. George Lance stated (see *Report from the Select Committee on the National Gallery*, 1854, pp. 346–53) that the picture had been damaged by heat during relining and was largely repainted by him, partly in water-colour, *ca.* 1833, and that he had added several figures. His statements are somewhat confused and he later withdrew them in part (see W. Stirling, *Velazquez and his works*, 1855, pp. 217/18, note; *Report from the Select Committee*, etc., p. 556, no. 7867; *The Athenæum*, 1856, pp. 1165/6). Nevertheless the cleaning of 1950–2 proved him to have been telling the truth to a large extent; the greater part of the landscape background, many of the secondary figures and the shadows were found to have been restored or considerably over-painted; this overpaint could have been of the earlier nineteenth century, but none in a water-colour technique

was identified. On the other hand, his only piece of pure invention was to provide a man standing against the canvas enclosure in the centre background with a horse; this was removed.

5. *Cf.* Velázquez's portrait of Mateos at Dresden; the identity of the sitter is certified by P. Perret's engraving in Mateos' *Origen y Dignidad de la Caça*, 1634.

6. *Cf.* Velázquez's portrait of him in the Prado (Mayer no. 294 and pl. 81).

7. C. Justi, *Velazquez und sein Jahrhundert*, 1888, I, p. 382.

8. Alonso Martínez de Espinar, *Arte de Ballesteria y Monteria*, 1644, f. 53 r.

9. Chapters 23–5.

10. Book I, chapter 19, and Book II, chapter 32.

11. A feeble engraving of a hunt of this kind, by P. Perret after Francisco Collantes, dated 1634, is in Mateos' book (see the illustration included by E. du G. Trapier, in *Gazette des beaux-arts*, 1963, I, pp. 293 ff.). Preparations for a hunt of a similar kind are shown in a painting by Snayers 'La caceria de Felipe IV' (Prado, no. 1734). This is believed to have been commissioned in Flanders by Philip's brother the Cardinal-Infante Don Fernando for the Torre de la Parada and painted before 1638 (see Prado catalogue). A drawing of a hunt of a similar kind, attributed to Snayers, is in the Kunsthalle, Bremen.

12. One side of the passage is visible above on the left.

13. Mateos, *op. cit.*, f. 12.

14. Owing to the damage suffered by the picture, some of the *horquillas*, including the King's, now lack their forked ends.

15. A. Rodríguez Villa, *La corte y monarquía de España en los años de 1636 y 37*, 1886, p. 71.

16. Rodríguez Villa, *op. cit.*, p. 259.

17. Justi, *op. cit.*, I, p. 385.

18. *Cf.* Martínez de Espinar, *op. cit.*, ff. 175–7.

19. W. Armstrong, *The Life of Velazquez*, 1896, pp. 91/2.

20. E. du G. Trapier, *Velázquez*, 1948, pp. 230–2, and *op. cit.*, 1963, pp. 304 f. Trapier's opinion appears to be accepted by López-Rey, *op. cit.* (no. 138), where there is a misleading account of the picture's state of preservation. López-Rey assumes, without any given reason, that the painting was in the Alcázar at Madrid when the building was burnt in 1734). Both writers attach too much importance to the resemblance in composition of no. 198 to works by Mazo.

21. It is attributed to Mazo in the Alcázar inventory of 1686.

22. Prado nos. 890–9 are attributed to Agüero in the Aranjuez inventory of 1700.

23. *Cf.* Lázaro Díaz del Valle, *Epílogo y nomenclatura de algunos artífices* (see p. 374 of F. J. Sánchez Cantón, *Fuentes literarias para la historia del arte español*, II, 1933), and Jusepe Martínez, *Discursos practicables del nobilísimo arte de la pintura* (see *Fuentes Literarias*, III, 1934, p. 38).

24. *E.g.* J. Allende-Salazar, *Klassiker der Kunst: Velazquez*, 1925, p. 279, note to p. 91, and Mayer, *loc. cit.*

25. An anonymous journal covering the years 1636–38 has been preserved (published by Rodríguez Villa, *op. cit.*).

26. Published by G. Cruzada Villaamil, *Anales de la vida . . . de Velázquez*, 1885, p. 93: '. . . para que pueda mejor acudir al servicio de V. Magd. en esta ocasión que se ha mandado pintar para la Torre de la Parada en la Rª[?] muy grande'.

27. See M. Rooses & C. Ruelens, *Correspondance de Rubens*, VI, 1909, p. 170.

28. This and the following entries quoted are based on copies of the Royal inventories in the library of the Prado Museum.

29. '539. Vna pintura de tres varas y media de largo y dos de alto; de vna monteria de jabalies, del Rey nuestro señor Phelipe Quarto, que sea en gloria; original de mano de Diego Velazquez; con marco negro tasada en ciento y cinquenta doblones'.

30. According to Cruzada Villaamil, *op. cit.*, p. 94: 'Una tela Real de javalies con cuatro horquillas; es lienzo grande'. The reference to four *horquillas* is inexplicable unless it applies to the King and the three others immediately around the boar.

31. '381. Vna pintura de cazeria de tres varas de largo y dos y quarta de caida original de don Diego Velazquez. 6 mil meales.'

32. '920. Otro de una caceria del Sr. Felipe 4° que llaman comunmente la del Oyo; de cuatro varas de largo, y dos y media de caida: original de Velazquez'.

33. '920. Quatro varas de largo dos y media de alto, la caceria de Felipe IV en el parage llamado del Hoyo'.

34. '1186. Otro de tres varas y media de largo y dos de caida de vna caceria original de Velazquez de jabalies del señor Phelipe quarto en el sitio del Pardo en nueve mil reales'.

35. '1186. Una cazeria de jabalies en el Sitio de el Pardo tres varas y media de largo dos de caida—Velazquez'.

36. '29. Otra [pintura] copia de Velazquez: De una caceria del Pardo, de dos varas y cuarta de alto y tres varas y tres cuartas de ancho con marco dorado en tres mil reales'. The corresponding inventory number, 29, is painted in white in the left bottom corner of the Prado copy.

37. '29. 4 varas largo 2 y tercia alto copia de la caceria de Felipe IV en el parage llamado del Hoyo cuyo original es de Velazquez'. See also the preceding note.

38. Prado no. 1230. The size given in the Prado catalogue, $74 \times 119\frac{1}{4}$ ($1·88 \times 3·03$), is apparently only the sight size. This copy follows no. 197 exactly except in a few unimportant details. (See also note 2).

39. Canvas ($0·61 \times 1·07$); exhibited Stockholm, *Stora Spanska Mästare*,

1959/60, no. 110 and Madrid *Velázquez y lo velazqueño*, 1961, no. 108.

40. 26¼ × 43¼ (0·68 × 1·10). Brought from Spain in 1826 by Sir Lionel Hervey. In the Northwick collection and lot 1096 in the Northwick sale 26 July–30 August, 1859.

41. As 'Study from the celebrated Boar Hunt, after Velazquez.'

42. Mayer no. 143 and pl. 54.

43. Approximately 20 × 30 ins.

44. 17½ × 22½ ins. The picture shows the man in red and his four companions and immediately to the right the men beating the donkey.

45. 18 × 30 ins. The picture shows the same group of five men and the group with the drinking man immediately to the left.

46. It appears still in a Royal Inventory of 1814 (see above).

47. See *Report from the Select Committee* etc., 1854, p. 557, no. 7880.

745 PHILIP IV OF SPAIN (BUST PORTRAIT)

He wears the badge of the Order of the Golden Fleece on a gold chain.

Oil on canvas, 25¼ × 21⅛ (0·641 × 0·537); comparison with the many copies suggests that it has been cut down slightly on the left.

In fair condition. The shaded parts of the collar, the locks on the left side of the face and the right background are worn; there is slighter wearing elsewhere in the rest of the hair, the dress and the left background. Cleaned in 1946/7.

There are various *pentimenti* in the collar: the right side at first extended beyond the locks; there is a slight alteration to the upper side of the left edge and a still earlier outline of it was originally sketched in about an inch above and to the right of the present one.

Philip IV of Spain, son of Philip III and Margareta of Austria, was born in 1605 and ascended the throne in 1621. He married first Isabella (Elisabeth) de Bourbon, 1615, and secondly his niece, Maria Anna of Austria, 1649. His reign saw the decline of Spanish power. He died in 1665.

The king is wearing a collar of the type called *golilla*. This kind of collar was first worn by the court in 1623 and remained peculiar to Spain.

There is a very similar portrait of the king in the Prado,[1] in which Philip appears to be some years younger. In that portrait the dress is unfinished (it lacks the gold ornament and the chain) and the general effect is livelier. The treatment of the head differs in many small ways between the two pictures. Signs of ageing are more pronounced in the National Gallery picture, in the sagging flesh of the face and neck, the puffy eyelids, the scaly eyebrows and in the almost total absence of highlights in the eyes. The two paintings also differ in the treatment of the hair and collar: in the Prado version the hair on the right side of the head is slightly dishevelled and the collar on that side projects beyond the edge of the bottom curl; in the National Gallery portrait the hair on the right side is arranged in more regular waves and the ends of the hair projects beyond the collar.[2] These slight changes make it possible to distinguish which of the two compositions formed the basis for each

of the numerous repetitions. Three copies are known of the Prado composition,[3] whereas there are about twenty of the National Gallery type (see versions and copies).

Despite the existence of the Prado portrait the present picture seems perfectly acceptable as an autograph Velázquez, in the artist's last manner. Subtleties in the texture and pattern of the sitter's dress and in the treatment of the cloak about his shoulders, none of which are adequately captured in the copies, suggest furthermore that the portrait is autograph throughout—though the lower part of the picture is a relatively neutral foil to the head and thus difficult to assess in quality. The existence of the Prado portrait has led some authors to doubt the authenticity of the National Gallery picture,[4] but it is a mistake to see it merely as a version of the Prado portrait, for it shows the king as an older man. This factor helps in part to explain the discrepancy in handling between the two pictures, which are otherwise so alike. The discrepancy is exaggerated by the poorer state of preservation of the National Gallery picture (the cracquelure in particular emphasizes the misty appearance of the face). It is certainly unusual in Velázquez's work to find two portraits corresponding in composition yet showing the sitter at different ages, and there seems to be no clear evidence as to why this should be so. The existence of so many faithful copies of the two types of composition would seem to indicate that they were used as models for the mass-production of replicas. Thus the pattern for these replicas having been established by the Prado type of composition, Velázquez presumably later substituted the National Gallery type of composition in order to record the altered appearance of the king's face. The National Gallery portrait may thus be the actual model on which copies were based, or an autograph replica of this second (now lost) prototype.

The Prado design must have been made before 1655, when the head was copied in an engraving by Pedro de Villafranca.[5] The National Gallery design was copied in a number of other engravings by Villafranca, beginning in 1657,[6] and a date of about 1656 seems reasonable for the portrait. Judging by the apparent age of the sitter the Prado portrait would appear to date from just over mid-way between the portrait of Philip painted at Fraga in 1644 (New York, Frick Collection) and the National Gallery portrait, and it was possibly painted not long after Velázquez's return from Italy in 1651.[7]

The copies of no. 745 at Edinburgh and Geneva and in the Academia de San Fernando, Madrid (see below), have (or had)[8] companion bust portraits of Queen Mariana,[9] all of them copies of the same design.[10] This led Mayer[11] to suggest that the portrait of Mariana in the Schloss Rohoncz collection, Lugano,[12] which is also of that design, was painted by Velázquez as companion to no. 745.[13] Although copies or variants of portraits of the Queen may have been produced in Velázquez's studio to serve as pendants to portraits of the King, there is no reason to suppose that Velázquez himself painted a companion to each of his portraits of the sovereigns; in any case, the Schloss Rohoncz *Mariana* is the work of the studio or a follower.

VERSIONS AND COPIES: The version in the Prado is mentioned above. There are many other variants and derivatives of the National Gallery portrait, none of which seems to be by Velázquez; they vary greatly in quality and many are very poor, some being obviously pastiches of later date. The list which follows does not claim to be complete.

The following correspond closely to the National Gallery picture with only slight variations: Hermitage, Leningrad;[14] Academia de San Fernando, Madrid;[15] Instituto de Valencia de Don Juan, Madrid;[16] Geneva Museum;[17] San Diego Gallery, California;[18] National Gallery of Scotland;[19] F. J. Gsell sale, Vienna, 14 March, 1872;[20] Bangel sale, Frankfort, 27 November, 1906 (lot 21);[21] Mayer no. 251a (whereabouts unknown);[22] L. W. Neeld sale, London, 13 July, 1945 (lot 46);[23] the late Morris I. Kaplan sale, London, 12 June, 1968 (lot 65).[24]

The following correspond to the National Gallery picture but the gold buttons and shoulder braid are omitted: Leo Nardus collection, Suresnes, 1907;[25] Sedelmeyer, Paris, 1911;[26] Van Horne collection, Montreal;[27] Holford sale, London, 17/18 May, 1928 (lot 148);[28] formerly in the collection of Dr. Alexander Patoff, Paris[29] (in the Van Horne, Holford and Patoff pictures the right sleeve is embroidered or cut).

The following copies show little more than the head, which corresponds to that of no. 745: Bilbao Museum;[30] the Louvre, Paris;[31] Turin Gallery;[32] P. M. Turner sale, London, 6 February, 1952 (lot 27).[33]

The picture in the Cincinnati Museum[34] is apparently a copy, the head corresponding to the National Gallery type but with a different arrangement of the chain and Golden Fleece (these are possibly later additions).[35]

In a number of portraits of Philip IV of entirely different composition the head alone is copied from one corresponding to that in no. 745, e.g. the full-length portrait by Pedro de Villafranca in the Prado;[36] the full-length formerly in the Huth collection;[37] the weak full-length in the Convento de la Encarnación, Madrid;[38] the equestrian portrait in the Balbi di Piovera collection, Genoa;[39] a portrait of Philip IV and his family at a balcony in a mural painting on the staircase of the Convento de las Descalzas Reales, Madrid.[40]

ENGRAVINGS: The National Gallery portrait was, directly or indirectly, the prototype for engraved portraits of Philip IV by Pedro de Villafranca in the following books: Francisco de los Santos, *Descripción breve del Monasterio . . . del Escorial*, 1657;[41] anonymous, *Difiniciones de la Orden . . . de Calatrava*, 1661;[42] anonymous, *Difiniciones de la Orden . . . de Alcantara*, n.d. [1662 or 1663?];[43] Fr. J. Martínez, *Discursos theológicos y politicos*, 1664;[44] P. Rodríguez de Monforte, *Descripción de las honras que se hicieron a . . . D. Phelipe quarto* etc., 1666;[45] L. de Castillo, *Viage del Rey . . . a la Frontera* etc., 1667.[46] No. 745 was apparently also the model for an engraving by Manuel Rodríguez of 1665 or later.[47]

PROVENANCE: In the collection of Prince Demidoff, San Donato, Florence,[48] by September, 1862, and still there in September, 1864.[49] Purchased from Emanuel Sano, Paris, in June, 1865. Arts Council Spanish Paintings Exhibition, 1947 (no. 32); Cleaned Pictures Exhibition, National Gallery, 1947/8 (no. 63).

REPRODUCTION: *Illustrations: Continental Schools*, 1937, p. 369 (before cleaning); *Spanish School: Plates*, 1952, pp. 37 and 38.

REFERENCES, GENERAL: C. B. Curtis, *Velazquez and Murillo*, 1883, no. 123; A. L. Mayer, *Velazquez*, 1936, no. 247; J. López-Rey, *Velázquez*, 1963, no. 273.

REFERENCES IN TEXT: **1.** Prado no. 1185. The painted surface now visible is $27\frac{1}{8} \times 22\frac{1}{8}$ (0·690 × 0·563) but a further $\frac{5}{8}$ inch (0·015) of painted canvas has been turned over the stretcher on all sides, and the original painted surface must have been at least $28\frac{3}{8} \times 23\frac{3}{8}$ (0·720 × 0·593). To avoid possible errors, it should perhaps be mentioned that the repro-

ductions of the National Gallery and Prado portraits in *Klassiker der Kunst: Velazquez*, 1925, pp. 143 and 144, have had their captions interchanged.

2. The right side of the collar at first corresponded more or less to that in the Prado version, but was altered by the artist. There is no evidence that he made this alteration at a later date and there is no sign of *pentimenti* in the hair.

3. *I.e.* those at Vienna (Mayer no. 253), Glasgow (Mayer no. 251) and one formerly in the collection of Sir Philip Sassoon, London (Mayer no. 252); so far as the size permits a judgement, the portrait in the background of Mazo's family portrait at Vienna also seems to be after the Prado version. The Prado type of head is also repeated in two portraits with different costumes: the full-length in armour in the Prado (no. 1219; studio work) and a bust portrait formerly in the collection of the Marquesa de Argueso, Madrid (Mayer no. 245a; pastiche?). A head of Philip IV in the collection of Alberto Domínguez Cobo, Seville (42·5 × 34 cm.), is recorded by López-Rey (no. 272) as perhaps a modern pastiche of the Prado portrait.

4. The attribution is doubted most recently by López-Rey, who catalogues the picture (*op. cit.*, pp. 219 f.) as a 'remarkable portrait by a pupil of Velázquez', without naming the pupil capable of such remarkable work or identifying other pictures by him. It is hinted elsewhere (p. 109) that the artist was Mazo, on the grounds that a similar portrait hangs in the background of the portrait of the artist's family by Mazo at Vienna (this portrait was taken by MacLaren (note 3, above) as a derivative of the Prado portrait). But there is no direct stylistic evidence to justify such an attribution (*cf.* nos. 2926 and 1315 under Mazo above) and none is brought forward by López-Rey. His theory (p. 108) that Velázquez would have been unwilling to record the ageing of Philip's features seems pure invention, whether or not the National Gallery portrait is acceptable as an autograph work. López-Rey rightly stresses the difference in the age of the sitter between the Prado and the National Gallery portraits, and he emphasizes the fact that the king has a more pronounced double chin in the National Gallery portrait. It is not, however, true that this double chin— a second fold of flesh curving upwards from the collar—reappears in all the copies and versions, whether of the National Gallery or of the Prado compositions. The difference in question being so slight, some degree of variation in copies, both painted and engraved, is in any case to be expected, but comparing, for example, the Vienna version of the Prado composition (see note 3) and the Leningrad version of the National Gallery composition, it is clear that they differ from each other in this respect as in all the others.

5. Oval bust, in armour; inscribed: *Petrus de Villafranca sculptor Regius fact, Matriti 1655.* (A. M. Barcia, *Catálogo de retratos . . . Biblioteca Nacional*, 1901, no. 633.12.)

6. In Francisco de los Santos, *Descripción breve del Monasterio . . . del Escorial*, 1657. Reversed; inscribed: *Petrus de Villafranca Sculptor Regius. delineavit et Sculpsit. Matriti.* 1657 (W. Stirling-Maxwell, *Catalogue of prints engraved from the works of Velazquez and Murillo*, 1873, p. 15). Miss E. du G. Trapier (who doubts the National Gallery picture) states in error (*Velázquez*, 1948, pp. 328–31 and 333) that Lázaro Díaz del Valle says Velázquez was painting a portrait of the King in 1656, and thinks this engraving is probably after it. What he does say is that of the many pictures by Velázquez he had seen in the palace, he most admired one Velázquez had just painted ('acababa de hacer'); he was apparently writing in 1656 but does not mention when he saw the portrait (see F. J. Sánchez Cantón's transcription of Díaz del Valle's text in *Fuentes Literarias*, II, 1933, p. 349). In any case there is nothing to connect the portrait he mentions with the Prado and National Gallery busts or the engraving.

7. Mayer (nos. 240 and 253) has suggested that the Vienna copy of the Prado version may be a fragment of a full-length portrait sent to Archduke Leopold Wilhelm in February, 1653 (see H. Zimmerman in *Jahrbuch der*

Kunsthistorischen Sammlungen, Vienna, 1905, pp. 171 ff.), but it is most improbable that the Vienna bust is a part of a larger portrait. It is presumably no. 67 of the Ambras Castle inventory of 1663: 'Ein brustbild Philipi Quardi, khünig in Hispanien' (Zimmerman, *op. cit.*, p. 192).

8. The Edinburgh *Philip IV* had a companion portrait of Mariana (Mayer no. 494) when it was in the possession of the Marqués de la Vega-Inclán who sold both portraits but afterwards bought back the *Mariana*.

9. The Academia de San Fernando *Mariana* is Mayer no. 502 (the others are not in Mayer). It does not seem to be by the same hand as its companion *Philip IV*.

10. All three, and the Schloss Rohoncz picture mentioned further on in the main text, are copies with slight variations of the bust of a composition known only in the form of a three-quarter-length in the Ringling Museum, Sarasota, which is a studio work. Both they and the Ringling portrait may have been copied from a lost picture by Velázquez or, more probably, the Ringling version is a studio variant of the Prado full-length with a handkerchief (no. 1191; Mayer no. 484).

11. In *The Burlington Magazine*, LXVII, 1935, pp. 174 ff.

12. Mayer no. 501 and pl. 174. 0·674 × 0·546. Its provenance is: E. G —— sale, Paris, 20/1 April, 1876 (lot 38); G. Mailand sale, Paris, 2/3 May, 1881 (no. 131); W. de Zoete sale, London, 5 April, 1935 (lot 149).

13. It is perhaps just worth noting that the reflection in the mirror in the background of *Las Meninas* (1656) shows busts of the King and Queen similar to no. 745 and the Geneva/Madrid etc. *Mariana*, but in reverse.

14. Mayer no. 258 and pl. 92.

15. Mayer no. 254 and pl. 93.

16. Mayer no. 256. Reproduced in F. J. Sánchez Cantón, *Catálogo de las pinturas del Instituto de Valencia de Don Juan*, 1923, no. 17; 0·93 (in error for 0·73) × 0·54. Reproduced by López-Rey, pl. 282.

17. 0·665 × 0·56.

18. Ascribed to Mazo in the San Diego catalogue, 1947, p. 92 (repro-

duced). 22 × 18 inches. Ex Salzedo collection, Paris.

19. Neither the shoulder braid nor the Golden Fleece are to be seen in the Edinburgh portrait, which otherwise corresponds closely to no. 745, but as it now measures only $19\frac{5}{8} \times 17\frac{3}{4}$ inches it is probable that strips containing them have been cut off the sides and bottom. Acquired in 1923; formerly in the possession of the Marqués de la Vega-Inclán, Madrid (*cf.* note 8). Reproduced by López-Rey, pl. 285.

20. Curtis no. 130g. 0·65 × 0·55. From the collection of Count Feztetics. Reproduced in lithograph by F. Gerasch in the Gsell sale catalogue.

21. As by Mazo. 0·65 × 0·51. Reproduced in the Bangel sale catalogue, pl. IV.

22. Reproduced in Mayer, pl. 94.

23. 28 × 23 inches. A photograph is in the Gallery archives.

24. $25\frac{3}{4} \times 21\frac{1}{2}$ inches. From the collection of Major Arthur Chambers, and presumably the same picture as that in an anonymous sale, London, 14 February, 1958 (lot 67). A photograph is in the Gallery archives.

25. 0·82 × 0·60. Reproduced in *Chefs-d'œuvre ... à l'Exposition de la Toison d'Or ... 1907*, 1908, pl. 35.

26. $24\frac{3}{4} \times 20$ inches. From the collection of Prince Brancaccio, Rome. Reproduced in *Catalogue of the 11th series ... Sedelmeyer Gallery*, 1911, no. 74.

27. Mayer no. 260 and pl. 94. 0·37 × 0·25.

28. Mayer no. 259 and pl. 94.

29. Mayer no. 248 and pl. 94.

30. Catalogued twice by Mayer, nos. 242 and 249 (reproduced pl. 93). From the collection of Prince Cheremetieff.

31. Mayer no. 257. Reproduced in A. F. Calvert, *Velazquez*, 1908, pl. 129.

32. Mayer no. 255 and pl. 93.

33. $16\frac{3}{4} \times 14$ inches. In the possession of A. V. Scully, London, 1934; a photograph is in the Witt Library, London. This is perhaps the picture in the Earl of Clarendon's collection mentioned by C. Justi (*Velazquez und sein Jahrhundert*, 1888, II, p. 310) and in the Clarendon sale, London, 13

February, 1920 (lot 109), the size then given in the sale catalogue being 17 × 14¼ inches.

34. Mayer no. 241 and pl. 90. 23⅞ × 20 inches. Published by Mayer in *The Burlington Magazine*, XLVII, 1925, pp. 63 f. as an original of *ca.* 1651/2. Said to have been in the possession of Marshal Soult's descendants.

35. Mayer (no. 241) noted that the chain had been restored; the looped-up bottom part of it and the Toison d'Or appear, in fact, to be on a later addition to the original canvas.

36. Prado no. 1232; Mayer no. 245 and pl. 98. Already attributed to Villafranca (active 1632–78) in the 1700 Buen Retiro inventory. The 1945 Prado catalogue erroneously states that the head follows that of the Prado bust portrait.

37. Mayer no. 244 and pl. 99. In an anonymous sale, Sotheby's, 21 June, 1950 (lot 81). Apart from the head, the pose of the king is derived from a much earlier Velázquez portrait of the type of no. 1129 of this catalogue. The picture, now in the collection of H. Kisters, Kreuzlingen, has been published as autograph by K. Gerstenberg in *Pantheon*, 1960, pp. 211 ff.

38. Archivo Mas, Barcelona, photograph no. 27960. The pose is like that of the ex-Huth portrait (see preceding note).

39. Reproduced in the catalogue of the *Mostra della Pittura del '600 and '700 in Liguria*, Genoa, 1947 (no. 8 and fig. 12). With the exception of the head, the picture is copied from van Dyck's equestrian portrait of Marquis Francisco de Moncada in the Louvre, of which another copy, with the head of Charles I of England substituted, is in the Prado (no. 1484).

40. Reproduced in M. J. Friedländer and E. Lafuente, *El realismo en la pintura del siglo XVII: Países Bajos y España*, 1935, fig. 634.

41. See note 6. This and the following engravings by Villafranca are discussed and illustrated by M. López Serrano, in *Varia velazqueña*, 1960, pp. 510 ff. The engravings show very slight differences from the National Gallery composition and its derivatives, most obviously in that the top of the dress immediately beneath the *golilla* is white, like the collar itself.

42. Inscribed: *Petrus de Villafranca sculptor Regius delineavit et sculpsit Matriti. 1660.* (Barcia, *op. cit.*, no. 633.13.)

43. Reversed; inscribed: *Petrus a Villafranca scultor* [sic] *Regis, sculpsit Matriti, Anno 1662.* (Stirling-Maxwell, *op. cit.*, p. 16.)

44. López Serrano, *op. cit.*, p. 512 and pl. 219a (the illustrations on pl. 219 are printed in the wrong positions).

45. Inscribed: *P. a Villafranca sculp. Matriti, Anno. 1666.* (Stirling-Maxwell, *op. cit.*, p. 17).

46. Inscribed: *Petrus a Villafranca sculptor Regius.invent.et sculpsit. Matriti. 1667.* (Stirling-Maxwell, *op. cit.*, p. 16.)

47. Inscribed: *Didacus Velazquez Pict. Reg⁵ pinx.ᵗ Emman.ˡ Rodrig.ᶻ del.ᵗ et sculp.ᵗ* The date of the king's death, 1665, is given on the print. (Barcia, *op. cit.*, no. 633.24.) In this rather crude engraving the hair on the right side of the head does not correspond quite so closely to that of the National Gallery type as in Villafranca's engravings mentioned above, and the order worn is not the Golden Fleece, but in all other respects it follows the National Gallery and not the Prado type.

48. The collection was begun by Prince Nicholas Demidoff (who bought the convent of San Donato in 1814) and continued by his son, Prince Anatole Demidoff († 1870). A seal with the Demidoff arms is on the back of the stretcher.

49. Seen there by Sir Charles Eastlake in September, 1862, September, 1863 and September, 1864 (Eastlake notebooks in the Gallery archives).

1129 PHILIP IV OF SPAIN IN BROWN AND SILVER

He wears the badge of the Order of the Golden Fleece on a gold chain.
Signed on the paper in his right hand: *Señor.* | *Diego Velasquz.* |
Pintor de V. Mg[1]

Oil on canvas, *ca.* $76\frac{7}{8} \times ca.$ $43\frac{1}{4}$ (1·95 × 1·10); it has not been relined but has been reduced in size[2] and at a much later date increased by additions on all sides to $78\frac{1}{2} \times 44\frac{1}{2}$ (1·995 × 1·130).

The general condition is very good. The chin shadow is very slightly rubbed and there is a small tear on the left arm. The red curtain and table cover have faded; some discolorations in the former were glazed over after the picture was cleaned in 1936.

There are numerous *pentimenti*. The bottom edge of the cloak has been lowered on each side; the right leg was at first farther to the left; earlier positions of the left foot are visible above and below the present one; the point of the scabbard and the raised part of the cloak on the left were once lower; the legs of the breeches have been altered on the inner sides. There are also *pentimenti* in the collar.

Several vertical strokes where the artist has wiped his brush on the underpainting are now discernible through the dark grey of the right background above the hat.[3]

The signature is in the form of the opening words of a petition from Velázquez to the King.[4]

The King's collar is a *golilla* (*cf.* no. 745). His dress in this portrait is of unusual splendour; in most other portraits he wears dark clothes.

The weaknesses some writers[5] have claimed to see in the painting were presumably distortions due to the dark varnish which covered the surface prior to 1936; its removal has justified Justi's and Beruete's belief[6] that the picture is entirely autograph. Some half dozen only of Velázquez's pictures (three of them youthful works) are known to have been signed;[7] it is hardly likely that he would have put his signature to one which was not completely his own work.

The portrait is almost certainly identical with the famous portrait of the King by Velázquez which was in the library of the Escorial in the eighteenth century; it was one of a series of four portraits in the library, having as companions the portraits of Charles V and Philip III by Pantoja de la Cruz and that of Philip II in the style of Pantoja, all three of which are still *in situ*.[8] The date when Velázquez's portrait was taken to the library is unknown, but it would probably have been within the lifetime of Philip IV. It is unlikely to have been commissioned directly for the Escorial, since it was Velázquez's principal portrait of the King of the 1630's and that on which workshop variants were based over a period of years. It is possible that the reduction in its size, noted above, took place at the time of its installation in the library, bringing it into closer relationship with the three portraits already hanging there.

Pacheco relates that the King had allowed no other painter to portray him during Velázquez's absence in Italy in the years 1629–31.[9] Beruete[10] supposed that the present portrait was painted very soon after

his return and the fact that he signed it suggests that Velázquez attached particular importance to it. The pose follows almost exactly that of Rubens' full-length of the King now in the Durazzo-Giustiniani collection at Genoa[11] which must have been painted during or shortly after Rubens' visit to Spain in 1628/9. Some confirmation that Velázquez had this composition in mind in 1631/2 is provided by the three-quarter-length studio variant of the same design at Vienna (see Versions) which was apparently sent there in September 1632.[12] On the other hand, although the head of the National Gallery portrait could reasonably be dated 1631/2 on stylistic grounds, it is difficult to accept this date for the execution of the costume which is nearer to the freer manner of *The surrender of Breda* (completed by 1635). The explanation may be that work on this portrait was spread over several years; this would explain also the rather exceptional number of *pentimenti* and there is reliable evidence that Velázquez was inclined to be slow.[13] The head of no. 1129 is almost exactly repeated in the portrait of the King in hunting costume in the Prado, which was probably painted about the same time as the *Baltasar Carlos in hunting dress* of 1635/6;[14] there is also an engraving of 1638 which repeats the same head in reverse.[15]

This dating of 1631/2 to about 1635, proposed by MacLaren, has not found general acceptance,[16] but close comparison with the other variants of the composition suggests that the portrait was indeed painted over a period of years. If it is accepted that the picture at Vienna was based on the National Gallery painting, and not, as seems unlikely, on a now lost original, then it would appear that in 1631/2 Velázquez had established the general outlines of the pose and begun work on the actual face. It is only in these respects that the two portraits correspond.[17] In particular the appearance of the hair and of the moustache differ in the two portraits. Philip wears his hair longer in the National Gallery portrait and curling forward from the ears in the manner which is recorded in the portrait in hunting costume of the mid-thirties (?)[18] and in the equestrian portrait (also in the Prado) which is probably of the same date. From this it would appear that the National Gallery portrait was begun in 1631/2, when Philip looked as he appears in the Vienna portrait, and completed towards the middle 'thirties, when the head was used for the hunting costume portrait.

The third portrait type of the King evolved by Velázquez in the 1630's also appears to be based on the National Gallery composition. This is recorded in the full-length of the King in armour at Hampton Court, a picture which was probably sent off to England in 1638.[19] The King's body is shown here almost from the side, while the face corresponds with that of the National Gallery portrait, except for being rather awkwardly flattened on the right side, giving the impression that the head too is turned to profile. More hair is visible than in the Vienna and National Gallery compositions, and it has apparently been allowed to grow yet longer, covering more of the neck.[20]

Mayer supposed, without grounds, that Velázquez painted a companion portrait of Queen Isabella,[21] but there is no evidence of this. It

has also been unconvincingly claimed that the portrait of Queen Isabella attributed to Velázquez, formerly in the Huth collections,[22] is the companion to no. 1129.[23]

VERSIONS AND COPIES: The Vienna portrait type, corresponding with no. 1129 in the treatment of the face, is known in three studio-variants: that in the Vienna Museum (three-quarter-length),[24] and (full-length) in the Ofenheim collection, Jaispitz, Czechoslovakia,[25] and the Hermitage, Leningrad.[26] An early engraving (in reverse) shows the head and shoulders of the Vienna portrait.[27]

The whole head of no. 1129 reappears in the portrait of Philip IV as a sportsman in the Prado,[28] and (in reverse) in an engraving of 1638.[29]

The Hampton Court portrait type is known in several studio variants and later copies: as a bust-length composition in which the King is dressed in black, wearing a *golilla*—Lord Walston sale, London, 12 April, 1961 (lot 39);[30] as a portrait where the King wears a lace collar—the full-length in armour at Hampton Court,[31] the bust-length portrait in the Marquesa de Zurgena collection, Madrid (where a *pentimento* shows a *golilla* beneath the lace collar)[32] and a more recent head and shoulders, apparently based on the Hampton Court portrait, in the Musker collection.[33]

PROVENANCE: Almost certainly identifiable with the portrait of Philip IV mentioned in 1764 as being in the library of El Escorial, and probably first taken there in the seventeenth century.[34] Removed in November, 1809, on behalf of Joseph Bonaparte, by whom given to General Dessolle († 1828) in January, 1810.[35] Purchased from Dessolle's daughter by Woodburn[36] and sold to William Beckford. Said to have been bought in at a Beckford sale;[37] at his death in 1844 it passed into the collection of Beckford's son-in-law, the 10th Duke of Hamilton. Purchased for the National Gallery at the Hamilton sale, London, 17 June *sqq.*, 1882 (lot 1142; 6,000 gns.). Arts Council Spanish Exhibition, 1947 (no. 31); Cleaned Pictures Exhibition, National Gallery, 1947 (no. 62).

REPRODUCTION: *Illustrations: Continental Schools*, 1937, p. 370: *Spanish School: Plates*, 1952, pp. 39 and 40.

REFERENCES, GENERAL: C. B. Curtis, *Velazquez and Murillo*, 1883, no. 117; A. L. Mayer, *Velazquez*, 1936, no. 216; J. López-Rey, *Velázquez*, 1963, no. 245.

REFERENCES IN TEXT: **1.** Reproduced in actual size in *Spanish School: Plates*, 1952, p. 55.

2. Marks along the edges of the original canvas show that at one time it was mounted on a stretcher measuring $75\frac{3}{8} \times 41\frac{5}{8}$ ($1·915 \times 1·055$).

3. Similar brushmarks on the underpainting are to be found quite frequently in Velázquez's pictures (*e.g.* the *S. John on Patmos*, no. 6264 below), the Metropolitan *Christ at Emmaus* and the portraits of the Infante Don Carlos and 'El Primo' in the Prado).

4. *Cf.*, for example, those published by G. Cruzada Villaamil, *Anales de la vida . . . de Velázquez*, 1885, pp. 93 and 159. See also Mazo, no. 2926.

5. *E.g.* J. Allende Salazar, *Klassiker der Kunst: Velazquez*, 1925, p. 276,

note to p. 48; Mayer, *loc. cit.* Justi at first (*Velazquez und sein Jahrhundert*, 1888, II, p. 106) doubted whether it was entirely by Velázquez but afterwards (*op. cit.*, 2nd ed., 1903, II, p. 42) accepted it as entirely autograph but a study.

6. A. de Beruete, *Velazquez*, 1898, p. 61.

7. For a list of signed pictures see note 11 under no. 1315, ascribed to Mazo.

8. See G. de Andrés in *Archivo Español*, 1967, pp. 360 ff. This identification is based upon the fact that the portrait (see Provenance) belonged to General Dessolle; it is recorded by Padre Patricio de la Torre in a report on objects taken from the Escorial, commissioned by the Prior in 1814, that the portrait taken by General Dessolle was that from the Escorial: 'El general De

Souls [*sic*] los siguentes . . . El Retrato de Felipe IV, de Velázquez . . .' (quoted in *La Ciudad de Dios*, LXXVI, 1908, p. 413. The document appears to be no longer at the Escorial. It was probably removed to the archives of the Palacio de Oriente in Madrid, but is not easily traceable there). On the two portraits by Pantoja painted for the library in the 1600's see M. Kusche, *Pantoja de la Cruz*, 1964, nos. 11 and 42. Velázquez's portrait may have been amongst those given to the Escorial by Philip IV in 1654 (Andrés, p. 362). In 1814 a portrait of Charles II (ascribed to Claudio Coello) was exhibited in place of the missing portrait of Philip IV (Andrés, p. 363). Despite the dating proposed for Pantoja's portraits by Kusche, it would appear that they were installed in the library before 1605 (see Andrés, p. 361 and note 4). The portraits occupy the four bays of the library where piers projecting from the walls interrupt the sequence of book shelves. The size of the space available between the book case frames for each portrait is approximately 2 metres by 1·10 metres.

9. F. Pacheco, *Arte de la Pintura*, 1649, p. 105. Portraits of the king which appear to date from between 1628/9 and 1632 are discussed in note 20 below.

10. *Loc. cit.*

11. A poor reproduction is in the catalogue of the *Mostra della Pittura del '600 e '700 in Liguria*, Genoa, 1947 (no. 5; fig. 6). A three-quarter-length studio version is at Munich.

12. See Cruzada Villaamil, *op. cit.*, p. 75. A dating in 1632 for the Vienna portrait would appear to correspond with evidence based on the appearance of the King (see below).

13. *Cf.* Philip IV's letter of February, 1650, to the Duque del Infantado (published by Cruzada Villaamil, *op. cit.*, p. 176).

14. Prado no. 1189. It bears a later inscription: ANNO ÆTATIS SVÆ·VI·; if this is trustworthy—and the Prince indeed appears to be about six years old—the portrait must be of 1635/6, since Baltasar Carlos was born in October, 1629.

15. Frontispiece of J. A. de Tapia y Robles, *Ilustración del Renombre de Grande*, 1638; bust (inverted), in armour, apparently engraved by Herman Paneels, inscribed: *Ex Archetypo Velazquez. Matriti. 1638*. Illustrated by M. López Serrano in *Varia velazqueña*, 1960, II, pl. 212a. A small copy of the engraving, printed on a title page in 1640, is illustrated on pl. 213b.

16. M. Soria, *Art and Architecture in Spain and Portugal . . . 1500–1800*, 1959, p. 259, dates the picture about 1635, making no mention of the related portraits. López-Rey, *loc. cit.* gives the date as 1631/2; he supposes that a simple stylistic analogy can be drawn with the *Prince Balthasar Carlos with a dwarf* of 1631 (Boston, Museum of Fine Arts). Justi, *op. cit.* II, p. 105, claimed that the date 1636 was visible in no. 1129 on the letter held by the King. There is no sign of this, and there is scarcely even space for it.

17. The hands in the Vienna portrait differ from those in the National Gallery picture; X-ray photographs of the hands in the latter show no signs of alterations. Evidence that a lapse of time could occur in Velázquez's portraits between the painting of the face and the completion of the rest of the picture is provided by a story in J. Martínez, *Discursos . . .*, ed. 1866, p. 132 (cited by E. du G. Trapier, *Velazquez*, 1948, p. 269).

18. The portrait in hunting costume is sometimes dated 1632 because of its correspondence with the National Gallery picture (for example by Trapier, *op. cit.*, p. 190), but it seems unlikely that it records the King's appearance at the same moment as the Vienna portrait. It should perhaps be noted that the hunting costume portrait corresponds in the arrangement of the legs with the full-length versions of the Vienna picture, of which one is at Leningrad (see Versions and Copies).

19. Mayer no. 225; there is a companion portrait of Queen Isabella (Mayer no. 479) and the two are presumably the portraits to which reference is made in a letter of 26 July, 1638, from Sir Arthur Hopton, British Ambassador at Madrid to Lord Cottington.

20. There are some weak portraits of Philip which appear to show his likeness in the years between Velázquez's full-length (Prado no. 1182) as repainted in the late 1620's and the Vienna type of composition of 1632. The full-length in the John and Mabel Ringling Museum of Art, Sarasota (Mayer no. 207, pl. 83), resembles the Prado full-length in the pose of the sitter, but it shows the King at the moment when his moustache was apparently beginning to grow. The portrait thus seems to show the King as he looked slightly later than when he posed to Rubens at some time in 1628/9. The appearance of the King's face slightly before the Vienna type of head was evolved, by which time the King had allowed his hair to grow long at the back, appears to be recorded in the engravings of Pedro Perete of 1633 and (in reverse) 1636—the latter is illustrated by M. López Serrano, in *Varia velazqueña*, 1960, II, pl. 211a. The full-length painting of the King in the Montreal Museum of Fine Arts (Mayer no. 214, plate 84) is closely related, for the head, to this likeness by Parete. There is no evidence as to how far Velázquez himself was responsible for these portrait types. If they are due to another artist the evidence of Pacheco that the King allowed no one to portray him in 1629–31 seems invalidated.

21. Mayer, *op. cit.*, no. 476; he reproduces (pl. 180) as the 'original study' for a companion portrait a very poor copy or studio version of the bust of a full-length of the Queen of which there are a number of versions by Velázquez's following, the best of which is the three-quarter-length at Vienna (Mayer no. 482 and pl. 169) sent there in 1632 (*cf.* note 12).

22. Mayer no. 471 and pls. 164, 167; 79 × 44 (2·005 × 1·12).

23. This claim is made in the catalogue of the June, 1951, F. T. Sabin exhibition, London (no. 28), in *The Connoisseur*, August, 1951, p. 4, and by T. Crombie in *The Connoisseur*, 1958, p. 242, where it was suggested that the National Gallery portrait might be identifiable with a painting (no. 188) in the 1794 inventory of the Buen Retiro Palace. The history of the Huth picture when in the Spanish Royal collection has been worked out by the same author (see *Archivo Español*, 1961, pp. 47 ff.); it is there shown that no. 188 of the 1794 Buen Retiro inventory refers to the full-length in the Prado (no. 1182). If the National Gallery portrait was ever included in any royal inventory, it could not—in the absence of numbers on the canvas—be traced with any degree of certainty. If the portrait was taken to the Escorial at an early date, it would not have borne inventory numbers; none are now to be seen on the picture and none are visible in X-ray photographs of the bottom edge of the canvas. X-ray photographs show that the Huth *Isabella* once corresponded exactly with the studio work in the Copenhagen Museum (Mayer 474 and plate 165). It has been claimed (in the Sabin exhibition catalogue, and in *The Connoisseur*, 1958, p. 242) that the National Gallery portrait has been similarly overpainted, but this is not so. Slight alterations to the eyes and to the hair at the side of the face may be present, though the dark marks visible here are possibly actual shadows. X-ray and infra-red photographs show that there are no major alterations in the portrait except those visible to the naked eye. The discrepancy in quality between the Huth *Isabella* and the National Gallery portrait makes it seem highly doubtful (though in theory not impossible) that the two were actually painted as companion pieces, however well the two may fit together in composition as a pair. López-Rey (*op. cit.*, p. 237) supposes that the Huth *Isabella* is akin in point of execution to the National Gallery portrait.

24. Mayer no. 220 and pl. 85.

25. Mayer no. 219 and pl. 85 (detail of upper part only).

26. Mayer 218 and pl. 99.

27. Inscribed: *FILLIPO QUARTO RÈ DELLE SPAGNE DELLE | INDIE.&. | J. Toorenvliet. del. Cor. Meijssens. Fe. Vien.*

28. Mayer no. 222 and pl. 86.

29. See note 15 above.

30. 24¾ × 18 ins. Possibly identical with the picture (24½ × 17½ ins.) offered for sale by Sedelmeyer, Paris,

1897, no. 62, p. 72 of printed catalogue (with reproduction).

31. Mayer no. 225 and pl. 95.

32. Mayer no. 226 and pl. 89. Mayer claims for no. 226, p. 55, that the head in this portrait and in that at Hampton Court correspond exactly with the Hermitage portrait. In fact the head of the Hermitage portrait corresponds with the Vienna portrait type.

33. 19⅛ × 13⅜ ins. A number of other portraits of the King deriving from these compositions of the 1630's—not necessarily from any specific one—appear to be un-recorded in the literature, but available in photographs in the Instituto Diego Velázquez, Madrid, and the Instituto Amatller, Barcelona. One of the earliest of these would appear to be the bust portrait (in black, with *golilla*) in the Duque del Infantado collection, Madrid (0·84 × 0·70 cms.).

34. G. de Andrés, *op. cit.*, p. 362; the series of portraits are mentioned in A. Ximénes, *Descriptión del Real Monasterio de El Escorial*, 1764, p. 206, and by A. Ponz, *Viage de España*, II, 1773, p. 220. In both cases the portrait of Philip IV is praised and Velázquez is named as the author.

35. It appears in a list of paintings removed from Royal palaces, suppressed convents etc. and given by Joseph Bonaparte to various French generals by a decree of 4 January, 1810. General Dessolle received also two *Evangelists* by Ribera and *S. Joseph and Jesus* by Guido Reni (according to the late nineteenth-century copy of the list in the possession

of the Duke of Wellington). M. Lasso de la Vega, *Mr. Frédéric Quilliet Comisario de bellas artes del Gobierno intruso*, 1933, which is cited by Andrés, *op. cit.*, contains (Appendix III) a list dated 1 November, 1809, of objects and paintings removed from the Escorial at Quilliet's instigation; in the 15th group of objects are listed portraits of Charles V, Philip II, III and IV, and these are probably the portraits from the library (the names of the painters are not given). The pictures given to Dessolle are listed by Lasso de Vega, p. 32, but it is not stated there that they were amongst those from the Escorial; for this see note 8 above.

36. According to W. Stirling, *Annals of the Artists of Spain*, 1848, III, p. 1397.

37. It is presumably the 'beautiful portrait by Velazquez . . . lately sold at Fonthill and . . . acquired by its former possessor, Mr. Beckford' mentioned by W. Buchanan, *Memoirs of Painting*, 1824, I, p. 147. It is not, however, in the catalogues of the Fonthill sales of 17–27 September (1–11 October), 1822 or 23 September–2 October, 3–9 October and 10–15 October, 1823, nor in that of the W. Beckford sale, London, 9 *sqq*. May, 1817, and neither J. Storer, *Description of Fonthill Abbey*, 1812, nor J. Rutter, *Description of Fonthill Abbey*, 2nd ed., 1822, mention it. It appears in an inventory of the property of William Beckford at Lansdowne Gardens, Bath, made in 1844 after his death (ms. in the possession of the Duke of Hamilton).

1148 CHRIST AFTER THE FLAGELLATION CONTEMPLATED BY THE CHRISTIAN SOUL

In the centre, Christ, his hands attached to the column; on the right the Christian soul in the form of a kneeling child, behind which is its guardian angel.

Oil on canvas, 65 × 81¼ (1·65 × 2·06).

The condition is, on the whole, good but there are many local damages, especially in the background which is also worn. The figures themselves are better preserved; Christ's body has a few small damages, and wearing in the shadows; the skirt of the angel has two vertical damages on its right side; the child has a damage on the underside of the right wrist. Cleaned and restored in 1962.

There are *pentimenti* in Christ's loin-cloth, right thigh and right arm,

the angel's right side and the lower half of the child's robe. X-ray photographs, taken of the more important parts of the picture, show no signs of changes in the composition.

Once described as a vision of S. Bridget of Sweden. The correct identification of the unusual subject is due to F. Schneider[1] and is confirmed by a similar picture (but of different composition) by Juan de Roelas, in the Convento de la Encarnación at Madrid;[2] the two secondary figures in that painting are described in a document of 1616 as a soul (*alma*) and an angel, and it is inscribed: *Alma, duélete de mi—que tu me pusiste asi*. Justi[3] mentions another painting, clearly of the same subject, in the Church of the Merced Descalza at San Lúcar de Barrameda. There are no good grounds for the suggestion[4] that the present painting was a votive picture.

The picture is usually dated immediately before Velázquez's first journey to Italy, or in the years spent in Italy (1629–31), or immediately after the journey.[5] MacLaren suggested that the picture was painted very soon after, or, more probably, during the visit to Italy. He saw Bolognese and Roman influence in the rather academically-conceived figure of Christ which is almost unique in Velázquez's work and a resemblance in the head of Christ to the work of Guido Reni. In style the painting is close to *Joseph's coat brought to Jacob* (Escorial) and *The forge of Vulcan* (Prado) which were painted (in the main at least) in Rome.[6] On the other hand the figures to the left of Christ seem untouched by Bolognese influence. They are related to Velázquez's early works in the manner in which their draperies are painted and in the matter-of-fact presentation of two such visionary figures.[7] The picture is in many ways analogous with *Los Borrachos* of 1628/9 (Prado) and it seems most likely that it was painted at approximately the same time. The Bolognese character of the figure of Christ can perhaps be partly explained in terms of the subject matter.

Beruete thought the model for the angel might be the same as that for the so-called 'Sibyl' or 'Juana Pacheco' in the Prado; the resemblance is slight but the pictures seem to be not widely separated in date.[8]

DRAWINGS: A charcoal drawing, formerly in the Jovellanos Institute, Gijón,[9] of a figure in the same pose and with the same drapery as the angel but without wings, has been generally supposed to be a preliminary study by Velázquez. It is, however, of inferior quality and is more probably a rough copy after the painting. The drawing of a head of a bearded man in the Biblioteca Nacional,[10] which has been mentioned in connection with the head of Christ in the present picture, seems to have nothing to do with it and is certainly not by Velázquez.

PROVENANCE: Bought in Madrid in 1858 by John Savile Lumley[11] (later Sir John Savile Lumley and Baron Savile); lent by him to the British Institution, 1860 (no. 81), and the Société Néerlandaise de Bienfaisance exhibition, Brussels, 1873 (no. 174), and presented by him (when Sir John Savile Lumley) to the Gallery in 1883. Arts Council Spanish Paintings Exhibition, 1947 (no. 27). Exhibited, Madrid, *Velázquez y lo velazqueño*, 1961 (no. 89).

REPRODUCTION: *Illustrations: Continental Schools*, 1937, p. 371; *Spanish School: Plates*, 1952, pp. 41 and 42 (both before cleaning).

REFERENCES, GENERAL: C. B. Curtis, *Velazquez and Murillo*, 1883, no. 10; A. L. Mayer, *Velazquez*, 1936, no. 12; J. López-Rey, *Velázquez*, 1963, no. 12.

REFERENCES IN TEXT: **1.** In *Revue de l'art chrétien*, 1905, pp. 92–4 and 157/8.

2. See E. Tormo in *Boletín de la Sociedad Española de Excursiones*, 1917, p. 185; also *Archivo Español*, 1936, pp. 263 and 267.

3. C. Justi, *Velazquez und sein Jahrhundert*, 1888, I, p. 424 (as perhaps by Roelas). In this picture the angel is holding the child by the hand and indicates the prostrate Christ. The picture in the Cook collection mentioned by Justi (reproduced in *Klassiker der Kunst: Murillo*, 1923, p. 98) may perhaps represent the same subject but both the onlooking figures are winged.

4. Justi, *op. cit.*, I, p. 426. It has been further suggested (see Thieme-Becker's *Künstler-Lexikon*, XXXIV, 1940, p. 191) that it was painted in memory of Velázquez's second daughter, Ignacia, but it is not clear whether the child is a girl or a boy, and it does not seem to be intended for a portrait.

5. Mayer, *op. cit.*, as about 1629; E. du G. Trapier, *Velázquez*, 1948, as before 1629; in the exhibition catalogue, *Velázquez y lo velazqueño*, Madrid, 1961, p. 86, as about 1631/2; López-Rey, *op. cit.*, as 1626–8; etc.

6. A. Palomino, *Museo Pictórico* III, 1724, p. 330.

7. D. Angulo Iñiguez, *Velázquez, Cómo compuso sus principales cuadros*, 1947, pp. 83 ff., notes a similarity in pose between the angel in the present painting and one in a woodcut by Dürer for the Apocalypse. This connection seems very tenuous.

8. A. de Beruete, *Velazquez*, 1898, p. 64.

9. Mayer no. 591 and pl. 195. Inscribed in a later hand: *Velazquez*. It was destroyed in a fire in 1936.

10. Mayer no. 593 and pl. 194. (Mayer connects it with *The Forge of Vulcan*.)

11. Letter of 1883 from Savile Lumley (in the Gallery archives). The picture was seen in Savile Lumley's possession in Madrid by Sir Charles Eastlake in October, 1859 (Eastlake diary for 1859 in the Gallery archives).

1375 KITCHEN SCENE WITH CHRIST IN THE HOUSE OF MARTHA AND MARY

Christ is seen through an aperture on the right, with Mary seated and Martha standing.

The remains of a date which must originally have read 1618 are visible near the right edge between the table and the aperture.[1]

Oil on canvas, $23\frac{5}{8} \times 40\frac{3}{4}$ (0·600 × 1·035).

Very worn in the background and in the shadows; the more thickly painted parts—figures and still-life objects—are well preserved, except for areas of local damage: a vertical tear runs through the face of the old woman on the left, passing between her right eye and her nose, and the right side of her face is worn; a damage runs vertically beside the right side of the face of the young cook and there is a damage in her forehead and in her left wrist; in the background patches of damage occur over Christ's head and that of Martha. Cleaned and restored in 1964, when clumsy repainting was removed and the date exposed.[2]

Radiographs taken of the more important areas of the painting show no traces of alterations in the composition. They do show, however, many marks where the artist has wiped his brush on the underpainting in the lower right corner and in the centre background.[3]

The subject of the background scene is taken from Luke, x, 38–42: 'Now it came to pass, as they went, that he entered into a certain village: and a certain woman named Martha received him into her house. And

she had a sister called Mary, which also sat at Jesus' feet, and heard his word. But Martha was cumbered about much serving, and came to him, and said, Lord, dost thou not care that my sister hath left me to serve alone? bid her therefore that she help me. And Jesus answered and said unto her, Martha, Martha, thou art careful and troubled about many things. But one thing is needful: and Mary hath chosen that good part, which shall not be taken away from her'.

Many conflicting theories have been advanced about the identification of the figures in the foreground, about the relationship of these figures to those in the background, and about the setting of the background scene—whether it is an aperture, a picture hanging on the wall, or a reflection in a mirror hanging on the wall.[4] It has become clearer than before, as a result of the restoration of the picture, that the background scene is indeed shown through an aperture, cut into the thickness of the wall, and shown in perspective so that the three sides of the aperture which are fully visible are of unequal widths. It has also become clearer that the old woman in the foreground looks out of the picture towards the spectator and points out to him the figure of the young cook. The cook is preparing, with apparent reluctance, the meal laid out on the table—she appears to be pounding garlic. She is clearly to be associated with the biblical figure of Martha, whose story is shown in the background. The two foreground figures wear what is evidently contemporary dress; the clothes of the figures in the background are more generalized. There is some resemblance between the dress of the old woman in the foreground and that of Martha in the background. The correspondence is not, however, sufficiently close for the old woman to be identified with Martha[5] and such an identification seems in any case to be ruled out because of the age of the old woman, and because of her secondary role in the picture vis-à-vis the young cook. The cook is dressed quite differently from the figure of Martha in the background; she is thus not a direct representation of the biblical figure, but presumably a modern equivalent to her.

The picture is one of a group of horizontal *bodegones*, with prominent still life and half-length figures, all of the artist's Sevillian period and perhaps all dating from the earlier part of this period (*ca.* 1618–20). It resembles especially the *Negro Servant* (Sir Alfred Beit collection) because in that painting there is a representation of the Supper at Emmaus in the background, seen through a hatch, the door of which is plainly visible. The model for the old woman is probably the same as that for the *Old Woman frying Eggs* (National Gallery of Scotland), which is also dated 1618 and the only other *bodegón* by Velázquez known to be dated.[6] A pestle and mortar and a green-glazed oil jug like those in the National Gallery picture occur in this painting and in the horizontal *bodegón* of *Two Men at Table* (Apsley House).

In no. 1375, as in all Velázquez's early works, the influence of Caravaggio is paramount, but the composition appears to derive directly from the work of Pieter Aertsen or one of his followers. A similar use of a view into another room frequently occurs in paintings of this and

other religious subjects by Aertsen and Joachim Beuckelaer;[7] several of Velázquez's earlier *bodegones* appear to be reminiscent of these or other Northern prototypes. The National Gallery picture appears to be connected in particular with Jacob Matham's engraving (after Aertsen) of a woman cleaning fish in a kitchen with the Supper at Emmaus in the background.[8] The background scene is reminiscent of that in Aertsen's painting of *Christ in the House of Martha and Mary* (Vienna, signed and dated 1552).

The National Gallery painting is also related to a group of *bodegones* attributed to Velázquez, like the *Three Men at Table* (Hermitage, Leningrad), where the figures look directly out of the painting and appeal by their gestures and glances to the spectator. The effect of this is to add still further to the confusion of time and place between foreground and background, which is present to a lesser extent in all these biblical kitchen scenes. The spectator appears to be invited in the present instance to judge the actions of the participants in the light of moral commentary upon their actions provided by the background scene.

The National Gallery picture seems to betray immaturity in the confusion of its subject matter; it is exceptional in Velázquez's work in its coupling of a direct appeal to the spectator with background commentary upon the action of the main figures. Inconsistencies of time and place are, however, present in later pictures by the artist of religious and mythological subjects; indeed almost all Velázquez's pictures of such subjects are disturbing because of the very nature of his style. *Las Hilanderas* (Prado) has some resemblance to the National Gallery painting because one episode of the fable of Arachne is enacted in the foreground as a genre scene, while a different episode of the same story takes place in fancy dress in the background.[9] In *Los Borrachos* (Prado) there is no background scene but unity of time and place within the picture is abused, as in the National Gallery painting, because of the presence, side by side with the god Bacchus, of figures dressed in contemporary clothes, who are put in direct communication with the spectator.[10]

PROVENANCE: In the collection of Lt.-Col. Packe,[11] Twyford Hall, Norfolk; Lt.-Col. Packe (deceased) sale, London, 18 June, 1881 (lot 18; 21 gns.),[12] bought by Sir William H. Gregory, by whom bequeathed to the National Gallery, 1892. Arts Council Spanish Paintings Exhibition, 1946 (no. 21) and 1947 (no. 28). Exhibited Madrid, *Velázquez y lo velazqueño*, 1961 (no. 35).

REPRODUCTION: *Illustrations: Continental Schools*, 1937, p. 372; *Spanish School: Plates*, 1952, pp. 43 and 44 (both before cleaning).

REFERENCES, GENERAL: A. L. Mayer, *Velázquez*, 1936, no. 9; J. López-Rey, *Velázquez*, 1963, no. 8.

REFERENCES IN TEXT: **1.** The letters of the date are in black paint, corresponding with those of other dated paintings of Velázquez's Seville period, including *The Adoration of the Magi* of 1619 (Prado) and the *Old* *Woman frying Eggs* of 1618 (Edinburgh; see M. Baxandall in *The Burlington Magazine*, 1957, pp. 156 f. and fig. 21). In the National Gallery picture the first figure one is invisible, the figure six can be clearly seen, the

second figure one is almost invisible, the figure eight is abraded at the lower left and looks at first sight like a figure nine. It is, however, unlike the figure nine of the Prado *Adoration of the Magi*, and corresponds exactly with the type of figure eight in the Edinburgh picture (see A. Braham in *The Burlington Magazine*, 1965, p. 362 and fig. 24). The date of the Edinburgh painting is framed between dots of paint; a dot is visible after the date in no. 1375. As pointed out by Miss Joyce Plesters, X-rays appear to show that a large group of early pictures by Velázquez were painted on canvas cut from the same roll. It is characterized by its relatively open weave, and was apparently used for the present painting, for the Edinburgh picture, for the *S. John* (no. 6264 below) and its companion, the *Immaculate Conception*, and for the *Water Carrier of Seville* (Apsley House). In contrast to this group of pictures is the Apsley House *Two Men at Table*, which is an early work painted on a fine canvas. Unfortunately no X-rays appear to have been taken of the 1619 *Adoration of the Magi*.

2. For an account of the cleaning see Braham, *op. cit.*

3. Such fortuitous brushmarks are extremely frequent in Velázquez's paintings (*cf.* no. 6264 below).

4. There have been, most recently, the following interpretations: E. du G. Trapier, *Velázquez*, 1948, pp. 72 f., sees the background scene as a framed painting, and believes that the old woman is directing the cook. M. S. Soria in *The Burlington Magazine*, 1949, p. 127, believes the background scene to be visible through an aperture, but he goes on to suggest that the old woman is pointing to the biblical parallel; his attempt to show that the painting is an illustration of a sentence from St. Theresa's *Libra de Fundaciones* (ch. V, verse 7), is unconvincing, since the text is so vague and commonplace in its implications. The same author in *Art and Architecture in Spain and Portugal . . . 1500–1800*, 1959, p. 254, suggests further that the old woman by pointing out to the cook the biblical parallel is attempting to encourage her in her work (see also K. M. Birkmeyer in *Gazette des beaux-arts*, 1958, vol. 52,

p. 67). This appears to be reading more into the painting and into the biblical story than is actually given. López-Rey, *op. cit.*, p. 32, suggests that the background scene is a reflection in a mirror, and says that the cook is identifiable with Martha, who is not, according to him, present in the background.

5. It was accepted by MacLaren that the old woman in the foreground might represent Martha.

6. See Baxandall, *op. cit.* The curiously clumsy *Young woman at a table* in the Bozo Maric collection, Santa Monica, U.S.A. (published by Soria, *op. cit.*, 1949, pp. 123/4 and pl. 1), appears to show the same girl as no. 1375, as Soria points out. If this is by Velázquez, as seems rather doubtful, it must be even earlier than the National Gallery picture.

7. Aertsen's compositions of this kind were derived, ultimately, from Tintoretto and his followers (e.g. *Christ in the house of Martha* at Munich). Velázquez's *bodegones* show no evidence of having been based directly on the latter.

8. A. Bartsch, *Le peintre graveur*, III, 1803, Matham no. 165. A. L. Mayer was the first to observe the connection (in *Kunstchronik und Kunstmarkt*, N.F. xxx, 1918/19, i, pp. 236/7). Matham's preparatory drawing is illustrated by J. Bruyn in *Oud Holland*, 1951, p. 46. His engraving is illustrated in F. W. H. Hollstein, *Dutch and Flemish etchings* etc., vol. XI, p. 232; the same composition engraved in reverse by Abraham van Lier (active ca. 1603–1618) is also illustrated there (p. 4).

9. See D. Angulo Iñiguez in *Archivo Español*, 1948, pp. 1 ff., where the connection with the National Gallery painting is considered (p. 16). It is suggested there that the two paintings are alike because both show two episodes of the same story. This appears to be an over-simplification of the National Gallery painting; the dislocation of time and place between foreground and background seems more extreme than in *Las Hilanderas*. It appears to be a more derivative picture, the biblical scene providing the justification for the genre scene in the foreground, as in the Flemish pro-

totypes (cf. the strictures of Vicente Carducho, *Diálogos de la Pintura*, 1633, f. 117, on a similar representation of the same subject).

10. Confusion of a more traditional kind is present in the *SS. Anthony and Paul the Hermit* (Prado) where S. Anthony appears no less than five times.

11. The 1881 sale catalogue gives the name of the former owner as 'the late Lt.-Col. Packe of Twyford Hall'; this could be either Lt.-Col. Henry Packe († 1859), who was in Spain during the Peninsular War, or his third son, Lt.-Col. Charles Frederick Packe (date of death unknown).

12. The markings corresponding to this sale are on the back of the picture.

2057 THE TOILET OF VENUS ('THE ROKEBY VENUS')

Oil on canvas (broken edges), *ca.* $48\frac{1}{4} \times ca.$ $69\frac{3}{4}$ (*ca.* $1\cdot225 \times ca.$ $1\cdot77$); possibly cut down slightly on the left.

In good condition; the shaded parts of Cupid's flesh and Venus's arm are rubbed, the reflection in the mirror is slightly worn and the paint cracked in places,[1] and there are a number of small areas of local damage (one in the centre of Venus's hair). There are old tears across Venus's arm and the small of her back; her hip and back were cut in seven places by a suffragette demonstrator in 1914.[2] Cleaned and restored in 1966, when some overpaint was removed from the side of the canvas to the left to reveal a toe which had been covered.

There are many visible alterations by the artist. To the left of Venus' head is an earlier profile, more erect and turned slightly more to the left so that the end of the nose was to be seen. An even earlier outline of the profile is about $2\frac{1}{2}$ inches still farther to the left and slightly higher than the present head;[3] an earlier outline of Venus's arm above the present one and more to the left corresponds to the first position of the head. The left shoulder also seems to have been at one time further to the left. There are *pentimenti* in the top and left side of the mirror, the back of Cupid's head and his buttocks. A horizontal seam in the original canvas (*ca.* $0\cdot14$ from the top) runs through the centre of Cupid's head and suggests that the picture may possibly have been smaller at first and shown Venus alone with her head in profile and that the addition to the canvas was made when Cupid and the mirror were added.[4] Possible confirmation that Cupid was an afterthought is provided by his left leg and foot which are apparently unfinished; the drapery between Venus's left leg and Cupid's right is also apparently unfinished.

The supposed signatures of Juan Bautista del Mazo and Anton Raphael Mengs in the bottom left corner[5] are purely accidental marks.

Various fanciful identifications of the model for Venus have been suggested; the features seen in the mirror are so vague as to make recognition impossible.[6]

The 'Rokeby Venus' was traditionally considered, on stylistic grounds, one of Velázquez's latest works, but MacLaren discovered that the picture was described in an inventory of paintings belonging to Don Gaspar de Haro y Guzmán of June, 1651.[7] The *Venus* was probably painted even earlier than 1651, for Velázquez did not return from his second visit to Italy until that year, according to Palomino not until

June.[8] It was obviously painted under strong Italian, particularly Venetian, influence and this, in conjunction with its appearance in the 1651 document, suggests that it may have been done by Velázquez in Italy, and sent back before his return. It is not, however, impossible that the picture should have been painted shortly before Velázquez's departure for Italy in November, 1648. The precise date is difficult to determine in the absence of comparable pictures which are datable to the late 1640's.

The subject of Venus at her mirror attended by Cupid was popularized by Titian, as was also the theme of Venus lying full length on a bed, and that of a full length nude seen from behind (*Nymph and Shepherd*, Vienna). Venus is shown with a mirror, from the back and sitting, in Venetian compositions of the sixteenth century and in one by Rubens (Vaduz, Liechtenstein Collection).[9] Justi[10] pointed out that Venus' pose may be a reminiscence of the classical antique statue of a sleeping hermaphrodite now in the Louvre, a cast of which was among those ordered in Rome in 1650/51 by Velázquez for the Royal collection.[11] The pose is still nearer to that of the draped Ariadne now in the Pitti Gallery, a cast of which also was sent to Madrid. (That Velázquez studied the antique statues at the Villa Medici during his earlier visit to Rome is attested by Pacheco.)[12] Various other sources for the pose of Venus have been suggested, in Northern prints and in the work of Michelangelo, but none are really convincing.[13] As might be suspected, direct borrowings of poses are extremely rare in Velázquez's work, and it is difficult to decide for certain what may have inspired some of his compositions. Some Bolognese paintings of the early seventeenth century, which Velázquez may have seen during his visits to Italy are related in subject matter to the Rokeby Venus.[14] The picture is, however, most unusual in the prominence given to the mirror, reflecting the face of the goddess; in this it is related to Velázquez's *Las Meninas*, where portraits of Philip IV and Queen Mariana are present in the composition, as reflections in a mirror.

The picture was shown shortly after being painted in a black frame,[15] black being also the colour of the mirror frame within the painting.

The *Toilet of Venus* is Velázquez's only surviving painting of a female nude; but although such subjects are rare in seventeenth-century Spanish painting he apparently painted at least four others of a similar kind. Two of these, *Cupid and Psyche* and *Venus and Adonis*, were probably painted for Philip IV.[16] A painting of a nude woman by Velázquez is mentioned in the estate of Domingo Guerra Coronel in 1651,[17] and a recumbent Venus by him was among his possessions at the time of his death in 1660.[18]

PROVENANCE: It first appears in the inventory of the possessions of Don Gaspar Méndez de Haro, Marqués del Carpio and de Heliche, in Madrid, June 1651;[19] it was apparently listed among the possessions of the Marquesa del Carpio in 1669.[20] It is not certain whether the painting was in the collection of pictures belonging to Don Gaspar sent from Rome to Naples in 1682 and still in Naples in 1688.[21] Don Gaspar died in 1687 and the picture passed to his daughter,

Doña Catalina Méndez de Haro y Guzmán, who married the 10th Duke of Alba in 1688; it remained in the Alba collection [22] until after the death in 1802 of Doña María Teresa Cayetana de Silva, Duchess of Alba, when her heirs sold it by order of Charles IV to the Queen's favourite, Don Manuel Godoy, Principe de la Paz.[23] It was bought between October, 1808 and September, 1813,[24] by G. A. Wallis for W. Buchanan, and brought by him to England in September, 1813;[25] in January, 1814, it was apparently in the possession of George Yeates [26] and was sold shortly afterwards to John Bacon Sawrey Morritt. In the Morritt collection, Rokeby, Yorkshire; Art Treasures Exhibition, Manchester, 1857 (provisional catalogue, no. 1079; definitive catalogue, no. 787); exhibited Royal Academy, 1890 (no. 135). Sold by H. E. Morritt in 1905; exhibited at Messrs. Agnew's in 1905 (no. 9) and purchased from them by the National Art-Collections Fund, by whom presented to the Gallery in 1906.[27] National Art-Collections Fund Exhibition, National Gallery, 1945/6 (no. 6); Arts Council Spanish Paintings Exhibition, 1947 (no. 30). Exhibited, Madrid, *Velázquez y lo velazqueño*, 1961 (no. 76).

REPRODUCTIONS: *Illustrations: Continental Schools*, 1937, p. 373; *Spanish Schools: Plates*, 1952, pp. 45 and 46 (both before cleaning).

REFERENCES, GENERAL: C. B. Curtis, *Velazquez and Murillo*, 1883, no. 34; A. L. Mayer, *Velazquez*, 1936, no. 58; J. López-Rey, *Velázquez*, 1963, no. 64.

REFERENCES IN TEXT: **1.** The state of preservation of the image in the mirror is far better than is sometimes claimed. No evidence was found during the cleaning of the picture in 1966 of the face having been extensively repainted, as has usually been supposed (see A. P. Laurie, *New light on old masters*, 1935, pp. 129 ff.). A largely misleading account of the condition of the picture is offered by López-Rey, *op. cit.*, ed. 1968, p. 104.
2. See *The Times* for 11 and 13 March, 1914.
3. This can be seen more clearly in infra-red photographs.
4. See N. MacLaren, *Velazquez, The Rokeby Venus*, The Gallery Books no. 1, n.d. [1943], pp. 14 ff.
5. *Morning Post*, 5 April sqq., 1910; *The Burlington Magazine*, XVII, 1910, p. 70.
6. It has been suggested that the same model appears in *The Coronation of the Virgin* and in *Las Hilanderas* (both Prado), and in a picture attributed to Velázquez, *A Woman as a Sibyl* (New York, private collection) (see López-Rey, *op. cit.*, p. 89).
7. This inventory is in the Duke of Alba's archives at Madrid, and had previously escaped notice. It was discovered with the help of Señor J. M. Pita, curator of the Duke of Alba's art collections (see J. M. Pita Andrade in *Archivo Español*, 1952, pp. 226/7). It is in a folder inscribed: 'M^d [*i.e.*

Madrid] 1° de Junio de 1651 | Libro Primero | del menage de la cassa del ex^m.o s. Don Gaspar | Mendez de haro y Guzman. Marques de Eliche' etc. Although the list of paintings itself is undated, internal evidence shows clearly that it is part of the general inventory to which the folder refers. It may also be noted that a *later* marginal annotation to the penultimate item on the list is dated 1653. Item no. 222 of the list is: 'Una pintura en lienço de vna muger des|nuda tendida sobre vn paño pintada | de espaldas recostada sob^re el braço derecho | mirandose en vn espejo q(ue?) tiene vn | niño de la mano de Velasquez de dos baras | y media de ancho y vna y media de cayda | con su marco negro' [= 50 × 83 inches; 1·27 × 2·11].
8. See A. Palomino, *Museo Pictórico*, III, 1724, p. 340.
9. See F. J. Sánchez Cantón in *Archivo Español*, 1960, pp. 137 ff.
10. C. Justi, *Velazquez und sein Jahrhundert*, 1888, II, p. 368.
11. See A. Palomino, *El Museo Pictórico*, III, 1724, p. 339.
12. F. Pacheco, *Arte de la Pintura*, 1649, p. 104. In this connection it is perhaps worth mentioning that *Mercury and Argus* also may have been partly inspired by a classical antique statue (*cf.* Justi, *op. cit.*, II, p. 367).
13. A derivation from one of the small bronze-coloured nudes of the

Sistine ceiling is proposed by C. de Tolnay, *Michelangelo*, vol. II, *The Sistine Ceiling*, 1945, p. 71, in *Varia velazqueña*, 1960, p. 339, and in *Archivo Español*, 1961, pp. 31 ff. M. S. Soria believed that the picture derived from the 'Venus and Adonis' engraved by Philip Galle after Antonie van Blocklandt, see *Archivo Español*, 1953, pp. 271 f., and *Art and Architecture in Spain and Portugal . . . 1500 to 1800*, 1959, p. 266. Three prints of a similar character to Galle's are reproduced in F. J. Sánchez Cantón, *op. cit.*

14. A full-length Venus with cupid on a bed by Guido Reni exists at Dresden. A toilet of Venus, including the figure of Cupid holding a mirror, by Annibale Carracci is at Washington. The bacchanalian scene by the same artist in Florence (Uffizi) shows principally a naked woman shown from the back, her head in profile; her pose derives from that of a figure in the foreground of Titian's *Diana and Callisto* (on loan to the National Gallery of Scotland).

15. See note 7.

16. These are listed in the Alcázar inventory of 1686 in the Salón de Espejos: 'otros dos quadros yguales, de a vara de alto y media de ancho, el vno Adonis y Venus, el otro de Siquis y Cupido: originales de mano de Velazquez'. Both were probably destroyed in the Alcázar fire of 1734. P. de Madrazo (in *Illustración Española y Americana*, 8 November, 1874) and Justi (*op. cit.*, II, p. 372) supposed the Psyche and Cupid of the inventory to be the 'Rokeby Venus', but the subject is certainly different, as also the size and shape, furthermore the latter was already in the collection of the Marqués del Carpio in 1651 (see Provenance).

17. This was an upright composition, $2\frac{1}{2} \times 2$ *varas* (83 × 66 inches); see the Marqués del Saltillo in *Arte Español*, XV, 1944, pp. 44/5.

18. No. 593: 'Vna Venus tendida, de Velazquez de dos baras' (2 *varas* = *ca.* 66 inches). (See F. J. Sánchez Cantón in *Archivo Español*, 1942, p. 82). Before the discovery of the Gaspar de Haro inventory of 1651 it was thought that this picture was the 'Rokeby Venus'.

19. See note 7.

20. No. 293, described as the *Venus del espejo*; the size is there given as $2\frac{1}{2}$ *varas* high by 3 *varas* wide (*ca.* 83 × 100 ins. or 2·11 × 2·54), according to the Duke of Alba in *Boletin de la Academia de Historia*, Madrid, 1924, pp. 22 and 88/9. The 1669 inventory cannot now be found in the Alba archives, and is believed to have been destroyed when the Palacio de Liria was burnt during the civil war (see J. M. Pita Andrade, *op. cit.*, p. 225 and note). Antonia María de la Cerda married Gaspar de Haro, Marqués del Carpio, in 1661 and died in 1669.

21. A. de Beruete, in *Cultura Española*, 1906, p. 161, and the Duke of Alba, *op. cit.*, p. 20. The 1682 and 1688 inventories, like that of 1669 (see note 20) cannot now be found, but Barcia refers to a picture described as 'Una Venus, de tamaño natural, echada, desnuda, con un niño que la presenta un espejo en el que se ve la pintura de la Venus. Original de Don Diego Velázquez' (see A. M. Barcia, *Catálogo de la colección de pinturas del Duque . . . de Alba*, 1911, p. 246). Barcia makes no mention of the date of the inventory containing this item. If the picture was indeed sent to Italy, then it should be recorded in the surviving inventory of 1687 of works in the collection in Italy on the death of Don Gaspar, but there is no mention of the Venus in this document (see J. M. Pita Andrade, *op. cit.*, pp. 233 f.)

22. A. Ponz, *Viage de España*, V, 1776, p. 333; H. Swinburne, *Travels through Spain in the years 1775 and 1776*, 1779, p. 353. Neither of these writers mentions Cupid, and Swinburne says that Venus holds the mirror in her hand (but their descriptions otherwise tally with no. 2057). This led some critics of the picture in 1910 to suppose that the 'Rokeby Venus' was not the Alba picture; identity is, however, proved beyond doubt by a pencil copy, made *ca.* 1756–9 by R. Cooper, which corresponds exactly in design to no. 2057 and is inscribed on the back: '"Venus and Cupid". Velasquez. Large as life. In the collection of the Duke of Alva, Madrid. (Velasquez painted this as a companion to the Venus of Pordenone). Not hung up owing to the

subject' (information given by C. H. Lee, according to the National Gallery catalogue, 1913).

23. Together with the 'Casa Alba Raphael' and Correggio's *Mercury instructing Cupid* (National Gallery, no. 10); see Barcia, *op. cit.*, p. 260.

24. The Spanish Government in 1808 ordered Godoy's property to be sequestrated and sold (W. Buchanan, *Memoirs of Painting*, 1824, II, pp. 225–7). It is not quite clear when his paintings were eventually sold; no. 2057 is included in a ms. list of them made by F. Quilliet and dated 1 January, 1808 (in the Archivo Histórico Nacional, Madrid): 'Velazquez. Venus nuë se mire: belle esquisse,'

but it is not in the Godoy inventory of August 1813. (Late nineteenth-century copies of these two lists are in the possession of the Duke of Wellington.)

25. Buchanan, *op. cit.*, II, pp. 237/8 and 243.

26. It is included by Yeates in a list of pictures for sale sent in a letter of 19 January, 1814 (see *Letters . . . to Thomas Penrice . . . 1808–14*, n.d., p. 39).

27. According to a letter of Stanley Cursiter, of which a copy was kindly provided by Mr. Denys Sutton, the picture was exhibited at the Royal Scottish Academy before being placed on exhibition at the National Gallery.

6264 S. JOHN THE EVANGELIST ON THE ISLAND OF PATMOS

S. John is shown on the island of Patmos writing the Apocalypse: his eagle sits to the left. He looks towards the vision of the woman of the Apocalypse with the dragon, small figures in the upper left-hand corner of the canvas with the sea beneath them.

Oil on canvas: $53\frac{1}{4} \times 40\frac{1}{4}$ ($1 \cdot 355 \times 1 \cdot 022$).

In good condition. The drapery of the saint is slightly worn in places; a tear runs downwards through the back of his head, crossing the ear. The landscape has evidently worn thin, allowing marks to become visible where the artist wiped his brush clean on the underpainting: (a) to the right of the tree behind the saint, and (b) on the stone where the eagle sits. This is a characteristic practice of Velázquez, especially in his early works (see no. 1375 above). Cleaned and restored in 1946.

The instep of the saint's left foot was possibly at first lower; other slight *pentimenti* appear to be concealed beneath the very prominent grey lay-in around the figure. X-rays of the head show no signs of alterations beneath the surface.

The vision in the upper left corner is based on the text of Revelation xii, 1–4 and 14: 'And there appeared a great wonder in heaven; a woman clothed with the sun, and the moon under her feet, and upon her head a crown of twelve stars: And she being with child cried, travailing in birth, and pained to be delivered. And there appeared another wonder in heaven; and behold a great red dragon, having seven heads and ten horns, and seven crowns upon his heads. And his tail drew the third part of the stars of heaven, and did cast them to the earth: and the dragon stood before the woman which was ready to be delivered, for to devour her child as soon as it was born. . . . And to the woman were given two wings of a great eagle, that she might fly into the wilderness, into her place, where she is nourished for a time, and times, and half a time, from the face of the serpent.'

No. 6264 and the *Immaculate Conception* (on loan to the National

Gallery)[1] must be the two pictures which are first recorded in 1800 in the Chapter House of the Convent of the Shod Carmelites in Seville.[2] The two pictures have very nearly the same dimensions; they are alike in style and closely related in subject matter. Both are clearly very early works by Velázquez, certainly painted before the artist's move to Madrid in 1623, and usually dated to about 1618.[3] They are probably earlier than the *Adoration of the Magi* (Prado no. 1166) which is dated 1619—the only dated picture of Velázquez's Sevillian period which is comparable in subject matter.

It is sometimes suggested that no. 6264 and the *Immaculate Conception* may not have been painted as pendants, because there is some difference in scale between the figure of S. John and that of the Virgin in the *Immaculate Conception*; and it might be further objected that other instances of these two subjects being represented in a pair of paintings are apparently unknown. There is, even so, good reason to believe that the two canvases were painted as complementary to each other and that they were intended to be seen together. As well as being alike in size, style and provenance, the two paintings appear to illustrate in conjunction with each other a particular aspect of the dogma of the Immaculate Conception, and at the time when they were painted this programme would have had an obvious importance as propaganda. S. John was the protector of the Virgin after the Crucifixion (John xix, 26/7) and the text from his Apocalypse illustrated by Velázquez was regarded as one of the proofs of the Immaculate Conception—the pictorial iconography of this event was in part derived from S. John's description of the Woman of the Apocalypse.[4] At the date when Velázquez's pictures were painted there was agitation, especially from Spain, to have the dogma of the Immaculate Conception officially established.[5] This led to the decree of 1617 of Paul V in which it was forbidden to affirm in public acts that the Virgin was conceived with Original Sin[6] and to the decree of 1622 of Gregory XV when this prohibition was extended to private acts. The order of Carmelites—Velázquez's paintings being in a convent of this order when first recorded in 1800—was one of those in particular committed to belief in the Immaculate Conception. For the Carmelites, moreover, the vision of S. John was of especial significance as a proof of the Immaculate Conception because of its relationship to the visions of Elijah on Mount Carmel itself.[7]

Velázquez's interpretation of the theme of S. John on Patmos follows the traditional pattern,[8] first given widespread currency by Dürer, but it is revolutionary in the lack of idealization in the figure of the saint, expressed mainly in the treatment of the head. In this respect the picture, like other early works by Velázquez, differs in spirit from the precepts and example of Pacheco, the artist's master and father-in-law. Pacheco recommended in his *Arte de la Pintura*, published in 1649, that S. John should be shown as an old man at the time when the Apocalypse was written (he criticized Dürer for making S. John a young man), and he ruled that the saint be dressed in white (for purity) and red.[9] The colour of the cloak in Velázquez's picture (described sometimes as

violet) appears to be a compromise between red and the muted earth colours he usually favoured in his early works. A drawing of S. John as a young man (writing the Gospel?) ascribed to Pacheco, and dated 1632, resembles (in reverse) the figure in Velázquez's painting.[10] Pacheco's drawing may well be based on Velázquez's interpretation of S. John, since the latter is so evidently drawn from the life.[11] The pose of the saint in Velázquez's painting may have been suggested by (rather than derived from) some earlier representation of the subject, but evidence for this is lacking.

The model who posed for the saint resembles models in other early paintings by, or supposedly by, Velázquez.[12] There are other instances in his early work of the same models appearing in several canvases (see no. 1375 above), but in this case, such is the angle of inclination of the head, it is difficult to be certain whether the same model reappears.

The representation of the Woman of the Apocalypse with the dragon is small in relation to the figure of the saint. This type of subject is more or less foreign to the work of Velázquez and it is rendered here in an almost diagrammatic way: the dragon is not red in colour and only three of its heads are clearly visible; the Woman is attended by the sun and the moon, but there are no stars around her head and it is not clear whether she holds an object (her child) in her arms away from the dragon; the wings on her back are mentioned in a later part of the relevant chapter of the Apocalypse, after the dragon had been cast out. It has been plausibly suggested that Velázquez may have derived the scene from an engraving after Juan de Jáuregui.[13]

VERSIONS AND COPIES: A drawing of 1632 ascribed to Pacheco of S. John is discussed above. A copy was apparently promised to the Carmelite Convent ca. 1810 when the picture was removed (see note 15 below).

PROVENANCE: Possibly painted for the Convent of the Shod Carmelites in Seville, together with the *Immaculate Conception* (on loan to the National Gallery); both pictures are recorded in the chapter house of this convent in 1800.[14] Both were bought from the convent by Don Manuel López Cepero, Dean of the Cathedral of Seville, and sold to Bartholomew Frere, who was Minister Plenipotentiary *ad interim* at Seville from November, 1809, to January, 1810; the pictures had arrived in England by 1813, when they were hung in a house in Brunswick Square.[15] They were later at 45 Bedford Square.[16] Bartholomew Frere died in 1851 and the pictures were apparently stored for many years until inherited by one of his great-nephews, Laurie Frere of Twyford House, Bishops Stortford.[17] Exhibited, Royal Academy, 1910 (no. 47). The pictures were lent to the National Gallery in 1946 by Mrs. Woodall and the Misses Frere. Arts Council Spanish Paintings Exhibition, 1947 (no. 26). No. 6264 was acquired by the National Gallery in 1956 from the executors of Laurie Frere with the aid of a Special Grant and contributions from the Pilgrim Trust and the National Art-Collections Fund. Exhibited, Madrid, *Velázquez y lo velazqueño*, 1961 (no. 31).

ILLUSTRATION: *National Gallery Catalogues, Acquisitions 1953–1962.*

REFERENCES, GENERAL: C. B. Curtis, *Velazquez and Murillo*, 1883, no. 19; A. L. Mayer, *Velazquez*, 1936, no. 35; *National Gallery Catalogues, Acquisitions 1953–1962*, pp. 82 ff.; J. López-Rey, *Velázquez*, 1963, no. 29.

REFERENCES IN TEXT: **1.** The picture has been on exhibition since 1946, when it was lent by Mrs. Woodall and the Misses Frere; Mr. B. J. C. Woodall is the present owner of the painting.

2. J. Ceán Bermúdez, *Diccionario*, 1800, vol. III, p. 179 'SEVILLA. CARMÉN CALZADO. Una Concepcion y un S. Juan Evangelista escribiendo el Apocalipsis, colocados en la sala de capítulo: pertenecen al primer tiempo de Velázquez.' See also F. Gonzalez de León, *Noticia artística . . . de esta ciudad de Sevilla*, 1844, p. 202. It is there hinted that the pictures were removed by the French, which is inaccurate (see Provenance). Ponz in his *Viage de España* (vol. 9 [Seville], pp. 103 ff.) speaks of pictures in the same convent, but he makes no mention of the Chapter House.

3. A. L. Mayer, *op. cit.*, about 1618; E. du G. Trapier, *Velázquez*, 1948, p. 34: 'One of the earliest paintings given to Velázquez . . .'; J. López-Rey, *op. cit.*, about 1619, etc. It has been pointed out by Miss Joyce Plesters that X-ray photographs show that these two paintings are apparently on canvas cut from the same roll as Velázquez no. 1375 above and the *Old Woman frying Eggs* (Edinburgh), both dated 1618. For further discussion see note 1 to no. 1375 above.

4. See *The Dogma of the Immaculate Conception*, ed. E. D. O'Connor, C.S.C., University of Notre Dame, 1958, pp. 32 ff. and 490 ff.; E. Mâle, *L'art religieux de la fin du moyen age en France*, 1922, pp. 208 ff.; A. B. Jameson, *Legends of the Madonna*, 1903, pp. 130 ff. On the iconography of the Immaculate Conception see above under no. 3910 (Follower of Murillo) and no. 1291 (Valdés Leal). The vision of the Woman of the Apocalypse is given as one of the sources for the Immaculate Conception by Velázquez's master, Pacheco, in his *Arte de la Pintura*, 1649, p. 482. Velázquez's painting is one of the earliest Spanish representations of the subject. His interpretation coincides with that laid down by Pacheco (*ibid.*, pp. 481 ff.), but Pacheco's datable paintings of this subject all appear to be slightly later than Velázquez's picture—see D. Angulo Iñiguez in *Archivo Español*, 1950, pp. 354 ff.

5. *The Dogma of the Immaculate Conception, op. cit.*, pp. 301 ff.

6. See Jameson, *op. cit.*, pp. 129 f. on the joyful reception of this decree in Seville.

7. *The Dogma of the Immaculate Conception, op. cit.*, pp. 241 f. For the relationship with Elijah's visions see B. Borchert in *Carmelus*, 2 (1955), fasc. I, p. 108.

8. Spanish pictures of approximately the same date and comparable as far as concerns iconography include one attributed to Zurbarán (Prat Collection, Barcelona)—see D. Angulo Iñiguez in *Archivo Español*, 1944, pp. 1 ff., fig. I; and by Sanchez Cotán (Museo de Santa Cruz, Toledo)—see the illustration in the *Bulletin of the Rhode Island School of Design, Museum Notes*, March, 1963, p. 18.

9. F. Pacheco, *Arte de la pintura*, 1649, pp. 560 f.

10. British Museum, London; the drawing is dated 6 September, 1632, and inscribed 'F.co Pacheco', illustrated by T. Borenius in *The Connoisseur*, 1923, Vol. LXVI, p. 8. A similar drawing attributed to Pacheco and dated 23 October, 1632, is in the Witt Collection, Courtauld Institute Galleries. It shows S. Mark, accompanied by his lion, and it resembles Velázquez's S. John in composition. The drawing is illustrated by A. L. Mayer in *Arte Español*, 1926, I, opp. p. 2. E. du G. Trapier in *Notes Hispanic*, The Hispanic Society of America, 1941, p. 15, suggests that the two drawings are studies by Pacheco for a predella.

11. D. Angulo Iñiguez in *Archivo Español*, 1944, p. 2, suggests that the general conception is Pacheco's.

12. Analogies with the *Saint Thomas* in the Orléans Museum, and with one of the men in the Budapest version of the *Three Men at Table* are cited by N. MacLaren (Arts Council Spanish Paintings Exhibition Catalogue, 1947, p. 16). Less plausible analogies with the figure to the right of Bacchus in 'Los Borrachos' (Prado, no. 1170), with the kneeling king in *The Adoration of the Magi* of 1619 (Prado, no. 1166) and with the right-hand figure in the picture of 'Musicians' attributed to Velázquez in Berlin are suggested by J. Pruvost-

Auzas in *Varia velazqueña*, I, 1960,
p. 318. It has also been implausibly
proposed that the S. John may be a
self-portrait (see J. Allende-Salazar,
Klassiker der Kunst: Velázquez, 1925,
p. 273); this is refuted by C. Peman
in *Varia velazqueña*, I, 1960, p. 699.

13. E. du G. Trapier, *Velázquez*,
1948, p. 38; the engraving was for
Luis de Alcázar's *Vestigatio Arcani
Sensus Apocalypsi . . .*, Antwerp,
1614; it is illustrated by M. Herrero
in *Arte Español*, 1941, 3, opp. p. 12.

14. See note 2.

15. See the entry for Bartholomew
Frere in the *Dictionary of National
Biography*. Copies of letters of 1813/14
between Bartholomew and George
Frere (National Gallery archives) con-
cern the removal of the paintings from
Hoppner's lumber garret to the house
of George Frere in Brunswick Square
(letters of 26 July and 2 August,
1813). A letter of 23 December, 1814,
from Bartholomew Frere, who was
then in Peru contains a passage de-
scribing how the pictures were ac-
quired. '. . . They were painted by
Velasquez for a convent of (Nuns I
think) at Seville. . . . He [Hoppner]
can perhaps tell you . . . the name of
the Dean or whatever he was of the
Cathedral of Seville (but I know he
was brother of the Archbishop) of
whom I purchased them—He had
bought them of the convent upon
condition of furnishing them with
copies, and they were at the painters
when I bought them. . . .' A note on
Don Lopez Cepero and his collection
is given by Curtis, *op. cit.*, p. 3. On
Bartholomew Frere (1778–1851) see
further *Burke's . . . Landed Gentry* (ed.
1952); he was the sixth child of John
Frere of Roydon Hall, Norfolk. The
eldest child was the diplomat John

Hookham Frere, British minister in
Spain in 1802–8 who is sometimes
wrongly said to have acquired the
paintings in Seville. George Frere of
Twyford House, Herts. (1774–1854),
was the fourth child and it was pre-
sumably he who looked after the
pictures in 1813/14—see above here.
(The statesman Sir Bartle Frere was a
nephew of Bartholomew Frere).

16. See W. Stirling, *Annals of the
Artists in Spain*, 1848, III, p. 1450;
as the property of 'Barth. Frere'.

17. See the letter of Philip Frere in
The Times, June, 1956: 'Bartholomew
Frere (who was married in 1817 by
proxy to a Spanish lady who died in
Spain in the autumn of that year,
before ever meeting her husband)
lived on in England until 1851, and
nothing more was heard about the
pictures until 1878, when a letter was
received by Messrs. Frere & Co., of
Lincoln's Inn Fields, from Messrs.
Child & Co., the bankers, intimating
that in consequence of the forth-
coming demolition of Temple Bar
they would have to give up the rooms
over the archway, used for storage
purposes, and would be glad to be
relieved of some pictures and boxes
labelled 'B. Frere' which had been
there in safe custody since the early
1830's. These pictures, which in-
cluded the two Velazquez mentioned
in your announcement, eventually
devolved upon the late Mr. Laurie
Frere, of Twyford House, Bishop's
Stortford, and the present acquisition
is from his executors, of whom the
writer is one.' Laurie Frere (1866–
1939) was a grandson of the George
Frere of Twyford House who housed
the paintings on behalf of his brother
Bartholomew in 1813.

6380 PORTRAIT OF ARCHBISHOP FERNANDO DE
VALDES (FRAGMENT)

Oil on canvas, $27 \times 23\frac{1}{2}$ ($0 \cdot 685 \times 0 \cdot 596$).

In fairly good condition. Slight wearing, especially in the cape and
grey background. Several small losses including some in the forehead
and across the cape.[1]

Alterations are visible down the side of the cape to the left. The hood
was possibly intended at first to project further backwards. The part of

the collar beneath the beard may at first have been more clearly visible.

Fernando de Valdés y Llanos (or Llano) was born in Cangas de Tineo (Asturias); he was of the family of the Counts of Toreno. He studied theology at Salamanca and he was appointed Bishop of Teruel in 1625. In 1632 he was made Bishop Elect of León, then in 1633 Archbishop of Granada and President of the *Consejo de Castilla* (or *Consejo real*). This was a post comparable to that of Lord Chancellor and it prevented him from leaving Madrid to visit his See at Granada. He died on 29 December, 1639.[2]

The present picture corresponds throughout its composition with part of a full-length portrait in the Conde de Toreno collection, Madrid,[3] and there exists a fragment showing the hand of an ecclesiastic, bearing a paper signed by Velázquez, which also corresponds with part of the same full-length composition.[4] These facts about the portrait were first established by Dr. Ainaud de Lasarte.[5] The full-length portrait bears a (probably later) cartouche identifying the sitter, and there exists a three-quarter-length version of the portrait in the Archiepiscopal palace, Granada.[6] As a result of these discoveries it was naturally supposed that the hand and head fragments, which are consistent with each other in style and size, belonged to a full-length portrait of the Archbishop by Velázquez which, before being cut down, was copied in the existing full-length in the Conde de Toreno collection.[7]

There are, however, certain variations between the two fragments and the full-length composition—the most crucial being that the sitter is clearly an older man in no. 6380. It has therefore been suggested that Velázquez painted two portraits of the Archbishop: there was firstly a full-length to which the hand fragment originally belonged and later on no. 6380 was produced as an independent bust-length portrait.[8] No. 6380 is recorded in a close copy, apparently of the seventeenth century, in the Museo de Arte de Cataluña in Barcelona.[9] For a number of reasons this two-portrait theory is unconvincing: mainly because no. 6380 makes no sense as an independent composition, especially by the standards of Velázquez, and because it is consistent with the hand fragment in every way, consistent in style and thus in date.[10]

It seems most probable, as an alternative to these two theories about the origin of the portrait, that the two fragments belong to a copy which Velázquez was commissioned to make based on the full-length in the Conde de Toreno collection (or a version of this composition).[11] In this way all the differences between the full-length composition and the two fragments become perfectly intelligible,[12] and the weaknesses and obscure passages in the two fragments can be understood. In the head fragment (no. 6380) the awkward passage where the sitter's beard overlaps the points of his collar is intelligible as a transcription of the same passage in the full-length where the beard is grey (not white) in colour and smaller, leaving most of the collar visible.[13]

There are some slight connections between the composition of the full-length portrait and Velázquez's three-quarter-length portrait of

1650 of Pope Innocent X (Rome, Palazzo Doria) but the composition of the full-length is in any case a traditional one and closely resembles that of a portrait of 1625 by Guido Reni of Cardinal Ubaldini.[14]

As a copy of a portrait Velázquez's painting would be exceptional in his known work and the most obvious reason why he should have been asked to make such a copy would be because the sitter was unable to sit to him in person. Since he is known to have remained in Madrid until his death in 1639, it is likely that the portrait was a posthumous one. The treatment of the mouth and moustache in no. 6380 suggests that Velázquez may have used a death mask to guide him for the painting of the face. As a posthumous portrait, the present picture must be dated after 1639, and it would be acceptable, together with the hand fragment, as a work of the early 1640's.[15]

It is not known who commissioned the portrait, but it is the kind of task which Velázquez performed on other occasions as part of his duties for the King.[16] The existing full-length was presumably made for the sitter's family, to whom it still belongs and a version of this composition exists at Granada, the See of the Archbishop. The date at which Velázquez's picture was cut down is likewise unknown, but this was presumably at a fairly early date, before the (?) seventeenth-century copy at Barcelona was painted.

VERSIONS AND COPIES: The various pictures related in composition to no. 6380 are discussed above and in notes 3, 4, 6 and 9: a full-length portrait (Madrid, collection of the Conde de Toreno) and a three-quarter-length version (Granada, Archiepiscopal palace), a fragment of the hand of the Archbishop, signed by Velázquez (Madrid, Palacio de Oriente) and a copy of no. 6380 (Barcelona, Museo de Arte de Cataluña).

PROVENANCE: Probably the picture described by Sir David Wilkie in the collection of José de Madrazo in Madrid in 1828 and in the Sir David Wilkie sale, Christie's, 30 April, 1842 (lot 683; 12½ gns.), bought Simpson.[17] Sir George I. Campbell of Succoth sale, Christie's, 19 July, 1946 (lot 20; 35 gns.).[18] Acquired in 1950 by Mr. Hugh Borthwick-Norton and by descent to Mr. Angus Bainbrigge, by whom lent to the National Gallery 1959–67. Exhibited Stockholm, Nationalmuseum, *Stora Spanska Mästare*, 1959/60 (no. 101); Madrid, *Velázquez y lo velazqueño*, 1961 (no. 62). Bought in 1967 with the aid of a contribution from the National Art-Collections Fund.

ILLUSTRATION: *The National Gallery, January 1965–December 1966*, pl. 4.

REFERENCES, GENERAL: T. Crombie, in *The Connoisseur*, March, 1960, pp. 102–4; J. Ainaud de Lasarte, in *Varia velazqueña*, I, 1960, pp. 310–15; J. López-Rey, *Velázquez*, 1963, no. 476; A. Braham, in *The Burlington Magazine*, 1968, pp. 401–3.

REFERENCES IN TEXT: **1.** A greatly exaggerated account of the condition of the picture is given by López-Rey, *loc. cit.*

2. On the life of Fernando de Valdés y Llanos see Ainaud, *op. cit.*, pp. 310 f.; the *Enciclopedia Universal Illustrada*, LXVI, p. 521, and the inscription on the full-length portrait mentioned below.

3. 191 × 118 cm. (*ca.* 75 × *ca.* 46½ ins.). The portrait is inscribed on a cartouche: 'El Yllᵐᵒ S.D. Fernᵈᵒ de Valdes Presidente d Castilla y Arzobispo d. Granada, Fundador de la Colegiata, y Estudios de la Villa de Cangas de Tineo, Thio de los Sʳᵉˢ Condes de Toreno.' The paper in the sitter's right hand is inscribed: Yllᵐᵒ S. Formerly collection of the Baronesa

de la Peña, Madrid; exhibited, Madrid, *Velázquez y lo velazqueño*, 1961, no. 60. Illustrated by Crombie (fig. 1), Ainaud (pl. 87a), Braham (figs. 68, 70, 73).

4. Madrid, Patrimonio Nacional, Palacio de Oriente; 24 × 27 cms. (*ca.* 9½ × *ca.* 10½ ins.). The paper in the sitter's hand is inscribed: *Illmo Señor | Diego Vela*(z)*q'*. Acquired by Queen Isabel II from the Marqués de Salamanca in 1848, previous ownership unknown. Exhibited, Madrid, *Velázquez y lo velazqueño*, 1961, no. 63. A. L. Mayer, *Velázquez*, 1936, no. 424 and pl. B; López-Rey, *op. cit.*, no. 480 and pl. 91. It was formerly supposed that the hand fragment might have come from a portrait by Velázquez of Cardinal Borja (see E. du G. Trapier, *Velázquez*, 1948, pp. 263 ff.).

5. Ainaud, *op. cit.*, p. 313, note 6.

6. Ainaud, *op. cit.*, p. 313 and pl. 87b.; Crombie, *op. cit.*, fig. 5.

7. As proposed by Crombie, *op. cit.*, when the picture was first published (1960) and more recently in *The Burlington Magazine*, 1968, pp. 580 f.

8. As proposed by Ainaud, *op. cit.* (1960).

9. *Ibid.*, p. 314 and pl. 86. 74 × 61 cms. (*ca.* 29 × *ca.* 24 ins.). Acquired by the Barcelona Museum in 1910. Exhibited Madrid, *Velázquez y lo velazqueño*, 1961 (no. 61). The picture is approximately two inches longer than no. 6380; more of the sitter's cape is shown and the section of the chair back is omitted; it thus makes a slightly more satisfactory impression as an independent composition.

10. See Crombie in *The Burlington Magazine*, 1968, p. 581.

11. See Braham, *op. cit.*

12. See *ibid.*, p. 402, for a full discussion of the differences.

13. It is not perfectly clear whether this passage is strictly a *pentimento*— the collar having been concealed by the artist and now becoming more visible—or whether it is intended to be in shadow. Either way the effect is obscure. The shadow around the head appears to be intended to give relief to the face. The folds of the curtain correspond fairly closely with those in the full-length portrait. The most puzzling feature of the hand fragment is that the hand should appear to be so young-looking; it is intelligible as a sequel to the smooth and uncharacterized hand of the full-length portrait. It is also clear that at first Velázquez made the hand correspond in size with that of the full-length portrait, later increasing the size by adding to the upper contour. The fussy lace cuff of the sitter in the latter portrait is completely transformed in Velázquez's painting.

14. Collection of Benjamin Guinness; exhibited at the Royal Academy, *17th Century Art in Europe*, 1938, no. 282 (illustrated in the Souvenir, p. 77), and now apparently missing. Connections with other Italian portraits are suggested by Ainaud, *op. cit.*, p. 315.

15. It is difficult to judge for certain when the portrait was painted, if the year of the sitter's death has no bearing on the date. The hand fragment is traditionally dated rather later than the early 1640's—according to Mayer, for example, *op. cit.*, no. 424, 'about 1650'.

16. The most important of such *ad hoc* undertakings was the adaptation of the royal equestrian portraits for the *Salón de Reinos* of the Buen Retiro Palace in the mid 1630's. It has been suggested that Velázquez's painting was damaged in the Alcázar fire of 1734. There appears, however, to be no sure evidence that the picture was in the royal collection at the Alcázar at this time. No. 6380 shows no evidence of having been damaged by fire.

17. A. Cunningham, *The Life of Sir David Wilkie*, 1843, II, p. 496, gives a letter of 28 January, 1828, from Wilkie at Madrid to Sir Robert Peel: 'Signor Madrazo . . . has in his house three fine specimens [of Velázquez]: a head of a Priest, a whole length of an Alcalde in black, with a duplicate of the Velazquez at Earl Grosvenor's. . . .' José de Madrazo was painter to the King of Spain and Director of the Royal Museum of Painting and Sculpture (see the sale catalogue of his collection, Madrid, 1856). It is not known whether he also owned the hand fragment, signed by Velázquez, which was until 1848 in the collection of the Marqués de Sala-

manca (see note 4). In Wilkie's sale the portrait is described as 'Velasquez . . . Portrait of an Abbot'.

18. As Genoese School, Portrait of a Cardinal. The picture came from Garscube, Dumbartonshire. It cannot be identified with any of the pictures in this collection described by Waagen, *Treasures of Art in Great Britain*, 1854, III, pp. 291 ff.

Francisco de ZURBARAN
1598–1664

Born at Fuente de Cantos (Badajoz Province) and apprenticed 1614–16 to an obscure painter, Pedro Díaz de Villanueva, in Seville, where, later, he was perhaps a pupil of Juan de Roelas. His first dated work is of 1616. His style shows some Italian influence, and knowledge of the work of Ribera and Velázquez. He was living in Llerena (Badajoz Province) 1617–28; in 1629 he came to Seville, where he settled, producing many pictures for Seville, and elsewhere in the neighbourhood, as well as for the Spanish provinces in America. At this period of his career Zurbarán evidently employed a number of assistants to help in his less important commissions. In 1634 he was in Madrid and was paid for the series of the Labours of Hercules (Prado); he apparently lived there from 1658 onwards. His later work is much influenced to its detriment by the early works of Murillo. He died in Madrid (27 August). Many dated and documented works survive from all periods of Zurbarán's career. His style, however, developed slowly, and it is difficult to place undated works with any real precision.

LITERATURE: M. S. Soria, *The Paintings of Zurbarán*, 1953; P. Guinard, *Zurbarán et les peintres de la vie monastique*, 1960—both contain catalogues of the artist's work.

230 S. FRANCIS IN MEDITATION

Oil on canvas, 60 × 39 (1·52 × 0·99); broken edges. The canvas has been cut down on the right.

At present obscured by darkened varnish but clearly much damaged and repainted; a number of old tears are visible.

Previously catalogued as *A Franciscan Monk* but the right hand bears a mark of the stigmata and the picture must therefore represent the saint.[1]

The Jesuits greatly favoured meditation on Death as a religious exercise and enjoined for this purpose contemplation of a skull. S. Francis and other saints are frequently represented meditating on a skull from the end of the sixteenth century onwards, especially in Italy and Spain.[2] The subject was depicted a number of times by Zurbarán (*cf.* no. 5655 below).

As far as can be judged in the picture's present condition, it seems a little earlier than no. 5655 (which is dated 1639). The habit worn by the Saint appears to be identical with the one in no. 5655 (and other related compositions).

COPY: A small copy is said to be in Le Havre Museum; a nineteenth-century painting of this composition was in the Wauchope sale, Christie's, 12 May, 1950 (lot 128);[3] a small pastiche was in an anonymous sale, Christie's, 22 March, 1957 (lot 168).[4] A copy by Lunterschutz is recorded.[5]

ENGRAVING: Engraved by Alphonse Masson (before 1854).[6] A lithograph by Forest is recorded.[7]

PROVENANCE: Acquired in Spain for King Louis-Philippe ca. 1835–7[8] and exhibited with the Galerie Espagnole at the Louvre, 1838–48.[9] Louis-Philippe sale, London, 6 May sqq., 1853 (lot 50; £265),[10] bought for the National Gallery.

REPRODUCTION: Illustrations: Continental Schools, 1937, p. 416; Spanish School: Plates, 1952, p. 50.

REFERENCES, GENERAL: M. S. Soria, The Paintings of Zurbarán, 1953, no. 166, 'about 1639'; P. Guinard, Zurbarán, 1960, no. 354.

REFERENCES IN TEXT: 1. It was correctly described in the Louis-Philippe sale catalogue (see Provenance) as St. Francis with the Stigmata; so also in Notice . . . de la Galerie Espagnole, 1838, if it is to be identified with no. 346, for which see note 9.

2. Cf. E. Mâle, L'art religieux après le Concile de Trente, 1932, pp. 206–12.

3. 52 × 36 ins.

4. 7 × 4¾ ins.

5. Cited by Guinard, loc. cit.

6. Masson's print is illustrated by Guinard in Revista de Estudios Extremeños, Badajoz, 1961, vol. XVII, facing p. 368.

7. Published in L'Artiste, XIV; cited by Guinard.

8. See Follower of Murillo, no. 3910, note 15.

9. It is presumably no. 346 (356 of the 4th[?] edition) of Notice . . . de la Galerie Espagnole, 1838; the measurements of that picture are given as 1·56 × 1·16 but it is the only one in the Notice which corresponds at all closely in size to the National Gallery painting and the discrepancy may be due to the cutting-down of the canvas noted above. (W. Stirling, Annals of the Artists of Spain, 1848, II, p. 775, identifies the National Gallery S. Francis with no. 351 (361) of the Notice but this was certainly lot 285 of the Louis-Philippe sale and was bought by Drax.) On the sensation caused by the picture in the Galerie Espagnole, see Guinard, op. cit., Badajoz, 1961, p. 370.

10. See note 1. The purchase was the subject of a number of letters in The Times in 1853—9, 10 and 12 May, and 8 July.

1930 S. MARGARET

Over her left arm are alforjas (Spanish saddle-bag); in her left hand is a shepherd's crook with a metal head.

Oil on canvas. The remaining original canvas measures 64 × 41¼ (1·63 × 1·05)[1] (it had later been enlarged, by additions on all sides,[2] to 76¼ × 44¼ (1·94 × 1·12), but the earlier shape was restored in 1965).

The lighter areas in good condition. Paint losses along the edges and in the background, mainly on the right; the largest runs vertically through the tail of the dragon. Scattered damages on the dress, especially near the right edge of the skirt. A damage runs horizontally across the jacket, and one vertically through the figure's left shoulder. A small tear across the bridge of her nose runs into her left eye. A small patch inserted in the canvas at the bottom edge on the right. Cleaned and restored in 1965.

S. Margaret (also called S. Marina), Virgin Martyr of Antioch, died at the beginning of the fourth century. She is variously supposed to have overcome a dragon, to be the princess rescued by S. George, or to have been swallowed by a dragon which afterwards burst. She is sometimes represented, as here, as a shepherdess since she is said to have guarded her nurse's sheep.

The head of the saint may perhaps be a portrait. Likenesses of men and women in the guise of saints (often their name-saints) were not uncommon in Northern painting from the end of the fifteenth century onwards[3] and were certainly being painted also in Spain in the seventeenth century.[4]

The picture is, however, unlikely to have been intended to function as an allegorical portrait. It was presumably destined for a compartment of an altarpiece, or possibly conceived as one of a series of female saints; a number of such series were produced by Zurbarán and his studio.[5] Almost without exception these series have been dispersed.[6] The great majority of the surviving Zurbarán female saints are studio works or by followers; no. 1930 is one of the few autograph paintings of this kind. It is certainly earlier in style than no. 5655 below which is dated 1639, and it is probably of the early, or possibly of the middle 'thirties.

VERSIONS AND COPIES: A variant[7] of approximately the same size was in the Royal Palace at Madrid in 1794;[8] a studio variant is in the Seville Museum; a number of other versions exist, apparently all derived from the variants rather than from no. 1930.[9]

PROVENANCE: No. 1930 was possibly in the collection of Prince Charles (later Charles IV of Spain) in the Casa de Campo (Casita del Príncipe) at El Escorial by 1789.[10] It was perhaps one of three pictures said to be from the Escorial and to have been presented by the King of Spain (ca. 1855?) to the 2nd Baron Ashburton († 1864).[11] Exhibited at the Royal Academy, 1871 (no. 74), lent by Louisa, Lady Ashburton. Purchased from her executor, the 5th Marquess of Northampton, in 1903 (with the aid of the Clarke Fund). Arts Council Spanish. Paintings Exhibition, 1947 (no. 41).

REPRODUCTION: Illustrations: Continental Schools, 1937, p. 417; Spanish School: Plates, 1952, p. 51 (both before cleaning).

REFERENCES, GENERAL: M. S. Soria, The Paintings of Zurbarán, 1953, no. 56 (about 1631/2); P. Guinard, Zurbarán, 1960, no. 275.

REFERENCES IN TEXT: **1.** It was formerly supposed that the picture had been cut down to its present size before being enlarged, but this is not necessarily so. The flattening of the dragon's tail along the right-hand edge of the canvas suggests that in width at least the canvas can have been but slightly reduced, if it has been reduced at all. There is some evidence that it could have been cut at the top (see note 10). A cross-section of the paint and ground is illustrated and discussed by J. Plesters, in Museum, XXI, no. 4, 1968, p. 262, and fig. 12.

2. $5\frac{1}{2}$ inches (0·14) at top, $7\frac{1}{4}$ (0·185) at bottom and $1\frac{1}{2}$ (0·038) at each side. The additions were apparently made after 1871, since the size of the picture is given as 64 × 41 inches (1·63 × 1·04) in the Royal Academy 1871 exhibition catalogue.

3. Cf. G. Glück in the Vienna Jahrbuch, 1933, p. 192.

4. E. Orozco Díaz (in Arte Español, 1942, trimestre 4, pp. 3–5) quotes two seventeenth-century Spanish poems on portraits of this kind. According to Soria, loc. cit., no. 1930 is the only Virgin Saint by Zurbarán in seven-

teenth-century dress. In other representations of S. Margaret by Zurbarán the costume is similar. The correspondence with seventeenth-century dress is in fact only very approximate and what connections there are can possibly be attributed to the fact that the saint is represented as a shepherdess. The presentation of the figure suggests to Guinard, *loc. cit.*, analogies with the *comedia* of Lope de Vega.

5. *E.g.* twenty-four full-length Virgin saints were commissioned from Zurbarán by the Convent of the Annunciation at Lima, Peru, in 1647 (see C. López Martínez, *Desde Martínez Montañés hasta Pedro Roldán*, 1932, pp. 224/5), and fifteen were sent by Zurbarán to Buenos Aires in 1649 (see M. L. Caturla, in *Anales del Instituto de arte americano y investigaciones estéticas*, 1951, 4, pp. 27 ff.

6. A set of eight Virgin saints (studio work), formerly in the Hospital de la Sangre, Seville, is now in the Seville Museum. On these and other series, see Guinard, *op. cit.*, pp. 147 ff. and E. du G. Trapier in *Apollo*, 1967, pp. 414 ff.

7. The principal variation is that the saint is thrusting her crook into the dragon's jaws.

8. Engraved by Bartolomé Vázquez in 1794. According to the title of this print the picture was known as *La Pastorcita de Zurbarán* and measured 5 *pies* 7 *pulgadas* by 3 *pies* 3 *pulgadas* (*i.e.* about 61 × 36 inches). The inscription states that the picture was then in the Royal Palace, Madrid (see also Ceán Bermúdez, *Diccionario*, 1800, VI, p. 52). Its present whereabouts are not known and it is not traceable in other Spanish Royal inventories. A small copy of this design in an anonymous Sotheby sale

(18 May, 1949, lot 77) was probably after the engraving.

9. The studio variant in the Seville Museum is one of the series from the Hospital de la Sangre; *cf.* note 6; it corresponds with the picture formerly in the Royal Palace at Madrid in that the crook is lowered. Another version of this is in the Göteborg Museum (from the Louis-Philippe (lot 389), Drax and Northcliffe sales and anonymous Christie sale, 10 May, 1935 (lot 18)); pastiches are in the Royal collection, Buckingham Palace (Louis-Philippe sale, lot 390), and Detroit Institute of Arts. In all of these the saint's crook is lowered, as in Vázquez's engraving, although the dragon does not appear in all. Other variants are recorded by Guinard: no. 280, Madrid, coll. Ruis de Armenteras; no. 281, Arnuero (prov. de Santander), coll. Luis Sanjurjo; no. 282, Madrid, coll. Pierrard; and no. 283, Madrid, coll. Gómez Moreno.

10. Inventory of pictures in the apartments of Prince Charles in the Casa de Campo made between 1772 and 1789, no. 191: 'Uno [cuadro]: de dos varas y media de caida, y cinco quartas de ancho; Retrato de una Paisana con unas Alforjas colgadas del brazo, en cuya Mano tiene un librito: Original de Fran^co Zulvaran' [*sic*] (from the nineteenth-century copy of the inventory in the possession of the Duke of Wellington). The size given for this picture (*ca.* 83 × 42 inches) does not correspond to that of either no. 1930 or the picture engraved by Vázquez (see note 8), but the former may possibly have been reduced in height (*cf.* note 1).

11. Information provided by Lord Northampton (letters of 1951 in the Gallery archives).

5655 S. FRANCIS IN MEDITATION

Signed on a *cartellino* in the lower right corner: *Fran^co Dezurbarā | faciebat |* 1639.[1] Inscribed below the *cartellino* by a later hand: H. 338.

Oil on canvas, $63\frac{3}{4} \times 54$ (1·62 × 1·37).

In good condition; a few local damages. Cleaned and restored in 1946.

The tear and upturned corner of the *cartellino* are afterthoughts of the artist.

For the subject see no. 230 above.

Pictures by Zurbarán of similar composition but possibly later are at Aachen[2] and Düsseldorf;[3] in both the habit worn by the saint appears to be identical with that in the present picture and in no. 230 above. A picture of a similar kind, but showing the saint in a plain habit, is in the Herron Museum of Art, Indianapolis.[4] The type of head in no. 5655 is close to that in a number of representations of S. Francis by Zurbarán, including the half-length picture at Munich,[5] which is generally dated to the 1650's.

PROVENANCE: In the collection of Sir Arthur Aston of Aston Hall, Cheshire (British Envoy in Madrid, 1840–3); Aston Hall sale, 6 August, 1862 (lot 5; £109), bought by Agnew. Exhibited at the Royal Academy, 1872 (no. 93), lent by Sam Mendel; Mendel sale, London, 23 April, 1875 lot 348; £150), bought by Agnew, who sold it to Mrs. Wood. Bequeathed by her son, Major Charles Edmund Wedgwood Wood, 1946. Arts Council Spanish Paintings Exhibition, 1946 (no. 24) and 1947 (no. 40); Cleaned Pictures Exhibition, National Gallery, 1947/8 (no. 61).

REPRODUCTION: Spanish School: Plates, 1952, p. 52.

REFERENCES, GENERAL: M. S. Soria, The Paintings of Zurbarán, 1953, no. 167; P. Guinard, Zurbarán, 1960, no. 355.

REFERENCES IN TEXT: 1. Reproduced in actual size in Spanish School: Plates, 1952, p. 55.

2. Reproduced in the Aachen catalogue, 1932 and by Soria, fig. 115; there is a copy in the collection of Señora de Pagés, Madrid.

3. The picture was formerly at Bonn; it is reproduced in the Bonn catalogue, 1927, pl. 96 and by Soria, fig. 116. A replica at Vienna (Kunsthistorisches Museum) is noted by Guinard, no. 357.

4. See C. G. Coley in Art Association of Indianapolis Bulletin, Feb. 1963, pp. 4 ff.

5. Reproduced by H. Kehrer, Zurbarán, 1918, pl. 75 and by Soria, pl. 94 (cat. no. 125).

PORTUGUESE SCHOOL

PORTUGUESE SCHOOL
First half of sixteenth century

5594 THE MYSTIC MARRIAGE OF S. CATHERINE

The scene is placed in a *hortus conclusus*. S. Joseph is in the left background; the woman in the right foreground is probably the Magdalen.

Tempera(?) on wood,[1] $13 \times 10\frac{1}{8}$ ($0\cdot330 \times 0\cdot257$). A narrow line of dark paint runs along the right edge (which is original). The framing is modern.

In fair condition.

Formerly ascribed to 'Frei Carlos';[2] also attributed to the French School.[3]

All that is known for certain of 'Frei Carlos' is that he was a painter of Netherlandish extraction who took the monastic vows at the Convento do Espinheiro at Évora in 1517. No documented work seems to have survived,[4] but a group of paintings—now mainly in the Lisbon Museum—are generally accepted as being by Frei Carlos,[5] and no. 5594 is connected stylistically with them. J. Couto[6] suggests that there were a number of artists working at the monastery, 'Frei Carlos' being perhaps the *caposcuola*.[7]

PROVENANCE: Said to have been since mid-eighteenth century in the possession of the O'Neill family, Portugal;[8] sent to London for sale by George O'Neil of Lisbon and bought in 1906 by Herbert Cook.[9] National Loan Exhibition, Grafton Gallery, 1909/10 (no. 77); Spanish Exhibition, Grafton Gallery, 1913/14 (no. 21). Purchased from the Cook collection in 1945.

REPRODUCTION: *Spanish School: Plates*, 1952, p. 53.

REFERENCES: **1.** The support is not visible, being at present veneered at the back with rosewood and enclosed by oak fillets at the sides.

2. On the back is a label in Sir Herbert Cook's hand: *Early Portuguese School. circa. 1500.* | *Bought by me 1906 from The O'Neill, Lisbon, Portugal. (Sent to Christies for sale)* | *who had it 150 years in his family. Supposed to be by Frey Carlos. Herbert Cook.*

3. *Cf.* J. de Figueiredo, *O Pintor Nuno Gonçalves*, 1910, p. 30, note.

4. A *Christ in the Tomb*, said to have been signed and dated 1535 (according to A. Rayczynski, *Les arts en Portugal*, 1846, p. 127) is now lost.

5. *Cf.* J. Couto, *A Pintura Flamenga em Évora no Século XVI*, 1943, pp.

12–20. Also the same author's *A oficina de Frei Carlos* n.d. [1955?]; R. de Santos, *Os primitivos Portugueses*, 1957, pp. 23 f. and 56 f., pls. LII–LVIII, and G. Kubler and M. Soria, *Art and Architecture in Spain and Portugal ... 1500 to 1800*, 1959, pp. 334 f.

6. *Op. cit.*, 1943, p. 20.

7. He lists no. 5594 amongst the works connected with the monastery, *op. cit.*, 1943, p. 10.

8. See note 2. This branch of the O'Neills settled in Portugal *post* 1709 (see Ruvigny, *The Nobilities of Europe*, 1910, p. 362).

9. See note 2 and *Catalogue of the Paintings at Doughty House*, III, 1915, p. 128.

LIST OF ATTRIBUTIONS IN THE PRESENT CATALOGUE CHANGED FROM THE CATALOGUE OF 1929 AND THE SUPPLEMENT OF 1939

Attribution in the 1929 catalogue or 1939 supplement	Inventory number	Attribution in the present catalogue
El GRECO	1122	El GRECO, Ascribed to
El GRECO	3131	El GRECO, After
El GRECO	3476	El GRECO, Studio of
JUAN de Flandes	1280	JUAN de Flandes, Studio of
MAZO, Juan Bautista del	1376	SPANISH School, seventeenth century
MURILLO, Bartolomé Esteban	1286	MURILLO, Style of
MURILLO, Bartolomé Esteban	3910	MURILLO, Follower of
MURILLO, Bartolomé Esteban	3938	MURILLO, Follower of
PAULUS	4786	PAOLO da San Leocadio
SPANISH School, seventeenth century	1308	LEÓN y Escosura, Ignacio de, Ascribed to
STANZIONI, Massimo, Attributed to	235	RIBERA, Jusepe
UNKNOWN	2526	SPANISH School, Ascribed to
VELÁZQUEZ, Diego	1315	MAZO, Juan Bautista del, Ascribed to
VELÁZQUEZ, Diego, Ascribed to	232	MURILLO, Ascribed to

ATTRIBUTIONS IN THE PRESENT CATALOGUE CHANGED FROM THE SPANISH CATALOGUE OF 1952

Attribution in 1952		Present attribution
El GRECO	3476	El GRECO, Studio of
El GRECO, Studio of	1122	El GRECO, Ascribed to
El GRECO, Studio of	3131	El GRECO, After
SEVILLE School, seventeenth century, Ascribed to	232	MURILLO, ascribed to
RIBERA, Jusepe de, Style of	244	RIBERA, Jusepe de
VELÁZQUEZ, Diego, and assistant	197	VELÁZQUEZ, Diego

The Adoration of the Kings (no. 3417 A) by 'RODRIGO de Osona the younger', included in the 1952 edition of the Spanish School catalogue, is omitted in the present edition, having been returned to the Victoria and Albert Museum.

PICTURES CATALOGUED AS SPANISH IN THE 1929 CATALOGUE BUT EXCLUDED FROM THE PRESENT CATALOGUE

Attribution in the 1929 catalogue	Inventory number	Attribution or school under which the picture has been, or probably will be catalogued
CAMPAÑA, Pedro	1241	Pasticheur of Federico ZUCCARI (XVI century Italian Schools catalogue)
CASTILLO, Antonio del	3647	ITALIAN School, XVII(?) century
COELLO, Claudio, Ascribed to	1434	GIORDANO, Luca
MARTÍNEZ, Jusepe	1444	CIPPER, Giacomo (XVIII century Italian Schools catalogue)
SPANISH School, late XV century	4190	TYROLESE School, XV century (German School catalogue)
SPANISH School, XVII century	741	NEAPOLITAN (?) School, XVII century
SPANISH School, XVII century	3590	After JACOB DE GHEYN III (Dutch School catalogue)

NUMERICAL INDEX
OF THE PAINTINGS INCLUDED
IN THE PRESENT CATALOGUE

Inventory number	Attribution in the present catalogue	Inventory number	Attribution in the present catalogue
13	MURILLO, Bartolomé Esteban	1473	GOYA, Francisco de
		1930	ZURBARÁN, Francisco de
74	MURILLO, Bartolomé Esteban	1951	GOYA, Francisco de
176	MURILLO, Bartolomé Esteban	2057	VELÁZQUEZ, Diego
		2526	SPANISH School, Ascribed to
197	VELÁZQUEZ, Diego		
230	ZURBARÁN, Francisco de	2926	MAZO, Juan Bautista del
232	MURILLO, Ascribed to	2930	RIBALTA, Francisco
		3131	El GRECO, After
235	RIBERA, Jusepe de	3138	FORTUNY y Carbó, Mariano
244	RIBERA, Jusepe de		
745	VELÁZQUEZ, Diego	3476	El GRECO, Studio of
1122	El GRECO, Ascribed to	3910	MURILLO, Follower of
1129	VELÁZQUEZ, Diego	3938	MURILLO, Follower of
1148	VELÁZQUEZ, Diego		
1229	MORALES, Luis de	4786	PAOLO da San Leocadio
1257	MURILLO, After		
1280	JUAN de Flandes, Studio of	5594	PORTUGUESE, XVI century
1286	MURILLO, Style of	5655	ZURBARÁN, Francisco de
1291	VALDÉS Leal, Juan de		
1308	LEÓN y Escosura, Ignacio de	5931	MURILLO, Bartolomé Esteban
1315	MAZO, Juan Bautista del, Ascribed to	6153	MURILLO, Bartolomé Esteban
1375	VELÁZQUEZ, Diego	6260	El GRECO
1376	SPANISH School, XVII century	6264	VELÁZQUEZ, Diego
		6322	GOYA, Francisco de
1457	El GRECO	6360	The MASTER of RIGLOS
1471	GOYA, Francisco de		
1472	GOYA, Francisco de	6380	VELÁZQUEZ, Diego

INDEX TO RELIGIOUS SUBJECTS

Abraham sacrificing Isaac:
El Greco, no. 1457

Adam:
Juan de Flandes, Studio of,
no. 1280

Adam and Eve expelled from Eden:
El Greco, no. 1457

Adoration of the Name of Jesus:
El Greco, no. 6260

Adoration of the Shepherds:
Murillo, ascribed to, no. 232

Agony in the Garden:
El Greco, Studio of, no. 3476

Annunciation to the Shepherds:
Murillo, Ascribed to, no. 232

Apocalypse, Woman of the:
Velázquez, no. 6264

Birth of the Virgin:
Murillo, After, no. 1257

Christ after the Flagellation:
Velázquez, no. 1148

Christ as a Child:
Murillo, no. 13

Christ at the Pool of Bethesda:
Murillo, no. 5931

Christ bearing the Cross:
Ribalta, no. 2930

Christ on the Cross:
Master of Riglos, no. 6360

Christ dead:
Ribera, no. 235

Christ driving the traders from the Temple:
El Greco, no. 1457

Christ healing the paralytic:
Murillo, no. 5931

Christ in the house of Martha and Mary:
Velázquez, no. 1375

Christ presenting the redeemed of the Old Testament to the Virgin:
Juan de Flandes, Studio of, no. 1280

Eve:
Juan de Flandes, Studio of, no. 1280

Female saint and martyr (unidentified):
Paolo da San Leocadio, no. 4786

God the Father:
Murillo, no. 13;
Valdés Leal, no. 1291

Hell:
El Greco, no. 6260

Holy Cypher:
El Greco, no. 6260

Holy Family:
Murillo, no. 13

Holy Ghost:
Murillo, no. 13;
Valdés Leal, no. 1291

Immaculate Conception:
Murillo, Follower of, no. 3910;
Valdés Leal, no. 1291

Jacob with the flock of Laban:
Ribera, no. 244

Judas:
El Greco, Studio of, no. 3476

Lamentation over the dead Christ:
Ribera, no. 235

Mystic marriage of S. Catherine:
Portuguese School, no. 5594

Purification of the Temple:
See Christ driving the traders from the Temple

S. Agatha:
Paolo da San Leocadio, no. 4786

S. Anne:
Master of Riglos, no. 6360
Murillo, After, no. 1257

S. Catherine:
Paolo da San Leocadio, no. 4786
Portuguese School, no. 5594

S. Francis:
Zurbarán, no. 230;
Zurbarán, no. 5655

S. James the Greater:
El Greco, Studio of, no. 3476

S. Jerome:
El Greco, Ascribed to, no. 1122

S. Joachim:
Murillo, After, no. 1257

INDEX TO PROFANE SUBJECTS
AND PORTRAITS

INDEX OF PREVIOUS OWNERS

All possible owners mentioned in the Provenance sections are included in this index. The dates of anonymous sales alone are given here.

149

LIST OF PAINTINGS ACQUIRED SINCE 1970

Diego VELAZQUEZ (1599–1660)
6424 The Immaculate Conception
Canvas, 135 × 101·6 cm (53⅛ × 40 in.)
Purchased with the aid of the NACF, 1974

Bartolomé Esteban MURILLO (1617–1682)
6448 Portrait of Don Justino de Neve
Canvas, 206 × 129·5 cm (81⅛ × 51 in.)
Purchased, 1979

Luis PARET y Alcázar (1746–1799)
6489 View of El Arenal de Bilbao
Wood, 60·3 × 83·2 cm (23¾ × 32¾ in.)
Purchased with the help of a donation from an anonymous group of benefactors, 1983

Francisco BAYEU y Subias (1734–1795)
6501 Saint James being visited by the Virgin with a Statue of the Madonna of the Pillar
Canvas, 53 × 84 cm (20⅞ × 33 1/16 in.)
Purchased, 1985

Luis MELENDEZ (1716–1780)
6505 Still Life with Oranges and Walnuts
Canvas, 61 × 81·3 cm (24 × 32 in.)
Purchased, 1986

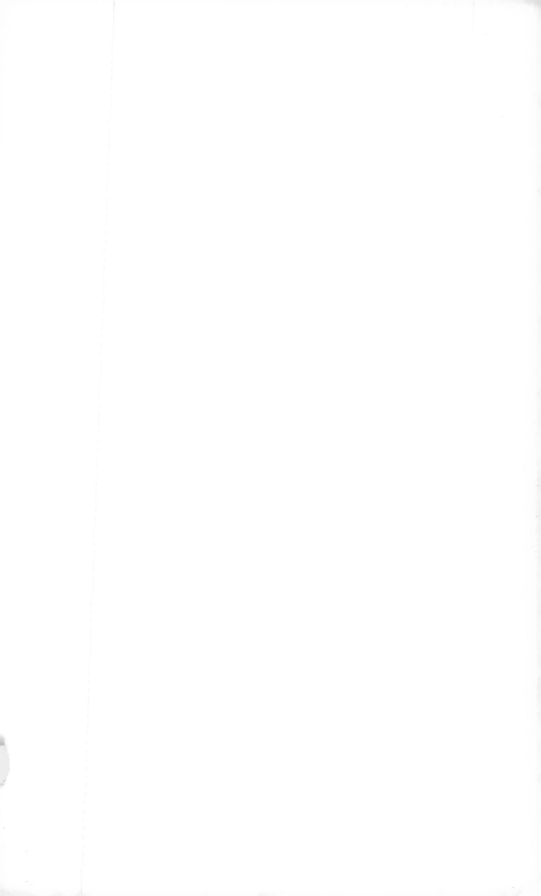